Image of the People

Image of the People

Gustave Courbet and the 1848 Revolution

T. J. Clark

with 50 illustrations

T & H

Thames and Hudson

© 1973, 1982 Thames and Hudson Ltd, London
First paperback edition 1982
Reprinted 1988

Printed and bound in Great Britain

Contents

Preface to the New Edition

This book and its companion volume, *The Absolute Bourgeois*, were written for the most part in the winter of 1969–70, in what seemed then (and still seems) ignominious but unavoidable retreat from the political events of the previous six years. Those events haunt the books' best and worst pages, and provide throughout the main frame of reference for the history of a distant revolution and its cultural dimension. Today, therefore, they are bound to seem dated, though whether to their detriment or ours is open to question. Certainly they seem to me to have been misunderstood in their main drift by commentators of Left and Right, and the misreadings have become the more bland and comprehensive as the 60's slipped away and the academic world returned to its old habits. It would be tempting to use the term 'recuperation' here were I not aware that the books themselves already took part in some such process. They were unashamedly – or at least unapologetically – academic, though less so, I hope, than they have lately been made to appear. The truth is that Left and Right were, and remain, ill-equipped to recognize the books' main line of enquiry: the Right because it wished to have them be a 'contribution' to some dismal methodological change of gear (how much I regret now the ironic courtesy intended to Arnold Hauser in the title 'On the Social History of Art'!); the Left because it went on pining either for the simplicities of socialist realism or the happy life on the avant-garde reservation. (Nowadays the latter has heavier semiotic furnishings than ten years ago, otherwise nothing has changed. A few young bucks have left for the city.)

So I owe it to the reader, confronting these relics of a slightly better time, to state again what I took to be the books' chief problem. They wished to establish what happened to art when it became involved, however tangentially, in a process of revolution and counter-revolution: in other words, when it lost its normal place in the machinery of social control and was obliged for a while to seek out other spaces for representation – other publics, other subjects, other idioms, other means of production. As my Jamesian title was meant to imply, one could hardly have expected the story, in an order already irredeemably capitalist, to be other than one of failure to find such space. Bourgeois society is efficient at making all art its own. The conditions for a rendezvous between artistic practice and the only class which henceforth could produce and sustain alternative meanings to

those of capital did not exist in 1850, and have only existed in botched and fragmentary form in the century since – against the grain of the Bolshevik Revolution, around the edges of the Workers' Councils in Berlin, Barcelona or Turin, and nowadays perhaps in the struggle of the Polish working class to reimpose soviet rule. Art may in any case be a victim of these circumstances, not a beneficiary. Yet the story told in these two books is none the less not simply futile: it has its incidence of grotesquerie and bad faith but also its moments of grandeur. The tone of the chapters on Courbet seems to me now to suffer from an occasional access of elation, but the narrative itself can largely stand. A bourgeois artist is shown to fail to make his art 'revolutionary', but his failure is in its way exemplary and at least serious: it provides us with a touchstone for other such attempts or claims, and in particular it suggests the way in which a struggle against the dominant discursive conventions in a culture is bound up with attempts to break or circumvent the social forms in which those conventions are embedded. That effort in turn seems to me necessarily to involve some kind of action against the place of art itself, as a special social practice in bourgeois society. The results of such action have undoubtedly been inconsistency, unseriousness and waste: so many diversions from the main line of art followed in due course by crestfallen, half-hearted returns to grace. But in saying this we say no more than that we have to do so far with failures. That is testimony to the hold of art and its capaciousness, but it does not mean that the original impulse was misconceived.

One of the moments I most enjoyed when the books first came out was being chided by a reviewer in a respectable art-history magazine – reviews in such places were unfailingly, nay hypnotically daft – for having dealt with Baudelaire in unkind fashion, since, though he 'may not have cut much of a moral figure [in 1848], only the most unregenerate discreditor could any longer care to deny his astonishing capacities as a poet and as a critic. (Along with the rest of us, Mr Clark should envy his powers.)' I feel embarrassed on the contrary, and apologize to the reader, for having steered too close to hero-worship in my treatment of the old *faux dévot*. The apology is all the more necessary because Baudelaire presents himself so insistently in 1981 as the only possible hero of my story. How could we fail to warm in the present circumstances to a strategy of *déclassement* and duplicity, of hiding, self-regard and self-destruction? It appears to be the appropriate heroism of the modern life which remains to us; yet I still would wish to present that of Courbet – to whom the same list of qualities applies, but with a relentless, off-putting *outwardness* added to them – as an alternative model, more difficult to emulate.

Cambridge, Massachusetts, 1981.

Preface to the First Edition

I am especially grateful to two people: John Golding, who supervised the research for this book in its earlier stages, and who has been patient and encouraging right up to the present, and Theodore Zeldin, without whose help and advice the book would certainly not have been completed; now it is, he will disagree with many of the things I have written. My thanks to Professor Francis Haskell and Professor Robert L. Herbert, who helped me at various stages of the research; and to Irene von Reitzenstein and Yoshio Abe, with whom I often discussed 1848 and after. I would like to thank John Barrell, who was the first to read and comment on the opening sections of the book, and Michael Podro, who read and criticized the whole thing. And my thanks are due to Alan Bowness, Lewis and Hazel Brodie, John Bull, Claudine Decostre, Gerhard Fries, Noella Smith, David Stewart and John Whiteley, who helped in different ways to make the book possible.

I should like to acknowledge aid from the Central Research Fund of London University, and the Research Fund of Essex University. In 1966–67 I was a research fellow of the Centre National de la Recherche Scientifique in Paris, and in 1969–70 I was Alistair Horne research fellow at St Antony's College, Oxford. My thanks to Mr Horne and St Antony's for their help.

This is a companion volume to my *The Absolute Bourgeois* already published. Each book stands on its own, but there are many links between them – the friendship of Baudelaire and Courbet, for example, or the question of Courbet's relations with the Bureau des Beaux-Arts, are matters which are broached in both volumes. The two books add up, I believe. But their subjects are separable and different.

1 On the Social History of Art

Art – in other words the search for the beautiful and the perfecting of truth, in his own person, in his wife and children, in his ideas, in what he says, does and produces – such is the final evolution of the worker, the phase which is destined to bring the Circle of Nature to a glorious close. Aesthetics and above Aesthetics, Morality, these are the keystones of the economic edifice.

A passage copied by Baudelaire in 1848 from Proudhon's *Système des contradictions économiques ou Philosophie de la misère* (1846).[1]

In our oh-so-civilized society it is necessary for me to lead the life of a savage; I must free myself even from governments. My sympathies are with the people, I must speak to them directly, take my science from them, and they must provide me with a living. To do that, I have just set out on the great, independent, vagabond life of the Bohemian.

Courbet, letter of 1850 to Francis Wey.[2]

To glorify the worship of images (my great, my only, my primitive passion).
 To glorify vagabondage and what one might call Bohemianism, the cult of multiplied sensation, expressing itself through music. Refer here to Liszt.

Baudelaire, *Mon cœur mis à nu*.[3]

M. Courbet is the Proudhon of painting. M. Proudhon – M. Courbet, I should say – does democratic and social painting – God knows at what cost.

The critic L. Enault, reviewing the 1851 Salon in the *Chronique de Paris*.[4]

Pen in hand, he wasn't a bad fellow; but he was not, and could never have been, even on paper, a *dandy*; and for that I shall never forgive him.

Baudelaire on Proudhon, letter of 2 January 1866 to Sainte-Beuve.[5]

These statements conjure up an unfamiliar time, a time when art and politics could not escape each other. For a while, in the mid nineteenth century, the State, the public and the critics agreed that art had a political sense and intention. And painting was encouraged, repressed, hated and feared on that assumption.

Artists were well aware of the fact. Some, like Courbet and Daumier, exploited and even enjoyed this state of affairs; some, following Théophile Gautier, withdrew

inside the notion of *l'Art pour l'Art*, a myth designed to counter the insistent politicization of art. Others, like Millet, accepted the situation with a wry smile – in a letter of 1853 he wondered whether the socks which one of his peasant girls was darning would be taken, by the Government, as giving off too much of a 'popular odour'.[6]

This book sets out to explore this specific moment in French art; to discover the actual, complex links which bind together art and politics in this period; to explain, for example, the strange transitions in the five opening sayings. To call a worker an artist; to call a painting 'democratic and social'; to condemn an anarchist because he failed to be a dandy – these are, to say the least, unfamiliar manœuvres. What kind of an age was it when Baudelaire took notes from Proudhon and three years later dismissed *l'Art pour l'Art* as a 'puerile utopia', saying that art was 'hitherto inseparable from morality and utility'?[7] Why did Courbet believe that art for the people was bound up with a Bohemian life-style? What was it about the *Burial at Ornans* that moved M. Enault to such anger? Such an age needs explaining, perhaps even defending.

It is not simply that the terms are out of fashion (or back in fashion, with a difference). It is the bizarre *certainty* of the arguments; it is the way they suggest an alien situation for art, an alien power. Power – no word could be more inappropriate, more absurd, now, when we talk of art. Which is if anything the reason for this book: it tries to reconstruct the conditions in which art was, for a time, a disputed, even an effective, part of the historical process.

When one writes the social history of art, it is easier to define what methods to avoid than propose a set of methods for systematic use, like a carpenter presenting his bag of tools, or a philosopher his premisses. So I begin by naming some taboos. I am not interested in the notion of works of art 'reflecting' ideologies, social relations, or history. Equally, I do not want to talk about history as 'background' to the work of art – as something which is essentially absent from the work of art and its production, but which occasionally puts in an appearance. (The intrusion of history is discovered, it seems, by 'common sense': there is a special category of historical references which can be identified in this way.) I want also to reject the idea that the artist's point of reference as a social being is, *a priori*, the artistic community. On this view, history is transmitted to the artist by some fixed route, through some invariable system of mediations: the artist responds to the values and ideas of the artistic community (in our period that means, for the best artists, the ideology of the *avant-garde*), which in turn are altered by changes in the general values and ideas of society, which in turn are determined by historical conditions. For example, Courbet is influenced by Realism which is influenced by Positivism which is the product of Capitalist Materialism. One can sprinkle as much detail on the nouns in that sentence as one likes; it is the verbs which are the matter.

Lastly, I do not want the social history of art to depend on intuitive analogies between form and ideological content – on saying, for example, that the lack of firm compositional focus in Courbet's *Burial at Ornans* [VI] is an expression of the

painter's egalitarianism, or that Manet's fragmented composition in the extraordinary *View of the Paris World's Fair (1867)* [2] is a visual equivalent of human alienation in industrial society.

Of course analogies between form and content cannot be avoided altogether – for a start, the language of formal analysis itself is full of them. The very word 'composition', let alone formal 'organization', is a concept which includes aspects of form *and* content, and suggests in itself certain kinds of relation between them – all the more persuasively because it never states them out loud. For that reason it is actually a strength of social art history that it makes its analogies specific and overt: however crude the equations I mentioned, they represent some kind of advance on the language of formal analysis, just because they make their prejudices clear. Flirting with hidden analogies is worse than working openly with inelegant ones, precisely because the latter can be criticized directly. In any discourse analogies are useful and treacherous at the same time; they open up the field of study, but may simply have deformed it; they are a kind of hypothesis that must be tested against other evidence. This is as true of art history as any other discipline. Faced with the strange and disturbing construction of the *Burial at Ornans*, it would be sheer cowardice not to give some account of the meaning of that construction; but I shall try to keep that account in contact and conflict with other kinds of historical explanation.

The question is: what in this subject can be studied, once these various comforting structures are set aside? Must we retreat at once to a radically restricted, empirical notion of the social history of art, and focus our attention on the immediate conditions of artistic production and reception: patronage, sales, criticism, public opinion? Clearly these are the important fields of study: they are the concrete means of access to the subject; time and again they are what we start from. But, to put it briefly, the study of any one 'factor' in artistic production leads us very swiftly back to the general problems we hoped to avoid. The study of patronage and sales in the nineteenth century cannot even be conducted without some general theory – admitted or repressed – of the structure of a capitalist economy. Imagine a study of the critical reaction to Courbet which had no notion of the function of art criticism in nineteenth-century Paris, no theory of the critics' own social situation, their commitments, their equivocal relation – half contemptuous, half servile – to the mass public of the Salons. Perhaps I should have said remember, not imagine: the kind of haphazard collage which results, the dreary mixture of 'absurd' and 'sensitive' remarks, is all too familiar to art historians.

Not that I want to ignore the critics and the texture of what they wrote: on the contrary. No less than forty-five writers had their say about Courbet in the Salon of 1851, and that mass of words is crucial evidence for us. It makes up a complex dialogue – between artist and critic, between critic and critic, between critic and public (sometimes that public makes an appearance, in imaginary form, within the criticism itself; for the most part it is an implied presence, a shadow, an occlusion; it is what critic and artist, in their civilized and hypocritical discourse, agree to leave out – but without success). In that weird, monotonous chorus, what matters is the

structure of the whole, and the whole as a structure hiding and revealing the relation of the artist to his public. For our purposes, the public is different from the audience: the latter can be examined empirically, and should be. The more we know about the audience – about the social classes of Paris, the consumption habits of the bourgeoisie, how many people went to exhibitions – the more we shall understand that curious transformation in which it is given form, imagined, by the critic and by the artist himself.

As for the public, we could make an analogy with Freudian theory. The unconscious is nothing but its conscious representations, its closure in the faults, silences and caesuras of normal discourse. In the same way, the public is nothing but the *private* representations that are made of it, in this case in the discourse of the critic. Like the analyst listening to his patient, what interests us, if we want to discover the meaning of this mass of criticism, are the points at which the rational monotone of the critic breaks, fails, falters; we are interested in the phenomena of obsessive repetition, repeated irrelevance, anger suddenly discharged – the points where the criticism is incomprehensible are the keys to its comprehension. The public, like the unconscious, is present only where it ceases; yet it determines the structure of private discourse; it is the key to what cannot be said, and no subject is more important.[8]

These are, I think, the only adequate attitudes to patronage and criticism in this period. And they lead us back to the terrain of those earlier theories I rejected – that is, the complex relation of the artist to the total historical situation, and in particular to the traditions of representation available to him. Even if one distrusts the notions of reflection, of historical background, of analogy between artistic form and social ideology, one cannot avoid the problems they suggest.

What I want to explain are the connecting links between artistic form, the available systems of visual representation, the current theories of art, other ideologies, social classes, and more general historical structures and processes. What the discarded theories share is the notion that all artists experience, answer and give form to their environment in roughly the same way – via the usual channels, one might say. That may be a convenient assumption, but it is certainly wrong. If the social history of art has a specific field of study, it is exactly this – the processes of conversion and relation, which so much art history takes for granted. I want to discover what concrete transactions are hidden behind the mechanical image of 'reflection', to know *how* 'background' becomes 'foreground'; instead of analogy between form and content, to discover the network of real, complex relations between the two. These mediations are themselves historically formed and historically altered; in the case of each artist, each work of art, they are historically specific.

What is barren about the methods that I am criticizing is their picture of history as a definite absence from the act of artistic creation: a support, a determination, a background, something never actually *there* when the painter stands in front of the canvas, the sculptor asks his model to stand still. There is a mixture of truth and absurdity here. It is true and important that there is a gap between the artist's social

experience and his activity of formal representation. Art is autonomous in relation to other historical events and processes, though the grounds of that autonomy alter. It is true that experience of any kind is given form and acquires meaning – in thought, language, line, colour – through structures which we do not choose freely, which are to an extent imposed upon us. Like it or not, for the artist those structures are specifically aesthetic – as Courbet put it in his 1855 Manifesto, the artistic tradition is the very material of individual expression. 'To know in order to be able to do, that was my idea'; '*Savoir pour pouvoir, telle fut ma pensée.*'[9] Nevertheless, there is a difference between the artist's contact with aesthetic *tradition* and his contact with the artistic world and its aesthetic *ideologies*. Without the first contact there is no art; but when the second contact is deliberately attenuated or bypassed, there is often art at its greatest. We shall return to this when we discuss the problem of the *avant-garde*.

The point is this: the encounter with history and its specific determinations is made by the artist himself. The social history of art sets out to discover the general nature of the structures that he encounters willy-nilly; but it also wants to locate the specific conditions of one such meeting. How, in a particular case, a content of experience becomes a form, an event becomes an image, boredom becomes its representation, despair becomes *spleen*: these are the problems. And they lead us back to the idea that art is sometimes historically effective. The making of a work of art is one historical process among other acts, events, and structures – it is a series of actions in but also on history. It may become intelligible only within the context of given and imposed structures of meaning; but in its turn it can alter and at times disrupt these structures. A work of art may have ideology (in other words, those ideas, images, and values which are generally accepted, dominant) as its material, but it *works* that material; it gives it a new form and at certain moments that new form is in itself a subversion of ideology. Something like that happened, we shall see, in the Salon of 1851.

I have been arguing for a history of mediations, for an account of their change and ambiguity. What this means in practice may become clearer if I tie it down to some familiar problems of art history. Take, for example, the artist's relation to the artistic world and its shared ideologies. In its usual form this is a question of the artist's membership of one particular 'school' – in particular whether or not he was one of the *avant-garde*. Clearly we want to know how the *avant-garde* was formed, but we equally want to know what it was *for*; in both cases what we need is a sense that the category itself is fundamentally unstable, illusory. To write a history of the *avant-garde* simply in terms of personnel, recruitment, fashion: nothing could be more misguided. It ignores the essential – that the concept of *avant-garde* is itself profoundly ideological; that the aim of the *avant-garde* was to snatch a transitory and essentially false identity from the unity of the Parisian artistic world. It is the unity that is fundamental, not the factions.

The more we look at the artistic world in Paris, the more its schools and dogmas seem an artifice; what really mattered was the ease of transition from attitude to

attitude, style to style, posture to imposture. Balzac was the great exponent of such transformations; below him (below his real, hard-won inclusiveness) lesser men traded allegiances, played at metamorphosis for a living. Gautier, the refined Parnassian poet and the agile, time-serving critic, could write a poem to the mummified hand of the poet-murderer Lacenaire (which Maxime du Camp kept in a jar), or could dash off a set of pornographic letters to Madame Sabatier.[10] The same Madame Sabatier, queen of the literary salons in the early 1850s, was portrayed at one time or another by Flaubert, Gautier (in his official role), Clésinger [5], Baudelaire, even Meissonier [4].[11] A minor figure like the novelist Duranty could combine aggressive Realism with a projected biography of Baudelaire;[12] Baudelaire himself was reconciled with his Catholic critic Veuillot.[13] These are random examples; the list could go on indefinitely.

In such a world, being *avant-garde* was just an institutionalized variant of everyone's gambit. It was a kind of initiation rite – a trek out into the bush for a while, then a return to privileged status within the world you had left. It was a finishing-school, an unabashed form of social climbing. When we look at Champfleury, Courbet's mentor and parasite, we shall see that process to perfection.

In this light the real history of the *avant-garde* is the history of those who by-passed, ignored and rejected it; a history of secrecy and isolation; a history of escape from the *avant-garde* and even from Paris itself. The hero of that history is Rimbaud, but it makes sense of many others in the nineteenth century: Stendhal, Géricault, Lautréamont, Van Gogh, Cézanne. It applies precisely, I think, to four of the greatest artists of the mid nineteenth century: Millet, Daumier, Courbet, and Baudelaire. Millet, desperately poor and deeply afraid of cholera and revolution, left Paris for Barbizon in 1849; Daumier lived quietly, almost furtively, on the Quai d'Anjou, the son of a glazier, married to another glazier's daughter; Courbet retreated to Ornans to do the crucial work of 1849 and 1850; Baudelaire wrote to his military stepfather in December 1848 and declared that he was 'separated for ever from the "respectable world" by my tastes and by my principles'[14] – in the June Days he had fought with the insurgents against the Government. Each of them had truck with the *avant-garde* and its ideas; each of them was part of it at certain moments or in certain moods; but in each case the relationship is shifting and ambiguous, a problem rather than a 'given'. We shall not solve the problem by counting heads known, ideas shared, salons visited. Count these by all means, but also measure the distance these men established from Paris and its coteries. We need to search for the conditions of this distance: the reasons for rejection and escape as much as the continuing dependence on the world of art and its values. We need also to distinguish *avant-garde* from Bohemia: they fought, for a start, on different sides of the barricades in June: the Bohemians with the insurrection, and the *avant-garde*, of course, with the forces of order.[15] We need to unearth the real Bohemia from the *avant-garde*'s fantasy of it; to rescue Bohemia from Murger's *Scènes de la vie de Bohème*. These are distinctions with some relevance to the present.

This brings us back to the problem of artist and public. I want to put back ambiguity into that relation: to stop thinking in terms of the public as an

identifiable 'thing' whose needs the artist notes, satisfies, or rejects. The public is a prescience or a phantasy within the work and within the process of its production. It is something the artist himself invents, in his solitude – though often in spite of himself, and never quite as he would wish. Sometimes, of course, the public is represented directly: the donors at the feet of the Virgin, the sitter in a portrait. In the greatest portraits we can see the tension between the sitter as subject-matter and the sitter as public; in Raphael's *Portrait of Leo X* we have on the one hand the painter's simple, ruthless sight of the Pope, and on the other his scrupulous representation of the sitter's effort to determine the way he is seen. But some such dialogue – and disagreement – goes on all the time, even when the artist is not concerned to give form to it so explicitly.

No art is hermetic; even Mallarmé dedicated *Prose* to someone, an imagined and imaginary 'Des Esseintes'. Des Esseintes was a character from another man's novel – abstract, therefore, but richly particularized; representing a phantasied elite, but an elite with real and specifically demanding faces. Mallarmé is even conscious (ironically conscious, but with an irony which reveals a real effort at a particular excellence) that he cannot satisfy this public; the poem, as the title says, remains merely *Prose, pour Des Esseintes*.

For the artist, inventing, affronting, satisfying, defying his public is an integral part of the act of creation. We can go further – we need to, if we are to understand the strength of mid nineteenth-century art and the desperation of what followed. It is when one of those stances towards the public becomes an autonomous or over-riding consideration (on the one hand, *épater le bourgeois*, on the other, producing specifically for the market), or when the public becomes either too fixed and concrete a presence or too abstract and unreal a concept, that a radical sickness of art begins.

All this is vital because Courbet was an artist for whom the public was very much present, richly, ambiguously defined: subject-matter and spectator, the mainspring of his art. I am talking here of Courbet in his thirties, from 1848 to 1856, the great period of his painting. His decline after 1856 had a lot to do with the disappearance of that public. But how and why it appeared at all, for that short period, is the central problem of this book.

Finally, there is the old familiar question of art history. What use did the artist make of pictorial tradition; what forms, what schemata, enabled the painter to see and to depict? It is often seen as the only question. It is certainly a crucial one, but when one writes the social history of art one is bound to see it in a different light; one is concerned with what prevents representation as much as what allows it; one studies blindness as much as vision.

In *The Golden Bowl*, Henry James put the matter thus – Charlotte has just expressed delight in the shopkeeper who has served the heroes –

The Prince was to reply to this that he himself hadn't looked at him; as, precisely, in the general connexion, Charlotte had more than once, from other days noted, for his advantage,

her consciousness of how, below a certain social plane, he never *saw*. . . . He took throughout, always, the meaner sort for granted – the night of their meanness or whatever name one might give it for him made all his cats grey.[16]

Whether James approved, or shared, that kind of blindness is beside the point; as described, it is a nineteenth-century disease. When the blindness is breached by extreme circumstances the result is pathos. Listen to Tocqueville, suddenly confronted, when the National Assembly was invaded by the clubs on 15 May 1848, with the arch-revolutionary Louis-Auguste Blanqui:

It was then I saw appear, in his turn at the rostrum, a man whom I never saw save on that day, but whose memory has always filled me with disgust and horror. His cheeks were pale and faded, his lips white; he looked ill, evil, foul, with a dirty pallor and the appearance of a mouldering corpse; no linen as far as one could see, an old black frock-coat thrown about spindly and emaciated limbs; he might have lived in a sewer and have just emerged from it. I was told that this was Blanqui.[17]

It is not merely that this description of Blanqui is untrue – though we have only to put Tocqueville's paragraph against the drawing by David d'Angers [1] (done eight years earlier) to show that. It is more that we are confronted with prejudice which clearly believes itself to be description: before our eyes depiction changes into ideology (Blanqui, incidentally, was a test-case for this kind of manœuvre – when Baudelaire sketched him from memory in 1850, with a certain degree of sympathy, even admiration, it is not surprising that he turns Satanic, agonized, a political Melmoth).[18]

So the problem of schema and pictorial tradition is rather altered. The question becomes: in order to see certain things, what should we believe about them? What enables an artist to make effective use of a certain schema or the formal language of a certain artist of the past? There is nothing unchanging or automatic about this. To take one example I shall discuss later in the book, it became quite fashionable in certain circles after 1848 to admire the art of the seventeenth-century brothers Le Nain. Several critics praised them; several artists attempted to imitate them. But your Le Nains and my Le Nains? Courbet's Le Nains and Champfleury's? Worlds apart, we shall discover – indeed, what Champfleury half-laughingly called their weaknesses, Courbet went ahead and used. What we want to know are the reasons for that difference; and we shan't find them by adding up 'influences'.

The same thing applies to popular imagery. When Courbet said, in his 1850 letter to Francis Wey, that he wanted to draw his science from the people, he meant, among other things, pictorial science. All his circle of friends and admirers were interested in popular art; but how many put it to use instead of collecting it? How many realized that they needed its forms and structures if, 'below a certain social plane', they were to see at all? Courbet did; his friend Buchon knew it but could not act upon it; I doubt if Champfleury, the great propagandist for popular imagery, really understood the point. So here too one must integrate the separate art-historical problem into a wider account; one must ask, ultimately, what kind of

'visibility' a certain symbolic system made possible; and in what specific circumstances one artist could take advantage of this, and another fail to. To answer merely in terms of artistic competence is just begging the question.

There is thus a general question which cannot be avoided, though the means of access to it must be particular: whether we can discover in the complex and specific material of a single artist's historical situation and experience the foundation of his unique subject-matter and 'style'.

Let us take the case of Courbet. It is fairly easy to list the various factors to be taken into account when we talk about his art: his situation in rural society and his experience of changes within it; the various representations – verbal and visual – of rural society available to him; the social structure of Paris in the 1840s; the iconography of Bohemia and his use of it; the nature and function of his notorious lifestyle in the city; the artistic ideas of the period; the aspects of artistic tradition which interested him. We shall have to give flesh to these bare categories of experience; but the list itself, however elaborate, stays this side of explanation. The real problem is to describe the specific constellation of these factors in 1849–51, and what determined that constellation. In other words, what made Courbet's art distinctive, effective, at a certain moment?

To answer that, we shall have to go far afield, from painting to politics, from a judgment of colour to more general concerns – concerns which touch the State, which move anger and delight because they are the concerns of many. But we shall discover these politics in the particular, in the event, in the work of art. Our starting point is a certain moment of historical coalescence – a gesture, or a painting, which is supercharged with historical meaning, round which significance clusters. The *Burial at Ornans*, the *Stonebreakers*, and the *Peasants of Flagey* are paintings like this – the more we look and enquire, the more facets of social reality they seem to touch and animate.

Take one small but significant gesture to illustrate the point. In May 1850, in Salins in the Jura, a religious procession took place. The Procurer General, the political prosecutor of the regime, reported on the matter to the Minister in Paris:

The situation in the town of Salins, the most degenerate of all the Jura towns, shows signs of improving. The processions for Corpus Christi day were very colourful and went off in a very orderly way; a special procession, ordered in this town by the Bishop of Saint-Claude, *to atone for Proudhon's blasphemies*, did not give rise to any disturbances, even minor ones. We were extremely surprised to see citizen Max Buchon taking part in this procession, candle in hand, and in a state of perfect composure; he is one of the leaders of the Socialist party, a professed advocate of the doctrine of Proudhon, and apparently his intimate friend. Did his presence at this ceremony indicate, as many have supposed, sincere contrition? I see it rather as one of those eccentricities which we have long since been led to expect from this man, who loves above all to strike a pose and make himself a talking-point.[19]

Max Buchon cracks a joke: one which typifies the time. Jokes resemble art, certain Freudians have suggested, in their treatment of unconscious material;

perhaps in their treatment of historical material too. Buchon's joke plays on his audience's doubts about history; he puts the unexpected in contact, confuses codes; instead of an argument he uses an act and its ambiguity. In this particular case, the tactic was advisable – it was difficult, even in 1850, to send a man to jail for a joke you did not quite understand, and Buchon wanted to avoid jail (he had been acquitted of revolutionary conspiracy four months earlier at the Jura assizes).

As with the pictures, I shall later have to explain the point of the joke and its material, spoiling it in the process. We shall have to know more about Buchon himself, Courbet's oldest friend, poet and translator, dedicated revolutionary. More also about Salins and the strange politics of 1850; about the radical confusion of religion and politics after 1848; about the nature of this kind of public irony, the whiff of the dandy and Baudelaire in the whole performance (if Proudhon was no dandy, some of his followers were). Knowing about Buchon and Salins (a twenty-five-mile walk from Ornans, and Courbet's point of political reference) will eventually lead us back to the *Burial at Ornans*, the beadles' red noses and Buchon's place in that particular religious procession (he lurks in the background, sixth from the left).

From a wisecrack to a masterpiece; but in both cases it is what is done to the historical material that counts. Joke and picture play with different contexts of meaning in order to constitute an individuality. Discover the codes by all means. Investigate burials, religion, Salins and Ornans; describe the political temper of the Jura, the social significance of a frock-coat and spats. But remember also that Buchon and Courbet juggle with meanings, switch codes, lay false trails and make *one* thing, not many. (A quick pun, not an immense shaggy dog story.) Look at the process of transformation – call it work, call it play – as well as what the work is done to.

Striking that balance is sometimes difficult, especially in the social history of art. Just because it invites us to more contexts than usual – to a material denser than the great tradition – it may lead us far from the 'work itself'. But the work itself may appear in curious, unexpected places; and, once disclosed in a new location, the work may never look the same again. That, at any rate, is this book's intention.

I have been saying that there can be no art history apart from other kinds of history. But let us restrict ourselves in a rough and ready way to art history 'proper'. Even within the discipline – perhaps especially here, just because its limits are so artificial – there is a problem of choice of perspectives.

So far, nineteenth-century art history has usually been studied under two headings: the history of an heroic *avant-garde*, and the movement away from literary and historical subject-matter towards an art of pure sensation. But what a bore these two histories have become! It is not that they are false in any simple sense – just that they are no more than fragments of the story. And one cannot help feeling that what they miss is precisely the essential. Try to understand, for example, the careers of Cézanne and Van Gogh with their aid! We shall retrieve the meaning of these concepts only if we demote them, uncover the *avant-garde* only

if we criticize it, see the point of an art of pure sensation only if we put back the terror into the whole project. In other words, explain Mallarmé's words to Villiers de l'Isle-Adam: 'You will be terrified to learn that I have arrived at the idea of the Universe by sensation alone (and that, for example, to keep firm hold of the notion of pure Nothingness I had to impose on my brain the sensation of the absolute void).'[20] Which leads us straight to Hegel and other disagreeable topics.

What we need, and what a study of any one period or problem in detail suggests, is a multiplicity of perspectives. Let me name a few, more or less in note form, which the substance of this book suggests.

First, the dominance of classicism in nineteenth-century art – not just the continuing power of academic classicism in the Salon, but the bias of French art towards an introspective, fantastic, deeply literary painting and sculpture which drew on antique form and subject-matter. An art history which sees Chassériau, Moreau, Gérôme, Rodin, Puvis and Maurice Denis as marginal episodes, rather than the most vivid representatives of a vigorous, enduring tradition – that art history will not do. Precisely because it fails to account for the ambivalence of artists whom we call *avant-garde*: the classicism of Corot, of Daumier, of Millet, Degas, Seurat. Realism is an episode against the grain of French art; and therefore its forms have to be extreme, explosive. Hence Courbet's Realism; hence Cubist realism which looked back to Courbet as its extremist founding father; hence, finally, Dada. And hence also the neo-classical reaction against all three.

Second, the progress of individualism in French art – which is something different from the movement towards an art of absolute sensation. It was a doctrine with confusing implications for the arts. Moreau and Rodin thought it meant the reworking of classical form and content. Courbet thought it meant immersion in the physical world, a rediscovery of the self the other side of matter (in this he was the carrier of his friends' Hegelianism).[21] Gautier and the classicists thought it an unworthy ideal. Individualism was the platitude of the age, contradictory, inflated, often absurd; yet somehow or other the idea that art was nothing if not the expression of an individuality, and that its disciplines were all means to this ambiguous end, survived. The Realist movement was shot through with this dogma; why it persisted, and what in practical terms it prescribed, is a central nineteenth-century problem.

Third, whether to sanctify the newly dominant classes or to look for a means to subvert their power. Whether to address your respectful, ironic preface *Aux Bourgeois*;[22] or to climb the barricades, hands black with powder, to dispute their rule. Baudelaire tried both solutions in the space of two years, and then gradually retreated into an icy disdain: 'What does it matter whether the bourgeoisie keeps or loses an illusion?' as he commented in 1859.[23] But it continued to matter for artists; they continued to wonder whether bourgeois existence was heroic, or degraded, or somehow conveniently both. They did so because it was a doubt that touched their own identity. Was one to be, as in Renoir's *Portrait of Alfred Sisley and his Wife* [3], the artist as bourgeois; or was one to be, in fact or dream, in a thousand evasive self-portraits, the artist as outcast? Or, perhaps, the artist as

opponent – Courbet's intention, which also persisted. (In the 1880s and 1890s art and anarchism renewed their contact.)

Fourth, the problem of popular art, which is part of this wider crisis of confidence. In its most acute form – in Courbet, in Manet, in Seurat – the problem was whether to exploit popular forms and iconography to reanimate the culture of the dominant classes, or attempt some kind of provocative fusion of the two, and in so doing destroy the dominance of the latter. On its own, a Utopian project. But one which haunted French art, from Géricault's London lithographs to Van Gogh's Arlesian portraits. Hence, once again, the connection of art with political action.

Fifth and last, the withering-away of art. In a century which 'liberated the forms of creation from art'[24] – the century of the photograph, the Eiffel Tower, the Commune – iconoclasm is not incidental. No theme is more insistent; it is, necessarily, part of the century's Realism. Iconoclasm and l'Art pour l'Art are different responses to the same unease. When Proudhon wrote in Philosophie du progrès, in November 1851, 'For our own most rapid regeneration, I should like to see the museums, cathedrals, palaces, salons, boudoirs, with all their furniture, ancient and modern, thrown to the flames – and artists forbidden to practise their art for fifty years. Once the past was forgotten, we would do something,'[25] he was, surprisingly, addressing himself to the same problem that exercised Gautier. His bluster is only the other side of Gautier's irony ('You think me cold and do not see that I am imposing on myself an artificial calm,' as Baudelaire put it later).

Somewhere between irony and bluster lie Courbet's attitudes, or Baudelaire's conviction in 1851 that 'art *had to be* inseparable from . . . utility'. In Baudelaire's case that belief lasted three or four years at the most; afterwards came blackness, despair, the first poetry to celebrate 'the theatrical and joyless futility of everything' (Jacques Vaché). If art was useless, so was life; and that was not an idiosyncratic conclusion. It leads us to Mallarmé's 'horrible vision of a work that is pure' ('*vision horrible d'une œuvre pure*'), to Tzara's 'Rhymes ring with the assonance of the currencies, and the inflexion slips along the line of the belly in profile', and to Miró's 'murder of painting'.

The inheritor of Baudelaire's short-lived belief is Surrealism: in Breton's words, 'We have nothing to do with literature, but we are quite capable, when the need arises, of making use of it like everyone else.' Though by then the implications of that belief were clearer: to quote the Surrealist Declaration of 1925, 'We are not utopians: we conceive of this Revolution only in its social form.'

When Proudhon talked in *Du principe de l'art* of creative activity entering the world and taking it as its material, to be altered directly and not just on canvas, he echoed Hegel but presaged the moderns.[26] Malevich said, 'Let us seize the world from the hands of nature and build a new world belonging to man himself.' And Mondrian: 'One day the time will come when we shall be able to do without all the arts, as we know them now; beauty will have ripened into palpable reality. Humanity will not lose much by missing art.'

2 The Courbet Legend

I have as my guarantee the hatred I bear towards men and towards our society, which will last as long as I live.
Courbet to Bruyas, 1854.[1]

Baudelaire once planned an essay on Courbet, after their friendship was over. He took as his motto a clumsy phrase from one of the painter's letters to Champfleury, 'Puisque Réalisme Il Y A'; and he began with a page of spleen against Champfleury and his third-rate enthusiasms. Then he jotted down two headings: perhaps they indicate what he would have written, once the anger had subsided –

'(*Analysis of Nature, of the talent of Courbet, of morality*).'

'*Courbet saving the world.*'[2]

These are cryptic notes, and as so often with Baudelaire, they suggest an effort to hold together in a single thread of narrative very different kinds of knowledge. To do so would be half a challenge to the subject in hand, half a homage to it. To analyse Courbet's talent would mean explaining Nature and its horrors, and mocking the Realist's worship of sanctified vegetables. But it would also mean discussing, with a certain baffled admiration, the eccentric morality of Courbet's art; it would mean taking seriously, for once, the enormous, beery cynicism of his greatest paintings. (One critic in 1853 called the great naked *bourgeoise* who steps from the water in *The Bathers* 'this heap of matter, powerfully rendered, cynically turning its back on the beholder'. That could stand as a motto for Courbet's art as a whole between 1849 and 1856.) And it would mean, above all, putting the talent alongside the pretensions; giving weight to Courbet's immense, rambling philosophy and his desire to save the world. I want to make a living art, I want to be a man: so Courbet thundered in his 1855 manifesto. The last of Baudelaire's headings sums that up. It adapts the proud title that Courbet had invented that same year for his

21

portrait of Jean Journet, the Fourierist prophet, 'setting out for the conquest of Universal Harmony'. Where Journet went, so the heading implies, Courbet followed: whether to universal harmony, which Journet never reached, or the padded cells of Salpêtrière, which he knew quite well.

What I want to do in this book is follow in Baudelaire's footsteps, or at least set myself the same sort of task. Since there is Realism, and since Courbet's version is a problem still – no less mysterious for being so blatant – I want to keep quite different kinds of explanation in contact. I want to distinguish the art from the life-style, but give each their separate weight. I want to suggest the purpose of Courbet's poses; to find what the egotism and the crazy ambition were for; to see why Courbet cultivated the confusion between his art and his life.

This is not to accept the poses at their face value, nor abandon Baudelaire's irony in the face of Courbet's bluster. It is not, above all, to apologize for Courbet; but at least to rescue him from one particular, patronizing myth. The myth in question goes like this: Courbet, a vain man, a simpleton, a *naïf*, a peasant who could not spell, '*rien qu'un peintre*', was led into Realism and politics by various friends, more or less unscrupulous; had them draft his theories; grew fat on their praise; ended by believing that his art was political; and paid for it in the fiasco of the Commune. The myth has many sources, but the main one is Champfleury. 'I am delighted that Courbet is working' – this is one of a score of such passages in his letters in the 1860s –

The way of life in the countryside will be better for him, and healthier, than the brasseries of Paris. The country should make him forget, I hope, his role of saviour of the world through painting. He is a painter, a robust, excellent painter. So let him remain what nature made him, simply a painter.[3]

Those instructions have been echoed often enough since; they are the staple diet, still, of books about Courbet. If only Courbet had stuck to his easel; if only he had not left us those blundering manifestoes, those vulgar pronouncements on politics; if only he had not listened to Proudhon (or Dupont, or Buchon, or whoever the writer's ideological villain may be): this is the myth in its modern form. And yet Champfleury's letters, the authentic source of the myth, are transparently dishonest: an inimitable mixture of personal pique and aesthetic despair; a giving up of the critical ghost. Take for example a comment like this:

Understand that it is not exactly the subjects Courbet chooses which shock me. If only they wore sufficient covering, I wouldn't mind if he showed a bather, some priests, or Proudhon's family.[4]

It is sad, I think, that phrase 'sufficient covering'. Sad from a man who had made a real effort at criticism between 1848 and 1855. It seems almost as if the myth itself were to blame: the myth of Courbet produces the critical bathos in the face of his work. And the question becomes why the myth survived at all, if these were its origins. But to answer that would lead us to France in the 1870s, after the

Commune, and the world of art in the twentieth century, which is much too far from 1848.

I shall offer instead one example of Courbet as his enemies saw him. This is Alexander Dumas the younger, writing his 'Lettre sur les choses du jour' on 6 June 1871:

From what fabulous crossing of a slug with a peacock, from what genital antitheses, from what sebaceous oozing can have been generated, for instance, this thing called M. Gustave Courbet? Under what gardener's cloche, with the help of what manure, as a result of what mixture of wine, beer, corrosive mucus and flatulent oedema can have grown this sonorous and hairy pumpkin, this aesthetic belly, this imbecilic and impotent incarnation of the Self? Wouldn't one say he was a force of God, if God – Whom this non-being has wanted to destroy – were capable of playing pranks, and could have mixed Himself up with this?

This is much better writing than most on the same subject.

Instead of the myth, let us go back to Courbet before he was famous, on the eve of the 1848 revolution. Evidence is scarce from this time, but what we have suggests a Courbet without a *persona*. (It is as if the life-style is chosen – almost constructed – in the next few years, at the same time that Courbet discovers his style as a painter.) When Baudelaire drew Courbet on a sheet of caricatures, perhaps as early as 1847, he already sported his Assyrian profile, and was already perhaps the *poseur*. But when Francis Wey saw him for the first time in his studio in 1848, he was still 'a tall young man, with superb eyes, but very thin, sallow, bony, gawky (so he was then), and he nodded to me without uttering a word'. He was already 'bizarre', already 'in revolt at one time or another against most theories, and imbued with a deliberate ignorance, which aimed at making an effect'.[5] But there is an air of sobriety, even sombreness, about Wey's account of Courbet at twenty-nine; and that is also the tone of the most reliable witness we have – he is the only one who writes free from hindsight – Prosper Haussard in his *Salon* of 1849:

M. G. Courbet, who has come to Paris from a village in the provinces, promised himself that he would be a painter and be his own master. He has kept his word. After ten years of studying, of painful effort and hesitation, after ten years of hardship, poverty and obscurity, at the very moment when he had run out of money and was ready to give up, here he is – a painter, and very nearly a master already. . . . These hard beginnings, this solitary apprenticeship, and the long trials endured by M. Courbet, are all visible in his paintings, which are marked by a certain sombre and concentrated force, by a sadness of expression and a certain savagery in their style. His landscapes . . . are no more than sketches; yet they have this same grave and penetrating character.[6]

This suggests someone quite different from the Courbet who struts towards *The Meeting* (painted in 1854), or even the Courbet of 1851 who stated that he was 'not only a Socialist, but a democrat and a Republican as well: in a word, a supporter of the whole Revolution, and, above all, a Realist, that is to say a sincere lover of genuine truth'.[7] It is a long way from Haussard's painter of 1849, whose works mirror his 'grave and penetrating character', to the Courbet of the 1860s, the

Courbet whom Zola described in his notes for *L'Oeuvre*: 'the monster puffed up with his own personality, unselfcritical, who has become God: Courbet, Hugo'.[8] (Not that this was Zola's last word on either of them.)

Once it was chosen, Courbet's *persona* was often described in print. The finest account is by Jules Vallès, Courbet's friend, novelist and *Communard*; he transcribes the artist's version of the French language in a way which has to be left intact:

COURBET. Eh lon lon laire, lon la! Quaî? quouâ? l'Hi-daî-ial? Mon maîre étai un hônge! – La Crrouâ, mon nhâmmi? Mais, si je voullâi, je pourrai me foutrrre un calvaire au cul . . . – En quârrant-huit i gn'iâvai qu'deux hômmes de prraîts: moâ et Peurrouddhon. Vous aîtes don un impôsteur qu'vous dites que Jaîsus-Christ i vivaî o daipens dais fâmmes ai qu'vous voulaî pas dire qu'c'étai un mâqquero? Commen qu'vous avaî dit ça? . . . l'Hidaî-ial?

And circumflexes, and modulations, with bursts of laughter exploding in his beard, which he would then wipe with the back of his hand. His belly danced, he pranced up and down, laughed till he cried, wiped away a tear from the corner of his cow-like eye with his fat fist. . . .

The most beautiful animal I have seen, this blessed fellow! Works like an ox, but as gay as a bear-cub: a beast of the fields and a beast of the fair. . . .

So naively vain, so grotesquely eloquent, disorderly and patient, hard-working and thirsty, with the paunch of Silenus, the pride of Jupiter, the beauty of Sesostris: on top of all this as careful of his purse as Sancho, wishing for windmills on his island, and talking of the 'million' to be won![9]

A hundred other caricatures and anecdotes tell the same story – the same deliberate rustic *patois*, the enormous stomach, the beer, the vanity, the laugh. The official police report of 1873 put it succinctly: 'the air of a jeering peasant'. A police spy sat next to him in the brasserie one day in 1872 and reported his truculent style of politics (a sad disguise for his own recantation in the previous year): 'It seems he reproached Martin Bernard with abandoning the Commune, and told him that he and Louis Blanc would be the first victims of a new commune.'[10]

But this, of course, is Courbet in full decline, dying of alcoholism and political shell-shock, the prisoner of his public face. In the period which concerns us, the *persona* was still under construction; the poses were being chosen, but the reasons for the choices were clearer. In the early 1850s, Courbet was well aware that 'to live the life of a savage', as he decided in the letter to Francis Wey which I used to begin this book, was a dangerous and *costly* project – a necessity, but a bitter one. For Courbet the alcoholic, Courbet the father of an abandoned bastard, the idea that his public personality was no more than a mask was not just rhetoric. He wrote to his patron Alfred Bruyas in November 1854: 'Behind this laughing mask of mine which you know, I conceal grief and bitterness, and a sadness which clings to my heart like a vampire. In the society in which we live, it doesn't take much effort to reach the void.'[11]

This is a rare moment in Courbet's letters, an important one. Its language is the commonplace of Romantic confession, borrowed and ill-digested, like Courbet's pictorial Romanticism of the 1840s. But its very clumsiness is revealing: the way

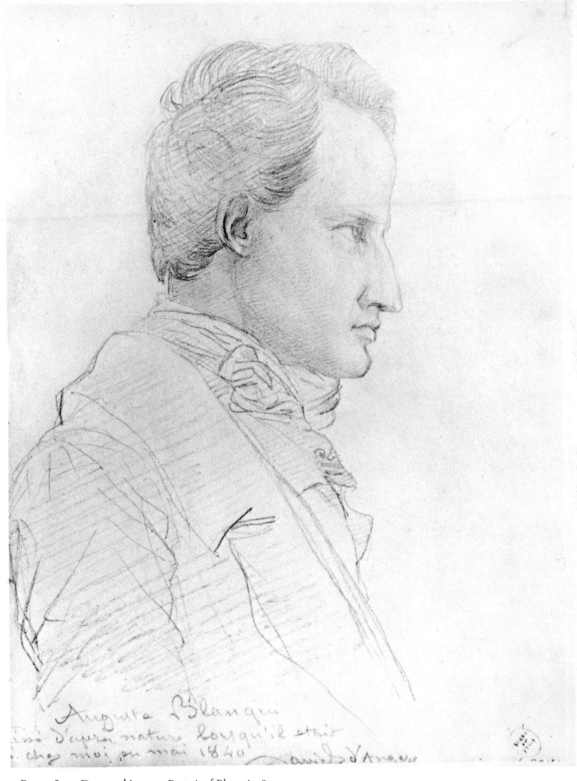

1 PIERRE JEAN DAVID D'ANGERS *Portrait of Blanqui* 1840

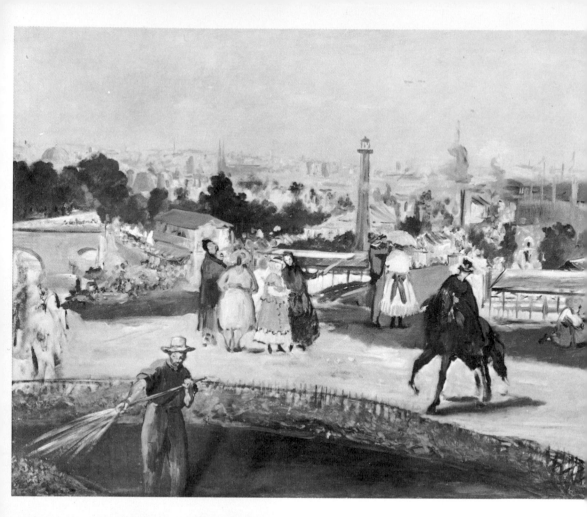

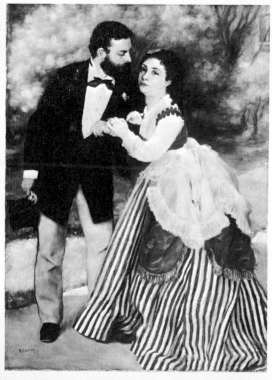

2 EDOUARD MANET
View of the Paris World's Fair 1867

3 AUGUSTE RENOIR
Portrait of Alfred Sisley and his Wife 1868

4 ERNEST MEISSONIER
Portrait of Madame Sabatier 1853

5 AUGUSTE CLÉSINGER
Woman Bitten by a Snake 1847

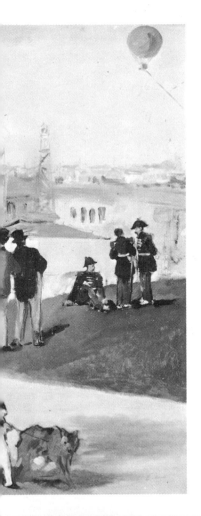

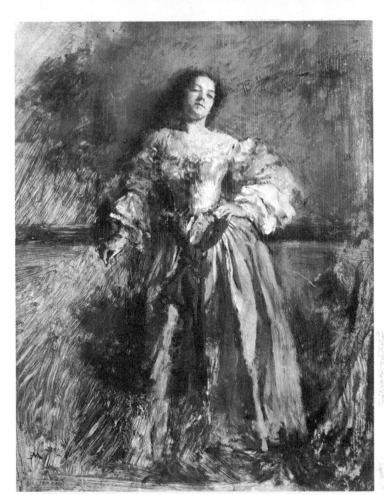

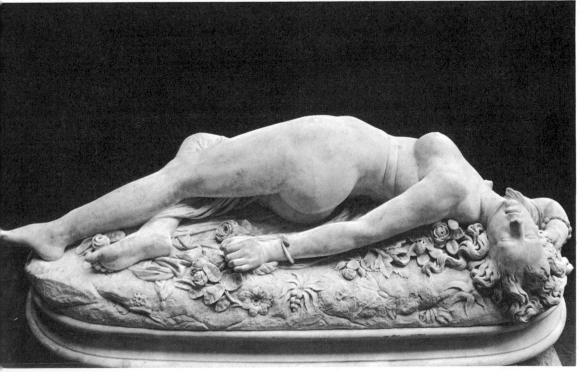

6 GUSTAVE COURBET
The Apostle Jean Journet 1850

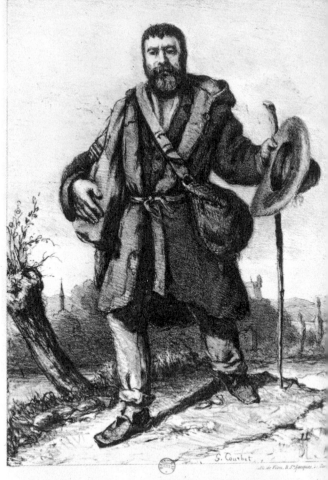

L'APÔTRE JEAN JOURNET
partant pour la conquête de l'harmonie universelle.

7 NADAR
Jean Journet 1857

the pale, sombre young man of 1848 suddenly reappears, only to be stoically repressed in the next sentence or two. Courbet himself is not at home in this vein; and the next sentence is a return to his public voice: he had met a Spanish woman in Lyons, and 'She prescribed a remedy which cured me completely'.

We do not know much of Courbet's sexuality, beyond the comic promiscuity depicted in a letter to Buchon and in another to Alfred Bruyas. In 1847 his mistress Virginie Binet bore him a son; and some time in the early 1850s she left him, taking her son with her. All that survives of that crisis is a letter to Champfleury, didactic, pathetic: 'I shall miss my boy very much, but art gives me enough to do without burdening myself with a household; moreover, to my mind a married man is a reactionary.'[12] This was anathema to Champfleury, a solid family man; much later he recalled Chenavard and Courbet poking fun at Proudhon in 1852 for his new-found bourgeois domesticity (he had married three years earlier, a few days after taking his *Confessions d'un révolutionnaire* to the press).[13] That was one of the few occasions when Proudhon came in for Champfleury's sympathy.

So this is the 'life of a savage' which Courbet chose in 1850: a disguise which was necessary (the letter to Wey is certain of that), but bought at some considerable cost. The question must be: what was the advantage in the elaborate disguise, what did it enable Courbet to do? I think the answer is this: the mask let Courbet remain inside Paris – at the very centre of the world of art, in a way quite different from Millet or Daumier – without becoming part of it. He acted the part of invader, outsider, vulgarian, in order to stay in the middle of things, but keep his own distance from them. My point is more or less the opposite of Champfleury's in the letter I cited: I think the evidence shows that Courbet needed the brasseries of Paris in order to sustain his painting of rural life; he played the rustic – believing in the role, of course – in order not to be a bourgeois, but to have access to everything that only a bourgeois knew.

Courbet wanted knowledge: there is no doubt of that. He pretended total ignorance of things, but he thrived on other people's sophistication. For a painter who, according to the myth, was nothing but an eye and a technique, Courbet surrounded himself with an unlikely collection of friends. Who frequented the Brasserie Andler and the Cénâcle de Bas-Meudon? Who but the intellectuals and philosophers of artistic Paris: Chenavard, the very type of artist-philosopher, acquainted with Hegel himself; Marc Trapadoux, mystic and Bohemian, 'brahmin' as Courbet called him in 1849, biographer of St John of the Cross; Francis Wey, friend of Rémusat and the official Republicans of the *National*, king of the *roman-feuilleton*, author of a weird and provocative *Almanach démocratique* in 1848; Jean Wallon, the philosopher of Murger's *Scènes de la vie de Bohème*, translator of Hegel's *Logic*, author of *De la nature hyperphysique de l'homme*; Champfleury, complex opportunist, in 1847 still planning a history of Egyptian art and at the same time writing pantomimes for the Funambules; Baudelaire; Planche, critic, academic, eccentric, friend of Balzac, enemy of Realism; Pierre Dupont and Gustave Mathieu, the worker-poets of 1848; the young Jules Vallès, just escaped from school; Proudhon, from time to time.

In some strange way, Courbet was the force that held the Brasserie Andler together (Herr Andler admitted it, rather ruefully: Courbet was good for business). He thrived on its mixture of the gross and the intellectual; the others sat and laughed at his hour-long tirades against the Ideal and in favour of Alsatian beer: they laughed but they listened, night after night. Courbet was, in fact as in legend, a *naïf*, almost an illiterate, with wild spelling and disintegrating syntax spilling over page after page. Yet he was also, in his own cantankerous way, a theorist, a doctrinaire. Proudhon himself groaned under the onslaught of the twelve-page letters, beer-stained and crumpled, which greeted his drafts of *Du principe de l'art*.

What Baudelaire feared and despised in Courbet was not his naivety but his theoretical determination, his manic resolve to push the theory of Realism to its logical conclusions: he had taken up Champfleury's half-laughing, casual catch-phrase and taken it seriously, ruthlessly even; he was the theorist of Champfleury's opportunistic practice. 'As for Courbet, he has become the clumsy Machiavelli to this Borgia. . . . Courbet has made a theory out of an innocent farce, with a strict-ness of conviction which is positively dangerous.'[14] And what was fearsome about that was the way in which theory, in Courbet's hands, became an instrument of *personal* domination (at least over such a fragile psyche as Baudelaire's). As Baude-laire put it later in *Pauvre Belgique*, 'the philosophy of our friend Courbet, poisoner with a vested interest. (Paint only what you see! I.e. *you* will paint only what *I* see.)'[15]

Courbet the theorist is an unfamiliar animal, but not simply a figment of Baudelaire's imagination. There is other evidence. In spite of the spelling and the syntax, there is plenty of intellectual force in Courbet's letters between 1848 and 1855. When late in 1849 he wrote Francis Wey a description of his own *Stone-breakers*, Wey took it over, word for word, as the centrepiece of a chapter in his own novel *Biez de Serine*. This was a calculated tribute (which the critics misunder-stood, thinking Courbet had based his picture on Wey's story), but appropriate. The letter itself solved problems:

There is an old man of seventy, bent over his work, pick in air, skin burnt by the sun, his head in the shade of a straw hat; his trousers of rough cloth are patched all over; he wears, inside cracked wooden clogs, stockings which were once blue, with the heels showing through. Here's a young man with his head covered in dust, his skin greyish-brown; his disgusting shirt, all in rags, exposes his arms and his flanks; leather braces hold up what is left of a pair of trousers, and his muddy leather shoes are gaping sadly in many places. The old man is on his knees, the young man is behind him, standing up, carrying a basket of stones with great energy. Alas, in this occupation you begin like the one and end like the other! Their tools are scattered here and there: a back-basket, a hand barrow, a ditching-tool, a cooking-pot, etc. All this is set in the bright sun, in the open country, by a ditch at the side of the road; the landscape fills the whole canvas.[16]

Courbet's rapid, accurate phrases; his visual accuracy at the expense of verbal

awkwardness; his casual interjection of a moral ('Alas, in this occupation, you begin like the one and end like the other!') which hardly interrupts the flow of description, which refuses to be a verbal climax: all this is language that Wey, or Champfleury, or Buchon, still struggling in 1849 to adapt older styles of rhetoric to new purposes, could justly envy. (It will be argued of course that Courbet simply did not see the problem. What, after all, had he to do with the writers his friends admired and imitated, people like Hoffmann, or Chateaubriand, or George Sand? But this does not explain away his management of description in this passage; or his effect on writers who knew Hoffmann and George Sand too well.)

Baudelaire's phrase 'clumsy Machiavelli' is a good description, an essential one. Even the 1855 Manifesto has the appearance of personal thought, not dictation from Champfleury or Bruyas. It is a struggle to appropriate a multitude (too many) of other people's ideas, but also to define their use for his own project, to turn a sequence of complex ideas into a creed. The result is confusion, but it is Courbet's confusion, no one else's.

We have come a long way from the Courbet of caricature, the *naïf*, the rustic, arranging his Assyrian profile for the camera of Nadar or Carjat. Let's go no further, for the camera does not lie. The naivety *is* the essence of the man: all we have to do is learn to take that naivety seriously. Seriously enough to see its purpose, the advantage for Courbet in his laughing mask, his *vie de sauvage*.

The advantage, in one word, was distance – detachment from the stifling, chaotic agreement which prevailed among the members of the Parisian *avant-garde*; openness to ideas and experience which were profoundly alien to that world and its coteries. To be in Paris but not of it: that was what Courbet wanted. To use the ideas and inventions of the *avant-garde* for his own ends: that was the ambition, spelt out in the letters to Francis Wey. One could not do this simply by changing places, though Courbet in his thirties was an adept at that – moving from Brussels to Montpellier, Munich to Berne, Salins to the Indre, with a mixture of unease and exhilaration. In the end one came back to Paris, to the Salon, to the brasserie, to one's own reputation. How to survive in that world? And not merely to survive, how to dominate, instruct, antagonize? One needed camouflage, and that Courbet had in plenty – obstinate *patois*, provincial manners, the pose of a peasant – but to dominate one needed more than that. This was where the naivety did its work: it was, for Courbet, a strategy of exposure to Paris, a kind of power over the city's confusion.

Buchon saw this clearly when he talked, in a famous passage, of the advantages of Courbet's spontaneity:

Courbet's greatest advantage, in the midst of the chaos surrounding him, is undoubtedly his rich spontaneity. . . . I have mentioned Courbet's spontaneity. Let me now mention the sureness of his glance, the subtlety of his moral sense, the ease with which he follows and often dominates the movement of current sane ideas [*saines idées ambiantes*], helped only by

his great intuitive power. Courbet has never had anything in the way of instruments of education and study except his magnificent vision, and that has been quite enough.[17]

The point here is not the general praise of Courbet's simplicity, but the fact that Buchon saw what it was for. It did not cut Courbet off from social and moral awareness; on the contrary, it was the source of his political assurance, his open responsiveness to the *saines idées ambiantes* of his time. (And the *ambiance* was not just Paris: Courbet's politics in 1850 had a different frame of reference, and that is why they proved so explosive in Paris itself.) There are moments when naivety does not close horizons, but opens new ones: does not shut a painter within the confines of his craft, but breaks those limits completely.

The Courbet I propose is both rustic and theoretician – a peasant in order to be doctrinaire, doctrinaire in order to stay a peasant. He is the *naïf* surrounded by intellectuals, the jeering peasant with the enormous paunch, in the brasserie with Chenavard, or Proudhon, or Villiers de l'Isle Adam. He is above all an extremist, an *excentrique*, a *réfractaire*. Which leads us back to Baudelaire's phrase: '*Courbet saving the world*'.

If there was one man who served as a model for Courbet it was Jean Journet, the half-mad, fearless, ridiculous prophet of Fourierism, whom Champfleury had described in an 1847 *feuilleton*,[18] and Courbet had painted 'setting out for the conquest of Universal Harmony' in 1850 [6]. Courbet *became* Jean Journet, as Baudelaire ironically implied: adopted his manic style, decided (in the 1850 letter to Wey) that he too would embark on 'the great vagabond and independent life of the Bohemian'. He became Journet, even in pictorial terms: he had based the 1850 portrait of Journet on a popular image from Le Mans of the Wandering Jew; and he used the same image as the source of his own definitive self-portrait in 1854, *The Meeting*.

To read Champfleury's essay on Journet is – in spite of the patronizing, trivial tone – to discover the prototype of Courbet's life-style. Journet was desperate, prodigious, unstoppable: raining pamphlets from the balcony of the theatre before the police closed in; breaking up a literary *soirée* at Lamartine's; persuading Dumas to give him an annual income; pouring scorn on Fourierist 'revisionists' like Considérant – 'omnivorous omniarch', he called him. Journet's language kept pace with his personal style. Two examples: prophesying doom, very accurately, on 20 February 1848: 'The frenzy is mounting from hour to hour, the abyss is gaping for its prey, the cataclysm is upon us. It is upon us, and none of us but knows it!'[19]

Or, more brilliantly, chiding Lamartine for his reception at the *soirée*:

Poet, you have eyes so that you may not hear. You are deaf to the cries of children and the groans of the aged. You are blind to woman's tears and man's despair. Poet, down with hypocrisy, enough of this feigned religiosity. The farce is played out: faint star, hide thy light! The sun of understanding is flooding the horizon. The Last Judgment will precede the social resurrection. Everything is stirring, seething, preparing; O future, future! 'May God enlighten you!'[20]

Shades of Baader in the Reichstag, or Douanier Rousseau at his banquet.

Talking of Journet, taking him seriously for a moment as a model for Courbet's life-style, leads us to the most important problem: what was Bohemia, and to what extent was Courbet a member of it? First of all, what Bohemia was *not*. It was not the sly, skilful dream-world which Champfleury had pioneered in his *Confessions de Sylvius* of 1845, and to which Henry Murger gave definitive form. About this *Sainte Bohème*, as Théodore de Banville called it, the best remarks were made by Albert Cassagne:

The *metteurs en scène* of Bohemia knew how to fashion it adroitly to make it agreeable to [the bourgeois public]. They knew how to use real resemblances between the Bohemian life and the life of the bourgeois student in the Latin quarter, in order to establish a useful confusion, a confusion which is already manifest in [Murger's] *Scènes de la vie de Bohème*. To sing of Bohemia was thus, to a degree, to sing of bourgeois youth.[21]

The reality of Bohemian life in the 1840s and 1850s was quite different. In the early days, for a few years after the 1830 revolution, Bohemia had been a comfortable part of the *avant-garde*, supported by doting fathers and therefore carefree, fashionable, unscrupulous (Gautier, Houssaye, Nerval, Roger de Beauvoir had been its leading lights). But that group had broken up and gone its separate ways, into various kinds of accommodation with the market and the official world of art. Bohemia, after that, was an unassimilated class, wretchedly poor, obdurately anti-bourgeois, living on in the absolute, outdated style of the 'Romantics', courting death by starvation. Nerval lived through that change in the definition of Bohemia, and died in madness and hunger; Journet was committed to the Salpêtrière more than once.

It was this Bohemia, this confused, indigent, shifting population, with its Romantic postures, that Jules Vallès tried to rescue from Murger and myth in his book *Les Réfractaires*, published in 1865. He tried to show the real Bohemia: a world of grinding poverty, of absolute refusal of bourgeois society, rather than the sowing of flippant wild oats. It was not an irrelevant book for Vallès the Socialist and revolutionary to write; for Bohemia in mid nineteenth-century Paris was a real social class, a real locus of dissent. And if we want to locate it within the complex social structure of Paris, we should put it alongside not the students of the Latin quarter but the *classes dangereuses*. It was this dangerous element – this mob of unemployed, criminals and *déclassés* of every sort, the first victims, the first debris of industrialism – which made up one part of the rebel fighting force in June 1848. The great social historian of the June Days, Rémi Gossez, closes his description of the class origins of the insurgents by saying that the last category of the rebels comprised 'social outcasts of all kinds: tramps, street-porters, organ-grinders, ragpickers, knife-grinders, tinkers, errand-boys, and all those who lived by the thousand little occupations of the streets of Paris, and also that confused, drifting mass known as *la Bohème*'.[22]

These are words which throw Bohemia and Bohemianism into new relief. They rescue them from Mimi and Sylvius, and reinstate them as part of working-class

Paris. This was the Bohemia to which Vallès gave credence and definition. This was Daumier's Bohemia: the ragpickers and organ-grinders of Gossez's list come straight from his canvases. This was Courbet's Bohemia, this was Journet's, this was Baudelaire's ('Perhaps the future belongs to the *déclassés*? . . .': letter to Ancelle, 5 March 1852).[23] It was a life-style *and* a social situation. It meant a dogged refusal to abandon the aims of Romanticism, a manic and self-destructive individualism, a 'cult of multiple sensation': 'Wine and Hashish compared as means for multiplying individuality,' as Baudelaire put it in 1851. It meant a place between the *classes dangereuses* of proletarian Paris and the intelligentsia; between two classes which were themselves strange, intricate misfits in any class system, and remained unsure of whose side they were on. So that in June the intelligentsia stayed loyal – ferociously loyal – to the Government, and many of Baudelaire's friends fought with the Latin Quarter detachment: and the *classes dangereuses* closed ranks with the Garde Mobile, and slaughtered rebels with the best of them. Courbet hesitated and abstained on utopian grounds. Baudelaire fought for the rebels, with Bohemia. One wonders what Journet did and said in June.

The effectiveness of the Bohemian style was this: in a city which still half-believed in the first dreams and ideals of capitalism, in the fairy world of arcades, exhibitions, the bazaar, the entrepreneur and the vote for everyone, the Bohemian caricatured the claims of bourgeois society. He took the slogans at face-value; if the city was a playground he would play; if individual freedom was sacrosanct then he would celebrate the cult twenty-four hours a day; *laissez-faire* meant what it said. The Bohemian was the dandy stood on his head: where the dandy was the bourgeois playing at being an aristocrat (hence his pathos), the Bohemian was the bourgeois playing at being a bourgeois – the heroic, absurd, mythical bourgeois of 1789. (One could say that the Bohemian style only works in a capitalism with a myth of itself, a belief in its future. Hence the failure of its British variants; hence its reappearance in California.)

Courbet's game was even more infuriating, in its way. He shifted identities from picture to picture, year to year. Was he peasant or Bohemian? Was there a reason for being both? In 1851, when the great Bohemian self-portrait *Man with Pipe* accompanied the Journet portrait and the *Burial at Ornans* to the Salon, which picture *was* Courbet? (However naive it may seem to us, it was the kind of question which critics asked in 1850.) The critics could accept the self-portrait easily enough: what hurt, what puzzled them, was its relation to the other pictures, to the other allegiances they suggested.

No doubt some will say that these allegiances and ambiguities never occurred to Courbet. The central tenet of the Courbet legend is, after all, that to be naive and untutored means to have extremely simple ambitions, a very narrow field of vision – to be interested in the technique of painting not just primarily (which goes without saying: any artist is involved first with his material and its problems) but exclusively. This is simply a non sequitur, a theory of naivety which has to be supported by proofs, like any other. I think the proofs are lacking. What evidence we have points to Courbet's naivety as a source of complexity, not of simplicity.

Of course the various implications of his life-style and his paintings that I have described so far did not all occur to Courbet, in the sense that he gave them verbal expression. But that is the privilege of painters. Who was more silent than Daumier; who was more verbose than Chenavard? There are silences which demand explanation, just as there are statements which ask to be ignored.

'I have simply wished to base upon a thorough knowledge of tradition the reasoned and independent feeling of my own individuality,' Courbet said in 1855.[24] That was not such a simple wish as it sounds.

3 Courbet's Early Years

Courbet arrived in Paris in October 1840. He was twenty-one, the son of a rich peasant who had made good, bought some vineyards, built a house in Ornans and dabbled in futile inventions. He came to Paris, much against his father's will, to seek his fortune as a painter; in the next ten years he sold almost nothing. A Dutchman called Van Wisselingh paid him 420 francs for two pictures in 1845 (Meissoniers were fetching five figures at the time), the local worthies of Ornans bought an occasional portrait, and the church at Saules took an altarpiece – but these were drops in the ocean. Courbet still depended on money from home. In the guarded, conventional letters which Courbet wrote to his father in the 1840s, there are traces of a quarrel over his allowance: the standard accusations that it was wasted, and the standard pleas that it was enough only for the most frugal existence, of days in the museums, the life class and the studio.[1] In other words an ordinary dispute between a bourgeois and his son – the same whining letters from Paris were locked away in a thousand closets in the nineteenth century, by proud, unbending fathers who always paid up.

In Paris, Courbet paid calls on his relations. Almost every year he went home to Ornans, and painted neat, decorous portraits of his father or his sisters – Zélie with a wreath of bindweed in her hair, Juliette sitting primly in a wicker chair, with a rich drape behind her and her favourite pot-plant. Back in Paris he studied under a

GUSTAVE COURBET *Man with Leather Belt* c.1845

II GUSTAVE COURBET *Self-Portrait, Man with Pipe* *c.*1846–47

mediocre master, Auguste Hesse, and complained of the degradation of bourgeois taste.

Women want portraits with all the shadows eliminated, men want to be painted in their Sunday best, there is no way to change these ideas. Better to turn a crank mechanically than earn a living with such daubs; at least one would not have to compromise with one's principles.[2]

Of course he never turned a crank, and he compromised: we have more than one portrait of a lady with the shadows eliminated, and more than one gentleman in formal black (the *habit noir*), complete with deferential inscription along the top.[3] Finally, Courbet sent pictures to the Salon, and the jury sent them back.[4] Before the 1848 revolution he tried no less than eighteen entries, and the jury rejected all but three: the *Self-portrait with Black Dog* in 1844, the *Guitarrero* in 1845, and the *Portrait of Monsieur X * * * * in 1846. The notorious jury of 1847 threw out everything Courbet entered.

 This is the story of every young bourgeois from the provinces trying to be an artist. Most of them, like Flaubert's Frédéric Moreau, returned home defeated, to help with the office or the estate. A few succeeded; many more stayed in the city, gave up art ('there's nothing in it') and became clerks or bureaucrats. For others the allowance stopped, and they slid imperceptibly into the working class. And sometimes – another variant of failure – they became Bohemians.

 In later years Courbet liked to display the shortcomings of his work in the 1840s. On the walls of his studio, according to George Puissant's obituary,

were two engravings, the only reproductions of another artist Courbet possessed, *Priests out Walking*, and *Seminarists in the Meadow* by Amand Gautier; a couple of erotic drawings (of Adam and Eve, naturally); and then a series of bizarre childish studies, the *Soldier's Rest* and the *Man in a Helmet*, various women smothered in lace, a plate of black cherries; the famous *Savage Crossing the Rapids*, a strange canvas whose origins no one could explain; a *Battle at Sea* (his second picture!), a great cascade of orangeade and redcurrant which would put off the most impudent flatterer – Courbet's artistic vanity consisted exactly in this almost affected display of the weakness of his beginnings in art – a *Pythoness* ascribed to Domenichino, and finally his attempts at sculpture.[5]

 Most of these works have disappeared, but we have plenty of others to prove what a bad, and what an *ordinary*, painter Courbet was when he began. The *Sculptor* [9], done in 1845, is one of the best examples, just because its failure is so commonplace. (Its companion piece, *Guitarrero*, was accepted by the Salon jury and almost bought by a wealthy banker; the sale fell through at the last minute.) It suffers first from formal contradiction. It tries to merge, in a way many painters attempted in the 1840s, two incompatible styles, the Baroque and the neo-classical. What results is a grating of forms against each other, a visual absurdity; as if the figure's hard, continuous outline physically prevented movement, as if the body was wrenched out of shape by its own contours. And not merely out of shape, but out of context. Instead of the complex unison of Baroque painting, where the

contorted pose is part of a functioning whole, echoed by the forms around it or integrated with the rest by light and shade, the Sculptor sits like a lay-figure in an added, irrelevant landscape. Where nature and man· actually collide – hand on branch, cape on boulder, foot at water's edge – the difference between the two is strongest.

This, to put it briefly, is Courbet's version of Romanticism. It illustrates precisely what Romanticism had become by 1845: either a matter of fancy dress, or a demand for a painting *on the edge of vision*. Either historical theatre, as here; or the paintings of Poe's character Roderick Usher, 'over which his elaborate fancy brooded, and which grew, touch by touch, into vaguenesses at which I shuddered knowing not why',[6] or of Novalis's Master:

Soon he became aware of the inter-relations of all things, of conjunctions, of coincidences. Ere long he saw nothing singly. The perceptions of his senses thronged together in great variegated Pictures; he heard, saw, felt, and thought simultaneously.[7]

Needless to say, Courbet was not ready to follow those implications: not many painters were. He chose instead the current version of Romanticism, the world where the troubadour jostles the *guitarrero*, the anguished young man (or the melancholy Empress Josephine) muses in the wooded glade, an Arab gestures defiance like a Greek, a new king is presented to a glittering court, knights joust, Faust dies, Italian peasants dance a tarantella, and battles are fought in every age and climate.[8] (Most of these were Salon favourites in the 1840s.) The repertoire was no better for being elastic. It expanded year by year as fashions came and went: this year the misfortunes of Pierrot, the next year Goethe, the next a revival of Lady Macbeth. But that altered nothing. What made the official form of Romanticism disastrous for painters was this: what it allowed in terms of subject-matter, it disqualified in terms of visual style. Its subjects were passionate, fantastic, colourful: the style it prescribed was the enemy of all three. Romantic painting, said Stendhal in 1824, was 'common sense applied to the arts'. Romanticism, wrote Thiers, was nature 'with the addition of reason'. And that meant painters like Champmartin, Scheffer and Delaroche; not Roderick Usher or the Master of Novalis, not even Delacroix or Théodore Rousseau.

In terms of ideology, Romanticism glorified the past; it was, in France, the invention of émigrés, and it pined for feudalism and despised the bourgeois usurpers. (That flavour remained in the 1840s, though Romanticism had by then its liberal or Socialist versions.) But in terms of style, Romanticism was rigidly, stiflingly contemporary. It cut off the painter from the visual art of the past and tied him to the mannerism of his time. It preached fashion and compromise: Courbet's broken-backed compromise, in the *Sculptor*, between classical and Baroque, the dismal example of Schnetz or Scheffer, or Couture in his troubadour vein.

Towards the end of 1845, Courbet began to change his style, and escape from the influence of painters like these. (The influence had been fairly direct at times: we know that Courbet copied Schnetz's *Prisoner*, and the style of the *Sculptor* may

derive from Couture.) The series of awkward portraits in landscapes ended, and Courbet began a series of portraits where the sitter is placed in a simple interior, against a blank wall or a single corner, or engulfed in shadow. He set himself simpler problems, and in these portraits he began to imitate and comprehend the art of the past: he went back to the seventeenth century, reproduced Rembrandt and Zurbarán, and slowly devised a style of his own. And at the same time he discovered a subject-matter: he moved gradually away from the paraphernalia of Romanticism and put in their stead the simpler, no less artificial trappings of Bohemia. The process did not end until after 1848, when his great portraits of Baudelaire and Trapadoux defined Bohemia and invented a new formal language.

Invention was a long time coming. When Courbet painted the *Man with Leather Belt* [I] in 1845[9] he was still between two centuries. The pose of hand and forearm, and the expression of the face, are unmistakably nineteenth-century, though they have a better pedigree than the *Sculptor*. (They are like the so-called portrait of Lord Byron [8] which the world believed was by Géricault himself. Or perhaps the pose is a failed version of Deroy's great portrait of the young Baudelaire, painted a year or two before.)[10] The attributes of the artist – book of prints, cast, and chalk in its holder – are still arranged too deftly, and the painting of the eyes is simply botched. But Courbet's colour sense is growing sharper: the dry, patchwork effects of the year before are gone, and in their place is put a single, sharp white cuff against a black tunic – a simple contrast, copied from Titian's portraits in the Louvre. It is the first time Courbet imitates older art directly, rather than doing a nineteenth-century pastiche.

The *Portrait of Monsieur X**** [11] was probably finished a few months later; it was accepted by the jury for the Salon of 1846.[11] Compared with the *Man with Leather Belt* it is a definite success, the first picture we can call Romantic without regretting the fact. It still conjures up Lord Byron, with its furrowed brow and its shock of hair, but it owes a lot more to Rembrandt and Zurbarán: it is a Rembrandt blocked in with violent and abrupt highlights, and the oily flesh of the previous portrait has become rough and tactile.

Courbet owed that directness to Spanish painting; and it is not just a technical directness, but an emotional one. The Mr X in question is Courbet himself once again; but no longer languishing and uncertain. He is the prototype for all the self-portraits to come, at last assertive without being coquettish, grim-faced without being self-pitying, suffering without going into a swoon. The portrait is melo-drama, but this time without bathos; Romanticism with a new kind of conviction. And this, exactly, was what Courbet borrowed from the Spanish paintings in Louis-Philippe's Musée Espagnol, not so much their formal qualities, though he sometimes copied these, as their sheer brutality, the unembarrassed emotion of the paintings, and of the painters' own legendary lives.

When the critics first saw Zurbarán's *St Francis with a Skull* [10] in 1828, when the Musée Espagnol opened, they reached for the word Romantic in a more or less automatic way.[12] But Romantic it was, in a certain sense; it proposed a redefinition of the term, and certain painters saw the point at once. Take Millet, for example,

writing home to a friend in 1838, describing his first impressions of the gallery: what he seized on was horror and atrocity, the new atmosphere of Spanish painting, not bold handling or striking light and shade.

In front of two Riberas, one of which represents the flaying of a saint, and the other Cato running himself through, you can almost hear the cracking of the skin coming away from the flesh. Inside Cato's gaping chest you can see his bloody entrails, and almost feel their warmth: the expression on his face is indescribable, sheer atrocity. He is crying out, and his screams are torn from his very guts, they are piercing and as you look they crush your soul – they are unbearable.[13]

Courbet could and did go elsewhere for the techniques that Spanish painting suggested; but not for its total effect. The Musée Espagnol revived the Satanic, the extreme, the impermissible. It was nature *minus* reason, not 'with the addition of reason'; and hence its effect on French painting came slowly, indirectly. For the painters of the new generation who went to devour Ribera and Zurbarán, it was a reminder of the bounds Romantic art had once transgressed, and an invitation to cross them again.

The *Portrait of Monsieur X* * * is Spanish, Romantic and extreme; it was Courbet's best picture to date. But it was also a flash in the pan. It suggests elements of Courbet's mature style, but it was two or three years before Courbet saw that for himself. In the meantime he flailed about among different influences, even different centuries. If we take the three works which he sent to the 1847 Salon, and which were all returned to him unshown, we have a summary of his inconsistencies.

The portrait of his friend Urbain Cuénot [13] – which was repainted later in the Spanish style, but has lately been restored to its probable first state – started life as a very neat, very effective compromise with neo-classical portraiture. The studied, harmonious pose; the crisp, undulating line of hat-brim, lapels, arm and shoulder, and the top of the chair; the gentle lighting, the clear separation of the figure from its neutral background: these are all features which recall the portraits of Ingres himself, or Géricault's *Portrait of a Vendéen* [12]. It is not surprising that Courbet covered them with harsher lights and darks when he showed the Cuénot portrait in the Salon of 1852.

The second picture, *The Cellist* [15], is Rembrandt confused by the same concern for elaborate posing and spatial arrangement – undecided whether to set the figure in a dissolving chiaroscuro or against a background which presses it to the canvas surface. It tries for a compromise, and straightaway the drawing disintegrates and the old contortions reappear.

The third picture, *Man with Pipe* [II], is different again. When it was shown in 1851 the critics called it, quite reasonably, an imitation of Guercino:[14] it has the same casual handling, the same clear oval of the face marked with deep shadow round the eyes. Look, for comparison, at certain background faces in the Guercinos in the Louvre: the faces on the left in the *Raising of Lazarus*, the upturned head of the figure second from the right in the *Patron Saints of Modena*. But it is typical of Courbet that the painting should have another source in the Louvre, and

one directly contrary to Guercino's High Baroque – a source as obvious and homely as Adriaen Brouwer's *Smoker*.

What is going on here is exploration, foraging for models, seeing how far they can be put to new uses, sometimes intelligent and successful, sometimes disastrous. There is, in formal terms, a kind of caution about Courbet at this stage; and a journey to Holland late in 1847 sobered him up still further.[15] *The Cellist*, remember, had been finished before he went; after he returned, his approach to Rembrandt was altogether more subtle, more circumspect. In the case of Hals, who was the other revelation of the trip, the problem was relatively simple: he taught one certain ways of painting, and Courbet put them to use in the detail of *Baudelaire*, or the colour modelling in his first sketch of *Berlioz* [26]. Registering the light and shade on Baudelaire's hand in terms of broad, dry strokes of colour; mixing a hectic red and a livid white incompletely on Berlioz's brow – these were devices, useful and exciting, which a painter could borrow. Rembrandt was not like that. If you borrowed devices from him, they turned banal or absurd in your hands, and the result was *The Cellist*. In Rembrandt devices were inseparable from attitude, intention; it was only when one had an intention of one's own, a parallel certainty about what had to be painted, that the borrowing could begin. It was only in 1851 that Courbet could plunder the *Night Watch* [14] for his *Firemen Going to a Fire* [16, 17]; only much later that he had the arrogant assurance to re-do a Rembrandt self-portrait stroke for stroke, and make it his own in the process.[16]

What mattered in 1847 was the search for a personal iconography. In the course of that year – before he saw the Rembrandts in the Rijksmuseum, and before the 1848 revolution – Courbet discovered the bare materials of that iconography, though he still did not know how to put them in contact with each other. He was not yet a Realist, and showed no interest in the Ecole Réaliste of the day, the school of Leleux, Hédouin and Chaplin. Their version of the picturesque – 'Breton subjects a speciality', as Baudelaire remarked in 1846[17] – had nothing to do with Courbet's complex intentions. He came at Realism by another way; crab-like, unexpected. In the first place he began to use popular imagery – the simple woodcuts of saints and heroes which were sold in the countryside, drawn by artisan engravers, blocked in with ochres, browns and greens – as one possible basis for his art. In the second, he began to paint the Bohemian life. Popular imagery was first explored, cautiously, clumsily, in a painting of *St Nicholas Reviving the Little Children* [20] which Courbet did for the little church of Saules, near Ornans; and Bohemia was given form in a series of charcoals of himself and his friends, and in the oil painting *Man with Pipe* that the jury sent back from the Salon. The best of this series, before the great pictures of 1848–49, is the second charcoal version of the same subject: the *Man with Pipe* [18], in the Wadsworth collection. Put the charcoal side by side with lumbering *St Nicholas* [20], and you have a kind of recipe for Realism – or rather, its unmixed ingredients, both pictures somehow in need of each other.

St Nicholas Reviving the Little Children is an odd picture, inconclusive, almost as if the painter took fright at his own idea, in the final stages of the work. In technical terms the painting owes a lot to Zurbarán, and Courbet handles the clash of

light and shade on the heavy vestments with tremendous confidence. He used his friend Urbain Cuénot as a model, and the saint has Cuénot's thick-jowled features; but the overall design comes from different sources. Someone – perhaps another of Courbet's local friends, Max Buchon, who was already an avid collector of such things in the 1840s – provided an old print of the saint [19] produced in a Besançon workshop at some time in the eighteenth century, and he borrowed from it the saint's pose, the children's wooden gestures, the building in the background.[18] Clearly enough, Courbet is struggling to make these various 'sources' work together: and equally clearly he fails. Zurbarán triumphs over the Besançon engraver; ponderous modelling replaces the ochres and greens; and where the artisan who made the print left his forms flat and separate, Courbet plods towards a rational arrangement in space; he puts enough shadow on the distant tower; he fills the background with hard-edged pilasters. In other words, the popular print is still a collector's item, a source of inspiration, not of form: its crudity is appealing, but in the end an artist corrects the obvious mistakes. We can guess that Courbet used the image from Besançon half for his own convenience (in religious painting, Courbet was an amateur, in need of simple models) and half to reassure the village congregation: here was an image of the saint that was familiar, ready-made. But he never forgets that he is a painter back from Paris; he remembers the lessons of the Louvre and Auguste Hesse. Popular art is a starting-point, a concession to the taste of his audience at Saules. Courbet did not really imitate the art of the folk – take over its cut-out flatness and reproduce its mixture of piety and cynicism – until the *Burial at Ornans* two years later.

The imagery of Bohemia is rather different from this: it is not a specific style, and it does not derive from certain identifiable visual sources. The Bohemian does not have a set of attributes, like the *Sculptor*'s dangling mallet or the painter's stub of chalk in its elegant holder. But when he appears, he is unmistakable. Put together the two versions of *Man with Pipe*, the charcoal portrait of Promayet,[19] the drawing of the Brasserie Andler [22], which Courbet did in 1848, and the portraits of Marc Trapadoux, Baudelaire and Jean Journet himself, and you have a chronicle of a certain kind of life: you have a Bohemian series, with its own coherence within Courbet's work. It is not exactly a coherence of costume, since the Bohemian plays with changes of dress quite deliberately: in the Wadsworth charcoal he sports an open shirt, greatcoat and hunting-cap; in the Brasserie Andler he has put on a silk hat and stock and plays the dandy for the evening. It is not a coherence of setting or handling, or even personnel, since Journet, for example, was despised by Baudelaire (he is lampooned in a footnote in *Le Salut public*) and Promayet was never a star of the Parisian *Bohème*. But there is coherence, nonetheless: if you compare the Bohemian with the Romantic – put the *Man with Leather Belt* alongside the oil painting of the *Man with Pipe* – the new identity is clear enough.

The *Man with Pipe* is a poseur, of course; still mannered and extravagant. But he does not flex himself any longer in an effort to hold the pose. His costume is less formal than before, his face is shrewd as much as sensitive; and for the first time in Courbet's art an image holds contrary meanings. The picture is built of two parts,

which work for the most part against each other: the fragile, provocative face in the centre, and round it the ragged frame of hair and beard. Inside the oval, evenly lit but with shadowed lids, the smoker's features are vulnerable and delicate in the old way: on its own it is still the face of the sculptor, or closer still to Courbet's most grotesque self-portrait, the *Despairing Man* of 1842.[20] But the head as a whole is stronger, different, deliberately unkempt and aggressive. Courbet called it later, in a subtle description he wrote for Bruyas in 1854, 'the portrait of a fanatic, an ascetic . . . the portrait of a man disillusioned with the foolishness that made up his education, and who searches for principles of his own to hang on to'.[21]

This is a good enough description of the Bohemian attitude – fanaticism, asceticism (or was it aestheticism? Courbet's spelling is dubious, as usual) and disillusion are its essential components. But they are also three complex, ambiguous attitudes in their own right, and not necessarily in the least compatible. Courbet's head suggests their separate identity; their conflict as much as their coexistence. It is the first time Courbet is equivocal about himself, which in this case is a sign of progress.

The Wadsworth charcoal of the same subject must have been done a bit later: it is close in style to a group of charcoal studies dated 1847, which includes the head of Promayet and an image of a *Sleeping Bacchante*.[22] It is as close as Courbet ever comes to a genuine use of visual ambiguity, of the kind we associate with Rembrandt's etchings and drawings: the kind of ambiguity that inheres in the image itself and the contrary readings it makes possible. Once again the smoker's pose is affected, but the blunt, concrete details of the cap and costume are set against it. And the face itself is built of signs we can only half decipher: the way the shadow of the hunting cap touches the eye but does not veil the glance; the tilt of the neck, strained but also casual; the uncertainty of the face's basic structure (how far recessed are the eyes, how prominent the chin and cheekbones?); the ambivalence of the expression as a whole. Is it the absorption of the smoker, intent on the bowl of his pipe? Or is it tense, almost querulous, looking towards us out of the corner of one eye? Or is it, as the critics sometimes suspected,[23] a state of mind that Baudelaire found words for?

Your attention will rest a little too long on the bluish clouds which are rising from your pipe. The idea of a slow, continuing, eternal evaporation will take hold of your mind and you will shortly apply this idea to your own thoughts, to your own brain. By a singular equivocation, by a kind of intellectual transposition or misunderstanding you will feel as though you are evaporating and you will attribute to your pipe (inside which you feel yourself to be crouching, and squashed up like tobacco) the strange power of smoking you.[24]

In 1880 Gros-Kost retold the story, evidently a famous one, of Courbet standing over the sleeping Baudelaire, chalk in hand, ready to record the sensations of the poet's opium trance: 'the obscure and incoherent wanderings of the starstruck Bohemian'.[25] So the leap from Courbet's charcoal to Baudelaire's 'Le Poème du haschisch' is not an unfamiliar one.

Is the Bohemian self-absorbed, or dependent on the audience he provokes? Is he

vulnerable or aggressive, is he playing with the world or constructing an artificial paradise? It is not too far from Courbet's image and its ambiguities to these more general questions – not too far to the whole problem of Bohemia and its strategy.

Courbet's next-Bohemian image was some kind of an answer: it was the wood-cut he did as a masthead for Baudelaire's newspaper *Le Salut public* [21]. In that image a young man in top hat and ragged smock climbs a barricade, waving a gun. In other words, if Bohemia was a revival of Romanticism – a last effort to preserve the attitudes of the old Romantics in a hostile environment – that in itself made the whole thing political. In Courbet's case, the charcoal *Man with Pipe* is the painter's first genuinely Romantic image, the first to stand comparison with Géricault's *Artist in his Studio* or Delacroix's head of Chopin. But its brand of introspection lasted a matter of months, no more. Bohemia led Courbet, fast, to politics and public safety; led him, unprepared, to 1848.

4 Courbet in Paris 1848-49

'In '48 there were only two men ready: me and Proudhon.'[1] So Courbet boasted, and Vallès set down. The best one can say in answer is that Proudhon was not ready, any more than Courbet. But when Courbet sent his electoral address to the paper *Rappel* in April 1871, in the middle of the Commune, he was as sure as ever of his revolutionary credentials:

In 1848 I opened a Socialist club in opposition to the clubs of the Jacobins, the Montagnards, etc. – the men I have classified as 'republicans of no particular type' [*républicains sans nature propre*], republicans out of the past.

The Republic, conceived as one and indivisible, as the sole authority, made people afraid; Socialism, not yet sufficiently worked out, was rejected, and the reaction of 1849 swept it away, in favour (a little later on) of a monstrous regime.[2]

The address did its work, and Courbet was elected. But the truth is more prosaic. Not a trace of activity in the clubs, Socialist or otherwise, has come down to us; hardly a trace of political involvement on the streets. Courbet was, for the first few months of 1848, a spectator. Toubin recalled him later, standing in the Tuileries Gardens with his new friend Baudelaire, watching the first great clash between the workers and the Garde Municipale on 22 February, and rushing off to the offices of *La Presse* to denounce atrocities.[3] As far as we know he did not fight on the barricades: he avoided claiming *that*, even in 1871. Like a good son, he wrote home monthly, reassuring letters, stories of diligence and detachment. He 'gave

little time to politics, as was his habit', there was 'nothing more futile than that'. He worked hard at his painting 'in spite of the Republic, which is not the form of government most favourable to artists, at least according to history'.[4]

Part of this may have been simple pique. Courbet had written home just before the revolution in an optimistic mood, 'I am on the threshold of success, for I am surrounded by people, very influential in the press and the arts, who are enthusiastic about my work. At last we are about to found a new school, and I shall be its representative in painting.'[5]

The revolution ruined all this. The influential friends went their separate ways, and Courbet's pictures were lost in the open Salon. The art market disappeared, and new schools of painting seemed a luxury no one could afford. The Republic was bad for artists, not 'according to history', but according to Courbet's own experience; and while the revolution was still in progress, on the streets of Paris from February to June, it stayed a puzzle to him, an absurdity, almost an affront. In his view, the men outside his window on 16 April, shouting *A mort les Communistes! A bas Blanqui!*' were wasting their time and his, chanting things that were 'ridiculous and meaningless'.[6] But the shouts *were* significant, and dangerous: it is Courbet's flippant detachment which is inane.

Courbet shared the annoyance, and confusion, of the ordinary bourgeois of his time. He made an effort to portray the revolution only once, in the masthead he produced for *Le Salut public*. And that was done for friends, in a hurry, with all the crudity of the artisan. It was Courbet's first popular image, and its iconography is a strange mixture of the bizarre and the commonplace. Delacroix was the starting-point, of course: every engraver quoted from *Liberty Guiding the People*, and, with Baudelaire as his editor, Courbet was not likely to be an exception. But what he does to Delacroix is odd, and seemingly deliberate. He mimics the format, and copies certain details, down to the signature written on a broken plank: but the central imagery of Delacroix's painting is changed, almost parodied. The man with the gun in the centre is a male Liberty, with flag and rifle reversed, but what he wears is borrowed partly from the bourgeois youth in Delacroix's picture, clutching his rifle and hanging on to his hat, and partly from the worker with a cutlass to his left. On the head of Courbet's hero is, once again, a battered top hat, emblem of the bourgeoisie; over his shoulders, a torn and shapeless smock, with the butt of a pistol sticking out of a tear. Where Delacroix pictured the worker and the bourgeois side by side, Courbet simply combined them (and according to Toubin, Baudelaire put on a white smock when he sold *Le Salut public* in the streets[7]).

As for the slogan on the flag, *Voix de Dieu, Voix du Peuple*, it sums up the ecstasy of February, and was repeated a thousand times. Even Proudhon allowed himself the same transition, in a prospectus he had written for his newspaper *Le Peuple* in 1847:

May the people, which means each individual worker as much as the entire mass of workers taken together, worship God without priests, work without masters, trade without usury,

become owners without mortgages, form their minds and hearts without prejudice, take part in the government of their country without being represented by heroes or villains.[8]

Courbet's slogan is in much the same vein. And the image as a whole – if we put it against Delacroix's, where each figure is stamped with the marks of class or occupation – is imprecise, out of focus. Part of this was hurry and ham-handedness, but part at least was done on purpose: juggling with attributes in a casual fashion, fusing classes, inventing the *bourgeois en blouse*, the bourgeois in a smock. As a picture of revolution, it is absurd or possibly sly. It avoids politics, because politics were difficult and dangerous; politics did not sell newspapers in March, fantasy did. So Courbet obliged, though the *Salut public* still went bankrupt.

By the time of the June Days things were different, and even Courbet slowly devised a politics of his own. He did not fight for either side in June, and he never gave a verdict on the actions of his friends Dupont and Baudelaire; but the civil war invades the letters to his parents, and he begins to explain – almost to justify – his own inaction.

It is the most distressing spectacle you could possibly imagine. I don't think anything like it has ever happened in France, not even the massacre of St Bartholomew. . . . I am not fighting, for two reasons: first, because I do not believe in war with rifles and cannon, it is not consistent with my principles. For ten years now I have been waging a war of the intellect alone. I should not be true to myself, if I acted otherwise. The second reason is that I have no weapons, and cannot be tempted. So you have nothing to fear on my account.[9]

This is no longer detachment, more a paralysis of will: casting around for reasons, more or less plausible. And it is also a typical statement of 1848; its furtive, high-toned panic is the normal reaction of the middle-class radical, or even Socialist, in June. It is not exactly a reactionary frame of mind that is expressed, and not exactly a revolutionary one, though it was shared by many would-be revolutionaries at the time. One thinks of Proudhon himself, the great non-participant, wandering from street to street, 'a gentleman in a frock-coat, a wearer of our decoration', talking things over with the rebels. 'I went out alone, I interviewed the insurgents. It was the social question, vague, general.'[10] And later, in his own newspaper,

I wept for the poor worker, whom I considered delivered up in advance to unemployment, to several years of poverty. . . . I wept for the bourgeoisie, whom I saw ruined, driven to bankruptcy, incited against the proletariat; and against whom I would be obliged – by the opposition of our ideas, and the force of circumstances – to fight, although I more than anyone was disposed to pity them.[11]

When Proudhon wept for all and sundry, so did other men of good will. They waged their private 'wars of the intellect' and refrained from buying a rifle. They regarded the June Days as an incomprehensible tragedy, an act of an (evil) God. Courbet was never more *quarante-huitard* than when he explained his own dazed abstention from the revolution.

In March 1848 Courbet sent ten works to the open Salon.[12] He threw together the

1847 refusals and work from long ago: some of his recent charcoals, the *Cellist* from 1847, and the *Hammock* from 1844, the portrait of Urbain Cuénot (perhaps already retouched) and a vast composition, *The Classical Walpurgis Night* (inspired by Goethe's *Faust*), which he had probably done as early as 1841. For good measure he added a picture called *The Middle of the Day*, a great 'black' landscape, with a young man in modern dress chasing a pot-bellied nude through a forest glade, and sweating, presumably, in his frock-coat in the midday sun.[13] (Was this Courbet's first comic attempt at a 'painting of modern life'? It sounds Baudelairian, in its uncouth way; but the canvas has vanished, and we can only guess at how it looked from the odd descriptions critics gave at the time.)

If the ten had been shown together, they would have made a fairly lunatic collection. As it was, however, they were dispersed among 5,000 entries – the open Salon was naturally the biggest yet, choc-a-bloc with old rejects brought down from the attic – and the critics could pick and choose. Courbet was noticed, and approved. As far as we know, his first mention in print was on 15 June, just ten days before the insurrection. It was a respectable beginning, in *Le National* itself. Courbet, wrote the paper's resident critic Prosper Haussard, 'looks like a real painter. His *Cellist*, in particular, has qualities of style and technique, and a skill in handling and chiaroscuro, which strike you forcibly: it is like a reminiscence of Caravaggio and Rembrandt.'[14] (Haussard became one of the best writers on Courbet in the Republic, and ran through the whole gamut of reactions to his painting: fulsome praise plus potted biography in 1849; angry, elaborate bafflement in 1851.) Three months later his friend Champfleury gave him more partisan praise, in *Le Pamphlet*,[15] though the picture he chose for special mention was the ancient *Classical Walpurgis Night*. He predicted a great future for its painter.

But these are really only preliminaries; the 1848 Salon was Courbet's farewell to the past, a résumé of 'seven years of my artistic life'.[16] (In 1855 Courbet was to paint *The Studio*, to determine the seven years following 1848, and stage a second, vaster retrospective.) After the Salon he drew breath, and began to paint at full speed. In the next twelve months or so, in the space between the two Salons, Courbet produced a string of pictures; and they are pictures which begin to add up, rather than contradict each other. Look first of all at the list of paintings, written out in Baudelaire's scrupulous hand, prepared the next summer for the Salon of 1849.[17] The list alone suggests the progress made. It is not single-minded or consistent – Courbet was never either of these – but it has its own coherence; it is totally different from the list of 1848. On the one hand, Courbet began to paint the life of the countryside: a massive painting called *After Dinner at Ornans* [24] is the linchpin of the entry, and there are four smaller landscapes of the Ornans valley [23] to go with it. On the other hand, he puts on show new and better pictures of Bohemian life; a portrait of Marc Trapadoux, eccentric philosopher, sitting in a corner of a studio looking over a book of prints, and a drawing called *The Painter* (perhaps the Wadsworth charcoal, or another self-portrait in the same style).[18] The works which the jury rejected in 1849 – three other landscapes of the Franche-Comté, and a drawing of his sister Zélie – only reinforce the pattern;

and the same goes for others that Courbet kept in his studio, a drawing of the Brasserie Andler, an oil sketch [26] and a finished portrait of Berlioz, and the final great portrait of Baudelaire [III]. (Nobody knows when this was painted, and its strange, unique style does not help us.[19] In the 1855 catalogue, Courbet dated it 1850; but at that time he had reasons to confuse his audience on the issue of dating in general, and Baudelaire's influence in particular. It was probably done in the first half of 1849, when other evidence shows the two men in close contact; perhaps Courbet retouched it later.)

In the list for the 1849 Salon, there are two different worlds side by side: Ornans with its home life and its landscape, Bohemia with its various saints. And the list reflects the biography without much distortion. Between the Salons, Courbet's life had a definite Parisian flavour: it was a year of intricate friendships, clans and *cénacles*, brasserie philosophizing. Courbet spent most of the year in the capital: he went to Ornans in September 1848,[20] but by December he was back in Paris. At about the same time, towards the end of 1848, he made the Brasserie Andler his headquarters, and began work on *After Dinner at Ornans*.[21] He was still poor, still touting for patrons. In May 1849 he got Baudelaire to draft and copy out a formal letter to the Bureau des Beaux-Arts, offering a picture to the Government lottery for needy artists – Baudelaire even forged Courbet's signature at the end.[22] (The explanatory list for the Salon was probably written in the same month; perhaps list and letter were part of the same rather crestfallen strategy.) In early summer Courbet went down with cholera, victim of the great epidemic. He survived, but Francis Wey described him in July, wretchedly thin, convalescing at the Weys' country house at Louveciennes.[23]

But by July 1849, in any case, Courbet's career had taken a new turn. In June the Salon opened, and the public noticed the *After Dinner at Ornans*: the State bought it, the critics liked it, the Jury gave him a medal, he was a rising star. And so he left Paris. In September 1849 he retreated to Ornans; this time not for two months' rest, but to go back – more or less consciously – to his sources, and paint the great trilogy of Realism, the *Stonebreakers*, the *Burial at Ornans*, and the *Peasants of Flagey Returning from the Fair*.

The year Courbet spent in Paris, between Salons, between town and country, is seen most clearly in the light of that final retreat to Ornans and what came out of it. What facts we have about 1848–49 suggest a man immersed in Paris for the moment, but discovering a rustic subject-matter at the same time as he lords it over Bohemia. It seems as if Bohemianism and the painting of Ornans go together, depend upon each other, in some curious way. Courbet said as much when he wrote his *credo* for Francis Wey in 1850.[24] Even after the retreat to Ornans, he stayed in contact with Paris and his friends: in the middle of painting the *Burial*, he found time to write back a dissertation on the mysticism of Marc Trapadoux, and console Champfleury for Baudelaire's withering critique of his poetry. He was still part Bohemian, and still relished the fact; the final Bohemian portrait, the lithograph of Jean Journet, was not produced until Courbet returned to the city in 1850.

So the question is: what kind of a world was Bohemia? Who were Courbet's

friends in 1848–49, and what did he learn from them? Was there a Bohemian brand of Realism? Did Courbet return to rural France as a gesture against the brasserie, or riding the latter's latest enthusiasm? There are no definite answers to these questions, and for good reason. I called Courbet's world in Paris 'intricate', but perhaps that is too delicate a word. Perhaps chaotic, drunken, formless, incoherent, would be better: the world evoked by Boudin in his Journal for 1859:

... it was monstrously noisy. Heads whirled feverishly, reason tottered. Courbet proclaimed his creed, needless to say in a totally unintelligible manner. . . . We sang, shouted and bellowed for so long that dawn found us with our glasses still in our hands. On our way home we made a din in the streets, it was all most undignified. . . . This morning our heads felt dull. . . .[25]

Courbet's Bohemia was highly intellectual, in its own fashion: beer and aesthetics, philosophy and billiards. It was highly political, and divided against itself on political issues, particularly in 1849. We do not quite know who were its leaders or its chief celebrities at any one time; we know even less who mattered from Courbet's point of view.[26] After the retreat to Ornans he corresponded regularly with Francis Wey, and wrote at least once to Champfleury; in those letters, the only first-hand source for these years, he sent his regards to Baudelaire, Trapadoux, Bonvin, and the musician Alexandre Schanne; Baudelaire and Trapadoux are mentioned most often.

Avoiding a head count, there seem to be six men who are vital to Courbet, each with a different claim to dominance: Baudelaire, Bonvin, Champfleury, Dupont, Trapadoux and Wey. None of them is exactly Courbet's master; none of them rules the rest. Champfleury wrote the most, and the most misleading, memoirs; as usual in the form, the writer emerges as the secret, infinitely humble mover of events. Francis Wey received the best letters at the time; Trapadoux was painted, drawn, written about; Bonvin was the only fellow-painter.

That leaves us with two very different poets, Dupont and Baudelaire. Pierre Dupont had come to fame with the revolution; he wrote ballads of working-class life and political songs for the Left-wing press. He was closest to Courbet in many ways: he had the same kind of background, part proletarian, part petty bourgeois; his poetry was 'popular' in ways that Courbet admired. (As Champfleury put it later: 'the fever of banal enthusiasms and a love of the gutter . . . made [Courbet] a blood-brother of Pierre Dupont'.[27]) Baudelaire, of course, is the enigma: Courbet's friend and collaborator in 1849, impossible sitter, sponger, dictator of opium dreams, doubter, schismatic, opponent of Realism; but involved with the Realists far more deeply than he liked to admit afterwards. 'They tell me that even I have been done the honour, though I have always worked hard not to deserve it'; his comment on his own presence in The Studio. A dishonest comment, naturally: he had made sure his mistress, Jeanne Duval, was painted out; why not himself?

Having chosen the six, I want to stress the contradictions between them: what a task it was to have all six for friends. They came from different classes, held opposite opinions, their ideas of art annihilated each other – and they quarrelled often,

bitterly at times. The six stand for the range of choices open to Courbet, and the range is bewildering: from mysticism to propaganda, from an art of the family to an art of the streets (in either sense: barricade or brothel), from piety to sacrilege, from Bonvin's *School for Orphan Girls* to Baudelaire's 'Reniement de saint Pierre'. In politics the differences were sharper still. Wey was a man of the centre, a friend of the men of *Le National*; he fought for the Government in the June Days, and helped to save Rémusat's young son.[28] (He was not, incidentally, a Bohemian.) Baudelaire and Dupont fought for the rebels. Champfleury abstained; he was a mild reactionary, and in his paper *Le Bonhomme Richard* he preached the virtues of family life and acceptance of one's lot. Trapadoux was above rebellion, politics, and this earthly life in general: later in 1849 his brand of religion offended the down-to-earth Champfleury, and Courbet was called upon to mediate. As for Bonvin, he had a good job at the Prefecture of Police; he enjoyed the times of fighting in the streets, because the Prefecture was closed and he could study in the Louvre.

The most contradictory of the six was Champfleury: and I shall take him as the touchstone of Bohemia at this particular moment. A critic in 1849 called him the 'king of Bohemia',[29] and he was the most prolific of Courbet's friends, he left the clearest traces. In later life he invented a history for his activities in 1849: he made himself the theorist of Realism, Courbet's helper, the man who discovered country life. He appears as the solid craftsman, the provincial, the writer, the neutral. But that later history is mostly dream. It cuts out the confusions of Champfleury, and they are the meat of the man in 1849: they are what save him, for a time, from becoming a bore.

The best comparison is with Dickens: it is one Baudelaire suggested in 'Puisque Réalisme Il Y A'. Picture a young Dickens, with some of Dickens's wit, all of his chaotic ambition, none of his sense of language. The Dickens of *Pickwick* rather than *Bleak House*; the Dickens who dwells on the impossible ménage, the Dickens who sketches the 'type' and his awful wife, and reduces us to tears or laughter in a single page: Champfleury could do that very well. On the cover of *Feu Miette* he announced, 'for immediate publication', three studies of the eccentrics and fanatics of Paris, and a 'history of Egyptian art'. In the same year, 1847, he published his essay on Jean Journet and had two pantomimes put on at the Funambules theatre. His short stories were brought out in three volumes that year, one dedicated to Balzac, another to Delacroix.[30] He was writing hack art criticism for the newspapers; he had just met Daumier, and at some time during the year he was introduced to Courbet.[31] His stories were sprinkled with references to art – any art that was fashionable that season. He set one story in an auction of Spanish paintings, he wrote a satire on a 'Realist' Dutch painter called Van Schaendel, he wrote a romance about a simple etcher, a 'primitive' who turns into a second Rembrandt.[32]

He was a Romantic, of a kind. He borrowed the style and subject-matter of some of his stories from the great German writer E. T. A. Hoffmann: he tried out Hoffmann's version of the supernatural, and imitated Hoffmann's ironic narrative voice.[33] Not that he could, or wanted to, copy the essentials of the German's style:

its sudden shifts of tone, the moments when the confusion of real and imaginary ceases to be comic and becomes agonizing, the menace of the supernatural. All that was alien to Champfleury's good sense, and soft heart. Romanticism for him was a manner, a convenience, an irony to hide uncertainties. 'The musician of sentiment', Baudelaire called him in 1855: he was George Sand using Heine as a disguise.

What he was best at was writing pantomime. It was the age of Deburau, the greatest of the mimes. Pantomime was 'popular', naive, ritual, fantastic: you chose the quality you approved of, you applauded. (Later on, in the 1860s, the Realists proclaimed the pantomime and the puppet theatre their own. Duranty set up a marionette theatre in the Tuileries, and even Courbet did a drawing of Pierrot. What made the two forms 'Realist' was their simplicity and their public: children and the poor.) In the 1840s everyone wrote or painted pantomimes: Nerval and Gautier had pieces performed at the Funambules, the Salons had a half-dozen Pierrots every year. Champfleury followed fashion, but the fashion suited him precisely: the mixture of farce and sentiment, the clash of ritual forms and ribald incident: these were things he knew how to exploit. He wrote at least nine pantomimes between 1846 and 1851, and the best of them are brilliant, irreverent. In *Pierrot marquis* of 1847 he rationalized the primordial, mysterious whiteness of Pierrot's face and costume: made him a miller's assistant. In *Les Trois Filles à Cassandre, pantomime bourgeois* (it was performed in 1849: was the subtitle irony or reassurance?) Pierrot gets married, and on his wedding night panics at the pinkness of his wife's skin. He waits until she falls asleep, then carefully paints her white from head to foot.[34]

In a curious way, the pantomime is the most satisfactory form of Champfleury's Realism: just because Realism here is an alien, farcical intrusion into a supernatural form: just because the tension between fantasy and physical detail can be exploited for laughs and does not constitute a problem for Champfleury, as it often did in his stories of provincial life. Gautier put it well in his review of *Pierrot marquis*:

You could write a symbolic study of the Funambules' repertory which would be as complicated and scholarly as M. Kreutzer's; but the sophistry of M. Champfleury consists in giving the allegorical whiteness of Pierrot a purely physical explanation.[35]

The point being that Champfleury's Realism is most effective when it operates within the framework of ritual, cocking a snook at conventions but depending on them for its meaning. For Champfleury, Realism was inseparable from parody: without a form or a style to travesty, he was lost.

All his best writing springs from these contradictions. In a short story (more a kind of ironical prose-poem) which Baudelaire singled out as his favourite – with the accurate comment, 'Champfleury, the poet, is a joker under the skin'[36] – the angry young author of a pantomime drafts a letter to the actress who plays Columbine. Her performance, he writes, was vulgarity itself: he recommends her to give up acting and open a tobacco shop. And her curtain-calls were worst of all: she

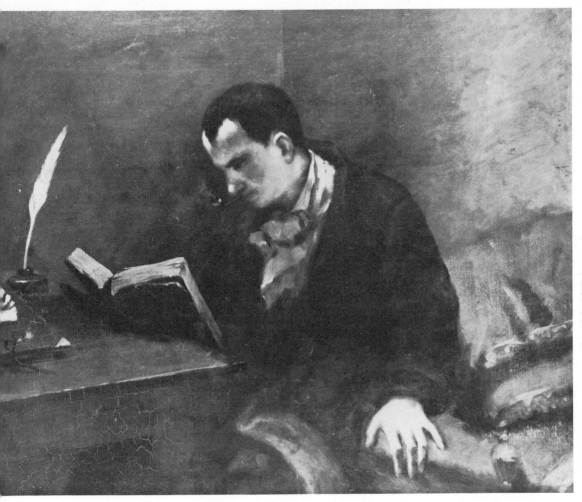

III GUSTAVE COURBET *Portrait of Baudelaire* 1849

IV GUSTAVE COURBET *Peasants of Flagey Returning from the Fair* ?1855

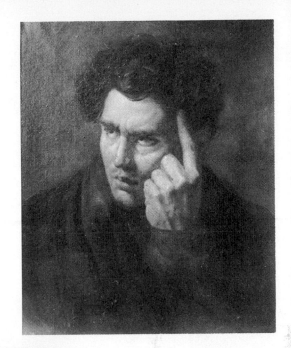

8 ANONYMOUS *Portrait of Unknown Man*
known as *Portrait of Byron*

9 GUSTAVE COURBET *The Sculptor* 1845

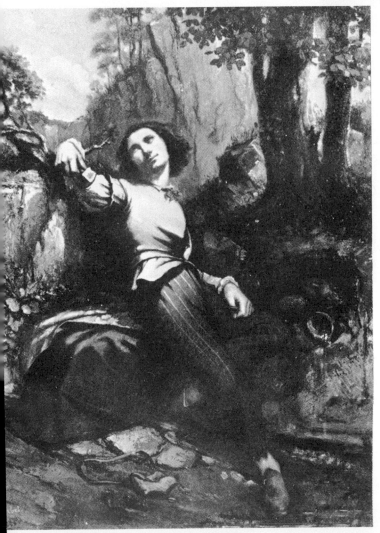

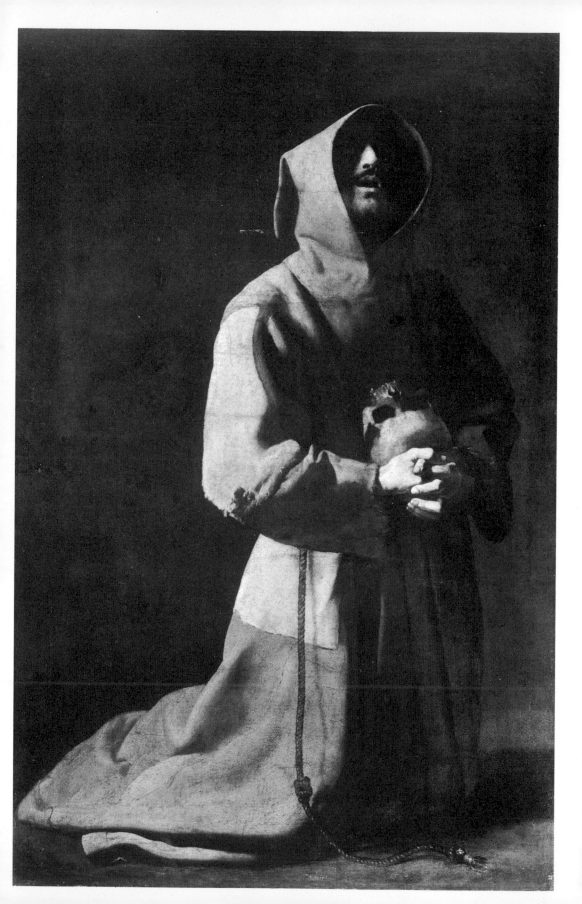

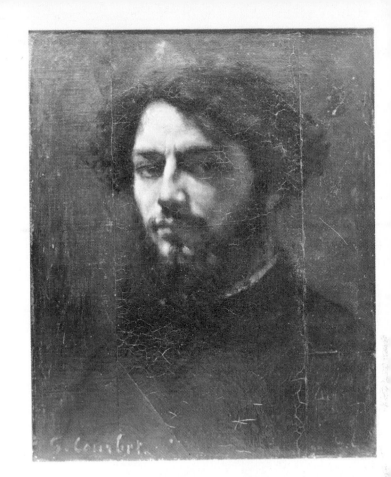

FRANCISCO ZURBARÁN
Francis with a Skull c. 1639

GUSTAVE COURBET
*Portrait of Monsieur X*** c.* 1846

THÉODORE GÉRICAULT
Portrait of a Vendéen c. 1822–23

GUSTAVE COURBET
Portrait of Urbain Cuénot 1846

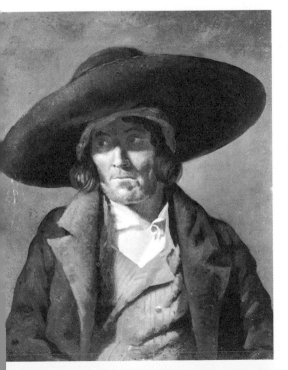

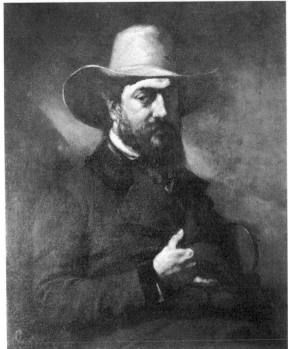

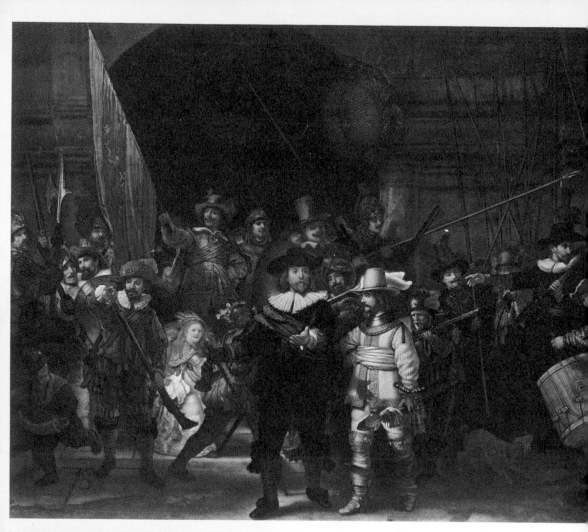

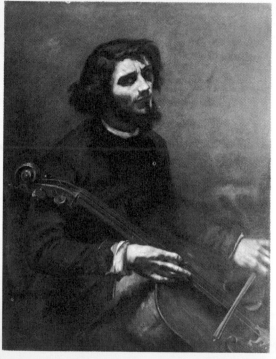

14 REMBRANDT VAN RIJN
The Night Watch 1642

15 GUSTAVE COURBET
The Cellist 1847

16 GUSTAVE COURBET
Firemen Going to a Fire 1850–51

17 GUSTAVE COURBET
Firemen Going to a Fire (detail) 1850–51

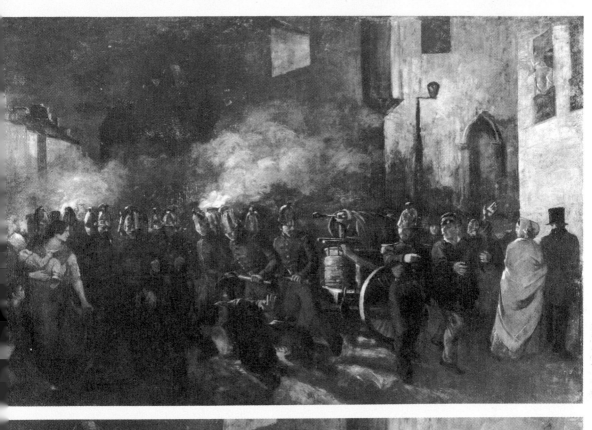

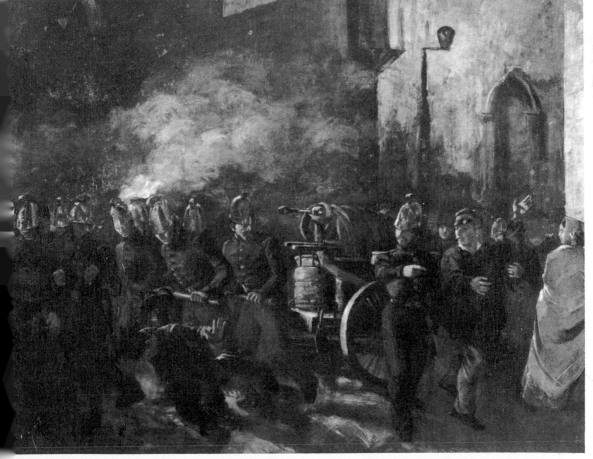

18 GUSTAVE COURBET
Man with Pipe 1846

19 ANONYMOUS
(Jean Tissot workshop, Besançon)
Canticle to St Nicholas Late 18th century

20 GUSTAVE COURBET
St Nicholas Reviving the Little Children
1847

21 GUSTAVE COURBET
Frontispiece for Le Salut Public No. 2 1848

22 GUSTAVE COURBET
The Brasserie Andler 1848

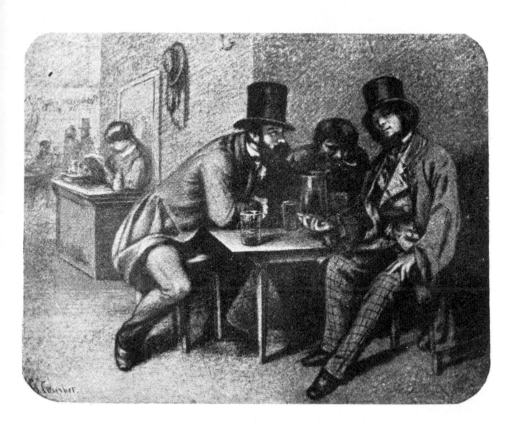

had scurried after the big bouquets from the front row, collected oranges like a grocer's assistant, and ignored a tiny bouquet of violets thrown from the gods.

In the gods, they take off their jackets when they are too hot, they eat apples when they are too thirsty, and never will you hear them complain, these poor wretches who seem like caryatids, supporting on their shoulders mountains of enthusiastic spectators.

The princes and the bankers, my dear, all smile condescendingly at the action on the stage; they laugh at the touching love scenes. Up in the gallery, men shed real tears and are not ashamed to show their feelings. The rich, with all their good taste, consider slapstick in bad taste, while great gales of laughter float down from the sixpenny seats. And in spite of this, actors have no respect for the real public, the public that makes their fortune and their reputation; for you know as well as I do, Columbine, that the Funambules would go out of business without the men in overalls.

You did not understand what delicacy there was in the gift of that little twopenny bunch of violets . . . you stepped towards the big bouquet and you left on the stage, in the dust, a beautiful little posy of flowers, which would wilt in an hour in the stale atmosphere of the theatre.[37]

It is easy to see why Baudelaire admired this passage: 'le bouquet du pauvre' he called it, inviting comparison with his own prose-poem 'Les Yeux des pauvres', where the same over-sensitive bourgeois laments a lady's rejection of the poor. It is the kind of subject-matter that he admired, for example, in Daumier's lithographs. It comes close to the tone – between tragedy and bathos – which Baudelaire used in his own prose-poems about Paris.

This was not the only Champfleury in 1848. Besides Hoffmann and pantomime, he had a third mode: he was the 'king of Bohemia'. Even towards that subject he had several attitudes. In 1845 he had published a story called *Confessions de Sylvius*;[38] it was ironic, witty, sentimental, and Murger copied its style for his *Scènes de la vie de Bohème* a year later. But Champfleury did not stop there. He went on to write his essay on Jean Journet, and plan studies of 'Les Grands Hommes du ruisseau, Les Excentriques d'aujourd'hui, Les Dieux et les apôtres du dix-neuvième siècle' (the three books his publisher announced on the back of *Feu Miette* in 1847). And he knew very well that these were the real Bohemians – the men of the gutter, the self-made gods, not the students and lovers of the Latin Quarter. When he wrote a public letter to Daumier about his book *Les Excentriques* in 1851, he put this very clearly.[39] The men in his book are the 'true Bohemians', and – so he admits obliquely – he has failed to find the tone to match their manic certainty. He compares his book with Diderot's masterpiece *Rameau's Nephew*, and the comparison is ultimately a damning one:

It took more courage than you'd think to get these models to pose; they are the true Bohemians, with difficult and gloomy dispositions, often as mysterious as the sphinx, and always as incomprehensible as the signs on the obelisk. . . .

All *Rameau's Nephew* is in this book. Diderot would never have written his finest work if the younger Rameau had not taken a delight in stripping himself naked, time and again, in front of the old philosopher. How many nephews of Rameau are walking our streets today? And what do these unknown geniuses lack? A man of genius who knows shorthand.[40]

That last sentence reveals Champfleury's limitations: it would take more than a stenographer to record Bohemia. And in any case, Diderot's eccentric wins his argument; Rameau confronts the narrator, with all his threadbare arguments in favour of the normal order, and stands that order on its head; he reduces him to silence. Champfleury was not capable of such doubts, or such reticence; he sniggers at his eccentrics throughout.

Finally, on the eve of 1848, there are some traces of Champfleury the Realist, the novelist of provincial life. These pages are still incidental in his work: occasional sketches of 'provincial malice and stupidity', small-town settings for magic or romance.[41]

In the Second Republic, all these modes survived: he wrote more pantomimes,[42] he published *Sylvius* in book form in 1850, he finished *Les Excentriques*. The revolution did not crystallize Champfleury's concerns, still less turn him into a Realist: on the contrary, it added to his confusion. In 1848 the people were revealed to him, but he did not much like the revelation:

I have at last seen the people, the real people, and I have understood them. Some are full of wisdom, but others have been truly terrible; they drank the cellars of the Tuileries dry and stood guard that night, stopping everyone, a hundred times more terrible than the Municipal Guard itself.[43]

So Champfleury wrote to his mother on 25 February 1848, and a few weeks later he went home to Laon, away from wisdom or terror. For the next two years his politics were as multiform as his literary style. He was, so he claimed, against the bourgeoisie, 'more red than reactionary; you know I have not much love for the bourgeois'.[44] And yet he was hand in glove with Jean Wallon, a Hegelian and a man of the Right, who dreamed about a new Holy Alliance to put down the spectre of Communism. To Champfleury, the people continued to be frightening; the Socialists were anathema; the Communist threat had destroyed the rural idyll: 'the farms are sad, the village women no longer gossip on their doorsteps'.[45]

Champfleury had become a collector. Instead of the people, he began to study the 'popular': old plates, peasant faience, songs, engravings: art as a counter-weight to Socialism.[46] Nothing enraged him more than Pierre Dupont's poetry, where the forms of the popular ballad were combined with the messages of politics; but there were other versions of popular art to choose from. He discovered Robert Burns in 1848; and Max Buchon introduced him to the poetry of Hebel, 'the singer of the family', as Champfleury eagerly described him. He planned already – it would take him twenty years to write – a mammoth work on popular prints. The engravings and woodcuts he collected all preached submission and social harmony, and that was why their history was worth discovering, in 1849. And the fact that they were being turned to new uses in the Second Republic – in his story 'Les Communistes de Sainte-Croix', Champfleury described the crude images of the Communist leader Cabet pinned to the cottage wall – made a plain, reactionary history essential.

He went on wavering. In summer 1849 he wrote home a sympathetic, almost

regretful account of the June uprising, and in the winter his novel *Les Oies de Noël* was published in Proudhon's newspaper.[47] In May 1850, he summed up his vacillation in a letter: he was just back from a civilized At Home, and was filled with vague good feeling:

Those jewellers would reconcile me to the bourgeoisie, but for the unfortunate fact that they form a tiny exception to the great class which is our enemy.[48]

The question is, who are the 'we' in this sentence? The people, the Bohemians, his family in Laon, the peasantry, the pious readers of *Le Bonhomme Richard*, or even the rabid subscribers of Proudhon's *Voix du peuple*? Champfleury never made up his mind, in these years: perhaps he never saw the problem of allegiances. If he imagined any political role for himself, it was the one he attributed to Hugo in a letter of 1850, 'a reactionary who is more of a revolutionary than any of the Reds'.[49] But that was a generous verdict on Hugo, and it had nothing much to do with the pattern of Champfleury's own politics: flirtation with the Left, blushes, withdrawal to the right. (*Le Salut public* in February, *Le Bonhomme Richard* in June; he wrote for Proudhon and the *Revue des deux mondes* concurrently.)

This imprecision spread like a stain from politics to art. 'Les Communistes de Sainte-Croix', Champfleury's brief, 'factual' description of a family of Cabétistes in a village near Paris, written in 1848, is sometimes seen as the turning point in his art, the first step towards Realism. Certainly he was trying to write in a new way in 1848–49: to lean less on fantasy, to stick closer to description, to become the 'stenographer' of the countryside. But what is striking about 'Les Communistes de Sainte-Croix' is its vagueness. For Champfleury in 1848, rural society has no geography, no distinctive features; his peasants dress in nothing in particular, their characters are not even indicated in his usual farcical shorthand. Their politics are a matter for sympathy and amusement, told in a few brief anecdotes – the images of Cabet on the wall, the 'Icarian almanac' (Icarie was Cabet's abortive colony in America), the supper at which all six of the family have their separate copies of *Le Populaire*. None of these people speaks or explains himself. Champfleury does the explaining.

This, for example, is his account of Communism: he is describing the countryside in 1848, in the pit of depression, with glut and uncertainty, stagnant prices, and no one willing to buy.

The people of Sainte-Croix took to Communism like a lark to a mirror, . . .
In the towns, in Saint-Quentin or Reims, one understands how men without work can become the agents of doctrines like this; they have everything to gain.
But in the villages where life is sweet and easy, once you have saved a little income, enough to die in peace [*quelques petites rentes pour mourir tranquillement*], why become a Communist?[50]

This is hardly Realism. If you could not grasp the obvious in 1848, that it was capitalism, not Communism, which made the farms look sad and stopped the women's gossip, then you would understand nothing else. If the essentials of the

crisis are blurred, the details will go out of focus. The strange thing is how quickly Champfleury took the point: in the space of a year, as the crisis in the countryside took on a political form, he shifted his ground completely. In *Les Oies de Noël*, as we shall see, he tried to mix romance and politics, and talk of debt and credit in the same breath as peasant ballads and porcelain from Tours. In the novel poverty and usury have become the threat to the rural idyll, the faience and the prints from Epinal are broken and neglected. In any sense that is relevant for Courbet, *Les Oies de Noël* is the beginning of Champfleury's Realism.

I have said a lot about Champfleury, because he is typical of Courbet's world in 1849. A typical juggler, a thermometer of enthusiasms: easy to read, difficult to pin down. Not the man to start a movement, except as a gambit or a joke; not a Realist, not a materialist, not a man who knew much of the countryside, although he sang its praises, vaguely. About the others of the six we have to be more cautious. Baudelaire, for instance, had no self in the Republic. He had no character; he enjoyed light and shade: he was everything and nothing, the most unpoetical of anything in existence. (If ever Keats's words applied, they do here.) He was reading Sade and Xavier de Maistre, but bursting in on Delacroix with talk of Daumier and Proudhon. He worked for newspapers of the Right, then went off and fought for the losers in June. He heckled the Left, helped edit *La République du Peuple*, expected a brutal 'Socialism of the peasants'. Opium and politics, Satanism and *socialisme mitigé*; 'Le Vin de l'assassin', 'Le Reniement de saint Pierre': Baudelaire's attitudes are not meant to add up. No wonder one acquaintance (Wallon, in his review of *La Presse de 1848*) expected his book of poems, announced for publication in 1849, to be Socialist and therefore bad – and no wonder he was wrong on both counts.

As for Pierre Dupont, he was Baudelaire's opposite and friend. During these years Baudelaire was elusive, two-faced, short-winded; Dupont was open, stable, prolific. He calmed Baudelaire down when they came away from the barricades in June; and in 1851 Baudelaire wrote an introduction to his friend's collected poems, praising Dupont for his simplicity, his political flair, his love of the Republic, and pouring scorn on the art that Dupont had supplanted – the art of private agonies, spleen and melancholy.

Taken together, their influence on Courbet could hardly have been simple. But one thing is clear. Their attitude to revolution was quite remote from Champfleury's – almost its opposite, at times. Their influence in 1849 must have been political as much as artistic. For the space of the Republic, they tried to make poetry from intractable facts: from the songs of the navvies on their way to work at dawn, from the mutterings of the ragman and the drunk, an image from Lesbos, a passage from Proudhon's *Contradictions économiques*. There were times when Baudelaire kept his distance from politics, and polished his prose on wine and hashish or his article on Edgar Poe. But the next month he is worrying about tactics, details: how to run a newspaper, how many handbills to print, how to avoid the attentions of the police. When he called on Courbet, it was either because he wanted a quick woodcut of the barricades, for the front page of his newspaper, or a friend to note down

his opium dreams. Both these incidents are typical: neither makes sense without the other: they are part of the same instinctive, baffled strategy.

Strategy is a grand word, but in the case of Baudelaire and Dupont it is more or less justified. They may have failed to use the revolution, to become part of politics: but they certainly tried. Compare for a moment the politics of Francis Wey, Courbet's patron. In 1848 he wrote a weird *Dictionnaire démocratique*, and proposed the following definition of 'Socialism':

It puts to use the changes in our way of life brought about by the course of political events; it regularizes, it organizes, it improves, but it avoids losing whatever influence it might have, and refrains from the use of force.

This was his entry under 'Strike':

When the workers, with the aim of imposing a wage increase, stop work, they substitute violence for equity, and in many cases provide the exploiters of capital with a powerful argument.

And, naturally, this was his definition of 'Insurgent':

One of a band of soldiers who dare not acknowledge any leader, a criminal horde without a flag, without principles, who dare to kill but not to proclaim their aims. . . . Such was the deplorable situation of the rioters in June 1848.

According to Wey, there was no proletariat after the introduction of universal suffrage. 'The bourgeoisie today is everybody.'[51] His dictionary had no entry under 'Peasant'. (Though Wey learned fast, like Champfleury. His novel *Biez de Serine* was published in *Le National* in January 1850, while Champfleury's *Les Oies de Noël* was still in progress: it likewise took peasant life as its subject, and mingled debt and dispossession with romance.)

Courbet painted three great pictures in this period: the *Portrait of Marc Trapadoux*, the *After Dinner at Ornans*, and the *Portrait of Baudelaire*. When the first two went on show in the 1849 Salon, the critics received them with a kind of sympathy. They were familiar images, part of the *Ecole Réaliste* that had continued through the 1840s. Gautier discussed Courbet in the same breath as Meissonier and the brothers Leleux; a critic named Lagenevais, less sympathetic, linked him with Leleux and Bonvin, 'my lords the Realists, with their fine airs and their claim to be revolution aries',[52] who end up imitating Chardin just the same. Everyone knew about Realism in 1849, and many considered it a bad thing – but not exactly a threat.

Louis Peisse was the most violent critic; he remarked of *After Dinner at Ornans* that 'no one could drag art in the gutter with greater technical virtuosity'.[53] This phrase evidently stuck in Courbet's mind; 'Yes, M. Peisse, art must be dragged in the gutter', was his comment in a letter to Wey. But Peisse's words in 1849 were mild, a mere damning with faint praise, in comparison with what he wrote two years later: 'The nation is in danger. . . . His painting is an engine of revolution.'

Lagenevais disliked the size of *After Dinner*, and its dry enumeration of details:

'he should show them to us, in the Flemish manner, through the wrong end of a telescope, so that they become poetic as they recede into the distance'.[54] But the picture's size produced 'ennui', not anger. Haussard had the same kind of objection, but he still admired Courbet's work; he linked it with Bonvin's 'triumphant' *Woman Cutting Bread for Soup*, and praised a 'domestic honesty which touches us profoundly. . . . It is, besides, a picture whose composition, light and colour have a skill, a frankness and a breadth of approach which are truly surprising.'[55] Compare the same critic in 1851: perplexed and angry, struggling for words.

'The canvases of Courbet are causing quite a stir,' wrote Francis Wey. 'They are energetically attacked, and equally energetically defended. This boy has his critics, and his admirers, but he is nonetheless one of the celebrities of the Salon.'[56] The Bureau des Beaux-Arts bought *After Dinner* for the decent price of 3,000 francs, hesitated for a month or two, then sent it off to the museum at Lille.[57] Courbet got a second-class medal, and was thus spared further truck with the Jury (this was a vital piece of luck: would the *Burial at Ornans* or the *Stonebreakers* have been shown at later Salons otherwise?). Finally, in the Jury des Récompenses which chose the first-class medals, he was given a single vote: was it from Delacroix? or, more likely, from Jeanron?[58] In other words, he was a young painter with a future before him.

Marc Trapadoux Examining a Book of Prints [25] is probably the earliest of the three great paintings of 1848–49. Trapadoux sits in the corner of Courbet's studio, pipe in hand, half leaning on a desk, with the book of prints spread open on his lap. Behind him are the blank wall of the studio and the stove in the corner; on the floor a coal-scuttle, the edge of some garment, a wood chip; and under the desk, a palette. He is swathed in a shapeless tunic and check trousers; they and the book of prints disguise his anatomy. The physical giant – his friends called him *le Géant-Vert* after a green greatcoat he always wore – is spread out in a casual perspective, his shiny black shoes the strongest note in the harmony of neutral blacks and greys. It is a portrait in which awkwardness vies with a kind of delicacy; in which the pose is part clumsy, almost sprawling, part relaxed and economical, intent on the task in hand. There is the same ambivalence in the composition. On the one hand, careful repetition of forms: the ellipse of the stove repeated in the scuttle below it, the oval print inside its square frame echoed by the artist's palette. On the other hand, a deliberate refusal to compose too tightly: the hard edges of desk, palette, hob and shovel not quite conforming to each other; the spine of the book and Trapadoux's head set just off centre.

In other words, a balance between composure and disarray: a giant, brooding amid the debris of the studio; a philosopher and a Bohemian. There is some reason to think that this was Courbet's intention, for Trapadoux was one of the archetypes of Bohemia, the model (with Wallon) for the philosopher Colline in Murger's *Scènes de la vie de Bohème*. Courbet had already drawn him in the Brasserie Andler [22], aggressive, enormous, crouched over the table in top-hat and green greatcoat. This portrait shows the other Trapadoux, the private man who 'believed that asceticism was a form of inebriation, helpful to the creative impulse', the Brahmin

who 'would finish his days with his hands in the air shadowed by his own finger-nails, like fronds of weeping willow, combining preexistence with the infinite'.[59] That was Courbet's description, given to Baudelaire; and it was not simply flippant. Trapadoux was eccentric, but not ridiculous; in the same letter Courbet called him 'a doctor, a soothsayer, of some savage tribe', but made no secret of his respect for him: 'I avow that he is very necessary to me.'

Trapadoux, if his scanty writings are any guide, was both mystic and materialist. When he wrote a biography of St John of the Cross in 1844, it was a work of homage to a great popular saint who faced the problem of poverty (he stressed that achievement in his introduction), but it was also, in a curious way, an attempt at analytic biography:

We shall explain the man and the saint, we shall reveal the natural and supernatural sources of his motivation, discover by what hidden routes, by means of what psychological truths, the heart must achieve results comparable to the deeds of St John of the Cross; and what kind of ideas and feelings and circumstances in turn bring about changes in his life.[60]

Trapadoux was the typical Bohemian: a real and erratic intelligence, a buffoon and an ascetic. The more we know about him, the more remarkable is the poise of Courbet's portrait (poise in the physical and psychological sense of the word). It is not a tense or dramatic picture, and there are no signs of conflict between the sitter and the painter: it is deliberately informal, affectionate. But it looks very hard at its subject: it finds physical means to suggest the complexities of his character. The character, in any case, was inseparable from the immense physique. It is a portrait of Bohemia, and a very subtle one: a portrait done from intimate knowledge.

With *After Dinner at Ornans* [24], Courbet shifted his ground. His explanation in the 'definitive list' he sent to the Salon Jury is the best starting-point: 'After dinner at Ornans – it was in November, we were at our friend Cuénot's house, Marlet had just returned from the hunt, and we had persuaded Promayet to play his violin for my father.' In other words, it was one specific moment in rural life. It was an or-dinary occasion, the time of the *veillée* between the evening meal and bed, when the head of the household read aloud from the *Bibliothèque bleue de Troyes*, the children sang a ballad or a carol, and a friend played the violin. The picture is not exactly particular, not exactly general; not incident, not autobiography, but not custom either, and certainly not ritual. It moves between the four, as the *Burial* will: though by that time the movement will be more abrupt, provocative, almost comic. There is nothing provocative in *After Dinner at Ornans*; with a few reserva-tions, one could read it as folklore.

It is a massive picture, over six feet by eight, and it covers that space very simply, with a kind of arrogant straightforwardness. We have to half reconstruct its first appearance, since time has cracked and darkened it: Courbet used too much bitu-men (it was cheap) and did not care for the science of pigment. But it must always have been a dark picture, taking its range of colours from Rembrandt, setting the four men in the gaping shadowy space of a hearth. In the gloom, colours are subtly deployed. There is a mastiff on the floor, painted in touches of black, brown and

grey; there is green in Promayet's coat and the waistcoat of Courbet himself, sitting pensively on the far side of the table; there is the white tablecloth, stained with wine, and the chalky whiteness of Marlet's hunting jacket; and a hint of flame in the grate, between Marlet's hand lighting the pipe and Promayet's hand on the violin. And there is already a tremendous sureness of design in certain areas: in, for example, the arrangement of mastiff, chair back, jacket, and fold of table-cloth.

Before I retail the sources of this assurance, let me state the obvious: this is not a picture in which a young painter borrows forms and experiments with styles; it is a picture which *absorbs* past examples and puts them to a new use. It is not parasitic on tradition. It does not repeat its masters, as Bonvin repeated Chardin; it does not even simply blow them up to a new scale. Yet it has masters in plenty; it is a synthesis of various traditions, and if we look at the materials Courbet used we shall understand Realism better.

First, Rembrandt; second, Velázquez; third, the brothers Le Nain. Specifically, Rembrandt's *Supper at Emmaus* [27], which was in the Louvre; a copy of Veláz-quez's *Supper at Emmaus* [28], which had been in the Musée Espagnol; and works like the Le Nains' *Peasants' Supper* [29], or the *Peasant Family* which came out of the Louvre cellars in 1848.[61] On one level, it is easy to see what Courbet borrowed from each. From the Le Nains he took a certain gravity of tone and a ruthless simplicity of arrangement, with the figures placed casually across the canvas surface, each one 'added' to the next without any transitions of gesture or linking of pose. From Velázquez and the Spanish school in general he took something of the treat-ment of the still-life on the table or the bowl upon the floor, some of the details of his own pose and expression, and something of the compressed space between the two right-hand figures; from Zurbarán perhaps something of the harsh but even light on Marlet's face and figure: compare his clothing with the tattered cassock of *St Francis with a Skull*. And from Rembrandt he borrowed the pose of Marlet, and most of all the rich variations of colour within a narrow range, greens, greys, browns, and black.

But having enumerated the influences, the strange thing is the way they evaporate when we look back at the picture itself. The painter borrows, but the image is not eclectic. It is partly the fact that his borrowings are approximate; and partly that, when they are direct, the debts annul each other. Courbet could at last imitate Rembrandt, because he had the Le Nains as a counterweight. He could paint the bravura mastiff as an open tribute – and a challenge – to Rembrandt, just because the whole composition, the deadpan spacing of the figures in a simple row of four, was so far from Rembrandt's practice.

Set the picture alongside Bonvin's Salon entry of the same year, *Woman Cutting Bread for Soup* [32], and you have the extent of Courbet's achievement. For Bonvin, it went without saying that Realism had to imitate, in its early stages: he made no secret of his debts to Chardin, he declared his sources and sought to reproduce them. In a way it was a reasonable attitude for a Realist to take, in the middle of the nineteenth century. In the midst of artistic confusion, and in the face

72

of the classical tradition, the Realist would look for an alternative tradition and digest it slowly and deliberately. Gradually, cautiously, he would adapt the style of Chardin or the brothers Le Nain to the subject-matter of his century; but he would begin with the old subjects, the old archetypes of domestic ritual, the woman drawing water from the urn, the anonymous peasants enjoying their beer. He would search for a pedigree and risk the gibes of the critics: the obvious sneer of Lagenevais, talking of Bonvin in his 1849 Salon: 'pastiche and parody always do well out of revolutions'.[62]

Or set Courbet's picture against another 'element' of Realism in 1849: Champfleury's new-found liking for the brothers Le Nain. If you compare his little pamphlet on the Le Nains, published in 1850, with the use that Courbet had made of them the year before, the differences are clear. In the pamphlet, Champfleury gave little indication that he knew what a painting by the Le Nains looked like, or whether they had a distinctive style at all. What mattered was the fact they once existed: they were another link in the Realist tradition, a convenient blot on the classical seventeenth century. He documented that existence very well, like any provincial art-lover; they came, after all, from his home town, Laon. But when he came to his conclusion, and tried to describe their art, his nerve failed him. He saw that the Le Nains' pictures were sombre, monochrome, and their characters were cheerless and careworn. He explained it like this: 'the melancholy sadness of their figures is only the reproduction of their own melancholy and sad temperaments'.[63] So much for the realities of peasant life in the seventeenth century: so much for La Bruyère! He risked one visual comparison, and was immediately absurd. 'The peasants of Le Nain always look as though they are *thinking*. In many of their pictures the workmen look towards the horizon, head in hand, and they recall the *Melancholia* of Albert Dürer.'[64]

Much later, in a book he published in 1862, Champfleury again tried to describe the Le Nains' style. 'They sought reality even in their clumsy way of putting isolated figures in the middle of the canvas; in this they are the fathers of our present-day experiments, and their reputation can only grow . . . it does not much matter to me if a figure is not in the right perspective or if at the back of a room it looks a quarter of a mile away.'[65] But this is hindsight, and what he calls 'our present-day experiments' had begun in 1849. What Champfleury describes in 1862 are the qualities Courbet had seized on in 1849, in the *After Dinner* or the *Peasants of Flagey*; and, even so, Champfleury is hedging his bets. Are the isolated figures and the dislocated backgrounds mistakes or qualities, 'present-day' or clumsy? Champfleury never quite decides, and in 1849 he made no comment on *After Dinner at Ornans*. When he wrote his *Salon*, he saved his praises for Bonvin, the 'painter of the family'.

Put Courbet against Champfleury, put *After Dinner* against Bonvin's *Woman Cutting Bread for Soup*, and Courbet's Realism only seems the more decisive. Instead of reverence, a brutal manipulation of one's sources. Instead of pastiche, confidence in dealing with the past: seizing the essentials of Le Nain and discarding the detail, combining very different styles within a single image, knowing what to

imitate, what to paraphrase, what to invent. In a sense, Courbet had no apprentice-ship as a Realist: as soon as the subject-matter was discovered, the problem of tradition, which had perplexed him for a decade, was resolved in the space of months.

Compare *After Dinner* with Bonvin's picture, just once more. The essential difference goes beyond style: it is a difference of subject and attitude. Bonvin's kitchenmaid is in any scullery, and the slate on the wall is any slate. Her history – Champfleury called this a 'historical painting' when he reviewed it in 1849 – is not located anywhere in particular. It is one moment, no different from the others it recalls or prophesies. Courbet's history has nothing in common with this. Not any kitchenmaid, but himself, his father and his friends. Not a faceless actor and an act repeated a thousand times, with the maid as anonymous as the gesture she makes; but a tension between anonymous forms and specific faces, an actual occasion. (When Courbet makes his actors anonymous – as he does, for instance, in the *Stonebreakers* – it seems as if this is something he works towards, against the grain of his particular, concrete intelligence. In the *Stonebreakers*, everything is par-ticular except the two men's faces, and feelings; and they are masked because Courbet saw, in the end, that they were the only things in the scene he did not know or understand.)

This seems to me the nub of Courbet's Realism, and many of the pictures of the next few years thrive on the same kind of tension. In the course of painting *After Dinner at Ornans*, Courbet saw that the commonplace was not the life of other people, but his own life. He located *himself* in the texture of town, family, customs, institutions. He saw the obvious: that autobiography begins where friends gather by the fire, or the town gathers at a graveside; where experience has an old context and an anonymous form, but is nonetheless specific. These were insights, elemen-tary but difficult, that he exploited in the pictures he did next.

But before he did so, some time in 1848 or 1849, he painted the portrait of Baudelaire. It is not like any other picture Courbet painted. It is not a confident, ironic icon, like Bruyas with his fist pressing his slim volume on Modern Art; not an affectionate image, like Trapadoux; not even regretfully harsh, like the portrait of Champfleury in *The Studio*, which ended their friendship for good. Baudelaire was a subject that called for a different style, a kind of painting Courbet never risked again.

The poet is seated at his desk, half hunched over a book, clenching a tiny pipe in his teeth, one hand resting on a ruddy-brown cushion. Behind his head, at the picture's visual centre, is the faint line of the corner of the room. Over his knees is a brown rug, and behind him is another cushion with huge tassels. It is a simple set-up, bare, workmanlike, but stylish. The same could be said of his dress and his hairstyle of the moment. Baudelaire was a great conjurer with his hair, chang-ing it from day to day. We are not quite sure, and nor were Baudelaire's friends, whether the clothes in the portrait are informal or the opposite: whether, as Buisson suggested in 1886, this was the authentic record of Baudelaire the dandy, his 'habitual black coat buttoned right down to the thighs'; or whether, as

Troubat said, this was the casual Baudelaire, the Baudelaire of Bohemia, his costume 'casual and unceremonious', wearing a blue shirt and a golden-brown cravat tied in a careless knot.[66] He might be dowdy or he might be *chic*; and perhaps Courbet himself was undecided. He found it hard to paint the picture at the time, and complained to Champfleury, 'I do not know how to *get to the end of [aboutir]* the portrait of Baudelaire; every day he wears a different face.'[67]

But it seems as if, in the end, he found a way to summarize those changes: almost as if he blocked in, over the original detail, an approximate image, with dress and features just out of focus. The light in the picture breaks on the forehead, nose, ear, collar and hands with a deliberate coarseness, applied in dry touches of pure white (on the fingers, highlight and shadow are blocked in with two parallel strokes, as Hals did it). And, around the figure, the walls, coat, cravat and cushions are painted fast, in broad, easy touches, as if the oil was thin and liquid in the final stages.

It is an approximate image, half obliterated. It is a portrait as subtle as its subject, disguising its attitude to the sitter, content to place him in this strange habitat, opulent but severe, a *décor semblable à l'âme de l'acteur*. It is almost, but not quite, Baudelaire as he saw himself, the Baudelaire of 'Paysage':

> L'Emeute, tempêtant vainement à ma vitre,
> Ne fera pas lever mon front de mon pupitre;
> Car je serai plongé dans cette volupté
> D'évoquer le Printemps avec ma volonté,
> De tirer un soleil de mon cœur, et de faire
> De mes pensers brûlants une tiède atmosphère.[68]

That is uncannily close to Courbet's image, and even the reference to revolution suggests a similar date. But the portrait has other aspects, difficult to fix in words. In the portrait there is more equivocation than in the poem: there is fragility as much as an effort of will; we could call the atmosphere hectic and tense as well as warm, the face pinched and pliant, half-formed like a foetus, the neck and body strained, the hand flexed (or resting gently?), the widow's peak eroded by the light. None of these adjectives is accurate on its own, but together they suggest what happens: the strange flicker of attention from feature to feature, detail to detail, the refusal of the image to 'add up'.

Klaus Berger first pointed out the 'anti-composition' Courbet used in this picture: the way he refused to give the head and face primacy in the picture, and built the image of separate and equal units of colour, 'every object . . . provided with a face of its own . . . all things of equal visual value'.[69] But Berger did not suggest a reason for the organization in this particular case; and later critics have not helped us much. They have called the portrait 'materialist', though Courbet hardly bothers to evoke the material substance of sitter or objects; or, even vaguer, they have called it 'democratic'.[70] A composition without a focus might take on that significance in other contexts. But not here, where the uprising beats in vain at the window and Baudelaire bends obstinately to his book. This is an image of privacy and self-absorption, a space where one man excludes the world of public statement.

Maybe Courbet did not agree with that kind of privacy, but his purpose here is clearly not satire. (He would save that for later, in his abortive allegory *The Hippocrene Spring*. There Baudelaire stood, notes in hand, doing homage to an obscene muse, who spat in return into the spring water.)

Courbet was a pragmatic painter. He chose the means most appropriate to the subject in hand, and he used the same techniques to very different ends. His aim in his portraits is the old one, the unavoidable one: to find a form to evoke his sitter's state of mind. When he struggled to finish this picture, what he wanted was a form as evasive and complex as Baudelaire himself, yet at the same time simple and concise. In the end he found it: a plain image, but one where our attention wanders; an image where the details do not quite harmonize; a record of a strange and short-lived friendship.

5 *Courbet in Ornans and Besançon 1849-50*

In October 1849 Courbet went back to Ornans. He was at last a successful painter; and the townspeople of Ornans were aware of it. A fortnight or so earlier the Government had finally bought *After Dinner at Ornans*; throughout July and August, the Salon critics had sung their qualified praises; in September, Courbet received his medal. When he got home, he had his first 1,500 francs in his pocket. The town gave him a great reception.

But it was not a triumph that lasted very long. The deal with the Bureau des Beaux-Arts quickly went sour. Instead of the promised place in the Luxembourg, *After Dinner* went off to Lille in a job-lot with Huguenin's statue of Hebe. (The mayor had asked for Rosa Bonheur's *Bulls* or Muller's *Lady Macbeth*: what he thought of the substitute is not recorded.)[1] The change of destination 'astonished' Courbet. By 19 March, when he wrote to the director of Lille museum, he was anxious to know whether the Government had changed its mind on other details. 'M. Charles Blanc had promised to change the frame of my picture, because the frame it had at the exhibition was only temporary. I'd like to know if M. Charles Blanc has kept this promise.'

He was right to worry, for he still needed the State's support. He was still an artist without patrons, casting around for sales: he did a quick portrait of an English dandy in the summer of 1849;[2] he depended on rich friends like Wey for commissions and hospitality. Courbet remained all his life an artist in search of patronage, and the patrons he acquired make up a contradictory, improvised collection. On

the one hand eccentric bourgeois willing to play the Maecenas in the old style, discuss the theory of painting with their artist friends, and pay them handsomely to put the theory into practice. Alfred Bruyas was the great example of this type; though the relationship with Francis Wey had something of the same flavour. On the other hand aristocrats and Napoleonic officials, like the Comte de Morny who bought the *Young Ladies of the Village* in 1852, or Louis-Napoleon himself, who made an offer for the *Man with Pipe* in 1851 and was proudly refused.[3] And again, the local bourgeoisie of the Franche-Comté: businessmen from Besançon, 'master smiths from my part of the world', eccentric radicals like Mazaroz from Lons-le-Saunier.[4] Finally, foreign connoisseurs like the English dandy Hawke or the Dutchman Van Wisselingh. That pattern lasted, in its essentials. Baudry replaced Bruyas, the foreigners became more numerous and exotic, and the aristocracy of the new Empire was less adventurous in its tastes than Morny had been. They wanted portraits of their wives, and Courbet obliged, following the ladies to their bathing resorts on the Normandy coast.

He never discovered – least of all in these first few years after 1848 – a new class of patrons, ready to support a Realist school. He painted some of his greatest pictures – like the *Burial*, or *The Studio*, or for that matter the *Portrait of Baudelaire* – not to be sold. He needed the State, the family, and the friends with money. He was a traveller for the simplest of reasons and the best: on the lookout for free food and hospitality. That life had its dangers, obviously enough. There is always a thin line between Bohemianism and sycophancy, at least if you have something to sell: but for the time being Courbet kept on the right side of the line. It was not till the 1860s that he lost his nerve, bought himself some shares, and began to speculate on what the bourgeois public wanted.

Between October 1849 and the summer of 1850 Courbet painted the *Stone-breakers*, the *Burial at Ornans*, and the *Peasants of Flagey*. It was the most productive six months of his life; and in terms of sheer energy, acres of canvas covered with paint, few painters have come near it. On one level the three pictures done in that time are plain images, purposely so: they take the common matter of the country-side and paint it piece by piece, attentively. On another level, they puzzled their audience at the time, and they are still profoundly obscure. If we ask the simplest questions of them – what are their subjects, why were they chosen, what are they about? – their plainness disappears. And if I offer an answer to these questions in the next two chapters, it will have to be prised from a complex of sources: a Parisian critic's careless aside, or a friend's advertisement in a Dijon newspaper; a novel by Wey or a greater novel by Balzac, an almanac and a caricature, a bloody image daubed on a tavern wall; the worries of a Prefect or the result of a trial at Lons-le-Saunier; political strife at Salins, political quiet in Ornans; Courbet collecting peasant songs, or Courbet at carnival time, whey-faced and black-suited, acting the part of Pierrot de la Mort.

These are, so to speak, the inflexions of the pictures from Ornans, the meanings they evoke but do not indicate. They are sometimes the matter, sometimes the intention; sometimes the context, sometimes the result of Courbet's paintings.

They are never, in any case, distinct and separate categories; and in this case the blurred edges between them are what counts. What is *in* the image, what's intended by it? What's the picture *of*, who's the picture *for*? Where does content end and context begin? The critics in 1851 were affected by Courbet's work precisely because they could not answer these questions and get their bearings for aesthetic judgment. In the rest of the book, I shall try to preserve that bewilderment as well as explain it.

Let me begin with descriptions. The *Stonebreakers* [31] was painted first, in November; it was taken from life, two labourers from Maisières seen on the road and invited back to Courbet's studio. It is, as Courbet stressed to Wey and Champ-fleury, a particular scene and also an image of a general condition. 'It is rare', he told Wey, 'to encounter the most complete expression of wretchedness, so all at once a picture came to me.' The same picture had come to many painters before him, and the task itself – breaking stones to surface the tracks and roads of the district – was almost as old as the rural community. The year before, in the Salon of 1849, Adolphe Leleux had painted a picture of 'Aragonese road-men sleeping beside the road they are repairing'.5 It was not, in other words, a new subject, or a modern one – and it did not need to be.

It is, like the paintings of the previous year, a simple image. But the more we look at it, the more that simplicity seems deceptive. There are two figures set against the dark green of a hillside, and their physical presence has been set down with the utmost care. Look at the leather strap across the young boy's back and shoulder, and the puckered cloth of his shirt where the strap is pulled tight by his effort: the way these details register the substance of the body beneath them. Or the same effect, produced as the old man's waistcoat rides up his back; or the thick, resistant folds of his trousers at knee and thigh. This is painting whose subject is the material weight of things, the pressure of a bending back or the quarter-inch thickness of coarse cloth. Not the back's posture or the forms of cloth in movement, but the back itself and the cloth in its own right. Pressure, thickness, gravity: these are the words which come to mind, and which describe the *Stonebreakers* best. (The one satisfactory comparison – though it only goes to show Courbet's originality – is with the painting of physical substance in Rembrandt's last pictures. I am thinking of the father's hands on the shoulders of the Prodigal Son, or the hands and sleeve in the *Bridal Couple*.)

But the *Stonebreakers* is also a picture of action: not of physical presence merely, but of physical labour (the kind we call, with a cynical euphemism, 'manual'). And this is where the painting stops being simple. In his letters Courbet talked of the boy 'carrying his basket of broken stones with energy', of the old man 'bent over his task, pick in air'. But the image he gave us is rather different from what this implies. It is an image of balked and frozen movement rather than simple exertion: poses which are active and yet constricted; effort which is somehow insubstantial in this world of substances. What Courbet painted was assertion turned away from the spectator, not moving towards him: it is this simple contradiction which ani-mates the picture as a whole. Courbet swivelled the boy and his basket of stones

into the picture; he drew the old man with averted gaze and a kind of hieratic (but also senile) stiffness. The force of their actions is implied in the pose, but also half concealed by it.

Where, to put it another way, will the momentum of the stonebreakers' actions carry them? Is the boy checked in his stride, the pannier balanced for a moment on his knee? Or is he striding vigorously back into the picture space? The clothes the men wear – for all their dense substance – actually prevent us from answering these questions. In the *Stonebreakers* the drapery (the very word seems out of place) articulates the figures' presence but not their particular configuration in space, and least of all does it indicate their movement. The man and the boy have no anatomy in the old sense; no point where the arm ends and the shoulder begins, no sharp and artificial distinctions between waist, torso, and pelvis. The clothes they wear mask or confuse these transitions: the holes torn in the boy's shirt reveal flesh but not muscle, the trousers disguise his buttocks and hips, even the old man's shoe seems a form quite separate from the foot inside it. (Which is true, of course, of clogs, or trousers made from cheap wool, or the physiognomy of rags.)

Clearly enough, Courbet wanted to show an image of labour gone to waste, and men turned stiff and wooden by routine. In both his explanatory letters at the time he stated the scene's simple moral: 'in this occupation, you begin like the one and end like the other [*dans cet état, c'est ainsi qu'on commence, c'est ainsi qu'on finit*].' Compare Yeats's two-line poem *Parnell*:

> Parnell came down the road, he said to a cheering man:
> Ireland shall get her freedom and you still break stone!

But the achievement here is that Courbet gets the moral down in paint, and does not lean on anecdote or pathos: he dissipates the weight his brushstrokes register, he turns the painting against itself. He concentrates on the task in hand: the action of labour, not the feelings of the individuals who perform it. And that is a rare achievement. There are pictures in plenty of worship, anguish, celebration, states of mind; but, for many reasons, there are few images of work. It is too obvious and too obdurate for form: painters avoid it. And when they paint it, they choose the dramatic action or the interlude, the sower's outflung arm, harvesters resting, Arachne at her loom. If we look for work alone, in its own right, in detail, we have to go to Courbet or to Bruegel: to the ploughman on the cliff in Bruegel's *Fall of Icarus*, watching nothing but the furrow turn; or to the two stonebreakers on the road to Maisières. At Maisières men are things, and the things ugly and monotonous. *The Stonebreakers* was (and is, in its pre-war photograph) a grim picture, a picture that called for an *antithèse psychologique*, a counterweight, as Buchon put it in 1850.[6]

The counterweight was the *Burial at Ornans* [VI], and a bizarre one it was. There are plenty of paintings of ritual, or the Christian sacraments, but none of them is much like this. It is not simply a question of sympathy or the lack of it, for there are many pictures of ritual which we are invited to contemplate with some degree of distaste: the long series of Bacchic dances, the *Worship of the Golden Calf*, or later,

in a more polemical mood, Hogarth's *Enthusiasm Delineated*. But the very word 'enthusiasm' indicates what is unique about the *Burial*. At least the Maenads or the Children of Israel were hell-bent on their pursuits; they were clearly animated by belief, even if in false gods; for the artists who portrayed them, it seemed unthinkable to dissociate ritual from some form of religious experience. But this is what Courbet has done in the *Burial at Ornans*. He has given us, in an almost schematic form, the constituents of a particular ritual, but not their unison. He has painted worship without worshippers; the occasion of religious experience, but instead of its signs, vivid or secretive, a peculiar, frozen fixity of expression. (This applies to individual faces and to the image as a whole.) It is not exactly an image of disbelief, more of collective distraction; not exactly indifference, more inattention; not exactly, except in a few of the women's faces, the marks of grief or the abstraction of mourning, more the careful, ambiguous blankness of a public face. And mixed with it, the grotesque: the bulbous, red faces of the beadles and the creaking gestures of the two old men at the graveside.

In formal terms, the *Burial* has many sources. It takes its general format from a painting Courbet saw in Holland in 1847, Van der Helst's *Banquet of Captain Bicker*. But it stiffens and simplifies that format, so that the components of the situation are each displayed with the greatest possible clarity, heads focused in an even light, crucifix silhouetted against the sky, the main figures arranged in distinct, almost rhetorical poses. The way in which this is done owes a lot to the popular print. Not, I think, to any print in particular, though there are echoes of several: the famous *Degré des âges* with its procession from childhood to senility, the various *Souvenirs mortuaires*, the *Mort et convoi de Marlborough* [33], even the *Convoi funèbre de Napoléon*.[7] But these are echoes more than borrowings, and Courbet owes most to the artisan engraver's general approach to his subject: his clear, cut-out forms, his clumsy, dramatic gestures, the way each part of his image is organized to convey the *units* of a ritual or a social situation. The popular print exists to give information, to leave its public in no possible doubt about what happened, who was there, who was most important, who lost, who won. Its form derives from its function, and Courbet copied both.

At the same time he looked again at the 'official' tradition. In the *Burial* he is less reliant on Rembrandt than before, and closer to Spanish painting: look at the pose and drapery of the beadle who stares out of the picture, and the way the head, shoulders and sleeves of the kneeling gravedigger are juxtaposed with the red and black behind them. (This is typical of Courbet: the pose of the gravedigger is taken straight from Van der Helst, but the way he is placed against the beadle owes nothing to the Dutch and a lot to Velázquez or Zurbarán.)

In other words, the *Burial at Ornans* is built from very disparate materials; and, in detail, the materials are fairly distinct. But structure is what counts, not detail; and looked at whole the *Burial* is anything but a hybrid. The most obvious thing about it is its simplicity; though even this is not straightforward. Simplicity on this scale, with this intractable material, is something a painter builds rather than finds.

Courbet has gathered the townspeople of Ornans in the new graveyard, opposite

the cliffs of Roche du Château and Roche du Mont. He has painted more than forty-five figures life-size in a great frieze over eight yards long, arranging the figures in a long row which curves back slightly round the grave itself; and in places, following the conventions of popular art, he has piled the figures one on top of the other as if they stood on steeply sloping ground. And towards the right of the picture he has let the mass of mourners congeal into a solid wall of black pigment, against which the face of the mayor's daughter and the handkerchief which covers his sister Zoë's face register as tenuous, almost tragic interruptions.[8] He has used colour deliberately and dramatically, in a way which has little to do with the careful materialism of the *Stonebreakers*, to symbolize matter; almost, as our eyes move right, to threaten the faces put upon the solid ground. (Compare the *Burial* with the preliminary charcoal sketch [30], and one can see quite easily how this was done. In the sketch, for instance, the second row of mourners appears intermittently *behind* the first, costumes and faces nearly obscured. In the painting they are moved upward, their faces are revealed, and their mourning dress provides a black frame *above* the faces in the front row, filling the spaces between the heads and continuing the black surface which begins at ground level. The effect is crucial: look, for example, at the faces and kerchiefs of Courbet's three sisters, in the front row towards the right, and compare the emotional weight of the image in the sketch and the painting.) Black is the basis of the *Burial at Ornans*, and two sequences of colour are played against it, over the picture's whole length. First the flesh colour of the hands and faces; second, the plain white of handkerchiefs and collars, lace caps, spats, the priest's trimmings, the gravedigger's sleeves, and the glossy hide of a dog. At the left of the picture [V] the same colours are put in negative: the black of crucifix, caps, and belts against the surplices of the choristers, black crossbones and black tears on the pall itself. (This last is a deliberate, and typical, reversal of the facts. All the prototypes in popular art and embroidery – for example, the coffin of Marlborough – show a black pall decorated with gold or white tears and skull. In the sketch the pall was still neutral in colour and without decoration; it was only when it was turned round and made part of the group behind the priest that its form and colour were decided.) Finally, Courbet added two notes of stronger colour, the beadles' costumes and the blue and grey of the old man's coat and gaiters. He cleared a space above the old man's head and used the grey and blue to punctuate the black surface at its halfway point; and he placed the crucifix and golden censer as a second hiatus at the left.

In other words, the *Burial at Ornans* is carefully and subtly constructed. The repetitive forms of popular art are animated and reorganized; the monotone of black is accented just enough to keep it alive and active against the faces. Look at the sketch once again, which is far closer to the crude straightforwardness of the *Souvenirs mortuaires*, and it is clear what kind of intelligence has been at work: breaking and turning the long line of heads; drawing the black into dense clusters and making the white area a more positive interval in the picture; creating just enough space, between crucifix and censer, or between priest and gravedigger, to make the various groups distinct. Nothing is enlivened too much: the forms of

popular art show through the picture like a skeleton; no device is strong enough to obscure the basic theme, the faces etched in even light against the mass of black below them.

This is the picture's structure. It is more complex than it seems at first sight, but it can be described step by step, with some kind of certainty. Beyond this point, when we start to ask about the picture's meaning, the real difficulties begin. What, to put it briefly, is the *Burial*'s affective atmosphere? What are the mourners' attitudes and emotions, and what is Courbet's attitude to the event portrayed? Is there some meaning – as Courbet's friend Buchon suggested – to the juxtaposition of the priest and the peasant gravedigger, linked as they are by the beadles' pock-marked faces?

We have to answer such questions in the face of an image which deliberately avoids emotional organization: by that I mean the orchestration of forms to mimic and underline the emotional connotations of the subject. In the *Burial* there is no single focus of attention, no climax towards which the forms and faces turn. Least of all is the picture organized around the sacrament of burial: hardly a single face, save perhaps the gravedigger's, is turned towards the priest, and the line of heads at the right of the picture looks the other way entirely – away from the coffin and the crucifix. (Compare the sketch once again: the faces there are all turned attentively towards the grave.)

There is no exchange of gaze or glance, no reciprocity between these figures. Only the inquisitive, upturned face of the serving-boy seems definitely to look at something; the rest are averted, impassive, the eyes seemingly focused on the air. Men share the same expression, but we could not indicate their state of mind – grief, gravity, even indifference – with any confidence. They share faces, but do they share emotions? Is the *Burial* a sacrament or merely a social occasion? It is both, clearly, but are the two tragically or comically mixed? Should we trust to our laughter at the beadles' noses, or yield to our empathy with the women's tears? Should we call it, as Champfleury did, a simple record of provincial life, or should we give it the force of allegory, as Buchon did, and call it a new Dance of Death?[9]

We are not inventing this perplexity. Critic after critic, when the *Burial* reached Paris late in 1850, asked the same questions, though with more rancour. It was precisely its lack of open, declared *significance* which offended most of all; it was the way the *Burial* seemed to hide its attitudes, seemed to contain within itself too many contraries – religious and secular, comic and tragic, sentimental and grotesque. It was this inclusiveness, this exact and cruel deadpan, that made the *Burial* the focus of such different meanings. It was an image that took on the colours of its context; and perhaps it was designed to do so.

The third picture, the *Peasants of Flagey Returning from the Fair* [IV], is less complex than the other two. In many ways it is a pendant to the rural proletariat of the *Stonebreakers* and the bourgeoisie of the *Burial*. It portrays a more familiar facet of rural life, the peasantry itself, dressed in smocks and stovepipe hats, driving their cattle or carrying baskets on their heads. It steers closer to the picturesque, to Max Buchon's *Return from the Fair*:

The subject itself was acceptable, and there were plenty more like it in the Salons of the 1840s. But in Courbet's hands the subject is deformed, almost laughed at openly. On the level of colour, the picture is, once again, carefully constructed. An olive green, mixed with brown but still luminous, links the trees at the left with the grass in the foreground and the distant hills. The same grey runs from sky to smock, to pathway and pig's skin, even to the hat and trousers of the ungainly man with the umbrella. The evening light adds its own sombre, and conventional, unity. But 'unity' is exactly the wrong word for the *Peasants of Flagey*, because colour is at war with form in this picture; and in terms of form, Courbet has broken the whole surface into a mosaic of distinct and clashing shapes. Look, for instance, at the medley of hoofs and shadow and pathway at the centre of the picture; look at the costume, hat, umbrella, and pannier bag of the man with the pig. The old man in the *Stonebreakers* was stiff and awkward, built of parts that fitted clumsily together; but the man with the pig is a manikin, a robot, built of odds and ends that were never meant to match. In terms of pigment pure and simple, no picture could be more consistent; the same weight is given to the gleaming flanks of the cows as to the chalky path below them; foliage, shawls, crude silk, are all painted in the same thick impasto. But when it comes to placing figure against figure in space, no picture could be more erratic. The man with the pig strides a separate landscape from the line of cattle behind him, his head and shoulders awkwardly repeated – and hardly diminished – by the woman in the blue-green shawl. The space between the two parts of the picture is absolute, absurd: no lines cross it, no gestures blur its edges. The string which holds the pig's hind leg only adds to the confusion; the old man's whip is held at no angle that the eye can measure at a glance. The man with the pig cancels what space we have.

All this was perfectly deliberate. When Courbet did a new version of the picture in 1854,[11] he corrected an obvious 'fault in perspective' – an immense figure of a peasant woman who stood at the right-hand edge of the canvas – simply because the picture did not need it. Better to avoid obvious inconsistencies of scale, and retain instead the strange discord of directions between foreground and middleground. The massive lady at the picture edge was perhaps too openly comic; and what Courbet wanted was an effect which was logical as well as absurd: two spaces which seemed to fit, but jarred against each other with a genuine pictorial ugliness.

The *Peasants of Flagey* is an ugly picture, deliberately misshapen. That is why the man with the pig was painted in: he is in the end the picture's crudest and most substantial figure. He is a double intruder, breaking two conventions at once. With his tawdry goods and his monstrous clothes, he laughs at the picturesque; with his pig and string he laughs at perspective. He is the real *campagnard* of 1850, 'the

cocoa-merchant', the 'little village farmer who, as soon as spring arrives, starts thinking of his winter provisions'.[12] He spoils the idyll, the scene in the midground which recalls the Middle Ages, the procession to the fair which even agrarian economists stopped to describe in vivid, if borrowed, phrases. (This is an economist called Moll, on a Government-sponsored *excursion agricole*: 'Thereabouts one could see unusual scenes reminiscent of the Middle Ages; sometimes it was a husband with his wife riding behind, sometimes papa and mama with a cob apiece . . . and finally large numbers of young and pretty Norman girls, sometimes three on the same horse, laughing, chattering, urging on their steeds. The cause of all these cavalcades was the market at Gisors which is held every week.'[13]) Courbet's man with the pig steps out of this dream. He *dates* the picture, announces the nineteenth century. No wonder he became the focus of the critics' wrath.

Before Courbet finished the *Peasants of Flagey*, he got news that the Salon of 1850 was postponed. The Government considered that the political situation in Paris was too delicate for art and big crowds at the Tuileries. So Courbet decided to put his pictures on show in the provinces while he waited. He showed the *Burial* and the *Stonebreakers* in the seminary chapel at Ornans; and then in May he took the same pictures to the market hall in Besançon. The first exhibition was free of charge, and Courbet's audience let him know he was a fool to give them something for nothing. So the second had an entrance fee of 50 centimes, it was advertised by billboards and announced in the local paper by his friend Buchon, and it made a decent profit.

Two months later he put on the same show in a converted café in Dijon. The café was a Socialist stronghold, and the pictures were mentioned only in the Socialist press. The exhibition was not a financial success; Courbet closed it early, and in August left for Paris.

What we have to know first about these three pictures is their material. They were shown first of all to a rural audience, to the workers and bourgeois of small provincial towns. And they showed that audience its own image, at a particular moment in time. They depicted the people of Flagey and Ornans and Maisières, the rural community in 1849. But the question is, what aspects of that community, and why? What are the links between the *Burial* and the *Peasants of Flagey*, and how do their subjects differ? And why did the reaction to the triptych modulate slowly, as the year went on – from success in Besançon, to stalemate in Dijon, to uproar and anger in Paris?

I take as my starting-point a comment by a critic from Besançon, written for the local paper *L'Impartial de 1849* on 7 February 1851.

By making the rustic theme *material*, Courbet will attain the ignoble. . . . One thing that M. Courbet will doubtless be reproached with is the fact that there is no unity in his compositions; no centre from which the action and the emotion radiate; no harmony between these scattered movements. . . . As a *harmonist* and a poet, M. Courbet leaves everything to be desired. Perhaps he wanted only to juxtapose on the same canvas different specimens of our mountain population.[14]

I have already said something about the force of that word 'juxtapose'. It is a good word for Courbet's composition, and it was something he did for a reason. What I want to show now is the appropriateness of that imagery to its subject-matter. I want to explain how dangerous it was, in 1850, merely to 'juxtapose on the same canvas', or on three, 'different specimens of our mountain population'.

Between the elections of May 1849 and the *coup d'état* of December 1851 the countryside was in turmoil. On 29 May 1849 the Catholic intellectual Louis Veuillot summed up the situation like this:

If only La Bruyère could see the peasant of today, in all the splendour of his political, intellectual and moral progress: no longer heeding his priest, neither recognizing nor believing in God, strong-minded, reading M. Proudhon's or M. Thoré's paper in the taverns, and voting in the Red list at the polls, in the profound conviction that he will then be able to get his greedy paws on a good portion of other people's property.[15]

What gave the edge – the edge of hysteria – to Veuillot's tone was the election two weeks before. In numerical terms, the Right had won easily: they had gained 450 seats out of 715, and their power in the Assembly was invincible. But the Party of Order was alarmed instead of satisfied. In the course of the election campaign the various parties of the Left had combined to form the *démocrates-socialistes*; and when the votes were counted, they had over two million, thirty-five per cent of all votes cast. Forty per cent of voters had abstained, and in country areas the percentage had often been much higher. But this was not something that reassured the Right; it was an unknown factor, in a situation which ought to have no such thing. And it was not simply how many men had voted Socialist, it was where they had voted. The returns had shown that the Left had a kingdom in the countryside: a belt of land which stretched south and east from the Massif Central, as far as Alsace and the Jura in one direction, as far as the Mediterranean in the other.

This was *la France rouge*. Almost at once it changed the shape of politics, and war began for the allegiance of the countryside. The Right was sure that Red France was a temporary aberration: rural society, surely, was the stronghold of order, and the provinces had sent their troops the previous June to save Paris from itself. A little more effort, and rural France would come back to the fold. The Left was looking for a new base on which to build the revolution, and from its point of view Red France was a godsend. In the city, politics were more or less at an end. They had their last comic renaissance in June 1849, when Ledru-Rollin and his friends, encouraged by the May elections and hoping for an answering insurrection in the countryside, set up a revolutionary Government in the Conservatoire des Arts et Métiers. The result was complete fiasco. The countryside stayed quiet, and the workers of the Faubourg Saint-Antoine, subdued by cholera and indifferent now to the fate of the Republic, 'left the bourgeois to settle their own affairs'. The Parisian worker had had enough, and not even the *coup d'état* would rouse him from his reasonable cynicism. He would go on voting for the Left; in March 1850 he would elect de Flotte, a sea captain who had fought for the rebels in the June Days. But he would no longer build barricades, and fight for the *République démocratique et*

sociale. Industry and trade were slowly recovering from the slump of 1847–49: better to stay in the factory or the workshop, and wait for better times.

In the countryside things were different. The crisis in farming continued, and Prefects and Procurers General began to record an old voice, the voice of 1789, raised again in raucous anger. On 14 June 1849 a man called Désiré Contessoure, a wood-turner from Saint-Claude in the Jura, aged fifty-three, was in a tavern at Saint-Lupicin

when he was heard shouting that they must be fighting in Paris . . . that the Reds would call on the people for help . . . that it was sure to happen . . . that among the Whites of Saint-Claude, there were six who had smuggled in 60 lb. of gunpowder. He added: 'What are they going to do? If we cannot get to them, we will barricade the streets and start fires. In that way we'll make them come out in the open, then we'll shoot them and kill them.'

And a few days earlier:

'When it comes to the big struggle, I'll be the one who fixes them. We will do it in a big way; there will be more than 40 of them. Like that cunt of a *curé*, who took a ballot-paper from old Verguet with Léon Crestin's name on it and gave him another. We'll really have them jumping, those priests.'[16]

Contessoure was jailed for six months, and there was no 'great struggle' in June that year. But he is the authentic voice of peasant revolution; his hatreds and his very phrases are those of Balzac's peasants; it was in his language that the propaganda war began in the countryside. Politics would not be fought any longer with official parties, resolutions and books. The worker of the Parisian *faubourg* might pore over Babeuf and Buonarroti, and learn their pages by heart; but for the peasant, other means were needed. There began a war of songs, images, ensigns, almanacs; a battle of secret societies which met in the woods; a struggle to suppress newspapers and round up the *colporteurs* who carried prints and almanacs from village to village; a war for *Jésus le Montagnard* versus Jesus the property of the parish priest. It was a hidden battle, less dramatic than the barricades of Paris, but its traces are not hard to follow.

It was a struggle against almost total ignorance, and for that reason its results were unpredictable. During these three years, the peasantry were inert and volatile at the same time. In certain times and places they stood like a rock against the efforts of Left and Right; in others they changed direction almost overnight. In the election of March 1850, for example, a strange candidate called Etchegoyen, who was a great landowner and a disciple of Fourier's Socialism, won the Loir-et-Cher for the Left.[17] He had behind him the votes of the proletariat of Blois and Vendôme, the day-labourers and woodcutters from the Beauce, and the servants and farm-workers from Sologne. These were not people who had evolved towards Socialism, or even towards the Left; to borrow Champfleury's phrase, they took to Etchegoyen's Socialism like a lark to a mirror. A year before they had obeyed their local gentry and voted for the Party of Order, and a year later they gave massive approval to the *coup d'état*. They were men who could not read, whose politics

consisted of memories of 1789 and reminiscences of Napoleon's army. They were tinder, waiting to be struck – tinder which might flash for a moment, or burn. But like it or not, they were the masters now. As the wisest observer of rural France at this time, the conservative economist Adolphe Blanqui – brother of the revolutionary Louis-Auguste whom Tocqueville saw with such loathing in the Assembly in March – put it in 1851:

The new fact in the present situation is the political arrival of this rural population, who are called to set a great weight in the scales of our destinies.[18]

Or, to quote the *Almanach du village* in the same year:

Peasants, you are the masters, the kings of this country. It is up to you to change the face of France.[19]

This is the context of the *Stonebreakers* and the *Burial*; a battle for the countryside, fought most often in the very terms Courbet had chosen; a struggle that put popular imagery to new uses, talking in signs and songs and ceremonies. Here, as elsewhere, the Left followed where the Bonapartists showed the way. The Bonapartist party had one obvious advantage: their hero had, in the space of twenty years, replaced Charlemagne and the medieval order as the central figure of popular culture, the focus of a national legend.[20] They knew how to exploit the fact. In October 1848, Charles Blanc was still bemoaning 'useless images which only feed the superstition of country people. . . . These tales of the Four Sons of Aymon or these illustrated ballads of the Wandering Jew, carried through our provinces by *colporteurs* with barbaric tastes'.[21] But by that time the Bonapartists were already producing the *Almanach de Napoléon* and its nephew the *Almanach de Louis-Napoléon*. Blanc in his speech called for 'handsome and instructive engravings' to replace the Wandering Jew, but the Bonapartists were already out on the roads, turning old myths to new purposes.

The revolutionaries learned fast, after the May 1849 elections. By the following winter the first almanacs of the Left were coming off the presses.[22] On 4 January, 1850, the Procurer General of the Doubs reported to the Minister in real alarm – 'They [the revolutionaries] operate first of all by propaganda almanacs, pamphlets and newspapers, which do most harm in the countryside at this time of year, due to the long winter evenings.'[23]

By this time Joigneaux, one of the leaders of the Montagnard party, had brought out his *Almanach du paysan*, and the great scientist and Socialist Raspail, having rather better astrological qualifications, his *Lunette de Doullens*. After them came the flood: *Almanach des Associations ouvrières*, *Almanach du peuple*, *Almanach des opprimés*, *Almanach du Nouveau-Monde*, *Almanach des proscrits républicains*, *Almanach phalanstérien*, *démocratique et sociale*, and – sinister prophecy hidden in its title – the *Almanach du village pour 1852*.[24] The new almanacs were not completely different from the old. They still had star charts, weather prophecies, practical hints or the small farmer; but they added their own kind of star-gazing. The '*prédictions*

V GUSTAVE COURBET *Burial at Ornans* (detail) 1849–50→

VI GUSTAVE COURBET *Burial at Ornans* 1849–50

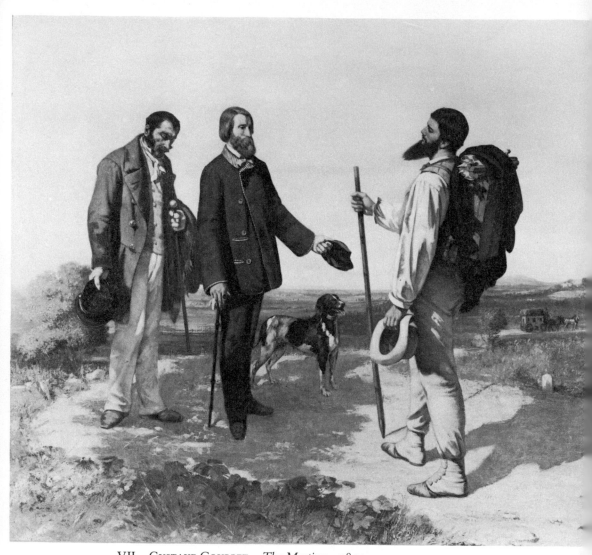

VII GUSTAVE COURBET *The Meeting* 1854

démoc-soc' for the year 1850, from the *Almanach démoc-soc, dédié aux Aristos*, are crazier than most, but their focus of interest is typical:

The constitution having been revised, and universal suffrage having been restricted, potatoes will grow ready cooked and tomatoes will ripen dressed with breadcrumbs and grated cheese. Streams of claret will flow on all sides. Viennese bread and sausages will hang from the branches of the trees. Larks, quails and partridges – all done to a turn – will fall from the sky.[25]

Most almanacs were graver than this, but all agreed that the future was political, and that it was the peasantry who would fashion it. The *Journal des débats* put it in its own angry words:

Mathieu Lansberg . . . has lost his telescope and is busier with the things of this world than with the affairs of the heavens. He has exchanged the astronomer's equipment for a pistol, a flaming brand, and a pick to dig up paving-stones.[26]

'Paris reigns, but the countryside governs,' proclaimed *La Voix du peuple* of Marseilles. 'If democracy arrives – as we hope and believe it will – it will come by way of the provinces.'[27]

All hopes, and all fears, were centred on the year 1852, when the people would vote for a new Assembly and a new President. In July 1850 Pierre Dupont composed his 'Chant des paysans':

> *Oh! quand viendra la Belle?*
> *Voilà des milles et des cent ans*
> *Que Jean Guêtré t'appelle,*
> *République des Paysans.*[28]

And some sang more violent songs, smacking of old times and the old terror:

> *Amis vignerons et paysans*
> *Que l'Aristo a exploités*
> *Enfin pour en finir*
> *Aux armes il faut courir.*
> *Dansons la Carmagnole . . .*[29]

It was little wonder that the Government retaliated, and began its own war of repression. The first effective law against the *colporteurs* was passed in July 1849; from then on pamphlets, songs, and prints which dealt with political matters had to be passed by the Prefect. In the ensuing months, this law was put into force with varying effect; if the police confronted the *colporteurs* in the street it could sometimes lead to trouble. As the Dijon Procurer General reported on 27 November 1849, when his men tried to arrest two vagabonds who 'were singing and selling in the streets, without the Prefect's authorization, songs containing several political allusions and some obscene ideas',[30] the gendarmes were surrounded by a crowd of 150 people or more, and the disturbance spread through the town. Almanacs and popular prints, so Proudhon's paper *La Voix du peuple* declared on 7 January 1850, were everywhere 'suspended, confiscated, ripped up, torn to shreds; everywhere

the hunt is on, and the police sniff out almanacs. Thanks to this persecution, and in spite of their inflated prices (50 centimes a copy), they are in everyone's pockets.' In the following year, the Minister forbade the sale of *any* books and brochures on the public highway without his permission; and sent round a list of forbidden almanacs to his officials in the Departments.[31]

Every kind of sign and image was drawn into the struggle. Men were arrested for carrying red flags or white, for wearing the *bonnet rouge* or the fleur-de-lys, for putting a sprig of thyme in their buttonhole and singing, 'Nous planterons le thym, il prendra, la Montagne fleurira.'[32] One last example, closer to our main story. In March 1850 the Procurer General in Dijon reported on the decoration of a café in the village of Brazey-en-Plaine, a few miles away:

On the walls could be seen pictures portraying various figures, the man of the people, the *sans-culotte* dressed in the red cap, and a woman dripping blood from her breasts who stands for the regeneration of 1793.[33]

The local paper added that the blood 'falls into a cup; one man washes his hands in this blood, whilst another person drinks a glass of it'.

We do not know what painter – a *colporteur* or a local artist – did *The Regeneration of 1793*; and we shall never have an opportunity to admire its crudity. A week later the police came and put a coat of whitewash on top. But this is the countryside of Champfleury's novel *Les Oies de Noël*, discussed later in this chapter; and three months later the same villagers could have seen the *Burial* and the *Stonebreakers* on the walls of a café parlour in Dijon. If nothing else, *The Regeneration of 1793* gives us a bizarre standard of comparison; it recalls the black hopes and anger of peasant life; it puts flesh on the lines Dupont wrote in July 1850: 'In two years, barely two more years, the Gallic cock will crow.'

> *C'est dans deux ans, deux ans à peine,*
> *Que le coq gaulois chantera.*

Finally, there was real political organization in the countryside. At first the clubs and parties were allowed to operate above ground. They gathered round their separate newspapers, read the articles aloud in their cafés, and used the paper's offices as the base from which the *colporteurs* set out, laden with prints and almanacs.

In the spring and autumn of 1849, the Procurers General moved against the clubs and the papers; in trial after trial they were condemned for 'fomenting hatred', or simply for not having the necessary caution money. Suddenly the Prefect and the gendarmes were everywhere; sacking the village schoolmaster with Republican convictions, unearthing plots, banning political meetings. In Paris the Assembly did its bit to help. On 31 May it voted an end to universal suffrage, and brought in a residence qualification of three years. At one blow the electorate shrank by three million, and the men who lost the vote were precisely those who took the dangerous ideas into the countryside: the landless labourers who followed the harvest, the village artisans, the nomads who moved from town to country seeking work. From autumn onwards, politics went underground, and the secret societies took over.[34] Every Prefect reported his own rumours, of meetings in the forest, of secret

rites and hidden weapons, and of plans for revolution. It was impossible to tell –
and we still know very little – how widespread the societies were and how firm
were their roots in the countryside. But they were feared and hunted by the
Government, and probably with good reason. In December 1851 they showed
their strength: they were the one force to resist Napoleon's *coup d'état*.

This, very roughly, was the shape of politics in rural France – a picture of inertia
and unrest, Right against Left, Ratapoil versus Contessoure. But what exactly was
politics about, in the countryside? We have to know, because by and large Courbet
did not paint the symptoms but the disease itself. Much later, in the 1860s, he
planned a picture of one Martin Bidouré, a peasant who had led the fight against
the *coup d'état* in the Var, and was executed in the first months of the Empire.[35]
But this was politics in retrospect; at the time, in the middle of the struggle,
Courbet was not a painter of conflict or even of movement. He gave us images of
a massive and stifling stillness, images which exposed the structure of his society
rather than its disruption.

The problem of the countryside was simple: too many people and not enough
land. This had been so since the early years of the nineteenth century, and emigra-
tion to the towns had made no appreciable difference. Those who took the train
for Paris or Marseilles included both the weakest and the most adventurous: for the
weakest the city was most often the 'antechamber to the hospital', and for the
most adventurous, sometimes, the streets were paved with gold. But the country-
side itself was still overcrowded; more people lived in the Alpine areas of France
in 1850 than at any time before or since. The men left behind wanted land to farm.
They fought to buy it from the great estates of the old nobility, they fought to
bring more land under cultivation, to break up the commons and farm them for
profit, or simply to buy their neighbours' fields at auction. In the 1840s the price of
land raced upwards at an ever increasing rate.[36]

The result of land hunger was very different in different places. On the plains, in
the wheat lands of the Paris basin or the Rhône near Lyons, the big estates got
bigger. There were new markets and big profits to be made, and the owner of the
largest acreage – often a bourgeois from the city, even more often a farmer depen-
dent on city money for 'improvements' – made the most money and bought up
his smaller rivals. On the plains there was something like a capitalist agriculture by
1848. In that year the Government's inquiry into the state of farming had this to
say about the Yonne:

For twenty-five years the condition of the small farmers has gone from bad to worse, while
that of the big landowner has gone from strength to strength. Generally speaking, the
fortune of one is based on the poverty and sometimes even the ruin of the other.[37]

In the south and east, in the Jura mountains and the Doubs, almost the opposite
happened. There were few big cities, and no attractive new markets. The village
was still an isolated unit, and trade was often still a matter of barter, even at the local
fair. Land hunger was just as great, population pressure was even worse, but in the
mountains the new land went to the small peasant or the man who owned a middle-

sized estate. Property divided and redivided like a living cell; more and more proprietors owned smaller and smaller plots of land; more and more peasants struggled to keep their common rights to the forest and the moor, fought with the Government officials who came to replant the forest, harried the big landowner who bought the common for his own use.[38]

What brought these problems to a head in 1848 was a prolonged economic crisis, which affected every part of France. It came in two waves: first scarcity, then depression. In 1846 there had been potato blight, a bad summer, a poor crop of wheat. In 1847 harvests were good and scarcity turned into glut; there were bad times in industry and trade, and that meant no one to buy the surplus rye and potatoes, no capital to invest in new machinery, no certainty about the future, food prices which slumped lower every year.

The peasant fought, pathetically, to survive. He clung to his vineyard and his field, he tried to buy more land, which he needed more than ever if he was to compete with the big estates. (Moralists in mid-century liked to decry the peasants' 'greed' for land. It was, as usual, the morality of those who have what other people want.) And when these various strategies failed, and the future looked completely bleak, the peasant began to listen to the politicians and read the *Almanach des opprimés*.

In all of France, but particularly in the backward lands, the heart of the matter was peasant debt. The animating hatred in 1851 was the hatred of the peasant for the notary and the bourgeois, the small-town usurer who held him in thrall, the small-town merchant who was ready to bid, too much, for the plot of land the peasant needed. Everywhere we look we see the same grievance and the same desire for vengeance. The *Carmagnole des paysans* from the Doubs ended thus:

> *L'hypothèque sera brûlée,*
> *Tous les greffes incendiés.*
> *Nos biens volés seront rendus*
> *Les usuriers seront pendus*
> *Leurs biens, châteaux, maisons*
> *Aux communes nous donnerons.*[39]

The malady was very simple. In a time of land hunger, the peasant had to borrow in order to buy; he borrowed on the short-term, at enormous rates of interest. While the prices of his goods went on rising, through the July Monarchy, he was able to cover his debts, but in a time of crisis he was suddenly unable to pay. Then came the time, in 1849–51, of forced expropriations, more and more each year; peasants thrown off their land, and the land most often sold to hungry buyers, perhaps to the very notary who had drawn up the contract a few years before.

It was exactly the future Balzac had prophesied in 1844, in his novel *Les Paysans*.[40] In this situation, the bourgeois replaced the *aristo* as the focus of peasant discontent. For the bankrupt peasant, the great landowner was no longer the enemy. His influence, even his presence, in the countryside had diminished; he was as hard hit by the crisis as his neighbour, and rarely bid for the expropriated land; and the

chance to put in a day's work on the great estate was a useful supplement to the peasant's income. No, it was the man from the town who was the enemy: the bourgeois who gave him in these years such wretched prices for the food he took to market, the bourgeois lawyer who drew up the usurer's contract or who did his own lending from the profits of peasant litigation, the small-town capitalist with the money for land and improvements.

The bourgeois and the usurer were the villains, and the propaganda of the Left seized on the animosity and exploited it. The almanacs harped on the problems of credit and debt, and their prophecies were bloodiest when they talked about the money-lender and his future. 'I don't hesitate to say it; usury is one of the causes of the success of Socialism,' said the Procurer General at Limoges in December 1849.[41] And what the Right admitted ruefully, the Left shouted or whispered through the countryside. Is not the peasant, asked the paper *Le Vote universel*, 'crushed by the interest on borrowed capital, by mortgages, costs, taxes, and a host of other expenses? Add them together and you find that each year he owes more than he harvests, in spite of his thrift and his so-called greed.' Or, more explicit still, 'Taxes, usury, the rising cost of farm rents, the insufficiency of wages, primary education and local restrictions – these are the real levers of revolution in the villages.'[42]

This, of course, was what Paris said. It was doctrinaire language, but in a time when peasants were being thrown off their land, it was readily repeated in the provinces. 'At this moment,' said the Prefect of the Basses-Alpes in 1850, 'the struggle is setting in between the capitalist and the owner of land who is in debt.'[43] Call him capitalist or call him bourgeois; he wore the same *habit noir*, the black dress-coat, and aroused the same hatreds. In a report of December 1849 the Prefect of the Drôme put the matter even more clearly:

The bourgeoisie have sold their lands and become the peasants' creditors; the subversives have made the peasant suspicious of the bourgeois – they have told him that the bourgeois were against the peasant getting his freedom, so that he could be kept in a kind of slavery. In this way war has been declared between the smock and the dress-coat.[44]

This was the war that Balzac had described in Les *Paysans*, though now the peasant realized he had exchanged one master for another; he had devoured the great estates only to deliver them into the hands of the middle class. Little wonder that when the peasant insurrection came, in December 1851, this conflict lay at the centre of things. Little wonder that the 'Comité Démocrate Républicain' of the small commune of Beaumont in Vaucluse proclaimed: 'Article 1 – Total abolition of usury . . . Article 3 – Free education for all children . . . Article 9 – Division of the common land for the benefit of the people. Long live the democratic and social republic!'[45] Or that at Chavannes the peasants marched against the *château* of their notary-usurer Gallard, led by the Republican mayor Boffard who had just been thrown off his land.[46] Or even that at times the opposition of town and country could provoke something very like an invasion: in the Diois five thousand peasants descended from the mountains and plateau on the town of Crest, to teach the townsfolk a lesson and in particular to break up the local 'association of usurers'.[47]

The opposition to the *coup d'état* in December 1851 was the last throw of the old peasantry, the last great act of resistance to the new order. It was scattered and disorganized; in the end it was easily defeated.[48] But it was all the same a real resistance to Napoleon, the culmination of the struggle in the countryside. In the Alpine Departments of the south between 25,000 and 30,000 peasants took up arms; there was insurrection in the Var, in the Nièvre and its surrounding provinces, in the south-west, in the Lyons countryside. It was a movement of the provinces, without a word of command from Paris; it was a movement of the peasants, led most probably by the secret societies. And in many areas it went far beyond the traditional peasant revolt: its actions and proclamations testified to a kind of political consciousness, a determination to forge, and this time to control, the *République des Paysans*. When the men of Beaumont wrote their proclamation, or when the 'Comité de Résistance des Basses-Alpes' decreed on 7 December the abolition of indirect taxes, and burned the archives of the tax office in the main square of Digue, they were aiming in their own crude way at the root of the problem.

It was their politics, the politics of December 1851, that Baudelaire had prophesied in December 1849, talking in his usual fashion to a middle-class Republican in Dijon:

He [the Republican] was acting the enthusiast and the revolutionary. So I talked to him about the Socialism of the peasants, an inevitable, ferocious, stupid, bestial Socialism; a Socialism of the torch and the scythe. He took fright and his ardour cooled – he retreated in the face of logic.[49]

And it was these politics that Marx described a little later:

The three years' rigorous rule of the parliamentary Republic had freed a part of the French peasants from the Napoleonic illusion and had revolutionized them, even if only superficially; but the bourgeoisie violently repressed them as often as they set themselves in motion. . . . In the risings after the *coup d'état*, a part of the French peasantry protested, arms in hand, against their own vote of 10 December 1848. . . . The interests of the peasants . . . are no longer, as under Napoleon I, in accord with, but in opposition to, the interests of the bourgeoisie, in opposition to capital.[50]

It did not of course succeed; nor could it do so while the north and west of France stayed dormant, and Paris itself did not respond to the call for barricades. The army crushed the resistance in a fortnight, and France voted Yes to Napoleon in a plebiscite on 21 and 22 December 1851. The spectre of 1852 had been averted – put off till 1871.

This, in broadest outline, was rural France from 1849 to 1851. And, slowly but surely, that world invaded Courbet's experience. By the time of the 1851 *coup d'état* he was writing to Wey in terms of simple political fear. Were his letters being intercepted; was he under police surveillance; had he been denounced to the

Prefect? Could he get back to Paris in safety – 'I am not anxious to be deported to Guiana at the moment, I can't say how I might feel about it later on.'[51] Nor were his fears unreasonable; of his closest friends in the Jura, Urbain Cuénot was under arrest and Max Buchon had fled to Switzerland.[52]

But before we talk of Courbet's politics, and his growing awareness of his own specific place in rural society in 1849–51, we have to know more of the immediate context of his experience. Not just the wider struggle, as he could have read of it in the *Voix du peuple* or the *Démocrate Franc-Comtois*, but the narrower round of the Doubs and the Jura. There are three places and one man who form the fixed points of Courbet's universe at this time: Ornans itself, Besançon, Salins, and Max Buchon. For Courbet's politics were nothing if not particular – the politics of places and friends rather than issues. If we are to interpret the fragmentary political statements which Courbet made during these years, and if we are to talk, however cautiously, of the 'politics' of the paintings done in Ornans, we have to know more of the places and friends.

In the elections of May 1849, the Doubs was a white island in a red sea. On all three sides, the Jura, the Haute-Saône, and the provinces of the upper Rhine had given a majority to the *démocrates-socialistes*. The Doubs had stayed faithful to the Party of Order. (Strangely enough it had given much *less* massive support than its neighbours to Louis-Napoleon in the December 1848 vote;[53] which indicates how little Napoleon was simply a candidate of the Right.) When we ask why the Doubs was more tranquil than its neighbours, the difficulties begin. It was not a matter of more prosperous economy. All the evidence we have suggests that the Doubs was a classic case of the ills already described. The great inquiry of 1848 painted a familiar picture. 'It cannot be denied', reported the canton of Roulans, 'that at the moment the agricultural interest is suffering badly. The farmers get the best possible yield from their fields, but the prices they receive for their crops are so poor that they can only count on covering their costs and seeing to their most immediate needs.'[54] Everywhere the same story: low prices, lack of credit, emigration to the towns; and the same forlorn remedy proposed. 'The cultivators must be provided with a means of borrowing which is simple and carries a low rate of interest.'[55] Most of the old estates had gone, and a chequer-board of peasant properties took their place in the mountain valleys. And the struggle for forest rights went on here as elsewhere: in the first months after the revolution Ledru-Rollin's commissioners had even encouraged the village communities to break the Forest Laws of 1837 and re-invade the commons for wood and forage.[56]

What marked the Doubs off from its neighbours was not a lack of grievances, but rather the power of the Church over the peasantry. The Doubs was a Catholic stronghold. It was the province of Montalembert, the man who called in 1849 for the Republic to send an army to protect the Pope against his own Republicans. (The Republic obliged.) We have already heard the artisan Contessoure's incoherent rage at the priests' political interference; but complaints to the commissioner in 1848 were often framed in more circumstantial detail. 'In the countryside,' wrote one petitioner, 'the primary election, which we wanted so much, is nothing but a

lie; the priests made their parishioners vote as one man.' Or again, even more sadly,

A large number of ballots bearing Montalembert's name were written on notepaper and in a handwriting which was too good for a peasant's; to make things even more certain most of these ballots were sealed. . . . Many of our peasant comrades broke the seals, and substituted other names, more or less democratic.[57]

For a while, in the first months of the Republic, the Left tried to improvise an opposition to the clergy: the schoolteachers of some mountain cantons were mobilized in support of the Republican candidate. All the same, on the level of parties and candidates, the Left did not make much headway. Every public prosecutor in France believed in the devout nature of the peasantry, even when they were firing ricks or voting the wrong way; but the Procurer General of Besançon was probably right when he gave this verdict on 7 June 1851:

This Department is still one where the population of the countryside is imbued with the best kind of spirit. The mountain area is excellent; the peasants have kept their religious principles and with them all the traditions of authority and respect. The clergy have a great influence in this part of the country, and they use it with great wisdom and discretion.[58]

As for Ornans, it was a conservative borough. It voted solidly for Louis-Napoleon in December 1848 (70·3% of votes cast), and in May 1849 it voted obediently for the list of the Right (69·6%). It was a town to warm the Procurer General's heart; in his report of 1 February he even singled it out as one of three exemplary cantons where 'public spirit continues to be satisfactory'.[59]

But even the Doubs could tremble in 1850. Even Ornans could show signs of weakening in its allegiances. As the purge of Republicans after the 1851 *coup d'état* was to show, Ornans had its quota of 'dangerous men': not only Urbain Cuénot, who had once been mayor of the town, but a butcher, and a merchant of bread and spices who 'would be very dangerous for society if there were an uprising; he would be capable of pillage and, I believe, of murder'; and oddly, a bailiff, 'a rabble-rouser, a propagandist, a worthless character'.[60] In the province as a whole, Prefect and Procurer General began to season reassurance with alarm. They still repeated their basic phrases, the fortunate indifference of the peasantry towards politics, the blame for the bad time put upon agitation and instability, the crippling divisions of the Left. But they began to worry about morals. There were 355 new taverns opened in the Doubs in 1850; there was prostitution in Besançon; there was even a revolt in the Lycée. 'The family spirit is diminishing every day; café and tavern life is replacing the domestic interior.'[61] Here, as elsewhere, anarchists were preparing for 1852; the society of *Bons Cousins* were meeting in the woods outside Besançon; the Left 'gathers together a crowd of men who are hopelessly in debt, who have no morality, whose violence knows no limits and who would be capable of any excess to ensure their victory – more than ever they count on victory and its benefits'.[62]

And in August 1850, when Louis-Napoleon visited Besançon on an official tour

3 GUSTAVE COURBET *Rocks at Ornans* c. 1850

24 GUSTAVE COURBET
After Dinner at Ornans 1848–49

25 GUSTAVE COURBET
Portrait of Marc Trapadoux
Examining a Book of Prints 1848–49

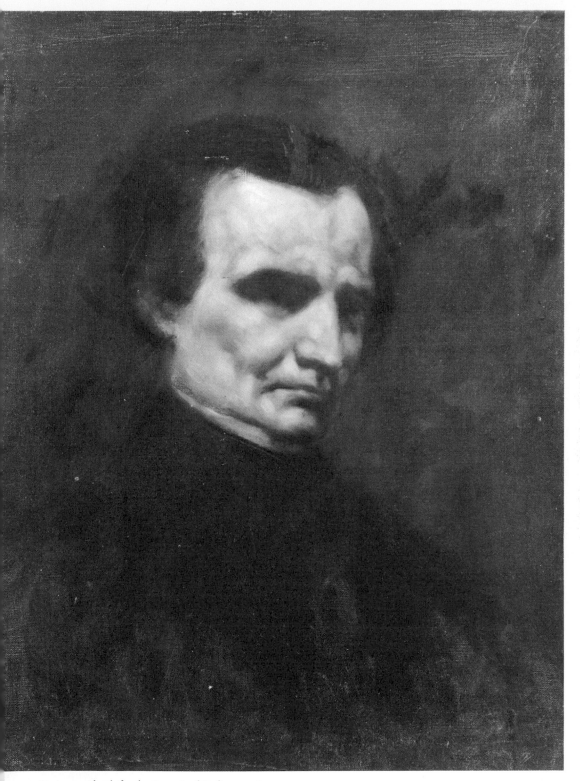

GUSTAVE COURBET *Sketch for the Portrait of Berlioz c.* 1849

27 Rembrandt van Rijn *Supper at Emmaus* 1648

Diego Velázquez
...at Emmaus 1628–29

Louis Le Nain
...asants' Supper 1642

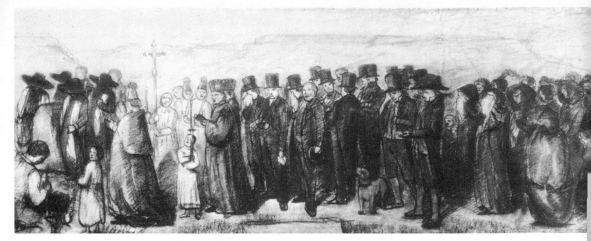

30 GUSTAVE COURBET *Sketch for the Burial at Ornans* 1849–50

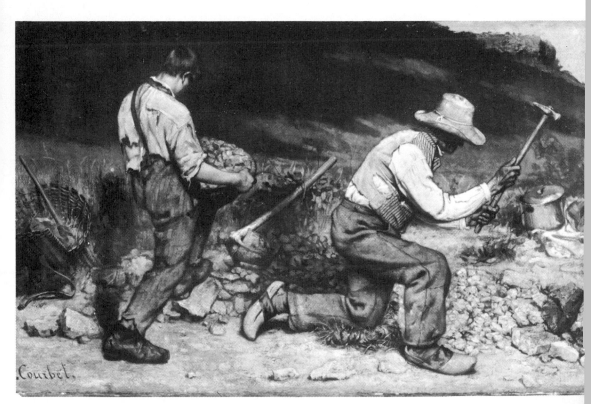

31 GUSTAVE COURBET *The Stonebreakers* 1849

FRANÇOIS BONVIN *Woman Cutting Bread for Soup*

TOMBEAU.

33 ANONYMOUS *The Funeral of Marlborough* Late 18th century

of eastern France, the Left had something very like a victory. The President was jostled and pushed by the crowd at a ball given in his honour; his coach was greeted with cries of '*Vive la République!*' as opposed to '*Vive le Président!*'. The same workmen of north Besançon, farm labourers, artisans in the town's clockmaking trade, who had voted solidly for Napoleon in December 1848 had, it seemed, turned against him. Well might the picture of 'men in workers' smocks who surrounded the Prince's person and shouted "*Vive la République!*" like someone shouting an insult'[63] haunt the Procurer General's sleep; hitherto, men in smocks had stayed quiet in their fields or in their workshops; they had been, essentially, absent from the scene of political struggle.

A scapegoat was not far to seek. Four days after the President's visit, on 22 August, the Prefect and Procurer General finally disposed of their most effective enemy in the Doubs, the newspaper called the *Démocrate Franc-Comtois*. The Prefect had explained its policies to the Minister early in April 1850:

The *Démocrate Franc-Comtois* attacks each week the progress and conduct of the Government, its opinions and ideas. It lays the blame chiefly on the spirit and influence of the clergy; I should point out that the excellent clergy of this area has great authority which it uses on behalf of the powers-that-be and the administration, and it is not for nothing that the democratic party tries to ruin this powerful helper.[64]

It was, they both agreed, the one blot on the Doubs's tranquillity, and all the more dangerous on account of its working-class readership. 'All its adherents belong to the working class, and its principal subscribers are innkeepers and café-owners.'[65]

In April 1850 its editor was gaoled for two months and fined 400 francs, 'for attacking the principle of property and for incitement to hatred and contempt of fellow citizens'. On 17 August, the day before the President arrived, the paper was seized for an article entitled 'Les Paroles et les actes de monsieur Louis-Napoléon'; though the Procurer was too late to prevent its being distributed in the town. Finally, like so many other radical journals that year, it was caught on a technicality (with information provided by a police spy), fined, and forced to close.[66] But before it disappeared, it had functioned for a few months as the real centre of Socialist opposition.

It was in the pages of the *Démocrate Franc-Comtois* that Buchon wrote his 'Annonce' (Appendix 1) advertising Courbet's March exhibition in Besançon. He was hardly exaggerating when he ended his account of the old man in the *Stonebreakers* with these words:

And yet this man is not the last word in human misery. Let the poor devil decide to turn to the Reds, let him be caught with a stray copy of the *Démocrate Franc-Comtois* in his pocket, and he will be envied, denounced, expelled, dismissed. Go into the Jura . . . ask M. . . *le Préfet* in person.

How irritating Buchon's piece must have been! And how puzzling, if the Prefect's spies ever visited the Salle Vernier, was Courbet's own massive comment on 'the spirit and influence of the clergy'.

But the Doubs, as Buchon indicated in his last sentence, was only part of the story. The other part was Salins, the Jura, and Max Buchon himself. And they represented a different world, volatile where the Doubs was slow to kindle, dangerous where the Doubs was safe. They were, for the inhabitants of Ornans, an immediate point of reference, just as important as Besançon itself. Salins was twenty-five miles by road across the hills, the great market-town of the area, the town from which Courbet's *Peasants of Flagey* are returning. And Salins, as the Procurer General said in July 1850, was a 'town of agitations and disorder, which the anarchists of the Jura have made something of a capital city'.[67]

It was not that the Jura's economic situation was very different from that of the Doubs – though perhaps in the mountain fastnesses it was even worse. The high Jura had not been touched by agricultural progress in the years before 1848; men still lived on rye bread, and their cattle starved for lack of decent fodder. But where the mountains ended and the plain of Bresse began – and it was here that Salins, Dôle, Poligny, and Arbois were situated – there was a different kind of economy altogether. Wine was produced and shipped along the rivers to Lyons; timber was exploited on a big scale; salt was mined; and in the valleys farming was turning to a new range of crops.[68] It was, relatively speaking, a prosperous area: but it was also an area with its own revolutionary tradition. One phrase summed it up, coined in 1834 when the vinegrowers of Arbois had risen in answer to the Lyons revolution, proclaimed the Republic, and been crushed by the army – 'Paris, Lyons and Arbois are quiet: France is pacified.'

In 1848 the Jura stayed true to its traditions. For the first few months of the Republic, there was a strange constellation of disorders. In the mountains, the peasantry fought for their common rights against the forest guards. In Dôle or Lons-le-Saunier, furious 'Republican committees' marched on convents and on orphans' workshops run by Catholic brothers, mixing economic resentment against the orphans' cheap labour with political distrust of the clergy's influence in the elections.[69] On 20 May the vinegrowers of Salins rose against the new tax on wine, and a mob threatened the itinerant inspector, one Chaboz. Even in face of the June Days the Jura was in two minds. Salins, Poligny, and Champagnole dutifully sent off their detachments to defend the Republic, but the story elsewhere was very different. At Dôle the municipal council tried to prevent the publication of the Government's call for armed help. At Arbois, there was a veritable insurrection in favour of the insurgents; a huge crowd of democrats gathered at the Town Hall on the night of 26 June and formed their own volunteer force, ostensibly to march to Paris and help the Government.

But when it came time to leave they were refused a safe-conduct; it was clear that these gentlemen were partisans of destruction rather than of order, and they intended to use their strength and courage not to put down the revolt but to support it – to try to spread the most terrible anarchy through the whole of the Republic, to revive the memory of the saddest days of the Great Revolution.[70]

These were the first, dangerous months of the Republic; and the Jura did not

stay like this for long. By the end of 1849 the Prefect and his gendarmes had quiet-
ened the countryside: forest disorders had stopped, there were no more attacks on
the clergy, and the Left had been hemmed into its strongholds of Salins, Dôle, and
Arbois. But the ingredients of insurrection remained; the explosive mixture of two
proletariats, that of the woods and that of the vineyards. And the Procurer General
was conscious of the dangers that still existed; as he explained on 5 February 1850:

The vinegrower possesses nothing; he cultivates someone else's vines and takes a portion of
the crop. If he is married and his family can help him he can farm more than a hectare;
farming takes up six or seven months of the year and gives him a revenue of 300–350 francs,
less charges; he has no other source of income for himself and his family. He has nothing to
do for five months, and he does not try to use the time at his disposal; he knows no other
work besides vine growing; he even has to pay a cartwright to make him a new shaft for one
of his tools.

In such conditions Socialism was bound to make great progress; its doctrines are ardently
and actively propagated, and it will be a long time before we heal the wounds it has opened.[71]

In this situation the most important person for Courbet was Max Buchon. He
was the son of a soldier in Napoleon's army. He had had a sombre childhood,
brought up on military lines and with strict religious training, and in the late
1830s Courbet and he had been schoolmates at Besançon.[72] They remained friends
for the rest of their lives, staying in each other's houses at Salins and Ornans,
swopping letters when Buchon was in political exile. Courbet was at Buchon's
death-bed in 1869.

Max Buchon was rich, with an income of 2,000 francs a year;[73] and in the 1840s
he mixed literary ambition with a little respectable radicalism – deferential to the
Monarchy but keen on the ideas of Fourier and Considérant (who came from
Salins); choosing epigraphs from Hugo and Gautier for his *Poésies allemandes* in
1846. He was already collecting popular prints and ballads, and translating from
the German peasant poet Hebel.

It is Buchon, more than anyone of Courbet's circle in Paris, who was directly
and immediately radicalized by the 1848 revolution. In the course of a few months
he became one of the leading revolutionaries in the Jura, deeply involved in the
violent politics of Salins itself, but moving to and fro across the province in the task
of political organization. Eight days after the February revolution he founded the
paper *Démocratie salinoise*, with a bankrupt vinegrower and road-surveyor called
Victor Richardet.[74] Between them they made the paper the linch-pin of Salins
radicalism. When the town voted on 2 May 1848 for its council, the Republicans
swept the board: Buchon became the mayor's first deputy. He was a member of
the infamous Club du Théâtre, in which, according to one contemporary witness,
'they preach hatred of the rich, the bourgeois and the capitalists. They prophesy a
century of happiness and prosperity for the workers and the proletariat.'[75]

Salins was a curious, almost a bizarre town. It had burned to the ground in three
days in 1825, in spite of the fire brigade's efforts – they had hosed the fire with wine.
All through 1848, its politics were like some scaled-down version of the battles in

the Parisian *faubourgs*: club fought club; Left and Right struggled for seats on the council; the Left founded a National Workshop after the Parisian model, and gave out ballots with the wage packets. It was a town of raucous political incident; in August 1848 Buchon even became – by a nice coincidence – the target of a popular ballad. The mayor had sawn off the crown of Orléans from the front of the Town Hall and put up a stuffed cock in its place, provided for the occasion by a pharmacist named Roch. It was too good an opportunity for the Right to miss:

> *Roch au coq a dit: Je t'empaille;*
> *Le coq à Roch a dit: Crénon,*
> *Veux-tu faire une bonne action:*
> *Au lieu de m'empailler, empaille*
> *Chavet, Richardet et Buchon!*[76]

The cock was hauled down from its pediment, to the rejoicing of the crowd. The Left survived to win its second town election in September.

By the middle of 1849, Buchon's paper had become the *Démocratie jurassienne* and Buchon himself the president of the Jura's 'Assemblée électorale des délégués de cantons'.[77] Then, in June 1849, he was arrested on two counts: first for his articles on the restoration of the death penalty for political offences, and second for plotting an uprising in Salins to coincide with the June revolt in Paris (he had sent a careless letter to a young lady of his acquaintance, and it had found its way into the hands of the police).[78]

When Courbet arrived in Ornans, his friend was still in Besançon jail awaiting trial. Then, at the end of November, he was marched across country to the assizes at Lons-le-Saunier, much to the Procurer General's satisfaction. 'I learned', he told the Minister two days later, 'that his political friends were planning to give him an ovation as he went through Arbois; I took measures so that he went by another route, and the journey took place without a hint of scandal.'[79] At the assizes the Left triumphed. Buchon was twice acquitted, on 5 and 25 December.[80] The verdict 'was greeted with numerous bravos', reported the *Franc-Comtois*; in his reports to the Minister, the Procurer General passed over the trial in gloomy silence.

This was Max Buchon; the same man who atoned, a few months later, for Proudhon's blasphemy, carrying his candle in procession through the streets of Salins, using the weapon of irony where polemic had proved too dangerous. In 1850 it was wiser to refrain from direct aggression – wiser to join the secret societies (as Buchon probably did that year), wiser to write one's politics in the form of an advertisement for the *Burial* and the *Stonebreakers*, wiser to stick to the poetry of rural life. The revolution had crystallized his views on art, if not his practice: the papers of Salins had already published his own clumsy, rhetorical attempts at popular verse; it was already clear to him, as he was to put it later, that 'one must join the people' (*il faut se faire peuple*).

Champfleury was already on Buchon's trail: he wrote about his verse in the *Messager de l'Assemblée* on 1 March 1851, pointing a strange and misleading contrast

with Pierre Dupont. 'Max Buchon', he said, 'takes up popular poetry where P. Dupont and G. Matthieu left off', but he avoids 'those powerful and wrathful songs whose every verse is a call to revolt'.[81] One wonders if Champfleury had read, or forgotten, Buchon's poem 'Confidence', on Louis-Napoleon and authority in general; one wonders if he knew of Buchon's time in jail and his articles on the guillotine.

Courbet, for his part, certainly did know about Buchon's politics, and as far as we can tell he approved of them. The advertisements which Buchon wrote for Courbet's shows are not exactly a programme for the *Burial* and the *Stonebreakers* (the latter was finished, and the former half-completed, while Buchon languished in Besançon jail), but they indicate, I think, the kind of reaction Courbet expected and encouraged in 1850–51. It is clear that to a certain degree he cooperated with Buchon on the advertisements; at some time early in 1850 he wrote to his friend assuring him that the pictures would not be retouched before they went on exhibition.[82] And later, perhaps in 1851, he thanked him in quite specific terms: 'I congratulate you on your article, I am very grateful to you for it, it perfectly captures the nature of my talent, and it is done with that art which I love so much.'[83] The advertisements translate Courbet's pictures into political terms, but not into the terms of polemic or propaganda: they are political criticism, but they use the politics of irony and insinuation; they joke, digress, extemporize; they are meticulous and far-fetched at the same time. And Courbet was right. They resemble, in those very contradictions, the nature of the talent they describe.

About Courbet's own politics in 1850–51 we have only fragmentary evidence. But those fragments are easy to read: everything we know points to a progress away from the flippant detachment of the letters of 1848. Slowly but unmistakably, Courbet turned to politics, to the simple statement, in his 1850 letter to Wey, that 'My sympathies are with the people; I must speak to it directly, draw my knowledge from it, live by it.' The 'people' in 1850 had, necessarily, a particular identity. Its members were the readers of *Le Peuple* in Dijon, or the Besançon subscribers to the *Démocrate Franc-Comtois*, those *'gens du peuple'* to whom Buchon addressed his advertisements, those working-class readers whom the Procurer General feared.

When Courbet wrote to the *Messager* in 1851 and called himself 'not only a Socialist but also a democrat and a Republican: in a word, a supporter of the whole Revolution', he was defining his politics in more specific, and more dangerous, terms. It was not that Socialism or democracy or Republicanism were outlawed in 1851, but it was forbidden to link them in this fashion. And to play with the double meaning of 'revolution' – did he mean February 1848, or did he mean the revolution still in progress, the oncoming revolution of 1852? – that was a special and risky equivocation. After all, to shout *'Vive la République démocratique et sociale'* was by then plain sedition. (To erase the date from an old lithograph of the February barricades and leave the simple motto *'Le peuple veille'* – 'The people watches' – even that could lead to prosecution in 1850. 'In erasing the date and the words "over the city", the printer's intention was obviously to adapt the drawing to the need to keep watch over the actions of the Government at the present moment, and to

revive for the future thoughts of barricades and insurrection': letter of the Procurer General of Bordeaux, 9 August 1850.)[84] Courbet's commitment, in the statement of November 1851, was more specific than the words themselves imply. He was not foolish to fear arrest two months later, especially since his family had hidden Buchon and helped him to escape.

But Courbet's politics were never primarily a matter of statements and definitions. At this level his commitment – as so many critics have assured us since – was in a sense second-hand. What we want to know is the politics of Courbet's experience in 1850, the politics of his first-hand statements in the pictures themselves, the evidence of attitude and situation in rural society, the unconscious awareness of one's place. For the three pictures of 1850 are 'historical' in a double sense: they display the elements of rural society at a particular moment in its history, but they also articulate the history of Courbet and his family.[85] They describe, in an almost secret manner, the family's ambivalent situation, their status between the peasantry and the rural bourgeoisie. In other words, the 'war between smock and dress-coat' goes on within the Courbet household.

In the *Burial*, Courbet's father stands stiff and rather stylish in silk hat, high collar, and greatcoat. He is in the back row at the centre, almost the highest figure in the picture. In the *Peasants of Flagey*, he is the old man astride the horse, wearing a worn blue smock, leggings, and stovepipe hat. Is he simply in the *Burial* a peasant in his Sunday best? Or is he as indubitably bourgeois as the two men to his immediate right: the first a notary and a justice of the peace, a cousin, strangely, to Pierre-Joseph Proudhon; and the second the mayor himself, Prosper Teste de Sagey? (Courbet's mother is taking care of the mayor's daughter at the far right.) And what are the *Young Ladies of the Village, giving Alms to a Cowherd*, in the picture Courbet painted late in 1851, but fashionable young women from Ornans, parading their parasols and bonnets through the fields, and indulging in that most bourgeois of pastimes, charity? And yet these are Courbet's sisters, the same trio who are draped in black, their faces covered by kerchiefs, in the *Burial at Ornans*. Two or three years earlier still, he had painted them in conversation with the village gossip – red-cheeked and laughing, lasses rather than ladies.

For the Courbet family these ambiguities were a simple matter of fact – and had been so for ten or twenty years. The family was, as George Riat put it, 'bourgeois more than peasant, not so bourgeois that the young man was deprived of the sight of nature, but too little peasant for them to think of anything besides a career in the liberal professions for their son'.[86] (Courbet himself was originally to have become a lawyer.) They maintained two houses, one a simple farmhouse in the village of Flagey, and the other, far grander, in the rue de la Froidière in Ornans.[87] Like many another peasant, Régis Courbet had acquired piece by piece a mosaic of arable land and vineyards, scattered for miles on the plateau of Flagey. He became rich; from time to time he was an official of the canton, and, final mark of respectability, he had enough property and paid enough tax to obtain the vote in the July Monarchy. He was, in short, building a bourgeois identity, shuttling between Flagey and Ornans, exchanging his smock for his dress-coat and spats.

But in 1850 that very question of identity became the centre of conflict in the countryside. What had been for two decades a natural, unselfconscious ambiguity – an evolution from one status to another – suddenly became a crucial choice, a matter of allegiance. In the course of a few months Courbet moved from an imagery which pictured the family from the inside, in its own terms – as an inevit able frame of reference for experience – to an image in which the family is pulled apart and reassembled in the context of a class, a community. He moved from *After Dinner* to the *Burial*: from being a 'painter of the family', in Champfleury's re-assuring, neutral sense, to showing a whole society, and the curious place of his family within it. It does not concern us whether the ambiguities I have pointed out were consciously or unconsciously devised: they are nonetheless *there*. And they are, I think, at the centre of Courbet's painting in 1850–51; they are the key to his pictures' irony and equivocation.

Looking at Courbet's letters in the winter of 1850 – especially the long report to Champfleury (Appendix 2) – one is struck by a dual attitude, of detachment from the society around him, and involvement in its pleasures and pastimes. He was, in his letter to Champfleury, to some extent *playing* with rural society: enjoying the chance to adopt its traditional roles, to play Pierrot de la Mort; but enjoying also the chance to translate the roles into Parisian terms. He is at once the collector (of folksongs and *assiettes à coq*) and the participant, the audience and the actor.[88] When he reported the slogan of the local carnival – 'Bourgeois, go back to your vices; for telling the truth, Carnival must burn' – he depended on Champ-fleury's appreciating (or perhaps not appreciating) its overtones in the context of the Second Republic. He mixes Bohemian detachment (and the letter is full of reminis-cences of Bohemia) with a delighted intimacy with Ornans.

The same is true, I think, of the pictures he painted. They are neither affectionate nor hostile to the material they portray. The *Burial* is a portrait of the small-town bourgeoisie, and in 1850 that was a subject that called for taking sides. But the picture does not take sides, any more than it lays down the law one way or another on the state of religion in the Doubs. These pictures share, as it were, the equivocal position of the bourgeoisie itself in 1850: on one level, the target of peasant hatred and distrust; on another, providing from its lower ranks the leaders of radicalism in the countryside. By December 1851 this position was crippling; in many communes the doctors, lawyers, and pharmacists who were the traditional chiefs of Republican-ism stepped back at the last minute from the use of force, fearing perhaps that their troops, once on the march, would turn against their leaders.[89]

The work that Courbet did echoes his own ambiguous situation: between Bohemia and the Franche-Comté, between the peasantry and the bourgeoisie. If we put together the letters to Wey and Champfleury, and the terms of Buchon's advertisement (Appendix 1), we have some notion of the complex significance of Courbet's pictures for himself and for his public. Buchon seized on and sharpened that significance, the pictures' claim to be a 'true synthesis of human life'. He chose the gravedigger as the one proletarian amid the 'good folks of Ornans', 'the great ones of the earth', 'the oppressors of the poor world'; he imagined him returning

the next day to his vinegrower's hut; he put him in command of the *Burial at Ornans*, presiding like Death in the old *danses macabres*; he called him the counter-weight, almost the avenger, of the hopeless stonebreaker in the other picture on display. Faced with this version of Courbet's meaning, we can admire *and* disbelieve. This is not 'what is in the painter's mind', exactly: it is too definite and circumstantial for that. But the concerns it works with, the world of meaning it inhabits, *are* Courbet's. Buchon may shape the implications too firmly, and give form to shifting significance. But one thing is clear: the prime subject-matter of Courbet's Realism was at this point the social material of rural France, its shifts and ambiguities, its deadly permanence, its total structure.

That was not just Courbet's concern. It was, in 1849–50, the problem of Realism as a whole. Let us put against Courbet's painting and Buchon's advertisement two novels published at almost exactly the same time, Francis Wey's *Biez de Serine* and Champfleury's *Les Oies de Noël*. They are both attempts at Realism, and in 1851 both were included by Max Buchon in a list of companion pieces to Courbet's three paintings.[90] Wey's novel was published in *Le National* from January 1850 onwards, and actually incorporated Courbet's stonebreakers into its narrative. Champfleury's came out in Proudhon's *Voix du peuple* in the same winter. Courbet, so he said, read a few instalments in Ornans as he was painting the *Burial* and the *Stonebreakers*; he congratulated Champfleury on the story's success, 'at least in our part of the world'. Both are novels of rural life, both are by friends of Courbet. In many ways they provide the closest analogies we have to Courbet's painting; they are a kind of check on its significance.

How did the Realists portray the countryside in literature? The simple answer is that they strove to incorporate all the political and social issues I have described into the old framework of rural romance. They tried to invent a kind of political pastoral: novels in which the reader could sense the invasion of the rustic idyll by usury, class conflict, and expropriation. The result was a bizarre and awkward compromise: a continual movement between the world of George Sand and the world of Socialist propaganda. On one level Champfleury was quite right when he assured his mother that there was in *Les Oies de Noël* no question 'of blood and revolution; on the contrary my novel is as gentle as a lamb. It's a Christmas story, and has more to do with decent family feelings than anything else.'[91] On another its content was summed up by its second title, *L'Usurier Blaizot*.

Wey's novel *Biez de Serine* is perhaps even more extraordinary. Gautier called it, in his 1851 *Salon*, 'the finest study of peasants that we have seen since Balzac'. Courbet's stonebreakers are in fact the novel's main characters; they have become a peasant farmer called Thomas and his son Jean Grusse. The old man once rented a farm from the notary of the district, Crochot; now he breaks stones for a living. The reasons, as he explains them to a passer-by, are familiar to us.

'You'd better tell them this,' interrupted the stonebreaker with a certain force; 'I was deprived of Jean Grusse's help when he was put in jail, and my son Valentin's when he went off to do his military service; then I was struck down by sickness, and I just couldn't keep up my rent on the old basis. And M. Crochot wanted it raised! It was a far cry from the rise

he wanted to the reduction I needed. He let March and April go by and then suggested we should let things stay as they had been. But the harvests were bad; I'd have misled him if I'd consented, or, worse than ruin, I'd have plunged myself into debt. I still had my cattle and my tools; and I'd have lost the lot. So I decided to end the whole thing right away and sell what goods I had to my neighbour Jean-Denis. I made a bit of money, which helps keep us alive; for this job and Jean Grusse's small garden wouldn't do, after the tax men have got at us.'[92]

Here are all the elements of rural crisis crammed into one speech – from conscription to the burden of indirect taxes, from peasant debt to the ruthlessness of the bourgeois. It is not that Wey's message is revolutionary. On the contrary, as befitted the *feuilleton* of *Le National*, his story shows the ruinous consequences of the conflict of peasant and bourgeois, for both sides.

In the disputes that put the workers and the masters at loggerheads, the bosses often forget that harm to one party means bad times for the other, and if you paralyse the man who works the field, capital itself is made sterile.[93]

Crochot the notary regrets having lost his tenant, and cannot find another to take over (unlikely story in 1850!). When the stonebreaker's son returns from the army the family is finally reinstated on the farm of Biez de Serine. The novel's message – in the mouth of the peasant Jean-Denis – is one of reconciliation:

'The bourgeois, or some of them – present company excepted, sir, of course – the bourgeois fail to see that the ruin of the peasant farmer rebounds on them.'[94]

Nevertheless, what strikes us about *Biez de Serine* is Wey's certainty about what constitutes the problem in the countryside: the old man's discourse to his son on the evils of usury for the poor, the 'clownish bourgeois solemnity' which reigns in Crochot's household, the occasional outburst of real peasant resentment:

'It's all the same, Froment: the devil take smuggling and all those—'
'Who buy the smugglers' goods. What about the Procurer's wife? She's got a fine cashmere, hasn't she? I've seen it round her shoulders.'[95]

The same is true of *Les Oies de Noël*. As Champfleury told his mother, his novel has no politics as such. Its problems are solved mythically: the villain dies of an apoplexy after eating a Christmas goose; the guilty are miraculously discovered and the innocent go free; the peasant heroes speak up against violent solutions.

'Bah!' said Cancoin, 'leave the rich alone and don't take the trouble to envy them. We're happier than they are.'[96]

At this level, *Les Oies de Noël* is as 'gentle as a lamb'. But like *Biez de Serine* it is a novel which is divided against itself: on the one hand the conventions and situations of romance (a dying child and a demented mother wandering through the woods, wrongful arrest, a love story of the bailiff's clerk and the peasant's daughter); on the other, the realities of rural society in 1850. The opening description of Blaizot is worth quoting in full:

Old man Blaizot was a *reneuvier*.

That was the name in Dijon for businessmen who used to lend an ox to a ploughman in return for a certain sum, and provided they got back an ox of the same age on the feast of St John.

They were honest men, in principle – but after a few tries they realized that money would yield more than the best piece of land under the sun.

Old man Blaizot was one of this school – a great midwife, only his patients and their children were made of metal. His money seemed feverish, permanently nine months gone; at any rate he knew how to make it sweat, and multiply! Blaizot began by lending oxen, in the old way; but the ranks of the borrowers swelled day by day, and Blaizot began to think that he'd need all the bulls in Burgundy and even then he wouldn't have enough. Dijon itself would not be big enough for his customers if it was converted into one vast stable.

So he lent money.

The people of Dijon knew nothing about it, or, more probably, did not want to know. For Blaizot only did business with peasants from outside the town. To his fellow townsfolk he remained 'old man Blaizot', a man of means who went to church regularly and would gladly do you a good turn. He was all honey to the men from the town, pure vinegar to the folk from the countryside.

And so every Saturday, on market day, Tillo Street was choc-a-bloc with farmers' carts; and the farmers who had come to bargain with old man Blaizot filled the road with noise and tumult. The peasants sat down on the stone benches outside Blaizot's front door and went into his office one by one when the housekeeper called out their names.[97]

What is remarkable here is the suggestion of evolution in the relations of town and country: from informal barter to full-scale capitalism; from aid to control to exploitation. And the suggestion, also, that this evolution is hidden from the bourgeoisie itself. Accurate truths in 1850, and familiar ones to the readers of Proudhon's books and newspapers.

And six pages later, in the next chapter, this is the countryside itself, and the effects of usury upon it:

At Black-Dyke farm the vast fireplace, the guns, the Epinal prints on the wall, the decorated earthenware, the bed and the kitchen crocks were all broken, spoiled, ripped, rusted, chipped and covered in cobwebs. The windows of the room, thick with dust, let in a chink of dreary daylight.[98]

In other words, the aspects of rural life that Champfleury most treasured are in full decay; the signs of community, which he was to spend the rest of his life collecting and describing, are torn and broken. Instead the countryside is ruled by the signs of difference, of separation; by the costume of the usurer and the bailiff; by Blaizot who 'had left off his summer clothes and carried winter with him in the folds of his vast topcoat', or the amorous clerk, 'forced to wear formal black', who 'bought "lasting" which was a cruel cloth to wear in winter. The jacket of his suit, the hat, the waistcoat and the shoes, were a little world of poverty and neatness.'

This is not the whole story. The old forms still retain their hold, the *colporteur* still delights the children with prints and stories. At the end of the novel he even sells a rough woodcut which rehearses the (romantic) themes of the book. And he

composes, in the last lines of the novel, a ballad to commemorate the occasion, which turns the new matter of rural society into familiar and reassuring shape:

> *Guenillon n'avait pas oublié*
> *L'usurier avaricieux*
> *Justement puni par Dieu.*[99]

As so often in Realist literature at this date, the reader has no single point of focus; the very different kinds of insight, explanation, and literary convention simply do not add up to a coherent account of the matter in hand. The parts of the novel are at odds with each other; and there are other elements in *Les Oies de Noël* I have not described (an overtly Dickensian strain, for instance, in the sketch of a seamstress and her dancing-master husband).

Champfleury and Wey were torn between George Sand and Balzac. They did not want to write deliberately escapist novels, deliberate idylls. They did not agree – in 1850 at any rate – with George Sand's declared intention in her preface to *La Petite Fadette*, dated 21 December 1851:

In times when men hate and misunderstand each other, and the result is evil, the mission of the artist is to celebrate gentleness, trust, friendship. . . . Direct allusions to present-day misfortunes, an appeal to those passions which are already stirring, this is not the way of salvation: better a sweet song, the sound of a rustic pipe, a story to lull little children to sleep without fear or suffering; better these than the spectacle of real evils, strengthened and made darker still by the colours of fiction.[100]

Or, more shortly,

Let us try to calm the fever of action in ourselves and in others by means of a little innocent distraction.[101]

In Sand's novels, rural society has no classes, no differences. The bourgeois are referred to only in passing; poverty and riches are merely incidental to rural life; and the same imprecision spreads to the land's geography. In Sand one has description but never articulation: field never joins field, there are never large estates and small, one encroaching on the other, there is never one complex community with its own divisions, physical and social. We never have, as readers, a map of the place; all transitions are magical, vague; everywhere the fluid, onward movement of narrative and romance. There is no incoherence, and yet the novel's coherence remains somehow insubstantial, unexamined.

Clearly Wey and Champfleury wanted something different from this, but they dared not or could not organize the alternative. This alternative was Balzac. In *Les Paysans*, he had simply discarded narrative; he had taken a tenuous story and allowed it to get lost in the matter of rural society.[102] He gives us a novel which mimics in its very structure the incoherence of the rural community; a complex of different scenes unconnected by the flow of a central 'action'. He provides a meticulous geography, but he destroys the transitions from place to place: scene follows scene like the slides in a diorama, each one a separate world from the next,

no scene subordinate, each with an equal and often opposing weight. In one chapter we are walking the alleys of the great estate, in the next we are inside the peasant tavern or the bourgeois household; the fragments of rural society are juxtaposed rather than connected; there is no plot save the description of those divisions, repeated and elaborated, deliberately held apart.[103] The different worlds hardly even confront each other, and when they do clash it is in symbolic rather than 'realistic' form. When the peasant Fourchon, in a famous speech, attacks the *seigneurs*, the language he uses is accurate enough in many ways – compare, for instance, the police spy's transcript of Contessoure.[104] But in terms of a credible fictional situation Fourchon is improbably articulate and improbably audacious; Contessoure did not build up a logical indictment, and least of all did he say his piece to the *seigneur* himself. What Balzac wants is a sudden exposure of one class to another, in a way that did not happen. After the contact, both sides go back to their separate worlds.

Les Paysans was not a success with the public in 1844: Balzac's readers were bored by a novel without a plot, and Balzac's editor called off the serialization halfway through. Five years later, it was still too radical a solution – at least for second-rate writers like Wey and Champfleury. In theory Balzac was their master, but they chose in practice to inject the elements of social description into the old framework of romance. They chose not to match the divisions they described with the narrative structure they adopted; in *Les Oies de Noël* Champfleury fluctuates between narrative and juxtaposition, between sentiment and analysis. Their novels are not so much incoherent as disorganized, and the difference is crucial.

It was Courbet who adopted Balzac's solution (without, in all probability, knowing anything of *Les Paysans*). He devised, as Balzac had done, a structure which deliberately refused to unite the elements of rural society; he represented their disunity, rather than merely reproducing it. What Macherey says of Balzac's plot-structure could be applied with very few modifications to Courbet's pictures of 1850:

To carry out the project he had set himself, Balzac could not content himself with writing his novel well, or harmoniously constructing it around a central theme: the kind of figuration he had chosen means that there is not in the front of the work a foreground behind which secondary planes are outlined in succession, but several foregrounds one after another with abrupt breaks between them.[105]

This is a visual description. It outlines a kind of figurative language, a particular attitude to space and to the hierarchy of forms. And each term of the description suits Courbet very well. Like Balzac, he could not be satisfied with painting well and constructing harmoniously. He had a different project in hand, which called for a different kind of composition. 'As harmonist and poet, he leaves everything to be desired.' And when the same Besançon critic wrote, 'Perhaps he wanted only to juxtapose on the same canvas different specimens of our mountain population', he was carping, precisely, at the essential of Courbet's art.

6 Courbet in Dijon and Paris 1850-51

So far I have discussed the nature of Courbet's subject-matter, and implied a series of relations between the rural community as subject and as public. I have not pressed those implications further for a very simple reason. It seems to me that the three pictures of 1850 were designed for an urban audience, for Paris rather than Ornans. The primary public which Courbet 'had in mind' (the indefiniteness of that phrase is useful at this point) was the public of the Salon.

Buchon is clear about that, in his ironical way, when he defines the significance of Realism, the context in which its meaning will become clear: 'this absolute Realism,' he calls it, 'which is henceforward as indispensable in painting as in politics, and which the good ladies of Ornans appreciate in advance, just as much as the *Presse* and the *National* will do at the next exhibition'. After the good ladies of Ornans, the opinions of Gautier and Prosper Haussard. It matters, of course, that the ladies of Ornans should be considered as in any way a public; to speak of them in the same breath as Gautier is in itself subtly offensive to Gautier and his readers; but nevertheless they *are* subordinate. It is the Salon that matters, in the last resort; it is there that pictures are bought and sold, and it is there that a mass public for painting exists. The exhibitions at Besançon and Dijon were in fact accidents, even if appropriate ones. They happened because the Salon was postponed, and that in turn was due to the political climate. The Government waited; the Salon opened, finally, on the last day but one of the year.

I have already described what happened to Courbet's pictures on their way to Paris: the gradual progress from enthusiasm to hostility. But the reasons for this

change of heart are still obscure. We cannot simply blame provincial naivety, an insensitivity to matters of 'style' in the Franche-Comté. It is certainly true that criticism in Paris was traditionally more 'partial, passionate, political', as Baudelaire put it in his Salon of 1846. But it is not true that the reaction to Courbet in Paris is explained by objections of an aesthetic kind: this type of objection, as we shall see, is strangely infrequent and perfunctory in 1851; it does not seem to be central to the critics' concern. Neither is it true that the critics of Besançon were in some way incapable of the kind of criticism we meet in Paris.

Courbet's first critic, apart from Buchon, was a gentleman called R. Desbois who, on 17 June 1850, wrote a full-scale review of Courbet's exhibition for the Besançon paper *L'Impartial de 1849*. What is remarkable about that review is that it already contains all the elements of the Parisian reaction, but none of the Parisian critics' savage uncertainty, none of their seemingly disproportionate anger. Desbois is critical, certainly. He understands the justification of Courbet's Realism (and he uses the word itself) quite well, and he has his own objections to it.

M. Courbet does exactly what he intends to do; he has seen ugliness and he has painted what he saw. This gentleman in a black dress-coat, whose nose, like that of Father Aubry, 'aspires towards the tomb': M. Courbet has shaken his hand. It's true, horribly true. Is that sufficient excuse? No . . . we believe that in painting as in poetry it is necessary to discriminate.[1]

Desbois goes further: he is the first to criticize Courbet for making a new mannerism out of his search for reality. Courbet 'falls into the very excess which he attacks in his enemies, and becomes mannered and schematic [*formulé*] like them'. Like most of the Paris critics, he is indifferent to the question of the pictures' enormous size; and like his Parisian counterparts he prefers the *Stonebreakers* to the *Burial at Ornans*, rejecting the 'poetic' and political interpretation of 'our friend Buchon', criticizing the faulty drawing and sketchy landscape, but in the end expressing real pleasure. 'The colouring is true, and so is the sentiment; and the expression is as charming as the colour. This conscientious study will last, and our museum would be fortunate to possess it.'[2]

These judgments are the stock-in-trade of the Salon critics. What is bizarre is Desbois's good humour, the absence of anxiety or defensiveness. All this from a critic who is sensitive, in his way, to the social differences Courbet portrays: he follows Buchon in identifying the gravedigger as 'the type of the peasant'; he refers to gentlemen in *habit noir*; he is unique in seeing the figure of the priest as in some definite sense satirical ('this little fat person with the gleaming pate and the sensual pug-nose, who turns the pages of his book and thinks, in all probability, of the trout from the Loue which are waiting for him for supper – somewhere or other he exists').[3] Desbois is evidently a man of conventional political views – his account of the *Stonebreakers* proves that – and yet he fails to react, on a political level, to the pictures before him.

In the light of what followed in Paris, this seems to me something of a mystery. It suggests that the differences in the reaction to Courbet in 1850–51 are not a simple matter; that they may involve a whole complex of differences between town

and country – or more strictly between city and provincial market town. It suggests, perhaps, that Courbet's art was not genuinely effective – and not meant to be – until it was seen by the public for which it was designed. For whatever else Courbet wanted from his audience in 1850, we can be sure it was not detachment, it was not this kind of easy-going reserve. He wanted his pictures to hurt – and hurt they did, in the city.

Dijon is perhaps the most fascinating case of all; here, it seems, the pictures first began to meet real hostility. We have no criticism from Dijon except Buchon's preview, and that fact itself is strange; in June 1850 the city had at least ten newspapers, and not a single one of them so much as mentioned Courbet's exhibition (one or two, like the *Union provinciale*, gave very full coverage to artistic events in the town: but then, as the Procurer General reported in September 1850, it was a paper 'devoted to the Government').[4] It was, I think, a deliberate silence: a silence which a few of the ultra-reactionary papers in Paris would adopt as the best attitude to Courbet; the silence of outrage and disdain.

The trouble with Dijon was that it was over-politicized – in the grip of factional struggle, absurdly sensitive to the least disturbance. Proudhon's *Voix du peuple* had already singled it out as one of the strongholds of the 'European Counter-Revolution', and had reported in December 1849 that the Procurer General of Dijon had seized the *Almanach du paysan* and the *Almanach du Nouveau-Monde* – two brochures which circulated freely in Paris.[5] Perhaps the Dijon authorities were right to be cautious. There had been riots in the city in the previous May; there were attempts at forming an *association d'ouvriers* among the railway workers; in the town elections of May 1850 'the candidates of the most advanced Socialism' were victorious.[6] A detestable result, said the Procurer, which split the council into two equal factions. Worse still, the allegiance of the surrounding countryside was in doubt:

The agricultural crisis still continues, the low price of cereals and wines is the ruin of farmers and vinegrowers, and quite a large number of farm rents are going unpaid.

There has been no occasion for the political feelings of the rural population to come into the open, and it would be difficult to decide what they really are.[7]

Only one thing was certain: 'Every day these ignorant folk hear the incessant propaganda of the demagogues, and under its influence they let themselves be led astray – all the more easily because they are discontented, above all with the low prices for their crops and the stagnation of trade.'[8] There reigned in the countryside 'a sort of terror and a lively anxiety'; there was burning of ricks and woodlands, and fights between foresters and peasantry; and everywhere, or so the Procurer imagined, there was the Socialist press, sent free to the innkeepers, farmers, and small proprietors.

The paper in which Courbet's show was advertised was, needless to say, the Procurer General's worst nightmare. *Le Peuple, journal de la révolution sociale* was the third metamorphosis of the far Left in Dijon; the two previous papers had

succumbed to fines and prison sentences. Its editors were 'more violent still' than their predecessors; its first number was seized for infringing the press laws, and it lasted until September, when it had its last fling on the eve of the President's visit.[9]

In this situation, it seems that Courbet's exhibition became too closely identified with a specific group and its politics. It was spurned by other sections of the Left as well as the Right; *Le Socialiste de la Côte-d'Or* ignored it, presumably because it smacked too much of the 'extremism' of *Le Peuple* (which the paper regularly condemned in its editorials).

But there may also have been other reasons, more profound and pervasive, to do with the nature of Dijon society.[10] Dijon in 1850 was a city on the verge of industrialization. In 1847 the building of the railway station began and the local traders and industrialists demanded a Chamber of Commerce; in the 1850s they got it, and a Bank of France, and railways to Paris and across the Burgundy plains. With that movement outward went the breakdown of the old structure of the city, the old jigsaw of *faubourgs*, each with a distinct character of its own, and a population half-rural, half-urban, tending market gardens which stretched right into the heart of the town, providing the citizens with their chief source of food.[11] That casual interpenetration of town and country was about to disappear: in the next decade factories would appear in the *faubourgs*; in 1852 the Dijon bourgeois were already dreaming, in typically utopian fashion, that their town would become 'a great and immense city, a town of the first rank'.[12]

In reality, trade and industry would come slowly, factories gradually replacing the tiny foundries and textile shops on the city outskirts, the chain stores and the central market edging out the small shopkeepers and the fairs in the *faubourgs*. But reality is not everything: there were stirrings in 1850 of an urban consciousness, an excitement (which was hardly present at all in Besançon) at the thought of a distinctly urban future.[13]

It was this situation – where a certain tension between urban and rural identity is apparent, where the presence of the country *inside* the town is no longer a simple, accepted matter of fact – which perhaps underlay the violence of Dijon politics. At any rate, Dijon reminds us of one fact essential to understanding the Parisian reaction to Courbet. It tells us that cities evolve in a complex and ambiguous way; that men assert an urban identity – call themselves, decisively, citizens or bourgeois – often against the facts. They make sharp distinctions where in fact the edges are blurred; they conceive of the city as separate from the countryside; they conceive of the countryside as different in every way from the city. They find it offensive and dangerous to be told, or shown, the way in which town and country touch, interpenetrate, have classes and institutions in common, imitate each other. Their identity depends on the difference. To be bourgeois, they need a vague but vivid idea of the world they have lost or rejected. They need an image of rural society, in a way the countryman or the small-town dweller does not. And if they are faced with an image which contradicts these preconceptions, they are liable to be perplexed and wounded in ways they do not themselves fully understand. This, I think, was what happened in 1851.

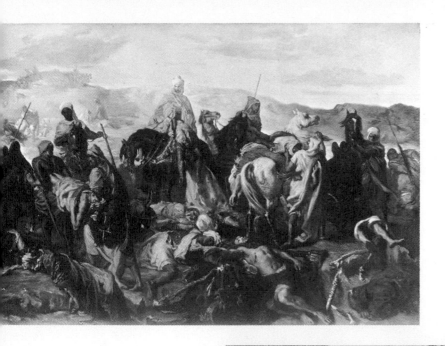

THÉODORE CHASSÉRIAU
Horsemen Carrying away Their Dead

JEAN-LÉON GÉRÔME
Greek Interior

CHARLES-LOUIS MULLER
Roll-call of the Last Victims of the Terror
50

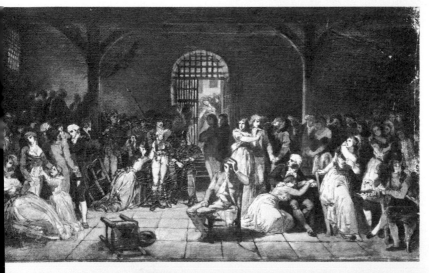

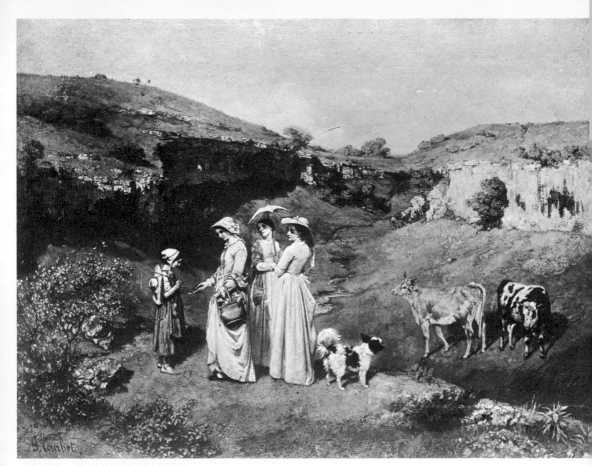

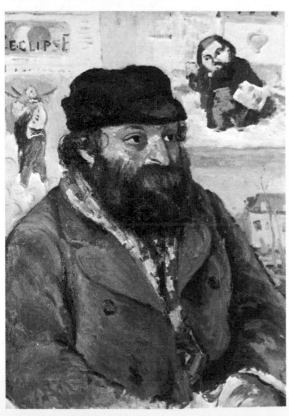

37 GUSTAVE COURBET *Ladies of the Village* 1851

38 CAMILLE PISSARRO *Portrait of Cézanne* 1874

Courbet was, in a third 'advertisement', introduced to Paris before the Salon opened. On 21 September, Champfleury wrote a review of the Dijon show in *L'Ordre*, a Parisian newspaper whose name explains its politics. Whether he had seen the *Burial* or the *Stonebreakers* at all at this date is doubtful – he had certainly not gone to Dijon.[14] His review is short on visual detail; almost a fantasy of what Courbet's pictures *should* look like, rather than a description of how they looked in fact. But the terms of Champfleury's imaginings are important in themselves. To him, Courbet is the new Géricault, imitating the travelling show of *The Raft of the Medusa*; even more important, he is Baudelaire's painter.

It is not yet time to say what impression these pictures will make – these scenes of domestic life, large as history paintings, where the author has not flinched from painting a full-length portrait of the modern bourgeoisie with its well-brushed provincial costume. The age of plumes has gone, and many pine for the costumes of Van Dyck; but M. Courbet has understood that painting must not deceive future centuries about the way we dressed.
'But all the same has not this much-abused garb its own beauty and its own native charm? Is it not the necessary garb of our suffering age, which wears the symbol of perpetual mourning even upon its thin black shoulders? Note, too, that the dress-coat and the frock-coat not only possess their political beauty, which is an expression of universal equality, but also their poetic beauty, which is an expression of the public soul – an immense cortège of undertakers' mutes (mutes in love, political mutes, bourgeois mutes). We are each of us celebrating some funeral.' [Baudelaire.]
The painter from Ornans has understood completely the ideas of a rare and curious book (the Salon of 1846 by M. Baudelaire).[15]

Champfleury saw immediately that the *Burial at Ornans* was a portrait of the bourgeoisie; he saw at once its specifically urban significance. What he did was write an introduction – provocative, quizzical – for the bourgeois of Paris, as a companion-piece to Buchon's address to 'the artists, the idlers, and, above all, the common people' of Dijon.

He put the painting in an urban context: he imagined the man from the Faubourg Saint-Denis in front of the *Burial*, seeing himself in its great cracked mirror, standing at the graveside in his cravat and polished boots. The haberdasher consults his catalogue, and discovers that this is not Paris but a place called, incorrectly, 'Ornus'. But he hardly believes what he reads; he looks up at the painting again and sees himself, 'celebrating some funeral'.[16]

In other words, these pictures have a specific iconography for a city audience: they have a different resonance, different meanings, once they get to Paris. Burial, for instance, was a matter of very special significance to Parisians. As one hack playwright put it:

> Il en coûte bien cher pour mourir à Paris.
> Et les enterrements, Monsieur, sont hors de prix.[17]

The bare statistics support the wretched couplet: between 1839 and 1847 an average of 78·6 per cent of Parisians were buried in the common grave, unable to afford the

dignity of a grave of their own.[18] Burial had become, in the spreading acres of Père-Lachaise and the Cimetière du Nord, a distinctive and central bourgeois institution; mimicking the pomp of an aristocratic past, but a pomp become private, competitive, almost at times a matter of speculation. No novel was complete, it seems, without its scene at the funeral. In *Les Oies de Noël* the usurer is given typical treatment:

Two days later the funeral of old man Blaizot took place, and a large part of the town was present; more sightseers than mourners. Men of affairs consoled themselves for the death of a good client with the thought that trouble over the fat inheritance would lead to endless trials and litigation – and they would take the best part of the estate.[19]

Compare the sad funeral of Dambreuse in Flaubert's *L'Education sentimentale*, which is set in February 1851; or Flaubert's own cry, in a letter written the next year:

I have to go to Rouen for a funeral: what a chore! It is not the funeral that makes me sad, but the sight of all the bourgeois who'll be there.[20]

A saddening sight, and one which could move to anger. For the working class attached great importance to the rite of burial, and there are plenty of signs that they resented the way it had become a bourgeois privilege. Pamphleteers attacked the speculators and the rising costs of a funeral; and Catholic newspapers deplored the fact that the Socialists often turned funerals into political demonstrations.[21] And when, as happened rather often, the clergy refused the comforts of religion to a man who had not received extreme unction, or whose coffin bore the emblems of a guild or a craft fraternity, there could be riots and disturbances. On one occasion in Paris the people celebrated mass without the priest; in Dijon in 1850 the friends of the deceased waited for the funeral of a local worthy, and broke it up with shouts 'against the clergy and even against the dead man's memory, since he had made the mistake of being rich'.[22]

As for the crowds who prayed each Sunday before the common grave at Père-Lachaise, one interpreted their feelings according to one's politics. The *Journal des débats* congratulated the crowd on its family loyalty and resistance to Socialist doctrine; the *Démocratie pacifique* did not agree.

To prove its case, the newspaper of the reactionaries would have to prove that they were not Socialists, these proletarians who went in thousands to pray at the foot of the cemetery's main cross – praying in memory of parents who died *too poor to obtain a grave to themselves*. We can assure the *Débats* that these poor folk were not reactionaries. And we have seen the enemies of Socialism, men and women in elegant outfits – they were not praying beside the common ditch nor beside the private graves, they were parading in the alleys of Père-Lachaise as if they were walking in the Tuileries.[23]

Thus burial took on barbed and complex meanings; it became an institution, a privilege, a matter for envy and dispute. This was, as it were, the second context of the *Burial at Ornans*, the implications it gained in the city. They were not *its* meaning, exactly; but they were not meanings it could wholly escape. And

Champfleury, with his eager identification of the ceremony as 'bourgeois', only helped the confusion of town and country, only reinforced the basic unease.

The last stage of this process was Courbet's picture of urban life pure and simple. He began the canvas of *Firemen Going to a Fire* [16, 17] some time in 1850, soon after his return to Paris: it was under way before the Salon began, and one critic mentioned, incorrectly, that it had been commissioned by the State for 6,000 francs.[24] Why it was never finished is not clear. Tradition has it that the *coup d'état* intervened; but Courbet rarely took a year to block in a picture, even on as vast a scale as this. It seems to me the difficulties were internal, that the *Firemen* is a failure rather than a misfortune. And perhaps the state of the canvas, with its figures no more than blocked in over a thick ground of black and mid-brown and grey – a ground which shifts in colour, through a narrow range, over the whole picture surface – is in the end appropriate to the matter portrayed. Courbet never did paint the epic of modern life in the city; this was his one and only try, begun, one feels, as an immediate sequel to the three pictures of 1850. It is as if in this picture the matter of city life remained too dense and alien and complex to be articulated in the same way as the *Burial at Ornans*. Once again he chose a subject where blackness dominated, where face and form would be shaped – almost carved – from that anonymous material. Only here the equilibrium of the *Burial* – the final substance of the individual bodies, the vividness of the faces against the black ground – was never achieved. What the *Firemen* tells us, as do many unfinished pictures, is the kind of effort involved in that final articulation, the solutions which the artist had to avoid. There is still visible in many of the poses and gestures – say, of the two main figures pointing the way – a curious insubstantiality, a weightlessness. And that was the quality which Courbet, above all artists, wished to avoid.

For his model, Courbet has moved from Van der Helst to Rembrandt: he has attempted his own version of the *Night Watch* [14].[25] That is the source of the pointing fire-officer and the workman beside him – they are Courbet's Captain Cocq and first lieutenant, and the firemen are the new militia. The *Night Watch* is the starting point of the picture's general arrangement and tonality, its dark setting and gleaming golds; and, in particular, it is the source of the strange figure of the boy in the centre, half running, half falling towards us, one hand thrown up to catch the light. He is Courbet's version of the uncanny racing dwarf at the left of the *Night Watch*, though the hand is painted as Hals would have done it (and as Courbet himself had done in the portrait of Baudelaire). There are other borrowings: from Daumier, perhaps, in the woman and child at the left, and the boy at her side peering in profile at the firemen; from his own pictures, certainly, in the bearded face which is caught by the light between the heads of officer and workman, and the constricted pose of the young fireman at the centre, pushing the cart – he seems close to the younger stonebreaker, swivelled towards us but still baulked and bowed down by physical effort.[26]

The sources are more transparent, and so is the intention: to give us some kind of comprehensive view of Paris, a repertoire of classes and types. On one side the woman of the people in a russet, sleeveless dress and with a child at her bosom; on

the other, a bourgeois lady on the arm of her husband, swathed in a great grey shawl, her acidulous profile emerging from a grey bonnet embroidered with red flowers. In the middle of the action, the officer is put next to the workman in peaked cap and blue-grey smock; between them is the impassive, abstracted face of the dandy in a silk hat. And finally the faces of the younger, beardless firemen; already, in their half-finished state, sullen and funereal, eyes veiled or averted, the urban counterparts of the Stonebreakers. At this early stage of the picture Courbet is still visibly organizing these elements: he has pulled Rembrandt's varied groups of figures into a single line across the canvas; he has, except for the falling boy who carves a space around him at the centre, disposed of Rembrandt's vivid spatial clues: the officer's pointing hand no longer casts a shadow on his companion's coat; the hauling-bars, the cart and its wheels push back in contradictory directions. He has lit the scene from several sources, and once again refused to unify the picture by a strong, consistent pattern of light and shade. In a word, he is moving towards the kind of organization we have already seen in the *Burial* or the *Return from the Fair*; another procession, organized but disparate, in which the elements of a situation, but not its significance, are laid out for our inspection.

The *Firemen* is not of course a finished picture, or a successful one. It testifies to Courbet's energy, to the work involved in Realism of the kind he wanted. It shows what failure would involve: a certain stiffness in social 'arrangement'; gestures which are conventional rather than awkward; individual forms smothered by the anonymous ground, an inability to extricate the particular from the general.

'The Salon of 1851', said the poet Théodore de Banville on 9 January, 'will be a date in the history of the arts.'[27] It would mark the victory of 'the feeling or at least the search for truth'. Most critics knew that for better or worse the Salon was political, and that it saw the birth of a new kind of Realism. 'We are ready to applaud', said Prosper Haussard, 'the formation of a school of painters of the people, of which MM. Courbet, Fr. Millet and Jeanron may be the chiefs.'[28] Add to those names the revolutionary canvases of Leleux, the *Barricade* of Meissonier, Bonvin's *School for Orphan Girls*, *The Fire* by Antigna, the *First Work after the Insurrection* by Lacoste, the canvases of Pils, and the *Carnage* of Préault, which was shown for the second time in the Salon that year – and you have the contours of the Realist 'school', as the critics understood it.

That school had existed all through the 1840s, but everyone agreed that in 1850 it had taken on a new form. It had become more ambitious, taken its subjects from more modern and less picturesque sources, painted bigger, adopted a certain political stance. Haussard exaggerated when he said 'these great canvases, done to provoke the eye, aim at painting the people – they aim to teach the people, by example, of its own life, and to teach society by the spectacle of the suffering and the disinherited within it'.[29] The school had no such shared aim, no such coherence, and other critics would point out the differences. What, after all, had the *School for Orphan Girls* to do with the *Burial at Ornans*? Both in a sense were paintings of religion, but

the first was gentle, sentimental, a favourite with the critics and the public; and the second was a provocation. But in spite of this people talked of Realism, of *L'Ecole Socialiste*; and Courbet was not the only target for attack. For a critic like Rochéry, Leleux was far worse than Courbet, for he degraded the worker and the revolution in one; all in all, Leleux got as bad a press as Courbet, though not so much coverage.[30] And poor Préault found himself once again the butt of critical wrath, for a sculpture done sixteen years before: 'Statuary, like painting, possesses a Socialist genre.'[31]

It was a political exhibition. The Salon Carré was filled with huge lessons in the history of the French Revolution: Vinchon's *Volunteers Enlisting*, Philipotteaux's *Last Dinner of the Girondins*, and the favourite, Muller's *Roll-call of the Last Victims of the Terror* [36]. All preached the horrors of revolution and the necessity of moderation: Muller, following Alfred de Vigny's *Stello*, added the poet André Chenier as his central victim, and 'corrected' Vigny's ragged melodrama by adding – as a kind of cage for his swooning aristocrats – a stiff, sequential, academic composition. Horace Vernet exhibited an equestrian portrait of Louis-Napoleon, and the shops were selling engravings of his latest major work, *Two Scourges of the Nineteenth Century, Socialism and Cholera*, in which, at the foot of the guillotine, Cholera plays a flute carved from a dead man's bone, and Socialism, 'represented by Death', reads a copy of Proudhon's newspaper.[32]

It was not surprising, in such a righteous atmosphere, that the *néo-Grecs* had a bad year. The most unpopular picture in the Salon – officially at least – was Gérôme's *Greek Interior* [35]: the critics agreed that it should be removed from the sight of women and children.[33] (Times changed very quickly; a few years later photographs of the picture were selling like hot cakes.) The interior in question is a brothel; the ladies in the foreground are displaying their wares, and various clients enjoy their post-coital calm. As usual with Gérôme, the eroticism is odd because it is *organized*: the broad, definite contours of the whores are put against a tessellated background, a criss-cross of verticals and diagonals in the surrounding decor. The multi-coloured interior may derive from a picture by Ingres, *Antiochus and Stratonice*, but Gérôme has made it hard and glossy, in his own fashion. The decor confirms the stasis, the enclosure of the subject; the design echoes but does not duplicate the languor of the people in the foreground. All these things are shrewdly calculated, and the picture itself seems to me successful; but it was not, that year, a picture for the times.

The heroes of the Salon, for the enlightened critics of the *avant-garde*, were Delacroix and Chassériau. Delacroix because he remained 'the greatest colourist, the greatest dramatist, the most passionate, the most inspired and the most individual master of our age'. (That was Banville's verdict, in spite of the fact that his own verse was cold, discreet, Parnassian.) And Chassériau, because he seemed on the point of transforming Delacroix's style and subject-matter, on the point of inheriting rather than imitating Delacroix's world. In his great work in the Salon that year, the *Arab Horsemen Carrying away their Dead* [34], he painted a kind of index to Delacroix, gathering Delacroix's poses and characters into one complex

group – making the transitions from figure to figure fluid and continuous, resolving the tensions of gesture which Delacroix usually left as they were, in isolation. (In a curious way it anticipates the *Lion Hunt*, which Delacroix painted three years later.) It was the form of classicism appropriate to 1851; 'living Greek art', one Socialist critic called it.[34] (Two years later, when the Empire had replaced the Republic, Gérôme's version of the classics came back in favour; and Chassériau painted his own Greek – or rather, Roman – interior: his half-naked ladies waiting in the Tepidarium. And the *Arab Horsemen* never had a sequel: once the Empire arrived, his relation to Delacroix became gradually, fatally, more bland and careless.)

As for Courbet, the nine pictures he sent to the Salon were, I think, carefully chosen. They make up a sequence, almost a code, in which each picture confirms or contradicts the next. Besides the three paintings of rural life, he sent the old Bohemian image of himself, *Man with Pipe*, and three other portraits. The first, in the manner of Rembrandt,[35] was of his friend and patron Francis Wey; the second, in the Spanish manner,[36] was of Jean Journet; and the third was of Hector Berlioz [26], the Romantic maestro, gloomy and withdrawn, his eyes all but obliterated by shadow, an image he himself rejected. The portraits alone were strange enough, as a trio: respectable Republican, outlandish Bohemian, and disillusioned *enfant terrible*. Several critics hinted at the disparity among the three. They came from incompatible worlds. Lastly, he showed two landscapes, a *View of the Ruins of the Château de Scey-en-Varais*, and the *Banks of the Loue, on the road to Maisières*: enough to stake Courbet's claim as a painter of landscape, not enough to allow the critics the option of calling him a landscapist who had attempted too much.

Courbet's landscape style was in fact an integral part of his Realism. Its failure, for it seems to me the weakest part of Courbet's art, is almost necessary to the figure paintings' success. It is as if he split his art in two, and made landscape the absolute antithesis of his paintings of the human world. He made it a world from which human beings, and even for the most part the traces of human industry and trans-action, were essentially absent. He adopted the new myths of solitude, the Romantic view of landscape. And in the process he rejected the most fertile tradition in landscape painting – its essential theme, in the hands of the French and Dutch masters of the seventeenth century – the record of a human presence, the painting of landscapes thick with the remains of a human past, landscape created by man, in fact as well as on canvas, dragged from the sea, drained, enclosed, cultivated; a landscape on which wilderness and solitude merely encroach, as reminders of the efforts men make to end them both.

Courbet's landscapes very quickly become imprisoned within a formula. They are, typically, close-up views of a dense, continuous surface of rock and trees; for the most part a surface which rises vertically, parallel to the picture plane. Recession into a far distance is relatively rare, and where it appears it is perfunctorily handled. The sky is all but absent, pushed above a high horizon line; except, that is, in the series of seascapes, which stand apart in quality from the rest, as if here the myth of solitude – just because it found its most perfect and explicit form – released the painter's energies. What is lacking – except in these seascapes – is Courbet's urge to

represent, in his 'earnest, empirical' fashion,[37] the particular surface and gravity of the things before him, their individual nature as well as the matter they share. In the landscapes – and this is in direct and limiting contrast to the greatest figure paintings – individual shapes and surfaces and weights tend to recede into the thick paste of paint. The palette knife takes over, the things themselves are lost. Foliage and cliff-face blur into a froth of pigment, indefinite without being in any effective sense ambiguous, since the paint is never precise enough to invite any one reading, or even suggest finite alternatives.

But all this came later. In 1851 landscape was still a subordinate part of Courbet's Realism. The landscapes for the Salon repeated the backdrops of the *Burial* and the *Stonebreakers*: simplified and sombre, hemming in the human world and pressing it closer to the picture surface. In the *Ladies of the Village* [37], painted later in 1851, Courbet went one step further: he painted a landscape with all the disjointed gravity of his figure style, and for once he put a human transaction – a cash trans-action, to be precise – awkwardly against it. He gave an equal weight to the cattle, the cliffs, the turf, and foliage, painting them all in close-up; and he masked the distances involved, between the barking dog and the cattle, or between the figures and the cliffs behind. (This curious evenness of focus was something Courbet worked hard to achieve. We have a preliminary oil sketch in which the figures are still dwarfed by the landscape, and the space between people, cattle, and cliffs is perfectly easy to read. There is even a graceful tree in the centre, to separate the ladies from their background.)

The *Ladies of the Village* was Courbet's final picture before the *coup d'état*. It is almost the first of his paintings to show us figures in a landscape, and make the two parts match, or even clash (the previous example was the *Peasants of Flagey*). And it is almost the last. When he tried again in the *Bather* of 1853, the result was farcical; though perhaps by then farce was what Courbet intended. By the time of *The Studio*, he puts a landscape on his easel which has many of the limitations I have outlined. And the skyline of the *Peasants of Flagey*, which originally hung on the back wall of the studio, was painted out. After a century it looms through the paint again.

The critical reaction in 1851 was far more equivocal and uncertain than tradition has it. There was a wide spectrum of reactions to Courbet, from admiration to out-rage, and even the attitudes of hostility (which did predominate) were most often marked by reservations, genuine puzzlement, distress, and an obvious effort to understand the incomprehensible. These things cannot be quantified, but for those who like figures I judged the overall reaction of eight critics to be one of outright fury; of eighteen to be unmistakable hostility; of five to be criticism without ran-cour; of seven to be some kind of equivocation, mixing criticism with praise and not opting definitely for either (of these seven, three are critics for Besançon newspapers); of four to be guarded, or in one case merely fashionable, sympathy; and of three only to be outright admiration: and these three are Buchon, Champ-fleury, and Sabatier-Ungher, the Fourierist. Some critics changed their attitude

from month to month: when A. de la Fizelière wrote his 'Salon' in *Le Siècle*, he was firmly critical of Courbet, when he wrote his more studied opinions in a Salon booklet he opted for sympathy; Gautier took Courbet to task in his 'Salon' in *La Presse*, but in *L'Artiste* in May he thought that Courbet should have been awarded a first-class medal.

One thing is certain: in official circles Courbet's exhibit caused embarrassment and distress. He could not be excluded from the Salon, since he had been a medallist in 1849; but the critic Ferry was probably right when he stated that the *Burial* would never have been shown but for Courbet's privileged status. Inside the hanging committee a rearguard action was fought; if Courbet had to be in the exhibition at all, then at least his canvases would be removed from the Salon Carré and taken to the obscurity of the upper storey. In the end the *Burial* alone was saved from this fate; it was merely moved upwards to the cornice, where it would at last gain more than its share of chiaroscuro. We have no record of the battle within the jury, though Léon Cogniet's explanation of his decision to keep the *Burial* downstairs indicates how sharp the controversy had been:

As all M. Courbet's pictures were supposed to be taken upstairs, we thought we could keep one of them in the Salon Carré – the one which was most useful to the arrangement of the gallery, and the one which had been most particularly the centre of a sharp controversy among the public, the artists, and in particular the jury.[38]

The removal upstairs had been passed by one vote, with several abstentions and considerable confusion. When we remember that the jury included ultra-conservatives like Picot, Abel de Pujol, and Horace Vernet, alongside Decamps, Delacroix, Corot, Théodore Rousseau and the landscape painter Français, we can guess at the lines of division. At the official level, Courbet seems to have survived by the skin of his teeth.

The strangest development between September 1850, when Champfleury wrote his preview in *L'Ordre*, and February 1851, when he wrote his 'Salon', is the appearance of a Socialist interpretation of Courbet. By February one of Champfleury's main concerns is to defend Courbet against this interpretation, to argue that his pictures had no such specific intention. Yet most of the critics operated in the light of a Socialist reading of Courbet: Enault called him the Proudhon of painting; Desplaces headed his discussion 'M. Courbet et l'art socialiste'; Peisse put it more strongly:

His painting is an engine of revolution. . . . It is even said, to make us more terrified still, that this new art is the legitimate child of the Republic; that it is the product and manifestation of the democratic and popular genius. In M. Courbet art makes itself part of the people.[39]

And the terms of this indictment – the half-contemptuous, half-alarmed statement that 'it is said that M. Courbet is a Socialist, and that he does Socialist painting'[40] formed a refrain to criticism from Right, Left, and Centre.[41]

But the difficulty is to explain where this Socialist interpretation came from. Only three critics in 1851 framed any sort of political apologia for Courbet:

Sabatier-Ungher, who called Courbet's art 'democratic' and who stressed the idea that his art was 'popular', for and of the people;[42] A. Léon Noël, in *La Semaine*, who praised Courbet for having realized that it was time for art to 'go plebeian, in other words become conscientious, grave, simple and natural', and who proposed that Courbet was the legitimate son of 1848; P. Petroz in the Socialist paper *Le Vote universel*, who described him as the painter of modern life and welcomed 'this eminently just and revolutionary idea'. But in the case of Noël and Petroz these are asides, preliminaries to reviews which criticize Courbet for false naivety, vulgarity of subject-matter, or carelessness of composition. These three reviews are scarcely enough to explain the way in which the Socialist interpretation appears, by the beginning of February, as something fully-fledged, commonplace: a bogey to which critic after critic refers, but which is formulated by no one except Sabatier-Ungher. (And of course by Buchon. But who knew of his advertisements in Paris? Champfleury perhaps did, though he never mentioned them in his subsequent memoirs of Realism; probably no one else.)

The answer seems to be that this Socialist reading arose on the edges of the world of criticism, beyond the pale of civilized society. Jules Vallès gives us precious testimony here, when he remembers his own reaction to the Salon of 1851:

It was, I believe, in 1850. We were walking, a few friends and I (the oldest must have been eighteen), through the galleries of the Exhibition. All at once we stopped in front of a canvas which, in the catalogue, was called the *Stonebreakers*, and which was signed in red letters: G. COURBET.

Our emotion was profound.

We were all enthusiasts. It was the time when heads were brim-full of ideas! We had a deep-rooted respect for everything that suffered or was defeated, and we asked the new art to play its part in the triumph of justice and truth.[43]

In other words, it was an opinion which grew in the Salon itself, or in the studios, rather than in the press. And when we examine the critics' conception of Courbet's public, we shall confirm Vallès's reminiscences. What the critics feared was precisely the irruption of a new public, not amenable to their own civilized and responsible instructions. It was this public which made Courbet's art political.

Taking the forty voices of 1851 together, the overall impression is of monotony, sameness, in what is said. True enough, approval or dislike of Courbet corresponds very roughly to the critic's place on the political spectrum. The Legitimists stand out from the rest by the sheer violence of their reaction: in *L'Opinion publique*, Alphonse de Calonne refused to discuss 'the arrogant daub signed with the name of Courbet' ('*l'orgueilleux charbonnage signé Courbet*'); in the *Gazette de France*, Thénot ignored Courbet completely. And the reasons for the Legitimist response are sufficiently clear – they of all parties had depended throughout the 1830s and 1840s on a myth of the countryside, a call for the aristocracy to return to their lands and cement a new unity of the classes.[44] They of all parties would find Courbet's imagery political anathema.

As for the reviewers of the Left, they were clearly more reluctant to criticize.

They provided one or two of Courbet's best apologists, but they also provided critics; men like Petroz, Rochéry, Desbarolles, or Haussard, who came to praise and stayed to blame. And some of Courbet's admirers were certainly not men of radical convictions: Méry, who wrote witty, lightweight chatter for *La Mode*; Fizelière, who decided that Courbet was a pictorial George Sand; even Champfleury himself.

What matters is the themes and uncertainties which the critics share. (Just as they share to a certain extent a class identity, many of them on the fringes of the old or Napoleonic aristocracy, members of the 'liberal professions'. Eleven of the critics carried the aristocratic or pseudo-aristocratic prefix 'de'. The rest were impeccably bourgeois, except those who were dilettante landowners like Sabatier-Ungher.) What matters is the curious repetitive rhythm of 'Salon' after 'Salon', the common structure of likes and dislikes, the agreed language in which the objections are framed, the sequence of images through which the critics move, as in a dream, or more properly a nightmare. We are dealing here with something like a myth – a story with a certain symbolic significance, which each member of the tribe inherits, and which he infuses with new meaning not by radical invention, not by new characters and new conventions, but by modifications of detail, insinuating the essential into the edges and connecting links of his discourse; changing the texture of the story by adding the irrelevant reference, or altering, very slightly, the texture of the language.

The critics of 1851 inherit a language of criticism and a structure of judgment which had dealt, year after year, with the disagreeable innovation or the 'improper' in style or subject-matter. By and large the critics use what they inherit. They have a notion that the size of a picture should correspond to the historical dignity of its subject-matter. They know that modern life is a dangerous subject for a painter; they object to triviality or vulgarity in Courbet's choice of human types; they repeat the belief that more and more artists deliberately prefer the ugly. They criticize the lack of elaborate composition with a clear dramatic focus, and they deplore the absence of chiaroscuro. They mention the ideal, and they say that Realism avoids the distinctive task of art, its transformation of the actual world and its selection of a better.

All these elements put in an appearance in 1851. But some of them, curiously, are fading from the critics' vocabulary, becoming the merest gesture towards criticism. The issue of size was all but dead, save for a few critics of the extreme Right. Only six critics frame a specific objection in these terms; another eight declare themselves actually in favour, or deliberately neutral; the rest do not even discuss the matter.[45] The word 'ideal' is out of favour. Delécluze can use it, with all the old confidence of the school of David, and it crops up in the criticism of the Left in Rochéry's 'Salon'. But these are rare incidents, and the concept itself seems to be in abeyance. Realism as such is widely accepted; it is Courbet's peculiar version of it that rouses the critics' fury.

More strangely, criticisms of a specifically stylistic kind – attacks on the flatness and monotony of the forms in the *Burial*, objections to the sombre colour and the

dull light, the lack of shadow and relief – are relatively rare in 1851. This is true even in terms of numbers: only thirteen writers framed any criticism in these terms, and one critic, Desbarolles of the *Courrier français*, actually defended Courbet's composition in terms of the conventional requirements.[46] But it is clearer still in what is actually said, the perfunctory way in which the criticisms are put forward, the air of an actor stumbling half-heartedly through a stale script.

There are exceptions to this. Haussard in *Le National* rises to a certain kind of mis-guided eloquence, and links his critique of Courbet's composition to his previous critique of subject-matter:

The mixture of degradation and prodigious eccentricity in Courbet's idea even affects his execution. The arrangement of lines seems calculated to break every rule and produce the maximum possible pictorial ugliness: figures in a line or back to back, groups which are incoherent or contradictory, a heaping-up rather than a building up of masses, continual discords instead of harmony – nothing is left out.

The painting is thus in unison with the subject-matter.

The overall effect is either a grey and dirty monotony or a kind of crude illumination. Yet what is needed to save scenes and types like these is either the vigorous conflicts and bright tints of Caravaggio, or the magic, all-enveloping chiaroscuro of Rembrandt.[47]

This is writing which at least believes in, and argues, its own distaste. For most of the other critics – that is, the minority that bother at all – the question of style is dismissed in a weary phrase or two: 'he does not compose, and lacks unity', 'M. Courbet's pictures have no light and shade, and have an extremely flat appearance', 'groups which are incoherent and piled on top of each other', 'all the figures are just slapped down on the canvas'.[48] Even Delécluze, the last spokesman of neo-classical 'style', is reduced to a single sentence: 'As to art [the very phrase suggests how incidental this type of consideration is felt to be in the case of Courbet], not only is there no shadow in this composition but it is clear that the painter has quite deliberately refrained from putting any in; he has affected an ignorance and simplicity which he is far from possessing in fact.'[49]

The issue of style led the critics back, immediately, to their primary concern: Courbet's attitudes, both to his audience and to the things he paints. To describe those attitudes, they used the language that came to hand. Almost all of them talked of 'the ugly' or of 'deliberate ugliness' ('*un parti-pris du laid*'), or even of Courbet as a 'mannerist of ugliness';[50] just as many objected to the 'vulgarity of the types', 'the pursuit of the ignoble', 'trivial figures', [51] the bizarre, the grotesque.

Nothing is simpler than to enumerate the phrases, the colourful variants on a single, disgusted theme; but nothing is more difficult than to discover what the phrases meant. The words themselves hardly help us: they are hold-alls of meaning; they refer to everything and nothing. 'Ugliness' could and did mean all things to all men in the mid-nineteenth century: it had been used against Couture's *Romans of the Decadence* in 1847; it was employed against Chassériau's *Two Sisters* in the Salon of 1843, when Arsène Houssaye accused the artist of 'a deliberate commitment to ugliness'.[52] It was the term which greeted any aberration, however slight, from the

norms of a critic's good taste. We want to know what exactly it signified in 1851, and why it was accompanied by such rage or perplexity. (The anger does not necessarily attach to the angry words: 'ugliness' is in some cases an automatic label, a cool incident in a discourse which does become enraged, but sooner, or later, about something different.) We have to discover meanings of which the critic himself was often unaware, or for which he chose not to find words. To find them, look at the detail of the critics' discourse, the words which occur, in 'Salon' after 'Salon', as a seeming aside or irrelevance – but which tie the critics' anger to certain concerns more specific than beauty or its opposite.

This is not to say that the critics never admit their perplexity. On the contrary, at times they come close to describing an unsureness which the language of aesthetics can hardly articulate, a kind of critical vertigo.[53] What worries these men is their sense that they are missing Courbet's intention: that the *Burial*'s weird mixture of comic and tragic, grief and indifference, must mean something, though *what* exactly they fail to see.

Once again, Haussard best finds the syntax and vocabulary to express this perplexity. What, he demands, are we to make of

this long file of ludicrous masks and deformities copied from life, this village cleric and his priceless acolytes; those two churchwardens with noses as crimson as their robes; this joker with the funny hat and turned-up moustaches who carries the coffin, this brawny grave-digger who poses solemnly on one knee at the graveside; this seriousness and this buffoonery, these tears, these grimaces, this Sunday-best mourning, in black coat, in smock, in beguine cap, all adding up to a funeral from some carnival, ten yards long, an immense ballad in painting, where there is more to laugh at than to make you cry?[54]

This represents the *Burial* very well. Its abrupt movement from image to image; its accumulation of contrasts which end in the contrast of costume; its final question-mark which qualifies its angry rhetoric – this seems to me hostile but appropriate description. Its metaphors are straight to the point. To take as one's comparison for the *Burial* the riotous mock-funeral of Carnival on Ash Wednesday,[55] and the popular ballads of the Parisian streets, was a first effort at understanding. They are both analogies that hint at the context of Courbet's art, the public it expected.

Bonnassieux made the same gesture in his review: 'One is tempted to see it as a cartoon, a carnival funeral.' And Arnoux, in *La Patrie*, the enlightened journal of progressives like Rémusat and Tocqueville, made the perplexity more explicit:

But there is something sadder still: who is it that cracks bad jokes, in the middle of the funeral ceremony, about the red noses of the choir and the beadles? Why come here to show me so obligingly all these loathsome, ugly people, all these ignominious, dirty faces, all these grotesque platitudes? Is it an epigram at the expense of the Church? But take care! You never warned me that you were painting a masquerade, that you were re-doing on canvas the comic funeral of 'Malbroug', carried to rest by his four officers – only this time giving the popular song the proportions of an epic.

I see now, it was Shakespeare you wanted to do. This skull you mix into the upturned earth at the graveside – that, in your mind, is the skull of Yorick.[56]

Here is a critic casting around for comparisons, and finding some which help us more than he realized. To invoke Shakespeare was standard in 1851: he stood for the mixture of comic and tragic, he stood on the edge of the comprehensible and permitted in art. He was most often mentioned to show that Courbet had gone beyond both limits. Though the comparison with Shakespeare could be pursued further: it is certainly true that Shakespeare is the greatest example of an artist whose language and sensibility draws and depends on a rich, vivid, popular tradition. This is not, typically, true of French verse, or French painting. Courbet is in this case a great exception, and closer to the English literary tradition than the French.

But to talk of the funeral of Marlborough, and the popular prints which kept the ballad of Marlborough alive in the nineteenth century, was closer to the mark. Read the last verses of the *Mort et convoi de l'invincible Marlborough*, and remember that the ballad begins as a real lament – slow paced and sad, Marlborough's lady waiting alone in the castle tower, his page in mourning black returning, and telling her of her Lord's burial. And then, after the description, this:

> *La cérémonie faite, mironton, mironton, mirontaine,*
> *chacun s'en fut coucher.*
> *Les uns avec leurs femmes, mironton, mironton, mirontaine,*
> *et les autres tous seuls.*
> *Ce n'est pas qu'il en manque, mironton, mironton, mirontaine,*
> *car j'en connais beaucoup.*
> *Des blondes et puis des brunes, mironton, mironton, mirontaine,*
> *et des châtaignes aussi.*
> *Je n'en dis pas davantage, mironton, mironton, mirontaine,*
> *car en voilà assez.*[57]

This is as close to the tone of the *Burial at Ornans* as we shall come: compare the casual, almost dignified introduction of the scurrilous aside in the middle of the funeral dirge; or the ease with which the singer combines the two. This is the way that Courbet's art is 'popular', and this – the collision of religious and secular, the abrupt movement within the same canvas from gravity to grotesque – is one source of the critics' panic.[58]

There was nothing wrong in using popular art as your point of departure: the Romantics had made the enthusiasm commonplace, and Michelet, Balzac and Nerval had already incorporated popular legend into the forms of official art.[59] It was clear to critics like Geofroy and Noël that Courbet's portrait of Jean Journet was a version of *Le Juif errant*, but that fact did not arouse their anger; on the contrary they were both enthusiasts for the portrait, both called it Courbet's best work in the Salon, 'painted with a highly seasoned Spanish gusto', 'fine in its character, its style and even, I would say, its colour'.[60] Reference to popular art was, in this sublimated form, another source of delight to the connoisseur who 'recognized' it, and praised the artist's transformation of his sources.

The point is this: the critics did not object to the exploitation of popular art; on

the contrary, it was already accepted as a source of imagery and inspiration, as one way to revive the exhausted forms of 'high art'. But to adopt the procedures and even the values of popular art – that was profoundly subversive. Instead of exploiting popular art to revive official culture and titillate its special, isolated audience, Courbet did the exact opposite. He exploited high art – its techniques, its size, and something of its sophistication – in order to revive popular art. His painting was addressed not to the connoisseur, but to a different, hidden public; it stayed close to the pictorial forms and the types of comedy which were basic to popular tradition; it transformed its sources, but only in order to enforce their supremacy; not, certainly, to excuse their shortcomings. He made an art which claimed, by its scale and its proud title of 'History Painting', a kind of hegemony over the culture of the dominant classes. Needless to say this was a utopian claim. His art, like any other, would in the end be assimilated. But for the moment, for a few years, the attempt troubled the public it excluded.

What the critics said they could not understand about Courbet was the man's intentions, the point of his art. If we look a bit closer, that amounts to two kinds of doubt: doubt about the conventions Courbet's art obeyed, and doubt about which public it was made for. I shall indicate later what kind of language the critics used to describe the latter mystery, that absent 'person' whom Courbet really addressed. But before that, there are other vacillations: doubts not about the intention but simply about what was being portrayed. I have already called the *Burial* and its companions ambiguous, sharing the equivocation of their central subject, the rural bourgeoisie in 1850. There is no doubt that the critics saw the point; that the root of their indignation at the men in the *Burial* (and almost without exception they are the focus of hostility) is the sense that here, unavoidably, is the bourgeois in the countryside. He is, precisely, where he should not be.

There was nothing new in the idea that Courbet's painting was bourgeois. Champfleury had already said so in his September introduction, and in his second review in 1851 he pressed home the point. But when we look simply at how the critics described the people in the *Burial at Ornans*, we find the traces, complicated and often bizarre, of a great confusion. Only one critic, Méry, followed Champfleury's lead and insisted on the picture's bourgeois nature – its universal imagery, its presentation of a class which ruled in country and in town. Yet very few critics took the opposite route and called the *Burial*, specifically, a portrait of the peasantry and nothing else. Enault amends the picture's title to *L'Enterrement des paysans d'Ornus* (*sic*), and 'N' is certain that Courbet shows the peasant as 'abject, crapulous, ugly, foul'; but these two critics are exceptions to the rule.

Most critics chose either a concealing vagueness, or outright indecision, about whether the subject of the *Burial* was bourgeois or not; in many cases the bourgeois terminology appears as if by accident, in the course of the critic's uneasy analysis. By vagueness I mean phrases like 'villagers' or 'the people of our countryside',[61] or, more common still, a total lack of definition. One group of critics, like Delécluze, Montaiglon, and Thierry, managed to discuss – and dismiss – the *Burial* without even giving its subject-matter a name. One critic resorted to the value-

free description 'menagerie of bipeds'.[62] Others, when describing the people round the grave, used a language which avoided the notions, or even the associations, of class. They talked in professional terms – 'clergy, beadles and churchwardens of the parish of Ornans'[63] – they attached their anger to specific (and often quite mistaken) identities. Chennevières savaged 'the ignoble and impious caricatures of the judges, the local constable, and all those whom you have put round the open grave';[64] but there were no judges and no constable in the picture he saw.

To avoid description altogether was a possibility but a dangerous one – the critic might find himself passing, in the course of a sentence, from gentle, indefinite adjectives to others which specified too precisely, which indicated nothing but a private nightmare. Thus Vignon:

We see black men plastered on top of black women, and behind, beadles and gravediggers with ignoble faces, and four black pallbearers sporting *démoc-soc* beards, Montagnard turn-outs and hats *à la* Caussidière. *Voilà!*[65]

Voilà indeed!

The most interesting and the most numerous critics are those who openly equivocate. There are those who recognize that Courbet's people are a distinctive, even a dignified, group in rural society, but who describe them again in terms which avoid the concept of class: 'the authorities of the commune' or 'these small-town notables, with the dress and bearing of tax-collectors, notaries and town councillors'.[66] This is an accurate – in the context of 1850 almost a pointed – vocabulary; but the critics never explore the differences they have suggested. The notaries and the tax-collectors are recognized but not identified. Others – critics of the Left, such as Petroz, Rochéry, and Sabatier-Ungher – begin with the notion that Courbet's art is of and for the common people. Yet they are fully aware that its central subject is no such thing. Petroz begins with the notion of 'the glorification of everyday life', and ends, in his detailed account, with 'the middle-aged men discussing business'; 'the idlers of the provinces, in their overcoats and black trousers, have not such attractive faces that the painter can neglect all the resources of technique'.[67] Compare Rochéry, who begins with a similar concept, and ends with the rueful complaint: 'Still less am I delighted by the common-place physiognomies of the bourgeois in topcoats who decorate the centre of the canvas.' The Fourierist Sabatier-Ungher believes that the *Burial*'s message is egalitarian: a voice from the grave pronounces Equality in death, and love in life. But his narrative seizes on the differences that exist: he imagines the girl in the centre who stares upward into space as 'a working girl, a stranger to the family, for she stays on the outside of things; a servant perhaps, but she loved the dead man well!' This is fanciful, but the world it imagines is closer to Courbet's than that implied by the slogan 'democracy in art'.

There are plenty of critics who call the mourners 'bourgeois' – these '*bourgeois campagnards*', '*ce monsieur en habit noir*', this '*deuil bourgeois*', this truth '*bourgeoise-ment parlant*'.[68] What they cannot, dare not, do, is explore the implications of their insight. There are those who grasp, in their way, the picture's ambiguity: who talk

of 'ces rustres mâles et femelles, dont quelques-uns en bourgeois';[69] or who call them in one place 'ces déplorables et vulgaires paysans' but in another recognize their audience as 'des bourgeois de province'.[70] Costume fascinates and alarms the reviewers; they know that the peasants, if they are peasants, are dressed to kill; they recognize the habit noir. Is it the peasant in his Sunday best, or are the figures at the graveside 'les hommes faits causant d'affaires'?[71]

Once or twice, a critic seems on the edge of illumination. Dupays defines his terms: 'Une trentaine de personnages grands comme nature, moitié paysans, moitié bourgeois'. He even sees, from his Parisian vantage-point, that Courbet's subject is 'ourselves' in other places, another bourgeoisie: 'the love of ugliness in its Sunday best, all the trivialities of our ungainly and ridiculous costume taken seriously'. Petroz makes the the same transition without knowing it. He turns from the Burial to the Stonebreakers with relief: 'Here it is no longer a question of modern bourgeois costume, much less picturesque than the rags of the poorest proletarians in our countryside'. As for Méry and Champfleury, they both make play quite openly with the picture's bourgeois nature – but they trivialize their own discovery. They evade the problem of the particular, embarrassing situation of the rural bourgeoisie by mechanically equating town and country. The bourgeoisie is everywhere, and everywhere the same. Here we are at the graveside, at Ornans or Père-Lachaise. But the point, in 1850, was the difference: the fact that there was more than one middle class, and more than one class struggle.

The important thing about this network of references is that they register the opposite of insight. They are the traces of a radical uncertainty; almost, one might say, the remnants of something the critics preferred to repress. Not one of the crtics we have mentioned examined the vocabulary he found himself using; or said to himself, if this is the subject, then is the form perhaps appropriate? The phrases we have listed are asides, remarks which are never followed up; they are as it were blurted out, they are hardly criticism, more like slips of the tongue. And yet of course they broach the problems essential to a criticism of Courbet's work.

Strangely, the words the critics cannot pronounce are the same from Salon to Salon. They form a pattern of transitions and evasions; it is the consistency of this pattern, its appropriateness, and its location at the point of puzzlement and anger (for the most part, à propos of the men in the Burial) which makes me think it important.

Anger was common to the Left and Right: nobody wanted the massive, ironic presentation of a rural bourgeoisie. The Left – or rather, its artistic spokesmen in Paris – wanted a glorification of the simple rural life, or perhaps a straightforward portrayal of its hardships. Hence Rochéry and Petroz preferred the Stonebreakers to the Burial: it corresponds, if one does not look too closely, to their abstract sympathy with the oppressed. The Right and Centre wanted a preservation of the rural myth, and the Stonebreakers could serve their purposes too. Even Desplaces, in the Legitimist paper L'Union, could admire it: 'this rustic ensemble, ennobled by labour, is handled with brushwork in the style of Decamps, with clear, warm tones'. The Stonebreakers was a subject, and to some extent a treatment, with which

LES CASSEURS DE PIERRE DE M. COURBET.

— Pourquoi donc, papa, qu'on appelle ça de la peinture socialiste?
— Parbleu! parce qu'au lieu d'être de la peinture riche, c'est de la pauvre peinture!...

Un homme du monde obligé de s'habiller en paysan pour faire peindre son portrait par M. Courbet.

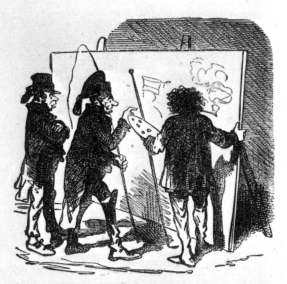

M. Courbet consultant un croque-mort sur son tableau d'un enterrement breton,

RÉFLEXION PHILOSOPHIQUE.

— Si c'est pas honteux!... des gens qui n'ont pas de quoi s'habiller et qui vont chez des peintres pour se commander leur portrait!

43 CHAM *Caricatures of Courbet from the 'Salon Caricatural'* 1851

the critics were familiar. It was unambiguous; it had nothing to do with the town, still less with their own identity. As Dauger put it, mixing his metaphors of space and social class in a touching fashion, the young boy with the pannier was 'a nature without great distinction, certainly, but *at least keeping its place*, and not aiming at the exaggeration of vulgarism'.[72] (My italics.)

The countryside must know its place: its place in a mythical schema. The artists who upheld the myth were Léopold Robert, George Sand, even Dupont 'five years ago'; and Courbet was compared with them all. But the strangest comparison – the most instructive for us – was with Millet. After all, Millet's *The Sower* was the other great Realist exhibit in the Salon of 1851, or so we should say in retrospect. And *The Sower* itself, in terms of anything *we* can recognize as deliberate ugliness, the mute brutishness of peasant labour, is as provocative as Courbet. Some critics saw the point in 1851 and groused at Millet's lack of refinement. But the gist of the criticism is unmistakable: it is a chorus of muted but definite approval. The writers are aware of the savagery of Millet's imagery, but for the most part they agree to call it melancholy, sober, strange, powerful. There is nothing wrong with ugliness as long as it is not one's own – as long as it is, without a doubt, an ugliness elsewhere. Enough to quote Dauger in *Le Pays*, who directly follows his discussion of Courbet with a section on Millet, and whose metaphors once again indicate the context of his judgment:

We know in this Realist school one young man of talent, a young man with a bright future . . . he at least has his own brand of poetry, a wildness which overawes us, a *mise-en-scène* which contrasts and sets back his figures, and *keeps them at a good distance*. His name is François Millet, and he has sent two pictures to the Salon. . . . They are still of nature in the fields; *but that's where we should be looking for it.* The *Sower* is a ragged peasant, who does not do things by halves, and *whose primitive roughness has nothing to fear from his stay in the heart of Paris; he will always stay what he is, a man of the countryside from head to foot.*[73] (My italics.)

This does not need much commentary. For Dauger, the painter of rural life portrays precisely, and only, what is alien to the town, what 'we should be looking for' in the fields. Millet's peasant is acceptable because he is distinctively other; his primitive grossness will not be altered by his stay in Paris, and we, it is implied, have little to fear from it. He will stay a countryman, even in the city. What Dauger means, unmistakably, is that he will not become proletarian.

All these things Courbet contradicted. He portrayed rural society as having its own classes and distinctions; he fixed his attention on the rural bourgeoisie, the very class in which town and country were confused. He portrayed the countryside as in some ways analogous to the town, rather than, as La Fizelière put it, 'a sunny interval in the storm of our agitations'.[74]

Everyone knew in 1851 that Courbet's art had made a strange progress to Paris. 'Moreover, we knew', said Fizelière, 'that M. Courbet, before confronting the hazards of the Salon, had travelled across the centre of France, showing his rustic productions to the accompaniment of drum and trombone – you may guess the public's anxiety to see the objects involved in such eccentricity.' The papers filled

with anecdotes of Courbet's rustic origins, of his anger that the Salon catalogue had misprinted Ornus for Ornans. (When he asked for a correction, Dantan suggested that he should get the town's name changed – 'They say you're a man of influence in the district?'[75]) But what disturbed the critics was precisely that Courbet's art could not be dismissed as a rustic curio, an 'invasion of the Barbarians'.[76] It had a Parisian public, and it seemed in some way designed for them. The *Burial* and the *Stonebreakers* were paintings which called for allegiance or enmity; they were 'a monster advertisement'; they constituted 'a breathless rush after popularity'.[77] And they *worked* – 'They have as their admirers', as Ferry accurately put it, 'a mysterious and formidable party.'[78]

That party haunted the critics' discourse, changing shape from 'Salon' to 'Salon'. It could never enter their monologue; it was everything their discourse excluded. It was 'the masses' who had been, so one critic reassured his audience, surprised but hardly delighted by Courbet's art.[79] It was merely 'a highly compromising faction of the Naturalist school'; it was 'opinion' which Courbet had somehow seized by the throat: 'Ask M. Courbet what you must do to take command of public opinion. Above all, you must do violence to it.'[80]

And occasionally the mystery is dissipated, and Courbet's public appears in its true colours: in the form of nightmare, but nonetheless vivid and specific:

The strange praises awarded to M. Courbet had as their first spokesman a certain inebriated man of the people who invaded the benches in the Salon Carré. What was there to look at, if not the worst daubs on show? – Then some art students took up the cry, and little by little, everyone was talking about M. Courbet:

To me, M. Courbet must have spent a long time painting signs, especially those of stove-setters and coal-merchants. Probably he aimed no higher than this when he travelled the fairs – so the rumour goes, and they tell us it is true – showing his incredible canvases in a booth with a sign: GREAT PICTURES OF COURBET, WORKER-PAINTER.[81]

This is Elisa de Mirbel in *La Révolution littéraire*. What she reveals, in the rage which disrupts her syntax, is the image which lay behind the neutral terms of her more temperate colleagues. She gives faces to the 'faction', to 'opinion', to the public. Who were Courbet's admirers but the horde of wine-besotted scum who crowded the Salon each year, and whose sweating bodies offended the bourgeoisie? (Daumier made hay with the subject of class conflict in the Salon; it was a regular item of his caricatures. And moves were made every year in the 1850s to inaugurate one day per week with special high prices, a day when the bourgeois could admire their portraits in peace.)[82] And who is Courbet but an *ouvrier-peintre* (Mirbel's slight, but significant, change of wording from the *maître peintre* on the posters in Dijon, which Champfleury had quoted in his September introduction)?

The worker-painter addresses the 'inebriated man of the people': that is a nightmare image, as I say, but it indicates a certain truth. It takes us towards an explanation of what happened to Courbet's art in Paris.

Clearly, Paris in 1851 was sensitive to the question of rural society, for straight-

forward political reasons. The newspapers were full of '1852'; the theatres staged plays with rustic titles like *Un Paysan, comédie en un acte*; in June, Eugène Sue began his 'Etudes sur le prolétariat dans les campagnes',[83] in March there was even a plan to republish Balzac's *Les Paysans* in the Bonapartist paper *Le Pays*. The city was obsessed by the 'other France' and by the conflicts within it. Even *Un Paysan*, a one-act comedy by E. Souvestre, did not avoid political controversy: 'We'll have done, I hope,' said an angry reviewer, 'with the "rich" and the "poor", and this systematic slaughter of one class by another. . . . Who benefits from declamation, and denunciation, and incitement? I'd like to know. Art rejects them, and real morality despises them.'[84]

But there was more to Courbet's exhibit than this. The question was not simply political opportuneness, though that gave an edge to the arguments. The sources of the critics' anxiety – and the explanation of its peculiar structure – lie deeper.

Why did the critics believe that Courbet had an urban public, and why did they fear that fact? What made these pictures popular? What did the townsfolk of Ornans signify to the citizens of Paris? What anger, and what evasion, underlay the critics' reluctance to name the things they saw – except in the pattern of asides that I described? These are questions about Paris, and Parisian identity; they lead us back to Dijon and its dreaming bourgeois, making their plans for megalopolis, tending their cottage-gardens. But here in Paris the questions are rather different; urban identity seems, after all, more assured; the reference of Courbet's three paintings is less obvious. Paris was already the city of the arcades and the dandy – commercial fairyland, urban ostentation. What had Ornans, or Ornus, to do with this?

The simple answer is that this Paris – urban, self-concious, rich, spectacular – was another fragile illusion. Paris in 1850 was many cities, or perhaps no city at all. 'There is no Parisian society, there are no Parisians, Paris is nothing but a nomad encampment,' said a despairing commentator in 1848.[85] And in May 1850, in a speech to the Assembly, Thiers himself echoed the diagnosis. Paris was prey to the 'vile multitude', the 'dangerous element' which had destroyed every republic, and which now threatened the decent Republic of 1848 (or rather, of 1849). This Paris must be denied the vote:

this confused multitude, this multitude of vagabonds with no identifiable home or family, so shiftless that they cannot be pinned down – these people who cannot build a shelter for their families: it is this multitude that the law is designed to exclude.[86]

Paris had always been a city of immigrants: every city beckons to the countryside, and feeds on farmhands and 'provincials'. But what frightened Thiers and his like was the pace of change in the nineteenth century, the desperate confusion of Paris in the 1840s. All through the July Monarchy the railways spread further into the corners of France, bringing back their waggonloads of peasants: those who had lost in the fight for land, or those who had won so decisively that they set off (or sent their sons) in search of city comforts or city fortunes. In the old days these peasants had hung on to their provincial identities and formed their own communities within the city: in 1842 the men from the Auvergne still spoke their own

tongue and every Sunday gathered to dance the *musette*.[87] But now these confident identities were fading; the peasant was still recognizable in Paris, and a thousand sources described the variety and strangeness of Parisian 'types', but the old communities and the proud artisan *sociétés de compagnonnage* were breaking up. The old diversity – the coexistence of town and country, almost in the manner of the gardens of Dijon – was slowly eroded.

Other diversities came instead. Paris had always been a city of *quartiers*, each distinguishable from its neighbour, but never before had these neighbourhoods possessed so sharp a class identity. In the July Monarchy the outlines of a new Paris emerged. In the west were the fashionable new strongholds of the bourgeoisie. South of the river the Latin Quarter was jostled by the dreary slums of south-eastern Paris, but still clung to its traditional identity. The old capitals of the barricade, the Faubourg Saint-Denis and the Faubourg Saint-Antoine, grew poorer and more crowded; commerce edged westwards from the Rue Saint-Denis towards the Bourse, leaving the former district to the small shopkeepers and, increasingly, to the criminals.[88]

In the centre, on the Ile de la Cité and round the Hôtel de Ville, was a wretched and proletarian city, a city of filthy and crowded lodging-houses crammed with migrant workers: peasants who came for a few months to seek work in the factories, nomads who moved from town to country with the seasons. Slowly, in the course of twenty years, the middle class evacuated the heart of the old city and left it to the 'savages' and the 'barbarians' who haunted the journalism of the time.

On the outskirts, in the *banlieue* beyond the ring of customs-houses, grew up a newer and uglier industrial sprawl: makeshift housing following the factories and warehouses, makeshift communities, poor and violent, spawning crime and disease, producing a new and ominous *classe dangereuse*. These too were peasant communities, but here the *quartier* absorbed its recruits, and taught them crime and the rudiments of class consciousness, in the space of a generation.[89] By the time of the June Days, the workers of the *banlieue* were ready to join the insurrection; when they heard of the trainloads of peasants coming from the provinces to crush the rebellion, they dynamited the railway tracks through their territory. And yet they were peasants themselves, in all but name: for the most part they still wore the peasant smock. At this point peasant fought peasant: what counted, what made the difference, was a few years of confused and bitter urban experience. (Daumier sometimes drew the *banlieue*, with his habitual accuracy. In one of his lithographs [40], a peasant and his wife, in smock and clogs, stand outside a ramshackle hut and, pointing to the domes and towers of Paris in the dim distance, congratulate themselves on being real Parisians at last.)

This was Courbet's public; these are Elisa de Mirbel's drunken plebeians. Not any one group in Paris: not an industrial proletariat, since no such thing existed as yet; not a Parisian 'peasantry', since there were peasants everywhere, losing or gaining a multitude of identities; not the older generation of the city's working class, hopelessly enfeebled by half a century of disease and political failure; not even the old race of artisans, losing its outlines in the general disarray. Courbet's

public was exactly this labyrinth, this confusion, this lack of firm outlines and allegiances. It was industrial society still in the making, still composed of raw and explosive human materials.

We know from the critics that the mass public reacted to Courbet's work in 1851, and it is sufficiently obvious why. We do not know, and can only speculate, *how* they reacted and to what: which of the pictures they preferred, which of the pictures' subtle social differences they perceived or had forgotten, to what extent they gave them urban or political meanings, seeing the *Burial* as privilege, or the two old men at the graveside as veterans of '93.

But one thing is certain. The *Burial* and the *Stonebreakers* reminded a part of their audience of places and experiences in their own past, perhaps a few years ago. They conjured up, on a massive scale, the world these working men had come from. Whether, as Daumier later suggested, they stood in the Salon and gaped in simple dismay, or whether, like Vallès and his friends, they broke into excited chatter, we have no means of knowing. They remain, as Ferry called them, mysterious and formidable.

All that we have instead is the reaction of the bourgeois: the judgment of Courbet's critics, and sometimes the verdict of the animal himself, scrawling in the complaints book of the 1855 exhibition, 'Please, M. Courbet, be so good as to patch the shirts and wash the feet of your stonebreakers,' and signing himself 'Clean and Fastidious'.[90]

And even the bourgeois was, very often, a man from the countryside. Paris was an immigrant city – this applies to the shopkeeper, the haberdasher, the merchant in spices, the *rentier*, almost as much as the working man. The bourgeoisie renewed itself not so much from the ranks of the Parisian working class as from the country-side. In every social class – even among the new aristocracy of finance capital – there were men who had been recruited in one generation from the provinces of France.[91] If there is one 'typical' figure of bourgeois Paris in the mid-nineteenth century, it is the wealthy merchant or shopkeeper whose father had been a peasant, who had come by train to Paris as a young man, made a good marriage – often to a well-off country girl – acquired a little capital, saved for a decade, and speculated at the right moment. This was the self-made man, Dick Whittington plus Robert Macaire, the focus of improbable legend and unfriendly caricature; but in the 1840s he was still a creature of fact as well as fiction. At least thirty per cent of Parisian shopkeepers were men of rural origins, and most of these were men from modest provincial families, men who had made their own meagre fortunes.[92] And fortunes were lost as well as gained: at the bottom of the bourgeoisie was an odd penumbra, a world of stallholders, street-traders, jobbing craftsmen, small stock holders – an area between the middle and the working class.[93]

This was a place where bourgeois status could be won and lost in the course of a few years: one year a trader borrowed and speculated, bought himself a shopfront and black dress-coat; the next year, the market tumbled, his creditors foreclosed, his shop window was smashed in an uprising, he put on his smock again. It was a world obsessed with social climbing and social descent, obsessed and puzzled by the

concept of bourgeoisie. The *Journal des débats* defined it in those terms in 1847: 'the bourgeoisie is not a class, it is a position; one acquires that position and one loses it. Work, thrift and ability confer it; vice, dissipation and idleness mean it is lost'.[94] There were a thousand other definitions, alternately cynical or absurd: the bourgeoisie was everyone, was no one at all; was the 'last vestige of the Middle Ages', 'the majority – number and intelligence', 'the bourgeois in a smock as well as the bourgeois in a frock-coat'.[95]

So much for the dream; but the real bourgeois was uncertain and afraid. He feared the ups and downs of the market, the sudden bankruptcy, the slow slide back to where he had come from. And increasingly he feared another enemy, the working class itself, 'savage' and 'barbaric', turning on its masters. Many a bourgeois – even one with a comfortable fortune – reached old age haunted by bitterness and a sense of failure. Here is a rich lithographer of the rue Dauphine who died in 1841 with a fine fortune of 29,000 francs, writing his last will and testament:

On this earth where I have spent such a miserable existence, where I was born poor, without education, without means of existence, by my labours as a lithographic worker I have gained the highest reputation . . . I had intelligence, then, and yet after thirty years of work and, I believe, irreproachable conduct, I cannot leave my wife and child the means to have the morsel of bread they need – and yet I have worked hard all my life.[96]

Men like this most likely disguised their origins. They were the bourgeois who, so the common story had it, greeted their peasant father and mother in a Paris street with consummate distaste.[97] Other young dandies walked the boulevard with their mothers on their arm, wizened old ladies dressed in stiff peasant calico. They earned the sociologist's applause:

They settled their debts of filial gratitude in front of the public, who silently applauded. Paris possesses nothing higher than that – How fine it is! How very fine![98]

For such a bourgeois – whether he occasionally paraded his peasant origins or grimly concealed them – the nature of rural society was crucial. It was part of his myth of himself: it was where he came from, and what he had rejected. By and large, he never went back to the countryside; he rarely kept any contact with his family and his place of origin; if he was left land by his father he got rid of it on the market; if he had capital of his own he invested it in city properties or perhaps bought a plot of land in the suburbs – almost never did he buy land in his old province.[99] Even if he died without wife or children, he rarely left a penny to those of his folk who had stayed on the land. (In all this Courbet and Millet were exceptions to the rule.)

The rejection in fact was all but absolute: he had become a Parisian, and he staked everything on bourgeois status. Return to the land was an aristocratic practice. But in fantasy his rural past stayed with him: it told him what it meant to be a bourgeois; it was the equal and opposite term in his personal equation. It was everything that bourgeois existence was not.

Thus in the 1840s and 1850s there evolved a distinct bourgeois myth of rural society

– a myth which was central to the structures of bourgeois self-consciousness.[100] Like all myths – but more than most, since this one is rarely formulated as a whole – it is inchoate: in a state of constant development and self-contradiction, and shot through with an uneasy sense of those very social realities it tries to mask. For the myth, rural society is a unity, a one-class society in which peasant and master work in harmony. Rural society is, in other words, the antithesis of the community in which the bourgeois actually lived. It is a world in which social conflicts are magically resolved, in which the tensions and class divisions of the city are un-known. More important still, emergence from rural society is an act of will rather than a social process: one made oneself a bourgeois, by a distinctive and conscious effort, an effort in which ambiguities of social status have no place. The peasant, of course, was greedy for land, gradually accumulated possessions, enriched himself; but, for the myth, the line between that gradual differentiation – that unconscious history – and the act of the bourgeois who had made himself and his own history, was absolute.

We could explain the function of the myth in this way. In practice, as we have seen, bourgeoisie was an unstable, precarious category of experience – especially for men in its lower and middle ranks. What the myth did, and here its purposes are typical of myth in general, was to strengthen that category by enforcing distinctions and eliminating ambiguities. In reality, there were many stages to becoming a bourgeois. In an 'ideal' life history, there were four terms to the process. First, peasant existence for father and son. Second, a slow and ambivalent enrichment, an evolution towards the *rural* bourgeoisie: a process which the father stayed to complete, but which the son left mid-way, for the city. Third, in Paris itself, a kind of regression from bourgeois status and a new evolution towards the *urban* bourgeoisie: the stage which one modern historian, A. Daumard, describes like this:

Most often the immigrant became established after a term of probation – more or less pro-longed – in an inferior position, either as a worker, or an assistant salesman, or an employee; it was only rarely that a provincial could become part of the Parisian bourgeoisie right away. This initiation, this passage through the capital's humbler, working-class milieux, seems almost like a necessary precondition of success – which is rather surprising when one re-members that not many *native* Parisians made much progress up the social ladder.[101]

Fourth, at last, came installation as a bourgeois proper: sometimes temporary, often clouded by doubt and uncertainty, always exposed to the whim of the market.

The key to the myth is its elimination of the two middle terms of this process, the unstable categories – equal but as it were inverse – in which bourgeois identity is gradually and painfully assembled, gained and lost and gained again (to be lost a second time?).[102] The myth cuts out this penumbra of historical fact. It does not deny the facts of the evolution, it simply ignores them. It even insists on the thrift and hard work of the self-made bourgeois, but it consigns that thrift and labour to nowhere in particular: before he was bourgeois, and after he was peasant, the man lived for a mysterious time in limbo, between identities, something much less than

human. First there was peasant, then there was bourgeois, the difference is absolute, and the change from one to another is an act which has no history. And thus the transformation is made safe; the category 'bourgeois' becomes stable; the gloom of the lithographer of the rue Dauphine is dispelled; the dandy displays his peasant credentials to the world.

We begin to see why Courbet's imagery was so profoundly offensive in 1851. That was the year, more than any other, when the myth was most needed and most under threat. At the very moment when the political domination and social confidence of the bourgeoisie were in doubt, rural society seemed about to spawn its own conflicts. Worst of all, at the heart of that conflict, the focus of peasant hatred, was an object whose very existence was unthinkable to the Parisian bourgeois, a profound embarrassment to his own identity – the *bourgeois de campagne*. He existed, and he was hated; nor did he exist as a result of an heroic act of will; he had, it seemed, evolved; at times he could even be unconscious of his bourgeois status and its demands. One day he could wear the black dress-coat; the next, the peasant smock.

Even the myth-makers knew this. All of them painted the general outlines of rural society in mythical terms; but more and more of them, around the mid-century, let slip the facts of social division and social complexity. At times the two conceptions clashed head on in the course of a few pages. On the one hand, the economist Adolphe Blanqui rehearses the familiar picture:

The peasant finds in his harsh, severe existence certain compensations which are unknown to the working classes of our great cities. He is the collaborator, rather than the employee, of the man who gives him work. He is part of the farmer's family, he eats the same black bread at the family table. . . .
And who can say what delight he feels when he runs his gaze across the little garden around his cottage, the tree he has planted, the cow that feeds his children; when he contemplates his vine and his fig-tree! He has few pleasures, but few needs; and often he pities us our life in the town, in the midst of temptation, just as we pity him his life in the village, cut off from our artificial emotions and our feverish passions.[103]

On the other hand, Blanqui knew the facts very well. He knew and described the fate of the migrant workers, moving back and forth from town to countryside, corrupted by one and corrupting the other. He knew the details of social division – 'this parallel, sinister progress of riches and poverty, in areas of big industry and in areas of large-scale agriculture'.[104] And he glimpsed the country bourgeois,

the man of the law, the real curse of the rural populace . . . a businessman, a retired bailiff, a clerk of the court who has sold his office, an advocate without clients, a failed lawyer, who cultivates his little garden and his little law-suits, and who lives on trifling fees, strung out until the plaintiff dies. It is he who practises, or directs, usury in the multitude of forms it takes in the countryside; it is he who divides the land into minute pieces for the sales, and who exploits with consummate skill the ignorance and passions of the peasant.[105]

Blanqui was not alone. Lesser writers repeated the phrases of the rural idyll – or, alternatively, described the peasant's total degradation and brutality, which was

really another version of the same idea, and just as comforting[106] – but stumbled on the facts of social tension. 'The peasant is generally jealous of the bourgeois,' said David de Thiais, 'whose moral superiority and fortune are offensive to him.' 'To-day's peasant', said Madame Romieu, 'distrusts the rich man who, dressed in a black frock-coat, owes his fortune to his own industry and pays the workers he employs very well.'[107] Or, more dramatically, 'To these chief characteristics is added an extreme distrust; to the countryman, a black coat is an enemy' (even though, for the same writer, 'The bourgeois of the countryside has the glorious mission of regenerating our lands').[108]

But all these writers maintain the myth, in spite of their nods towards the real world. David de Thiais's book ends with the son returning from his travels in the New World and the city, deciding after all to be 'one more peasant'. If the myth was under pressure, all the more reason to preserve it. What Courbet did, in his 1851 exhibit, was explode the myth entire. He showed the countryside as a complex whole, with a strange, interleaved class structure of its own – so that, when the critic Louis de Geofroy facetiously imagined himself standing by the roadside at Ornans, watching the stonebreakers at work, while a group of peasants rode past, and a funeral procession trooped by in the opposite direction, he saw the point of Courbet's pictures very well. What Courbet did was reinstate one of the pair of middle terms which the myth set out to eliminate: he showed a countryside which included, had almost secreted, a bourgeoisie. And everyone knew how much that class was despised by its inferiors in 1851; everyone could see, under the cornice of the Salon Carré, its peculiar, gross, legible form on canvas. In presenting the one term, Courbet conjured up the other, for his urban public: becoming a bourgeois, in both country and town, was given back its ambiguity. It was pictured as a process, not an act of will; and a process with opponents, imperfections.

Once the mid-terms reappeared, distinctions became uncertain, categories weakened, the myth foundered. Not only was the shopkeeper or the rich litho-grapher confronted with a rural past which he had staked everything on rejecting, but that past was given a familiar, and intolerable, form. It imitated urban life, instead of standing as its opposite. The Parisian bourgeois justified his privilege, or masked his insecurity, in a variety of ways. But one idea he held very dear: the notion of arrival or insurgence, of bourgeois status as a prize won in an heroic struggle: 'one acquires that position . . . ability confers it'. Looking at Courbet's three paintings he was robbed, for a while, of the mask or the justification; his past lost its mythical shape, his identity fused with others, he saw himself in a vast distorting mirror. And his unease was all the stronger because he could not put a name to what disturbed him; the pictures were a puzzle, not an insult.

Hence the runaway anger and the critics' sense of some personal injustice. Hence the focus of the critics' rage, the evasive vocabulary when they mentioned the middle term – those mourning gentlemen of Ornans. Hence the drunkards on the Salon benches, and the jostling crowds in front of the *Burial*. When Méry stood there and spoke favourably of the picture to his friends, he was 'seized violently by the shoulders and several figures, red with fury, asked me if I was talking seriously.

. . . These words, pronounced in a calm fashion, caused a veritable riot all around us.'

Those lines, like Mirbel's, are part fact, part fantasy. But that does not make them any less important; since fantasy is what we are left with, in the Salons; and fantasy is what Courbet's painting worked upon. We know something by now of the fears which flushed the red faces of the bourgeois, and provoked the leer of the 'inebriated man of the people'. This was painting that disturbed an iceberg of theories and emotions; it was history painting, not of other people's history, but of one's own. 'Socialist painting', Roux-Lavergne called it; 'an engine of revolution', said Peisse. They were both, of course, meaning to be sarcastic. But were they so very wrong? And, further question, if *this* is Socialist painting – embedded so deep in the matter it describes, so accurate in its sense of what disturbs its public, so appropriate to one kind of politics – what do we say about later claimants to the title? After Courbet, is there any more 'revolutionary art'? After the Commune, and what Courbet did in that particular revolution, is there the possibility of any such thing?

Postscript

Les Paysans, which I have just read, and a new novel, *Madame Bovary* . . . seem to show that the public is tired of novels of observation. *Madame Bovary* will be the last bourgeois novel. We must find something else.

Champfleury, *Notes intimes*, 1857.[1]

It's the common people who will soon set the tone in person; so sing in tune with their fanfares – they have on their side the sanction of the past and the certainty of the future. . . .
 If you want the people to understand you, put on a blue smock right away, in the work you do; jam down a cotton cap on your head, try on a pair of large-size boots. A bit of manure on your hands from time to time would not do you too much harm. . . . Yes, yes, manure! I insist on the word. Hold your nose if it offends you. Everything comes from manure in what feeds and clothes us, and we ourselves are nothing more than manure, according to chemistry and the Bible.

Max Buchon, *Recueil de dissertations sur le réalisme*, 1856.[2]

The last few chapters have told a complex story, but I do not see any way of simplifying them. Courbet said of himself in 1855 that his masters in art were nature, tradition, work, and the public.[3] The point, in the great period of Realism I have described, was to keep all four factors in play; and when we know that he defined nature, in another conversation, as 'the *ensemble* of men and things',[4] the aim seems even more ambitious – perhaps foolhardy. Courbet was to suffer for his ambition, later. In the 1860s tradition went dead in his hands, nature turned mechanical, the public stayed hostile but became blasé. The Commune came almost as a way out of this dilemma. But for a while, in the years after 1848, the ambition worked – the complex dialogue of artist, public, and the '*ensemble* of men and things' actually took place.

 Can we call the result political art? In a sense it is a fruitless question. Courbet did things – certainly painted things – by instinct, in silence. As Buchon said, it was his lack of words, his naivety, that let him dominate the ideas of his time. It was his simplicity that made it possible to cut through the complexities, and arrive at the matter of fact – the fact that lay at the centre of things in 1850. If he had found words to describe his intention in the *Burial at Ornans*, we should have to distrust them; here as elsewhere, it is the inarticulate response that counts, or rather, the response articulated in oil paint on canvas, with knife and rags and brushes. So if politics are words and programmes, Courbet's painting has nothing to do with them (it was only later, when intuition failed him, that he began, disastrously, to paint to a

programme: witness the *Return from the Conference*). He did not mind the political reading of his work; all the evidence we have suggests he thrived on it. He lapped up Buchon's polemical advertisement, he rode the wave of criticism in Paris and began the *Firemen Going to a Fire*. By December 1851 he was one of the select few to welcome Proudhon out of jail and take him to Meudon to celebrate, predictably, with an orgy of beer and song.[5] But these are incidental facts: the *Burial* and the *Stonebreakers* are open to meaning, complex and yet compact, in a way that Buchon or Proudhon would not really understand.

There are of course other definitions of 'political'. The world of politics is not just a verbal world, though it is that primarily. There is a politics which is wordless, in the way that hunger is, or greed. It often ends in a wordless gesture – a scythe on the shoulder, a burning rick, a barricade. And this is the kind of politics the artist thrives on; he makes the distinction, as he must do, between an ideology and the facts it attempts to describe. Nobody made it better than Courbet in 1850. (Except perhaps Chekhov, in *his* great description of rural life, 'In the Ravine', published in the Russian Marxist magazine *Zhizn'* in January 1900. The case, if you think about it, is close to Courbet's. Was Chekhov's art 'political'? And yet what did the choice of subject and the context of its publication imply, if not a readiness to accept the implications of his tale?)

I want to end with two pictures, one by Courbet, one by Camille Pissarro: the first to suggest Courbet's strategy in the first few years after the *coup d'état*, and the second to suggest what Courbet meant to later artists.

The question of strategy was awkward for Courbet and his friends, and ultimately it was what destroyed them. After the *coup d'état*, when politics once again became the preserve of the Emperor and the politicians, what price revolutionary art? What could it possibly do now? Some of Courbet's friends tried to hang on to the world of 1850, and recreate the war of images and almanacs. In 1854 and 1855 Pierre Dupont brought out two editions of *Jean Guêtré, Almanach du Paysan* [39]. On the cover was a clumsy lithograph – perhaps by Martin Nadaud, or Gustave Doré in his Realist vein, or even Courbet himself – which retains something of the flavour of the Republic: insolence and gloom, awkward stance, obstinate stare. But inside the booklet, obedient to the censor, politics was barred: the pages were filled with pastoral verse by Max Buchon, bucolic short stories by Champfleury.

Courbet was not given to this kind of nostalgia. He tried a new tack. In 1854 he did a large painting of himself and his new patron Alfred Bruyas, meeting on the road outside Montpellier. Bruyas was the man who had bought Courbet's *Bather* from the 1853 Salon, and had greeted it as the 'solution' to modern art – he never made clear what the word solution implied. He was immensely rich, vain, wildly eccentric; his writings teeter on the edge of lunacy, stringing together gnomic sayings, snatches of wretched verse, occasional homage to Louis-Napoleon (whom he saw as the saviour, of something obscure), repeated thanks to God for his own good fortune.[6] He wanted, as far as one can decipher his writings, an art of sentiment and humility, of disengagement, and even of obedience. 'Love, Labour,

Religion' was one of his slogans. Another, his advice to the artist, was 'Those in power have the last word.' ('*Les puissants ont sur vous raison.*')[7]

A strange enough man for Courbet and the Brasserie Andler – especially as Proudhon was one of the thinkers singled out for attack in Bruyas's writings (he disliked the phrase 'Property is Theft')![8] And yet for two years patron and painter coexisted. Bruyas had money, and his ideas were vague enough to ignore or learn by rote. After the breach – it came in 1855, when Champfleury wrote a cruel, comic essay on Bruyas, using material he could have got only from Courbet – the patron complained of the four months Courbet had spent in Montpellier and the 'miseries' he had forgiven him at the time.[9] But for a while, each man hoped for great things from the other.

The greatness of *The Meeting* [VII] is that it gives form to those hopes and those miseries: the tension, the affection, and the absurdity of their relationship. It was one of a series of paintings that Bruyas ordered of himself in the company of his artist friends, but while the others are obsequious and tactful, giving the patron pride of place, Courbet's picture is close to a parody of the whole private icono-graphy. In it artist, patron, and servant stand apart, and equal; facing each other in a cut-out, uneasy clarity; registering as three parts of an unresolved equation.

The source of *The Meeting*, we know now,[10] was a popular image [41]. Courbet borrowed a detail from a print of the Wandering Jew: the detail [42] which shows Ahasverus's most modern incarnation, on the road outside Brabant. Its caption suited his purpose well: *Les bourgeois de la ville parlant au juif errant.* This was the same print that Courbet had chosen for the portrait of Journet, but here he has made more radical use of it. He has stuck close, rigidly close, to the forms of the artisan engraver: he has kept the Jew's staff and the hat he clasps in one hand; he has put Bruyas in the same pose as the central bourgeois, with his hat nearly touching the painter's stick; he has changed the pose of the third man just enough to emphasize the servant's special role. Above all, he has kept things clear in the way the engraver wanted – made the colours flat and bright, with the sky an acid blue back-drop, like a theatre curtain; made the edges of things sharp against the sky, and left the three men apart from each other, separate bodies not so much linked as frozen by Bruyas's uncertain gesture with his hat. Once again, Courbet has seized on the essential of popular art: its ability to present in the clearest possible form, hierati-cally, emblematically, the essentials of a social situation or a ritual. Whether he treats a funeral, a battle, the Ages of Man, the attributes of a saint, this is what the popular artist wants to do, and this is why Courbet follows him so closely.

Why did Courbet choose this episode from the legend of the Wandering Jew? Some of the reasons are clear enough. This is a portrait of the artist as outsider and wanderer; it goes back to the boast Courbet had made to Wey – 'I am just setting out on the great, vagabond, independent life of the Bohemian'. And the legend itself carried those connotations; the Jew himself, wearing his workman's apron, already stood for the outcast of every kind. But beyond that point, the implications of the choice are less conventional. For this is not merely the artist-outcast on his own, in the melancholy quiet of his studio, observing his misunderstood features

in a mirror. This is the artist-Jew confronting the 'bourgeois of the city', his pose straightened and turned to face the two men he meets. To understand the meaning of the confrontation, we need to know a little more about popular art itself.

The art of the people in France – the blue books, the almanacs, the *complaintes* – had never been a spontaneous growth, a mere 'putting-down' of folklore and time-less legend.[11] That was the Romantic myth of popular art; the reality was very different. Popular culture had since the Middle Ages derived its subject-matter, and even its style, from the ideology of the dominant classes – from the romances of chivalry or the *chansons de geste*; from all the lively, resistant forms of Christian culture; from the wisdom of the alchemists; from the historical legend of Charlemagne. Even the Breton peasant costume, which Gauguin was to paint so lovingly in the 1880s as 'primitive', was nothing but an imitation of the courtly finery of the Middle Ages. Popular culture remained, until the French Revolution, stuck in the past – but a historical past. It used and adapted the ideas and values of the feudal aristocracy and the medieval Church.

Then, after 1789, popular culture went through a series of transformations. The Revolution turned its imagery and ideas head over heels; for a while the books of piety and the saints' images disappeared from the tinker's sack, and the old magic, the new novels, and the sudden flood of political tracts took their place.[12] That was the first transformation; the second came with Napoleon. For fifteen years the presses poured out the imagery of that new legend, and Napoleon became the new Charlemagne. Even after Waterloo, the Napoleonic legend survived, in spite of lawsuits and repression; and in the July Monarchy the powers-that-be allowed the presses free reign.

So by the middle of the nineteenth century, popular art was a strange amalgam of different ages and ideologies. Napoleon rubbed shoulders with St James; a Book of Dreams with a tract about Cabet or Fourier; farming hints with Tom Jones. Strangest of all, popular art began to catch up with the imagery of bourgeois Paris. With lithography, mass production began in earnest; and the peasant of Ornans could see the latest Paris fashions or have crude drawings of the marvels in the Exposition Universelle, the very same year they were worn or put on show. In 1854, a bourgeois popular art existed alongside one which still used the imagery of feudalism.

It was this disjunction that Courbet exploited, in his usual instinctive fashion. Popular imagery had always developed – in other words, carried new information – by a series of transformations, reversals of terms, exaggeration and distortion of detail. It was these transformations that kept alive the culture of the medieval aristocracy into the middle of the modern age. What Courbet tried was a new, a last transformation – to close the sequence begun in the Revolution and the Empire. He tried to use this system of changes and inversions, and stay within the understanding of a mass audience – to forge images with a dual public, and a double meaning. In *The Meeting* he took a detail of legend and retained very faithfully the visual form of the original; he retained the bourgeois, but gave their presence a new significance; retained the landscape, outside town, outside time;

transformed the outcast and his attitude towards the people he meets. In other words, he stuck close to the text, but made certain essential changes.

Here as elsewhere, Courbet chose an image which was already archaic. The style of the Wandering Jew print would have looked old-fashioned to a peasant in 1854; it had nothing to do with the slick, updated lithographs which poured from the Paris presses in the same decade. It had staying-power, all the same; Epinal brought out a version on the old lines as late as 1860. Courbet chose to be modern in his own way, against the grain of the time: he took an utterly medieval image, and simply displayed its relevance to the 1850s. In *The Meeting*, the bourgeois appears in a medieval frame of reference. That, perhaps, is what enabled Courbet to 'place' him so confidently, so straightforwardly – to take him out of the context of nineteenth-century myth, and put him on a level with the artist and the servant. What he exploits is another age's imagery of the bourgeoisie – an age which lived on in the art and attitudes of the people. It is as if, to get the bourgeoisie in focus and place himself against it, Courbet needed to take the class back through time, to an age when it was part, not master, of the social body.

This does not mean Courbet adds his voice to the medieval revival, or echoes the aristocrat's hysterical disdain for *la bêtise bourgeoise*. On the contrary he uses the vestiges of medieval culture that remain, and do not need reviving. He exploits the area in which men still think and make images with materials long since falsified by history. That applied to popular art and thought in the 1850s: what Courbet wanted was to add new materials to the old, give the old attitudes a modern, more polemical, significance.

Face to face with the bourgeois in this picture, trying to find a form for him, Courbet seems to shift between various ideological approaches: proud egalitarianism of the Romantic kind, the cool matter-of-fact of the feudal aristocracy, and a hint of an attitude which is harsher still. For up to now we have neglected the third figure in *The Meeting*, the servant Calas. He, after all, is deliberately given an equal weight; and he is an equivocal presence in the picture, subservient, deferential, eyes averted, doing homage by a kind of reflex action. He represents the truth of the 'free' confrontation of patron and painter; his presence puts a sharper, more ironical edge on the meeting of the Jew and the bourgeois.

It is not surprising that when Champfleury reviewed the modern versions of the Wandering Jew in his *Historie de l'imagerie populaire*, he passed over Courbet's in silence. What Courbet had done has nothing to do with the connoisseur's enthusiasm for popular art – the attitude Frenchmen sum up, with untranslatable contempt, in the epithet *folklorique*. And even less does it enforce the conservative, quietist bias of popular culture, which is what Champfleury so much admired. That view of popular art had always been one-sided: for every Bonhomme Misère there had been a Robin Hood. Is not one of the first phrases we imbibe from the surviving world of popular romance, 'He robbed the rich to feed the poor'? And did not the folk sing *Broom, Green Broom* and *Sabot cassé*, as well as canticles to St Mark? In any case, since the Revolution popular art had changed decisively – it thrived now on the mixture of past and present, the confusion of legend and politics. What

Courbet did in *The Meeting* was only to try to make sense – his own sense – of that confusion; but that in itself was subversive. No wonder Champfleury never mentioned the work in all his writings on Courbet; and no wonder the Jury for the Exposition Universelle admitted the painting only grudgingly, after first rejecting it on the grounds that it was 'too personal and too pretentious'.[13]

The last picture is Pissarro's *Portrait of Cézanne* [38], done in 1874. Cézanne was thirty-five at the time, Pissarro nine years older, and the picture was done in the middle of two years of intense collaboration, the years when Cézanne 'learned' Impressionism. He sits in a soft cap and shapeless jacket, in front of a wall; and on the wall are tacked three works of art. A simple landscape by Pissarro, which Cézanne clearly loved. A front page torn from a satirical newspaper, with a cartoon by André Gill: Thiers, the leader of the Third Republic, delivers France of a curious baby, a sack of 40 billion francs loaned by patriotic citizens to pay off the Germans for the war. These two images alone are an odd enough pair, politics and landscape juxtaposed. But what matters to us is the third image: Courbet himself, tankard in one hand, palette in the other, prancing over Cézanne's left shoulder. Behind Courbet is another wall and another selection of pictures – this time, naturally, nothing but Courbet's own!

We do not really know why these three images were chosen. They were chosen with care, deliberately: that much is clear. The whole picture is a kind of response to – almost a travesty of – Manet's earlier *Portrait of Zola*, where the critic sits in his studio, elegantly dressed, cunningly posed, the wall behind him filled with images of a deadly refinement – Manet, Velázquez, Japan. The choice in this case is a plain contradiction. Instead of elegance, a greatcoat and cap; instead of aesthetics, land-scape and politics, with Courbet presiding.

Pissarro's *Portrait of Cézanne*[14] is popular and political. It is popular in its choice of images – two cartoons from the Left-wing press, and a glimpse of a road in Pontoise – and in the 'style' of its sitter, with his country clothes and his untrimmed beard. It is political in its references, poking fun at Thiers and the monetary patriot-ism of the French bourgeoisie. And Courbet stands, aggressively, for the conjunc-tion of the two – pipe and beer and *patois*; the opposite and enemy of Thiers; the villain of the Commune, paying through the nose for his sins at the time the portrait was painted.

Pissarro's picture sums up the legacy of Courbet. It stands for his image in his own time, in the eyes of younger men, as long as his influence lasted. We do not know how much, in 1874, Cézanne agreed with Pissarro's anarchism, or whether this political portrait was appropriate to his frame of mind. But it is certain he worshipped Courbet; and Courbet-worship, in 1874, was of necessity offensive to the bourgeoisie. The portrait stands at the end of an epoch in French art, the time when political art and popular art seemed feasible – seemed part of the same project. For a moment, in the years around 1848, it seemed as if the art of the ruling classes was threatened with real collapse. In the middle of the nineteenth century both bourgeois *and* popular culture were in dissolution: the one shaken and fearful, trying to grapple with the fact of revolution; the other swollen with new themes

and threatened by mass production. What might have happened – what Courbet for a while tried to make happen – was a fusion of the two. Not high culture condescending to the folk, not popular imagery aping the Paris fashions. Not an adjustment, but a sea-change. A fusion in which the dominance of one culture over the other might have ended. (Naturally it never happened that way. What we had instead was a fusion in which the culture of the ruling classes jettisoned its most precious themes and values, abandoned, as time went on, even the pretence of a privileged 'creativity' or coherence, but clung like a leech to its status as the only Art – defined itself by the mere fact of dominance. It opened the flood-gates to anything, as long as it claimed – or accepted, after a little fuss about the boundaries of art and life – the magic and material status of Art: Original, Fragile, 10,000 Guineas, Do Not Touch.)

Courbet was once asked for a self-portrait. He painted a picture of a pipe, and wrote along the bottom 'Courbet, sans idéal et sans religion'. That is the clumsy Machiavelli to the life, atheist and materialist, a pipe and a philosophy, words and object, constant provocation. The problem was, and always had been, how to put the philosophy into practice. And by the time he painted the pipe and its caption, in 1869, Courbet was waiting for a better chance than paint and canvas offered. It came two years later, and for Courbet it was unmitigated disaster.

His best work was not done in politics proper. It was done in the years after 1848, while there was still a chance that art, in the old sense, could founder, and a new one take its place. This book is about that period, that chance. It sets a minimum definition of political art; a set of criteria for the 'popular'. That last word haunted artists long after Courbet was dead, as if the world of art had a bad conscience about its privileges. From Mistral to Verdi, from Bartók to Léger, artists have plundered or imitated the art of the 'populace'. Mondrian perfected his fox-trot; Eliot wrote lugubriously about Marie Lloyd. But all of them wanted the popular as an adjunct to Art itself – as a blood-transfusion, an act of nostalgia, something we admire and domesticate. Courbet had tried something different; to dislodge the hierarchy, to put an end to the connoisseur. He had come very close: close enough to enrage one public and invent another; close enough to stick in the minds of Pissarro and Cézanne. But he failed, of course, and his friends were inaccurate prophets. Madame Bovary, alas, was not the last bourgeois novel; and as for the people, it will be some time before they set the tone in person.

'Yes, M. Peisse, art must be dragged through the gutter.'

'Yes! Long live the Revolution!'

'Still! In spite of everything!'

These are Courbet's instructions to the connoisseur, and Baudelaire's to himself, in 1865. They don't seem to me to have dated.

Appendix 1

Max Buchon's Advertisement for Courbet's Exhibition in Dijon, 1850. Published in Le Peuple, Journal de la révolution sociale, *7 June.*

<div align="center">

Variétés

Exposition de 1850

Les Casseurs de Pierres à Ornans. – Un Enterrement à Ornans.

Par M. *Gustave Courbet*, d'Ornans (Doubs)

Médaille d'Or de 1849.

</div>

Il paraît que l'exposition de cette année n'aura lieu qu'en décembre; cela tient sans doute à ce que d'ici là M. Baroche se propose de nous en faire voir de toutes les couleurs, si Dieu lui prête vie! que sa majorité nous soit légère! Ainsi soit-il!

Entre temps, voici un de nos amis, M. Gustave Courbet, qui se met en tournée d'artiste, par nos villes de province, avec les toiles qu'il destine aux honneurs du prochain salon; puissent les amateurs dijonnais faire à notre cher pèlerin l'accueil qu'il mérite, tant par la vigoureuse bonhomie de son talent, que par cette nouvelle manière de se rendre à Paris, imaginée par lui, dans le seul but de leur être agréable.

L'an dernier déjà, M. Gustave Courbet obtenait, au salon de peinture, un des premiers succès de l'année, avec son *Après-dîné* [sic] *à Ornans*, dont la *Presse* et le *National* ont fait un si explicite éloge, et qui vient d'être légué par le gouvernement à la ville de Lille, où effectivement, certaines affinités réputées flamandes lui assignaient tout naturellement sa place.

Le musée commencé l'an dernier par M. Courbet va se continuer très-certainement cette année, au moyen des deux toiles énoncées ci-dessus.

Les *Casseurs de pierres* sont un tableau à deux personnages grands comme nature, un enfant et un vieillard, l'alpha et l'oméga, l'aurore et le crépuscule de cette existence de forçats. Un pauvre jeune gars, de douze à quinze ans, tête rasée, teigneuse et stupide, comme la misère en façonne trop souvent aux enfans du pauvre peuple; un garçon de quinze ans soulève avec effort un énorme panier de cailloux prêts à être *métrés* ou saupoudrés sur la route; chemise en loques, pantalon retenu

par une bretelle en corde, rapiécé aux genoux, lacéré par le bas et guenilleux partout; souliers rouges d'usure, éculés, tordus et lamentables, comme ceux de tel pauvre manœuvre de votre connaissance: voilà pour l'enfant.

À droite, vient le pauvre casseur en vieux sabots cerclés de cuir, en vieux chapeau de paille *naisie* par le temps, la pluie, le soleil et la poussière, les genoux tremblottant [*sic*] sur un torchon de paille et soulevant un marteau casseur avec toute la précision automatique que donne une longue habitude, mais aussi tout l'affaissement que suppose un pareil âge. Au milieu de tant de misères, la physionomie est cependant restée calme, sympathique et résignée. Dans la poche de son gilet n'a-t-il pas, le pauvre vieux, sa vieille tabatière de corne bordée de cuivre, avec laquelle il offre, quand il le veut, la *prise* de l'amitié à tous les allans et venans qui s'entre-croisent sur la route, son domaine?

La marmite à soupe est là tout près, avec la cuillère, la hotte et la croûte de pain noir.

Et cette homme est là toujours à lever sa massue débonnaire; toujours, depuis le nouvel an jusqu'à la Saint-Sylvestre; toujours, pour aplanir la voie à l'humanité qui passe; toujours, pour gagner de quoi ne pas mourir de faim; et, cependant, cet homme, qui n'est pas du tout une imagination du peintre; cet homme, qui vit bien réellement en chair et en os à Ornans, tel que vous le voyez là; cet homme, avec son âge, avec son rude labeur, avec sa misère et sa douce physionomie de vieillard, cet homme n'est pas encore le dernier mot de la détresse humaine. Pour peu que le pauvre diable s'avise de tourner au rouge, il peut être jalousé, dénoncé, expulsé, destitué. Demandez plutôt à M. le préfet.

De cette page qui, pour être si saisissante, n'a eu qu'à rester imperturbablement sincère et fidèle; de cette page, en face de laquelle on se sent si éloigné de toutes tendances pleurnicheuses et de toutes ficelles mélodramatiques, passons à la pièce principale de M. Courbet cette année: *Un enterrement à Ornans*.

Vingt et des [*sic*] pieds de long sur douze de haut, avec cinquante-deux personnages grands comme nature... pas plus que cela de multitude, d'étoffe et de travail.

Pour qui a, comme nous, l'honneur de connaître un peu cette bonne population d'Ornans, c'est d'abord une rencontre d'un effet assez naïf, que celle de ce tableau où se groupent, s'alignent et s'étagent toutes ces figures que vous venez de saluer tout-à-l'heure dans la rue, et qui ont été rassemblées là par le pinceau du maître avec tant de naturel, d'intelligence et de bonhomie. M. le curé, M. le maire, M. l'adjoint, rien n'y manque. Ils sont là, dis-je, au nombre de cinquante, tous dans leur caractère propre, dans leur tenue traditionnelle, dans leurs préoccupations particulières.

Et cependant, quand, après avoir parcouru l'ensemble de cette vaste composition, les yeux retombent sur le fossoyeur qui est là, genoux en terre, sur le bord de la fosse où il va descendre le cadavre, je ne sais quelle pensée austère se dégage tout-à-coup de cette fosse béante, flamboie comme un éclair sur ces physionomies, et, grâce à ces grands lointains de paysage, à ces ciels mornes et grisâtres, et à l'air de recueillement qui plane sur tout, en fait une véritable synthèse de la vie humaine.

Autrefois, dans les vieilles danses macabres, c'était la mort en personne qui faisait pirouetter, bon gré malgré, les rois, les papes, les empereurs, tous les grands de la terre, tous les oppresseurs du pauvre monde.

M. Courbet nous semble avoir obtenu, avec son fossoyeur, un effet tout aussi énergique et significatif, sans être néanmoins sorti de ce réalisme absolu, aussi indispensable désormais en peinture qu'en politique, et qu'apprécient les bonnes femmes d'Ornans par anticipation, tout aussi bien que la *Presse* et le *National* pourront le faire à l'exposition prochaine.

Au fond, cet homme, ce fossoyeur, n'accuse rien de méchant dans sa robuste carrure. Lui seul même est à genoux dans cette immense réunion, et cependant, voyez! lui seul se rengorge, lui seul commande.

Demain, cet homme qui est dans la vigueur de l'âge retournera tranquillement à sa hutte de vigneron qu'il a quitté hier; aujourd'hui seulement il se sent le dernier anneau des choses d'ici-bas, le portier de l'autre monde.

Et pourtant, faut-il le dire? à travers l'oppression vague où sa contemplation vous jette, on en revient involontairement, par idée de compensation sans doute, à notre pauvre casseur de pierres, dont ce fossoyeur-ci pourrait bien n'être, dans la pensée du peintre, que l'antithèse psychologique, le contre-poids; je dirais presque le vengeur.

Bref, avant de partir pour Paris, ces deux tableaux seront exposés ces jours-ci, à Dijon, comme ils viennent de l'être à Besançon. Que les artistes, les flâneurs, et surtout les gens du peuple, aillent juger de cela par eux-mêmes. Ces dimensions colossales sont inusitées, sans doute, pour ces tableaux dits *de genre*, qui sont la spécialité de M. Courbet. Qui oserait se plaindre des vastes dimensions de la bouteille, si le vin qu'elle renferme est de bon aloi?

M. Courbet peint comme il sent, et non d'après tel maître, telle école, ou en vue de tel applaudissement. La peinture qu'il lui faut, c'est ni de la peinture italienne, ni de la peinture flamande: c'est de la peinture d'Ornans, c'est de la peinture à la Courbet.

A ces allures de corps-franc, qu'il justifiera de mieux en mieux chaque année, il est facile de reconnaître le véritable Franc-Comtois, le véritable enfant de cette âpre contrée, où naquirent ces trois rudes insurgés du monde idéal et littéraire: Fourier, Proudhon et Victor Hugo. Cette méthode-là, du reste, nous semble la seule vraie, la seule rationnelle, la seule acceptable; aussi nous empressons-nous de lui souhaiter toutes sortes d'appréciateurs.

Appendix 2

Letter from Courbet to Champfleury, written from Ornans, Spring 1850.

Je relis votre lettre, mon cher ami, tout rouge de honte; mais vous n'avez besoin que je vous écrive pour savoir que je pense à vous.

Puisque j'y suis, je vais vous faire un grand journal sur le temps que j'ai passé loin de vous. Auparavant, j'éprouve le besoin de parler de Trapadou, cet ami exotique (je dis exotique, car j'ai toujours pensé que Trapadou était un médecin, augure, d'une tribu sauvage). En outre, il apporte une telle persistance et une telle invariabilité à la science de la vie qu'il me fait aussi l'effet, la main sur la bouteille, de Mutius Scœvola [*sic*], la main sur le brasier.

En tout cas, je vous prie, ne vous laissez pas démolir par lui, d'autant plus que votre roman de LA VOIX DU PEUPLE est un vrai succès (dans notre pays du moins). J'en ai lu quelques feuilletons seulement (car ce journal n'était pas à ma disposition), ça me plaisait considérablement.

Pour Trapadou, je vous en prie aussi, ne le démolissez pas; c'est un monument précieux, quand bien même chacun vous le conseillerait. Il manquerait à trop de monde; pour mon compte, j'avoue qu'il m'est tres nécessaire. Je le vois toujours, une chandelle à la main, soit au bordel, soit dans mon atelier, parcourant l'obscurité avec l'écarquillement du nez et des yeux. Ça ne m'étonne pas qu'il veuille se faire prêtre; j'avais déjà dit à Baudelaire qu'il était né brame, qu'il finirait les mains en l'air ombragé de ses ongles, comme des rameaux de saules pleureurs, combinant la préexistance avec l'infini. Le surnom que vous lui donnez de premier GÉANT-VERT me séduit tres suffisamment. – Je me connais fort peu en vers, mais si Baudelaire déclare que les vôtres sont illogiques, c'est, je pense, que le second devrait être le dernier.

C'est une bien belle saison que l'hiver. Outre que les domestiques boivent aussi frais que leurs maîtres, de tous côtés on entend conter des exploits qui enchanteraient Trapadou. Par ici, c'est un braconnier qui a vu un sanglier gros comme une vache; par là, c'est un paysan tenant son fusil d'une main qui a pris un loup de l'autre par l'oreille; pour moi, j'ai tué une oie sauvage qui pesait douze livres à la grande admiration du pays. Nous étions les deux Fromaget et moi; il était dix heures du soir;

la neige était éclatante et la lune dans son plein. Aussitôt, nous sommes revenus faire une entrée triomphale au café; l'oie était pendue au bout du canon de mon fusil. A l'heure qu'il est, il y en a qui n'en dorment point, rien que de jalousie; l'histoire de l'oie tuée par les deux artistes se racontera dans le pays aux petits enfants de nos enfants et avec amplification.

Voilà pour la chasse, parlons des tableaux. J'ai déjà plus fait de peinture depuis que je vous ai quitté qu'un évêque n'en bénirait.

D'abord, c'est un tableau de Casseurs de pierres qui se compose de deux personnages très à plaindre; l'un est un vieillard, vieille machine raidie par le service et l'âge; la tête basanée et recouverte d'un chapeau de paille noire; par la poussière et la pluie. Ses bras qui paraissent à ressort, sont vêtus d'une chemise de grosse toile; puis, dans son gilet à raies rouges se voit une tabatière en corne cerclée de cuivre; à son genou posé sur une torche de paille, son pantalon de droguet qui se tiendrait debout tout seul à une large pièce, ses bas bleus usés laissent voir ses talons dans ses sabots fêlés. Celui qui est derrière lui est un jeune homme d'une quinzaine d'années ayant la teigne; des lambeaux de toile sale lui servent de chemise et laissent voir ses bras et ses flancs; son pantalon est retenu par une bretelle en cuir, et il a aux pieds les vieux souliers de son père qui depuis bien longtemps rient par bien des côtés. Par-ci, par-là les outils de leur travail sont épars sur le terrain, une hotte, un brancard (pioche), un fossou (fossoir), une marmite de campagne dans laquelle se porte la soupe de midi; puis un morceau de pain noir sur une besace.

Tout cela se passe au grand soleil, au bord du fossé d'une route. Ces personnages se détachent sur le revers vert d'une grande montagne qui remplit la toile et où court l'ombre des nuages; seulement, dans le coin à droite la montagne qui penche laisse voir un peu de ciel bleu.

Je n'ai rien inventé, cher ami, chaque jour allant me promener, je voyais ces personnages. D'ailleurs, dans cet état, c'est ainsi qu'on finit. Les vignerons, les cultivateurs, que ce tableau séduit beaucoup, prétendent que j'en ferais cent que je n'en ferais pas un plus vrai.

Ici, les modèles sont à bon marché; tout le monde voudrait être dans l'Enterrement. Jamais je ne les satisferai tous; je me ferai bien des ennemis. Ont déjà posé: le maire, qui pèse 400; un des bedeaux, avec un nez rouge comme une cerise, mais gros en proportion et de cinq pouces de longueur. Que Trapadou aille s'y frotter! le curé, le juge de paix, le porte-croix, le notaire, l'adjoint Marlet, mes amis, mon père, les enfants de chœur, le fossoyeur, deux vieux de la Révolution de 93, avec les habits du temps, un chien, le mort et ses porteurs, les bedeaux, mes sœurs, d'autres femmes aussi, etc. Seulement je croyais me passer des deux chantres de la paroisse; il n'y a pas eu moyen; on est venu m'avertir qu'ils étaient vexés, qu'il n'y avait plus qu'eux de l'église que je n'avais pas tirés; ils se plaignaient amèrement, disant qu'ils ne m'avaient jamais fait de mal et qu'ils ne méritaient pas un affront semblable, etc., etc.

Il faut être enragé pour travailler dans les conditions où je me trouve. Je travaille à l'aveuglette; je n'ai aucune reculée. Ne serai-je jamais casé comme je l'entends? Enfin, dans ce moment-ci, je suis sur le point de finir 50 personnages grandeur

nature, avec paysage et ciel pour fond, sur une toile de 20 pieds de longueur sur 10 de hauteur. Il y a de quoi crever. Vous devez vous imaginer que je ne me suis pas endormi.

Autre histoire: Ornans est en combustion, Ornans danse sur la tête depuis le Carnaval. On croirait qu'il y a des morts dans les familles, surtout chez les jeunes mariés. – Il est bon de vous dire avant tout que la coutume dans notre pays est que, quand un homme se marie, il est forcé de donner des Piquerais le dimanche de Carnaval et le lundi gras; ce qui consiste d'abord dans la matinée de ces deux jours à distribuer aux enfants des pois frits, et, le soir, à recevoir les masques qui vont leur dire leurs vérités et manger et boire, et emporter d'énormes collations qu'ils ont dû preparer, chacun selon ses moyens. Ces choses durent toute la nuit.

Or, j'ai mis cela avec mes amis sur un pied cruel et terrible. La précaution principale est d'être masqué hermétiquement, puis de changer sa voix de façon à n'être pas connu absolument, sans quoi vous pouvez être éreinté.

Nous avions imaginé une bande de pierrots de toutes couleurs. J'avais à remplir le rôle du Pierrot de la Mort; j'étais tout en noir, seulement la collerette et la tête blanches. (On parlera encore plus longtemps du pierrot noir que de l'histoire de l'oie.) Puis, il y en avait en blanc, en rouge, en jaune, en vert, en rose, en bleu, et tous ainsi que moi remplissaient des rôles appropriés à leur couleur, la bande était nombreuse, grâce à Dieu.

Nous avons terminé ce Carnaval par une procession solennelle par toute la ville; Carnaval était embroché dans une perche de vingt pieds de hauteur, et au sommet de cette perche était un immense transparent où était écrit en gros caractères: Bourgeois, rentrez dans vos vices; pour avoir dit la vérité, Carnaval sera brûlé!

L'effet était funèbre et sinistre; tous les acteurs pendant le Carnaval, étaient à la suite avec des masques et des sacs sur la tête; la population suivait muette; puis enfin on vint au centre de la ville, sur la petite place du Marché: c'est là que commença l'exécution accompagnée de rondes, de danses autour de Carnaval qui brûlait. Tout ce qu'il y avait de chaudrons, de bassinoires, de grosses caisses et autres instruments de cuisine se trouvaient dans le musique.

J'ai reçu dernièrement une lettre du directeur des musées de Lille qui m'annonce qu'à sa requête le gouvernement a fait cadeau de mon tableau à cette ville. Il me demande des renseignements sur ma vie et sur les maîtres qui ont dirigé mes études.

J'ai déjà fait des démarches infructueuses pour les assiettes à coqs; j'aurai des chansons de paysans, et je vous porterai les Bons Sabots de Besançon.

Je vous serais très obligé si vous m'écriviez de suite ce que vous savez sur l'Exposition prochaine et à quel temps elle est fixée.

Si vous êtes à portée de voir Baudelaire, donnez-lui le bonjour. Dites-moi aussi ce que fait mon ami Bonvin; allez le voir de ma part. Saluez les gens de ma connaissance, Trapadou, Chonne, etc.

J'espère que voilà une lettre qui compte; j'aimerais mieux faire un tableau, j'aurais aussitôt fait.

GUSTAVE COURBET.

Brief Chronology

1848

22 Feb.	Procession of protest against banning of 'Reform' banquet in Paris.
23 Feb.	National Guard turns against Government.
	Evening, clash with troops on Boulevard des Capucines.
24 Feb.	Hôtel de Ville occupied. Tuileries taken. Provisional Government proclaimed.
26 Feb.	National Workshops set up.
28 Feb.	*Commission pour les travailleurs* set up.
5 Mar.	Universal Suffrage decreed.
16 Mar.	Demonstration of the *bonnets à poil* (reactionary sections of the National Guard).
17 Mar.	Counter-demonstration of the working class.
16 Apr.	Abortive demonstration of the Left-wing clubs. (It demanded postponement of the elections.)
20 Apr.	*Fête de la Fraternité.*
23–24 Apr.	Voting in election for National Constituent Assembly. Conservative victory. Left-wing uprisings in Rouen, Limoges.
15 May.	Invasion of Assembly by the Clubs. Abortive attempt to proclaim a new Provisional Government.
21 May.	*Fête de la Concorde.*
21 June.	Decree abolishing National Workshops (climax of campaign against the social measures of the Provisional Government).
23–26 June.	June Days uprising. Cavaignac made president of the Council of Ministers.
July.	New laws restricting Press freedom.
4 Nov.	New constitution adopted by the Assembly, with a single chamber and single head of government.
10 Dec.	Louis-Napoleon elected President.

1849

13 May.	Elections for Legislative Assembly. Conservative victory, but this time marked by the emergence of a 'Red France'.
13 June.	Abortive Left-wing uprising in Paris.
31 Oct.	Louis-Napoleon dismisses the Conservative Barrot ministry, puts in its place an extraparliamentary ministry of his own choosing.

1850

	Politica struggle in the countryside intensifies.
10 Mar.	By-elections in Paris and the provinces. Victory for the Left.
15 Mar.	The *Loi Falloux* passed by the Assembly, reviving Church control of education.
31 May.	Law ending universal suffrage, disqualifying 3 million Left-wing militants and itinerant workers.
Summer.	Louis-Napoleon stages propaganda tours in the provinces.

1851

Jan.	Louis-Napoleon dismisses the Republican general Changarnier.
Aug.	Trial of the Lyons conspiracy.
2 Dec.	*Coup d'état* by Louis-Napoleon in Paris.
4–14 Dec.	Scattered resistance to *coup d'état* in the provinces.
21–22 Dec.	Plebiscite gives massive approval to Napoleon.
	Purge of Republican opposition.

1852

| Dec. | Louis-Napoleon becomes Emperor. |

Notes

Table of abbreviations:

AN Archives Nationales.
AD Archives Départementales.
Da. Daumard, A. – *La Bourgeoisie parisienne de 1815 à 1848*.
R. Riat, G. *Gustave Courbet, peintre*.
B.C.G. Baudelaire, C. – *Correspondance générale*, ed. Crépet and Pichois.
B.O.C. Baudelaire, C. – *Oeuvres complètes*, ed. Le Dantec and Pichois.
C. Courthion, P. – *Courbet raconté par lui-même et par ses amis*.
Ch. Chevalier, L. – *Classes laborieuses et classes dangereuses à Paris*.
M. Mack G. – *Gustave Courbet*.
M-N Moreau-Nelaton E. – *Millet raconté par lui-même*.

Fuller bibliographical details in these cases will be found in the Bibliography. In other cases, the notes give the author's name only, plus the bibliography number where necessary, and full details will again be found in the Bibliography. The exceptions to this rule are the various Salon criticisms written in newspapers or pamphlets at the time. A bibliography of the Salons of 1851 is incorporated in the notes to Chapter 6, when the critical reaction to Courbet is discussed.

I have preferred to put English translations of French citations into the text, except for verse, and for Courbet's patois. Almost always, when the citation is from an original or inaccessible source, I have given the French text in the notes – and likewise in cases where the texture of the French seemed vital. When the original French is in the main text, an English translation is provided in the notes.

1. On the Social History of Art (pp. 9–20)

1 Baudelaire (6), no. 218 bis. cf. Proudhon (2), II, 375.

2. Cited C., II, 78.

3. B.O.C., p. 1295.

4. 'M. Courbet est le *Proudhon* de la peinture . . . M. Proudhon – je voulais dire M. Courbet – fait de la peinture démocratique et sociale – Dieu sait ce qu'en vaut l'aune!' 'Salon de 1851', *Chronique de Paris*, 16 Feb. 1851, p. 120.

5. B.C.G., V, p. 201.

6. M-N, I, 109, to Sensier, early 1853.

7. 'Pierre Dupont', B.O.C., pp. 605, 606.

8. This concept of the unconscious is now most persuasively argued by J. Lacan. See Lacan, p. 830 (which is only the most forceful, and schematic, statement of an argument which runs through the whole of Lacan's work).

9. Courbet, Exhibition, cited C., II, 60.

10. See Gautier (2), pp. 13–14; and Gautier (3).

11. She is one of the sources of Rosanette in Flaubert (2), she is Apollonie in Gautier's poems 'A Une Robe Rose' and 'Apollonie'. She was the model for Clésinger's statue *Une Femme piquée par un serpent*, 1847 Salon; Baudelaire addressed a cycle of poems to her, including 'A Celle qui est trop gaie', B.O.C., pp. 140–1.

12. See Crouzet, pp. 128–32.

13. See Pichois, pp. 163–86.

14. B.C.G., I, 108–9.

15. On the role of the intellectuals, and in particular the National Guard of the 11th Arrondissement, in the June Days, see Gossez (2), p. 441. On Bohemia in June, see *ibid.* pp. 451–2 and below, Ch. 2.

16. James (2), p. 99.

17. Tocqueville, p. 135.

18. See Pichois and Ruchon, plate 174, pp. 177–8.

19. 'La situation de la ville de Salins, la plus démoralisée de toutes celles du Jura, tend à s'améliorer. Les processions de la Fête-Dieu ont été très brillantes et se sont faites avec le plus grand ordre; une procession spéciale, ordonnée dans cette ville par Mr. l'Evêque de St. Claude, *en réparation des blasphèmes de Proudhon*, n'a pas donné lieu à la moindre agitation. On a été fort surpris de voir figurer à cette procession, un cierge à la main et avec un recueillement parfait, le citoyen Max Buchon, l'un des chefs du parti socialiste, partisan avoué des doctrines de Proudhon, dont il passe pour être l'ami particulier; sa présence à cette cérémonie est-elle, comme bien des gens l'ont supposé, l'indice d'un retour sincère? J'y vois plutôt un de ces actes d'originalité, auxquels nous a habitués depuis longtemps cet homme qui aime avant tout à poser et à faire parler de lui'. A.N., BB30 373, *plaquette* 1. Report of the Procureur-Général, 11 June 1850.

20. Mallarmé, p. 259, letter of 24 Sep. (1867).

21. See two major statements in 1861, the first published in the *Précurseur d'Anvers* (cited in part, C., I, 160–1) and the second, a letter to his pupils, in the *Courrier du Dimanche* (*ibid.*, II, 204–7). The latter preaches a rigorously materialist doctrine of representation, and the former points to the philosophical underpinning of this materialism: it is 'la négation de l'idéal', and *because of that* 'j'arrive en plein à l'émancipation de l'individu, et finalement, à la démocratie'. A confused argument, but one which is unmistakably struggling with a complex notion of individuality and its realization in the world.

22. See Baudelaire's 'Salon de 1846', B.O.C., pp. 874–6.

23. 'Qu'importe que la Bourgeoisie garde ou perde une illusion?' B.O.C., p. 669.

24. Benjamin (1), p. 88.

25. Proudhon (4), p. 97, note de Proudhon.

26. E.g. pp. 176–85. 'Une chose à méditer profondément pour l'artiste: c'est que les idées s'idéalisant pour ainsi dire, de plus en plus par leur détermination, il vient un moment où, sur une multitude des choses, l'idéal se confond avec l'idée, au point que l'art semble hors d'emploi, et l'artiste sec.' The best examples of this process are the achievements of the engineers – here, says Proudhon, the idea is 'realized' and artistic decoration clearly superfluous. Compare

Proudhon's language with Courbet's in his 1861 statements.

2. The Courbet Legend (pp. 21–35)

1. Cited Borel (1), pp. 71–2.

2. B.O.C., p. 637. The notes were probably written late in 1855.

3. 29 Oct. 1864, cited Troubat (2), p. 177.

4. 'Remarquez que ce ne sont pas précisément les sujets choisis par Courbet qui me choquent. S'ils étaient recouverts d'un manteau suffisant, peu m'importe qu'il montre une baigneuse, des curés ou la famille de Proudhon.' 23 Apr. 1865, cited Troubat (2), pp. 180–1.

5. Wey Mss., cited C., II, 184–5.

6. 'M. G. Courbet, venu du village à Paris, s'est dit qu'il serait peintre et son maître à lui-même. Il s'est tenu parole. Après dix ans d'études, d'efforts et de tâtonnements douloureux, après dix ans de privations, de pauvreté et d'obscurité, au moment même d'être à bout de courage et de ressources, le voilà peintre et, peu s'en faut, déjà maître. . . . Ces durs commencemens, cet apprentissage solitaire et ces longues épreuves de M. Courbet se lisent sur ses ouvrages empreints d'une certaine force sombre et concentrée, d'une expression triste et d'une manière un peu sauvage. Ses paysages . . . ne sont que des esquisses; mais de ce même caractère grave et pénétrant.' Le National, 7 Aug. 1849.

7. 'Non seulement socialiste, mais bien encore démocrate et républicain, en un mot, partisan de toute la Révolution et par dessus tout, réaliste, c'est-à-dire, ami sincère de la vraie vérité.' Letter to Le Messager, 19 Nov. 1851, cited R., pp. 93–4.

8. B. Nat. Mss. Nafr. 10316 fol. 286, cited Hemmings, p. 216.

9. 'Journal d'Arthur Vingtras, Courbet, portrait-charge', in Gil Blas, 9 May 1882. See Vallès (2), pp. 250–1.

10. 'L'air d'un paysan goguenard'; 'Il y aurait reproché à Martin Bernard d'avoir abandonné la Commune, et il lui aurait dit que lui et Louis Blanc seraient les premiers victimes d'une nouvelle commune.' Archives de la Préfecture de Police, Courbet file, Ba. 1020. For the spy's report, see 1872, Fiche 173.

11. Cited Borel (1), p. 55.

12. Cited M., p. 86, written in winter 1851–52.

13. See Troubat (2), pp. 125–7, undated letter to Buchon.

14. B.O.C., p. 635.

15. B.O.C., p. 1429.

16. 'Là est un vieillard de soixante et dix ans, courbé sur son travail, la masse en l'air, les chairs hâlées par le soleil, sa tête à l'ombre d'un chapeau de paille; son pantalon de rude étoffe est tout rapiécé, puis dans ses sabots fêlés, des bas qui furent bleus laissent voir les talons. Ici, c'est un jeune homme à la tête poussiéreuse, au teint bis; la chemise dégoûtante et en lambeaux lui laisse voir les flancs et les bras; une bretelle en cuir retient les restes d'un pantalon, et les souliers de cuir boueux rient tristement de bien de côtés. Le vieillard est à genoux, le jeune homme est derrière lui, debout, portant avec énergie un panier de pierres cassées. Hélas! dans cet état, c'est ainsi qu'on commence, c'est ainsi qu'on finit! Par-ci par-là est dispersé leur attirail: une hotte, un brancard, un fossoir, une marmite de campagne, etc. Tout cela se passe au grand soleil, en pleine campagne, au bord du fossé d'une route; le paysage remplit la toile.' Cited C. II, 75–6.

17. Where Buchon wrote this passage is obscure. It is usually quoted from Léger's transcription, in Mercure de France, 1928, and

Léger calls it there an extract from Buchon's 1855 *Recueil de dissertations sur le réalisme*. But it does not in fact come from that book, and I have not found the original source.

18. Reprinted in Champfleury (2), pp. 72–101.

19. See Champfleury (2), p. 101.

20. See Champfleury (2), p. 84.

21. Cassagne, pp. 121–2.

22. Gossez (2), p. 451.

23. B.C.G., I, 151–2.

24. *Exhibition . . .* , cited C., II, 60.

3. Courbet's Early Years (pp. 36–46)

1. See M., pp. 29–30.

2. Cited R., p. 42.

3. E.g. the portrait of Théodore Cuénot, *c.* 1846, in the Courbet exhibition, Ornans, 1969. Along the top is written 'Ce Portrait est un don de l'auteur à mère Cuénot supérieure de l'hôpital d'Ornans et en souvenir de M. Théodore Cuénot bienfaiteur de cet hospice mort en 1847'. The Cuénots were family friends of the Courbets.

4. In 1844 Courbet had two pictures rejected: perhaps the *La Nuit de Walpurgis* and a picture which might have been the first version of *L'Homme blessé*, entitled *L'Homme délivré de l'amour par la mort*. In 1845 he had four rejected: *Portrait de Juliette*, *Le Hamac*, *Les Joueurs d'échecs*, an unidentified *Portrait d'un homme*. In 1846, seven pictures were sent back; and in 1847, the *Violoncelliste*, *L'Homme à la pipe*, and *Portrait d'Urbain Cuénot*.

5. 'Aux murs deux gravures, les deux seules reproductions d'un collègue, la *Promenade des curés* et les *Seminaristes aux champs*, d'Amand Gautier; un couple de charbonniers érotiques figurant au besoin Adam et Eve; des études bizarres, enfantines, la *Halte du soldat* et *l'Homme casqué*, des dames embuissonnées de dentelles, une platée de cerises noires; le fameux *Sauvage traversant les rapides*, cette toile fantastique dont on n'a jamais pu s'expliquer l'incubation; un *Combat maritime* (sa deuxième toile!) cascade d'orangeade et de groseille à terrifier le flagorneur le plus impudent – la coquetterie d'atelier du maître consistait précisément dans cet étalage presque affecté des infirmités de son début – une *Pythonisse* prêtée au Dominiquin; enfin ses essais statuaires.' Published in *La Lanterne*, 26 Jan. 1878, collected in Arch. de la Pref. de Police, Ba. 1020, Fiche 562.

6. Poe, pp. 145–6.

7. Novalis, pp. 7–9 (translation slightly modified).

8. E.g. Prud'hon's *Portrait de l'impératrice Joséphine*, the various Arab subjects of Vernet or Decamps, Deveria's *Naissance de Henri IV* (1827 Salon), Léopold Robert's Italian peasant subjects. Couture showed *Le Trouvère* in the 1843 Salon, and later painted an *Orgie parisienne*, complete with Pierrot and Harlequin.

9. A much disputed date, but this seems the most likely on grounds of style. It may have been retouched later, perhaps *c.* 1849. It is not the exhibit in the 1849 Salon called *Le Peintre*; this was a drawing with quite different dimensions.

10. The pseudo-Géricault is now in the Musée Fabre, Montpellier, the Deroy is at Versailles.

11. There has been confusion about which picture the *Portrait of Monsieur X**** really is. Léger says it is the Besançon self-portrait; its style and the closeness of its dimensions to those in the Salon registers suggest he is right.

12. See Guinard, pp. 284f. for the latest account of the critical reaction. Courbet went regularly to the Gallery in the 1840s.

13. Letter of 21 July 1838, cited M-N, I, 29–30.

14. E.g. by L. Peisse in *Le Constitutionnel*, 8 Jan. 1851. Many critics admired the picture in 1851, even if they were hostile to the rest of Courbet's exhibit. But a few attacked its bad taste: 'un homme ivre qui fume une pipe éteinte . . .' J. Labeaume, *Lettres sur l'exposition des artistes vivants*, p. 6.

15. I am indebted to Dr Irene von Reitzenstein of the University of West Berlin for the precise dating of the visit: late in 1847, rather than in the summer as has been thought hitherto.

16. He copied the Rembrandt self-portrait in Munich in 1869. It is now in Besançon Museum.

17. 'Spécialités des sujets bas-bretons', B.O.C., p. 911.

18. See Nochlin (1), pp. 52–7, for the identification of this source, and discussion; also Fernier (1).

19. Dated 1847, now in the Louvre.

20. In the Marcel Cusenier Collection, Paris.

21. '. . . le portrait d'un fanatique, d'un ascète, . . . le portrait d'un homme désillusionné des sottises qui ont servi à son éducation et qui cherche à s'asseoir dans ces principes.' See Borel (1), p. 37.

22. See discussion of dating, Nochlin (1), pp. 47–8.

23. See note 14. The hostile critics in 1851 did not, of course, make the link with hashish directly, though later on Champfleury was caricatured as a drug addict, complete with syringes.

24. 'Le Poème du haschisch', B.O.C., p. 365.

25. '. . . les divagations obscures et incohérentes du bohémien sidéré.' Gros-Kost, p. 33.

4. Courbet in Paris 1848–49 (pp. 47–76)

1. Vallès (2), p. 250. See p. 24 of this book.

2. Published 15 Apr. 1871, see C., II, 47–8.

3. See Toubin's *Souvenirs*, in Bandy and Pichois, p. 92.

4. Cited R., p. 47.

5. Cited M., p. 45.

6. 'Choses très ridicules et insignifiantes', cited R., pp. 49–50.

7. Bandy and Pichois, p. 98.

8. Cited Dolléans and Puech, p. 13.

9. Letter of 26 June, cited R., p. 50.

10. Déposition de Proudhon devant la Commission d'Enquête, cited Dolléans and Puech, p. 50.

11. Article in *Le Peuple*, 19 Feb. 1849, Dolléans and Puech, p. 16.

12. The Salon *livret* reads 1011, *Jeune fille dormant*, 1012 *Le Soir, paysage*, 1013, *Le Milieu du jour, idem*, 1014, *Le Matin, idem*, 1015, *Violoncelliste*, 1016, *Portrait de M. Urbain C(uénot)*, 1017, *La Nuit classique de Walpurgis; dessin*, 1018, *Portrait de M. A(lphonse) B(on?); idem*, 1019, *Portrait N.C.S.; idem*, 1020, *Jeune fille rêvant; idem*.

13. *Le Milieu du jour* was described by the critics Montaiglon and P. de Chennevières in their 1851 Salons. Montaiglon accused Courbet of being still an academic in 1848; he had shown 'un petit paysage un peu confus et à la Corot; une jeune fille dormant dont nous ne nous souvenons point, et un paysage intitulé le Milieu du jour, grande

toile toute noire, avec des personnages de grandeur naturelle, dans laquelle un garçon de notre temps courait apres une femme nue qui se sauvait'; cf. P. de Chennevières, who describes a Salon painting of a young man in 'redingote noir comme toi et moi, courant, au détour d'un bois, après une grande fille toute nue, une créature à gros ventre et à jambes grêles, un modèle de huitième choix, qui représentait, je crois, l'Illusion'. For dating of *Walpurgis Night*, see Estignard, p. 149.

14. '. . . fait apparition de peintre. Son *Violoncelliste*, notamment, a une étoffe de style et de manière, une manœuvre de touche et de clair-obscur qui se recommandent avec éclat: c'est comme un ressouvenir du Caravage et de Rembrandt.'

15. On 28 Sep. 1848, cf. Champfleury (12), pp. 171–2.

16. The title of *The Studio* was 'Intérieur de mon atelier, allégorie réelle déterminant une phase de sept années de ma vie artistique', see *Courbet, G., Exhibition*. . . .

17. See *Précieux livres, reliures et manuscrits*. My thanks to Y. Abe for pointing this out to me. Cf. Courbet's *Notice* for the 1849 Salon in the Archives du Louvre, which reads: 'Liste definitive dans l'ordre complette [*sic*]. 1. Une après dîner à Ornans – c'était au mois de novembre nous étions chez notre ami Cuénot, Marlet revenait de la chasse, et nous avions engagé Promayet à jouer du violon devant mon père. 2. M. M. . . . T. . . . examinant un livre d'Estampes. 3. La vendange à Ornans, sous la roche du Mont (Dp. Doubs). 4. La roche du misère dans la vallée de la [heavily erased]. 5. La vallée de la loue prise de la roche du mont, le village qu'on apperçoit [*sic*] au bord de la loue est Montgesoye Doubs. 6. Vue du Château de St-Denis, le soir, prise du village de Scey-en-Varey (Doubs). 7. La vallée de la tuillerie, et le ruisseau du Sie de Leugniey, avant le coucher du soleil (doubs). 8. Rochers dans la vallée de l'essart-cendrier (doubs). 9. Les communaux de Chassagne soleil couchant. 10. Le peintre. 11. Etude d'après Melle. Zélie C. Gustave Courbet.' Entries 4, 7, 8, and 11 were rejected.

18. In the Louvre *Enregistrement des ouvrages*, No. 3358 is called *Courbet I dessin le peintre* 75 cm × 60 cm ($29\frac{1}{2}$" × $23\frac{5}{8}$"). The Wadsworth charcoal is 11 inches by $8\frac{1}{4}$, much smaller, but the first dimensions included framing, which was often vast in the case of drawings. Incidentally, *L'Homme à la ceinture de cuir* is 1 m × 82 cm ($39\frac{3}{8}$" × $32\frac{1}{4}$").

19. Almost every year between 1845 and 1854 has been suggested by one critic or another. Courbet dated it 1850 in his Exhibition catalogue of 1855, but various dates there are dubious, as if he is trying to hide his hesitations between 1846 and 1850. One interesting dating is 1852, which Silvestre gave to Bruyas in a letter of 14 Sep. 1874, now in the archives of the Bibliothèque Municipale de Montpellier, Ms. 365.

The closest stylistic comparison is, I think, with the dry, broad, Hals-like treatment of the strange falling boy in the foreground of *Le Départ des pompiers* painted 1850–51 – especially the treatment of the light on the outstretched hand. My tentative dating would be 1849, the time of the explanatory list, the forged letter, etc.; then retouched about eighteen months later. See Abe (3), for fullest discussion.

20. Mentioned by Champfleury in his Salon.

21. See Champfleury (12), pp. 185f. on the Brasserie Andler; on date of *Après-dîner*, see Francis Wey, Mss., cited C., II, 184.

22. B.C.G., I, 111.

23. Cited C., II, 188–9.

24. See the epigraph to this book. When Courbet wrote 'je viens donc de débuter dans la grande vie vagabonde et indépend-

ante du bohémien', that last word had, of course, several connotations: wanderer, gipsy (cf. his plan for 'une bohémienne et ses enfants' to accompany *Les Casseurs de pierres*, letter to Bruyas, 1854, Borel(1), p. 43) and Bohemian. The last, in the context of his other letters and pictures from this date, seems to me the best translation. Cf. Baudelaire's use of a very similar phrase in 'Du Vin et du haschisch', published a year later, in 1851. Talking of Paganini and a Spanish guitarist: 'Ils menaient à eux deux la grande vie vagabonde des bohémiens, des musiciens ambulans, des gens sans famille et sans patrie.' We know that for Baudelaire the specific connotations of 'bohémiens' were clear.

25. Jean-Aubry, p. 39, cited M., p. 155.

26. There are at least twenty-five people whose names are linked with Courbet's in the years 1848–51 in Paris. A. Delvau, in his *Histoire anecdotique des cafés et cabarets de Paris*, 1862, mentions on pp. 282–8 Banville, Bonvin, Murger, Champfleury, Baudelaire, Christophe, Malassis, Schanne, Watripon as composing the Courbet circle in 1849. Courbet himself, in a letter to Pierre Dupont, mentions Monselet, Champfleury, Murger, Baudelaire, Bonvin, and A. Gautier (see C., II, 145). Champfleury mentions Planche, Chenavard, P. Dupont, G. Mathieu, Corot, Français. Add to these Clément Laurier, with whom Courbet stayed in 1851, Jules Vallès, J. Wallon, Proudhon, Journet, Trapadoux, Francis Wey, and possibly Alexandre Weill, to whom Wey wrote about Courbet and whom Buchon mentioned as a 'Realist' in his review of the *Les Paysans de Flagey*. The Constitution of the Cénacle of Bas-Meudon, written out on restaurant paper on 1 June 1849, mentions Bonvin, Champfleury, Courbet, Trapadoux, and Jean Wallon as members. The drawing of the Brasserie Andler has Wallon and Trapadoux as Courbet's companions.

27. 'La fiévre des admirations banales et

l'amour de la canaille . . . en fait un frère de Pierre Dupont.' Letter to Buchon, 23 Apr. 1865, Troubat (2), p. 180. Champfleury does not mention Courbet in his *letters* until 1852, which he later calls the year of their separation; see Champfleury (12), p. 192. Wey, Trapadoux, and Baudelaire were painted by Courbet around this time; Champfleury and Dupont not till later. There is a possibility – no more – that Courbet did a portrait of Bonvin in 1846, see Léger (6), p. 27.

28. See Rémusat, IV, 337.

29. See Champfleury (7), p. 337. Internal evidence here suggests the date is c. 1849.

30. *Chien-caillou*, *Feu miette*, dedicated to Balzac, *Pauvre trompette* to Delacroix.

31. See 'Autobiographie manuscrite' de Champfleury, Bib. Nat., Nafr. 24264 folios 457–61.

32. 'Le Fuenzes' in *Feu miette*. 'Van Schaendel, Père et Fils', ditto, 'Chien-caillou', in the book of the same name.

33. The 'supernatural' sections of 'Mémoires d'une serinette' in *Chien-caillou* are typical. He mentions Hoffmann in 'Le Fuenzes' and in 1856 translated Hoffmann's later, more down-to-earth tales – in an attempt to domesticate him.

34. Both pantomimes described in Champfleury (7), pp. 100–5, 247–55.

35. Cited Champfleury (7), pp. 100–5.

36. 'Champfleury, le poëte, a un fond de farceur.' B.O.C., p. 636. Baudelaire refers to 'la lettre à Colombine, le bouquet du pauvre', i.e. the second is one specific passage from the first story. 'La lettre à Colombine' is in *Contes d'automne*, pp. 264–74.

37. Champfleury (7), pp. 269–70.

38. In *Le Corsaire*, 16 May 1845.

39. First published in *Le Pays*, 24 July 1851. Cited from Champfleury (2), pp. 8–9.

40. 'Il a fallu plus de courage qu'on ne croit pour faire poser ces modèles, *bohèmes* véritables, à l'esprit difficile et chagrin, souvent mystérieux comme des sphinx, et toujours indéchiffrables comme l'obélisque. . . . Tout le *neveu de Rameau* est là-dedans. Diderot n'eût pas fait son plus beau livre, si Rameau jeune ne s'était complu dans un déshabillement perpétuel devant le grand philosophe. Combien de *neveux de Rameau* marchent aujourd'hui sur les trottoirs? Et que manque-t-il à ces génies ignorés? Un homme de génie qui sache sténographier.'

41. 'Serinette' is again a good example of this. Its sketch of the Dijon bourgeoisie is quite acute; but its main theme is mystery and imagination – flavoured with sentimentality.

42. Including *Les Trois Filles à Cassandre* in 1849 and *Les Deux Pierrots* in 1851.

43. Cited Troubat (3), p. 72.

44. Letter of 9 Feb. 1849, Troubat (3), p. 90.

45. In 'Les Communistes de Sainte-Croix', first published in *Le Corsaire*, 12 July 1848, cited from Champfleury (2), p. 190.

46. The best account of Champfleury's 'popular' enthusiasms at this time is in Bouvier, pp. 165f. Bouvier's work – though I have contradicted it on some points – is still basic to any study of Champfleury.

47. From 8 Nov. 1849 to 31 Mar. 1850.

48. Cited Troubat (3), p. 105.

49. 'Un réac plus révolutionnaire que tous les rouges'. Troubat (3), p. 117, letter of 23 Oct.

50. Champfleury (2), p. 189.

51. All from Wey (1), pp. 189, 106, 186, 410 and 14 respectively.

52. In *Revue des deux mondes*, 15 Aug 1849, p. 577.

53. 'On ne saurait encanailler l'art avec plus de science technique.' Cited e.g. Bouvier, p. 229; and cf. 'Oui, M. Peisse, il faut encanailler l'art', in Courbet's letter on the *Stonebreakers*.

54. In *Revue des deux mondes*, 15 Aug. 1849, p. 578.

55. 'Une honnêteté domestique qui touche profondément . . . C'est d'ailleurs un tableau dont la composition, la lumière, la couleur, ont une habileté, une franchise et une largeur surprenantes.' *Le National*, 7 Aug. 1849.

56. Cited Estignard, p. 23.

57. AN. F21 22 Courbet. Ordered by letter on 22 Sep. Cf. Courbet's letter to Lille director, 19 Mar. 1850, cited R., p. 68.

58. AN. F21 527. Session of 2 Aug. 1849.

59. Repeated in Courbet's letter to Champfleury, Appendix 2.

60. Trapadoux, p. ii.

61. The Rembrandt link was pointed out by Nochlin (1), pp. 61–2, the Le Nain link by Meltzoff, figs. 4 and 5. The original Velázquez is now in the Metropolitan Museum, New York; a workshop version of it – thought at the time to be an original – was in the Musée Espagnol, and was last heard of on the London art market. See López-Rey, p. 128, no. 20. I think the treatment of space in the Le Nain *Une Famille des paysans* is more important to Courbet than the more conventional grouping of *Repas des paysans*, though the latter is obviously closer to the detail of Courbet's picture.

62. In *Revue des deux mondes*, 15 Aug. 1849, p. 577.

63. Champfleury (1), p. 48.

64. Champfleury (1), p. 49.

65. Champfleury (9), pp. 15–16. It should be clear by now that I agree with Bouvier's verdict on the relationship between Courbet's Realism and Champfleury's: that Courbet's painting made the change to Realism first, and it was under its influence that Champfleury passed, eventually, from Bohemianism to Realism. See Bouvier, pp. 244–5.

66. Buisson in Pichois, p. 42. Troubat in Troubat (1). My thanks to Y. Abe for pointing out the latter account.

67. Champfleury (12), cited C., I, 80.

68. 'The Uprising (the Storm?), buffeting in vain against my window-pane, will not make my forehead lift from my desk; For I shall be deep inside this pleasure of evoking the Spring by my own will, drawing a sun out of my heart, and making from my burning thoughts a warm atmosphere.' B.O.C., p. 78.

69. Berger, p. 28. The whole article is excellent.

70. E.g. Nochlin (1), pp. 68–9. 'In comparison with Chardin's painting, then, which is arranged according to an established hierarchy of values, one might indeed say that Courbet's is a democratic portrait in every sense of the word.'

5. Courbet in Ornans and Besançon 1849-50 (pp. 77–120)

1. See Mayor's letter, 13 Sep. 1849 in AN. F21 36 Huguenin.

2. See letter from the Englishman Peter Hawke to Courbet, 18 May 1849, in Courbet Docs., cited M., p. 46.

3. See letter to Bruyas, 1854, cited Borel (1), p. 38; the offer was for 2,000 fr.

4. Two landscapes were sold for 2,000 fr. to 'un maître de forges de mon pays' in 1854 or 5 (see Borel (1), p. 62). Mazaroz owned the oil of Jean Journet. German collectors were some of Courbet's best patrons.

5. Gautier's description, La Presse, 8 Aug. 1849.

6. In his Annonce; see Appendix 1. Lest there should be any confusion about the direction of my argument as to the 'personal' nature of Une Après-dîner à Ornans as compared with the anonymity of Les Casseurs de pierres, let me say that it seems to me an achievement to see and represent one's personal involvement in an institution or a class situation, when that involvement is a reality, even if a hidden one. (This is the case with Une Après-dîner, and even more so, in a far more complex way, with Un Enterrement à Ornans.) Equally, it is an achievement – and in this case a rare one – to avoid such a reading of a class-situation or a work-situation, when avoidance of personal reference corresponds to the facts: the 'facts' of a bourgeois's radical incomprehension of the psychology of the working man, for instance. Hence the anonymity of Les Casseurs de pierres, as opposed to the conventional bourgeois reading of such scenes in terms of a personal tragedy or a generalized, but 'individual', dignity of labour.

7. Schapiro, p. 165, pointed to the Degré des âges and the Souvenirs mortuaires, Nochlin (1), p. 138, to the Convoi funèbre de Napoléon. The Mort et convoi has a pall, decorated with tears as is Courbet's. On the Van der Helst debt, see Fernier (2).

8. Nochlin (1), p. 144, argues that Courbet has 'whenever possible . . . attempted to distinguish separate skirts by slight variations in the quality of their blackness', and the merging of their dresses 'is more the result of a simple statement of fact – they all wore black to the funeral – than that of abstract

contrivance on Courbet's part'. There seems to me plenty of contrivance in the form Courbet chooses; compare the sketch with the finished work. The variations in the blackness are slight indeed; it is the unity that counts. The essential choice in the *Burial* is one of *disposition*; to arrange the two files one on top of each other, and to do nothing to minimize the effect of that disposition – to leave intact, and to my eye to relish, the wall of black it produces. Cf. the verdict of Montaiglon in *Le Théâtre*, 26 Feb. 1851: 'Dans le groupe des femmes, celles du fond n'ont que des têtes, mais n'ont pas de corps derrière les corps des figures du premier plan, car leurs têtes sont aussi en avant que celles-ci. La couleur est des plus laides; le peintre avait pris le parti brave et intelligent de grandes teintes plates et unies qu'on modèle ensuite par des teintes de lumière et d'ombres, mais il ne les a pas relevées et il semble que son tableau, une fois peint, il l'ait frotté avec un balai chargé de suie.'

9. Champfleury in *Messager de l'assemblée*, Nos. 10 and 11, Feb. 1851; Buchon in his *Annonce*.

10. 'These into the valleys and those into the plains, an umbrella on their backs and both their pockets full, Driving ahead of them their filly or their calf, or leafing through some new almanac.' Buchon (3), p. 244.

11. See the complex argument in *Gustave Courbet, exposition* (Rome), pp. 26–7, by H. Toussaint, which suggests that the Besançon picture is an 1854 repeat, on a slightly smaller scale.

12. Desplaces in *L'Union*, 29 Jan. 1851; Proudhon (1), p. 190.

13. 'Il y avait là des scènes originales et qui rappelaient le moyen-âge; tantôt c'était un mari ayant sa femme en croupe, tantôt le papa et le maman, chacun sur son bidet . . . enfin bon nombre de jeunes et jolies Nor-mandes, quelquefois jusqu'à trois sur le même cheval, et jasant, riant, pressant leur monture. La cause de ces nombreuses cavalcades, c'était le marché de Gisors qui se tient toutes les semaines.' Moll, p. 16.

14. 'A force de matérialiser le rustique, il atteindra l'ignoble. . . . Une reproche qu'on adressera sans doute à M. Courbet, c'est qu'il n'y a pas d'unité dans ses compositions; pas de centre d'où rayonnent l'action et l'émotion; pas de concert entre ces mouve-ments épars. . . . Comme *harmoniste* et comme poète, M. Courbet laisse tout à désirer. Peut-être n'a-t-il voulu que juxta-poser sur une même toile divers échantillons de notre population *montagnonne*.'

15. 'Situation morale des campagnes', *L'Univers*; in Veuillot, p. 227.

16. 'Lorsqu'on l'entendit s'écrier qu'on devait se battre à Paris . . . que les rouges appeleraient le peuple à leur secours . . . que cela voulait bien aller . . . que parmi les blancs de Saint-Claude, il y en avait six qui avaient fait passer soixante livres de poudre en contrebande. Il ajoutait: que feront-ils? si nous ne pouvons les atteindre, on barri-cadera les avenues, on mettra le feu. Par ce moyen, on les fera sortir, alors on leur tirera dessus et on les assommera.' . . . 'Quand la grande lutte viendra, c'est moi qui ferai leur affaire. On fera le grand; il y en aura plus de quarante. C'est comme ce con de curé, qui a pris au père Verguet un bulletin sur lequel était porté le nom de Léon Crestin [Crestin was a candidate of the Left] et qui lui en a donné un autre. Ils sont bien sûrs d'y sauter, ces calotins.'

See AN. BB30 359. Report of Procureur-Général of Besançon, 5 Sep. 1849.

17. Dupeux, pp. 384–5. Dupeux's whole account of this period in the countryside is superb; to be compared with Vigier (1) and Armengaud, as examples of the recent revaluation of these years in the Second Republic.

18. Blanqui (2), p. 216, cited Vigier (1), II, 169.

19. Cited Vigier (1), II, 225.

20. See Mandrou, pp. 167–8, and cf. pp. 145–7.

21. 'Rapport au citoyen ministre de l'Intérieur', *Moniteur universel*, No. 284, 10 Oct. 1848.

22. See the *Catalogue de l'histoire de France*, vol. 4, for lists of almanacs, and cf. Nisard and Gaillard.

23. 'Ils agissent d'abord par la propagande des almanachs, des petits livres et des journaux, qui font plus de mal en ce moment dans les campagnes qu'à aucune autre époque de l'année, en raison des longues veillées d'hiver.' AN. BB30 373.

24. See the list – a typical one – in the Dijon P-G's report, 21 Dec. 1849. AN. BB18 1449.

25. *Almanach Démoc-Soc . . .* , p. 15.

26. Cited in an article by 'A.C.' entitled 'Les Almanachs', *La Voix du peuple*, supplement, 7 Jan. 1850.

27. 7 Oct. 1849, cited Vigier (1), II, 169.

28. 'O when will come the Fair One? It is now thousands and hundreds of years that Jean Guêtré has called for you, Republic of the Peasants.' See pl. 39, *Almanach de Jean Guêtré* (a mythical champion of peasants' rights).

29. 'Our friends the vine-growers and the peasants whom the aristocrat has exploited, to finish with it finally we must take up arms. Let us dance the Carmagnole.' Cited Marlin (2), p. 4.

30. 'Chantaient et colportaient, sans autorisation du préfet, des écrits contenant quelques allusions politiques et des idées obscènes'. AN. BB30 377.

31. Compare this letter in the files of the Prefect of the Doubs (AD. M. 736). 'Parmi les écrits que les amis de l'ordre doivent s'efforcer d'opposer à la propagande démagogique, ils n'en est pas de plus nécessaire qu'un bon almanach populaire. Le comité général de l'association pour la propagande anti-socialiste et pour l'amélioration du sort des populations laborieuses a résolu de donner tous les soins à une publication de ce genre.' They ask for the Prefect's help.

32. 'We will plant the thyme, it will take, the Mountain will blossom'. See Vigier (1), II, 267.

33. 'On remarquait sur les murs des tableaux représentant divers personnages, l'homme du peuple, le sans-culotte, coiffé du bonnet rouge, et enfin une femme répandant du sang par les seins et représentant par allégorie la regénération de 1793.' See A.N. BB18 1470C, which includes the report in the *Tribune de Beaune*.

34. On the secret societies see Vigier, Tchernoff and especially Ténot. On the Bons Cousins society in the Doubs in 1850–51, see P-G's reports on 7 Aug. and 8 Sep. 1851, AN. BB30 373.

35. See Clark (2), p. 288, note 15.

36. The price of land actually dropped in the Second Republic – as a result of the general agricultural depression.

37. Cited Vidalenc (2), p. 351. On the plains, the large proprietors suffered from the agricultural depression and turned to the Party of Order. In the south and east the small man was the chief victim.

38. See Vigier (2), pp. 51–2 on the continuous splitting up of cultivable land in the south and east of France. Cf. Laurent, pp. 103–5 on the 'morcellement' of land in vine-growing areas.

39. 'The mortgages will be burned and all the record offices sent up in flames. Our stolen

goods will be given back, the usurers will be hung, their goods, their *châteaux* and their houses we shall give to all.' Cited Marlin (2), p. 4.

40. See Balzac, esp. pp. 235, 252.

41. Cited Bouillon, p. 89.

42. 'Ecrasé par l'usure du capital emprunté, par les hypothèques, les frais, les impôts et autres charges qui, étant accumulées, font que chaque année il doit plus qu'il ne récolte, malgré son économie et sa prétendue avidité.' . . . 'L'impôt, l'usure, le taux élevé des fermages, l'insuffisance du salaire, l'instruction primaire, la circonscription, voilà les véritables leviers révolutionnaires des communes.' 'Aux Paysans', *Vote universel*, 20 Feb. 1851. The paper was seized by the police as a result of this article.

43. P.V. du Cons. gén. des Basses-Alpes, 1850, pp. 9–10, cited Vigier (1), II, 62.

44. 'La bourgeoisie ayant vendu ses terres et étant créancière des paysans, les démolisseurs ont rendu les bourgeois suspects aux paysans, parce qu'ils ont dit à ceux-ci que les bourgeois s'opposaient à ce que le paysan pût se libérer afin de le tenir en quelque sort en servage. C'est ainsi qu'on a fait déclarer la guerre par la veste à l'habit.' Report of 21 Dec. AD. Drôme M. 1354, cited Vigier (1), II, 62–3.

45. AD. Vaucluse M. 11–70, cited Vigier (1), II, 332.

46. Vigier (1), II, 96.

47. Vigier (1), II, 163–4.

48. On the resistance, see Vigier (1), II, 307–37, Ténot, Blache, and numerous articles esp. Dessal, Lévy.

49. 'Il faisait l'enthousiaste et le révolutionnaire. Je lui ai parlé alors du socialisme des paysans, – socialisme inévitable, féroce, stupide, bestial comme un socialisme de la torche ou de la faulx. Il a eu peur, cela l'a refroidi. – Il a reculé devant la logique.' B.C.G., I, 113–14, letter to Ancelle, Dijon.

50. Marx, pp. 335, 336, 338.

51. Cited R., p. 100.

52. For Cuénot, see Marlin (2), p. 20 and Courbet's later account, letter to Castagnary, 16 Dec. 1869, cited C., II, 117; for Buchon see below.

53. See Marlin (1), p. 41.

54. AN. C.915 Roulans, Doubs.

55. AN. C.915 Besançon, Doubs.

56. See Préclin, p. 286. On the Doubs situation, see also Marlin, Cobban.

57. Both in AD. Doubs 16M. 47, cited Cobban.

58. 'Ce département est toujours celui dont les populations rurales sont animées des meilleures dispositions. . . . La partie des Montagnes est excellente; les paysans ont conservé avec leurs principes religieux toutes les traditions d'autorité et de respect. Le clergé exerce dans ce pays une grande influence, et il n'en use jamais qu'avec une prudente réserve.' AN. BB30 373, report to Minister.

59. Percentages, Marlin (1), tables; report, AN. BB30 373.

60. 'Meneur, propagandiste, homme sans valeur'. Report of the Commission Mixte du Doubs, which superintended the political purge after the *coup d'état*, cited Marlin (2), pp. 18–22.

61. 'L'esprit de famille disparaît chaque jour; la vie de café et d'estaminet remplace l'intérieur du ménage'. Report of P-G, 8 Nov. 1851, AN. BB30 373.

62. Report of 9 Sep. 1851, cited Marlin (2), pp. 5–6.

63. Report of P-G, 2 Sep. 1850 on visit of 18 Aug. AN. BB18 1487.

64. 'Le *Démocrate franc-comtois* attaque chaque semaine la marche et la conduite du gouvernement, ses tendances et ses idées. Il s'en prend surtout à l'esprit et à l'influence du clergé, or le clergé très-sage dans ce pays a une autorité qu'il exerce au profit du pouvoir et de l'administration, et le parti démocratique ne cherche pas sans motifs à ruiner ce puissant auxiliaire.' AD. Doubs M.736, report of Prefect, 8 Apr.

65. 'Tous ses adhérents appartiennent à la classe ouvrière, et ses principaux abonnés sont les aubergistes et les cafetiers.' P-G report, 10 Aug. 1850.

66. On the trial of 24 Aug. see *Compte-rendu du dernier procès du démocrate franc-comtois*, and various reports of P-G. Compare AN. BB18 1487 – dossier on the paper, included in file of 'subversive' newspapers for 1850.

67. 'Ville d'agitation et désordre, dont les anarchistes du Jura ont fait en quelque sorte leur capitale.' P-G report, 17 July 1850, concerning *Délit de presse*, AN. BB18 1470B.

68. Vidalenc (2), p. 146.

69. Desaunais, p. 145, on the diversity of reasons for the unpopularity of *Ateliers d'orphelins*. Compare Bonvin's apologia for orphan schools.

70. Manuscript notes of 28 June 1848 in Arbois municipal library, cited Desaunais, p. 287. See his whole account, pp. 284f.

71. AN. BB30 359.

72. Biographical details: Frey; Bouvier, p. 181; Mack, pp. 21–3, 51–2.

73. See Desaunais, p. 100.

74. Troubat (2), pp. 81–2, citing a narrative by C. Baille in *Le Doubs*, 18 Dec. 1869.

75. Verdict of one P. Marmorat, cited Desaunais, p. 201.

76. 'Roch said to the cock: I'm going to stuff you, the cock said to Roch: For Christ's sake, do you want to do a good deed? Instead of stuffing me, stuff Chavet, Richardet and Buchon!' Desaunais, pp. 299–300.

77. His title in *Affiche* of 28 June 1849, in AN. BB18 1449 (seditious posters, etc.).

78. See AN. BB18 1470B, P-G report of 2 Aug. 1849, which mentions Buchon's letter to Mlle Bonnavent.

79. 'J'ai appris que ses amis politiques se disposaient à lui donner une ovation, lors de son passage à Arbois; j'ai pris des mesures pour que le voyage se fît par une autre route et ce voyage a eu lieu sans le moindre scandale.' P-G report, AN. BB30 373, 30 Nov. 1849. Cf. Courbet's own angry account, in 1869, letter to Castagnary 16 Dec., cited C., II, 116–17.

80. On 6 Dec. On the press offence, he was charged with Sommier and Richardet; on the June uprising charge, with Chavet, Lacroix, Ch.-Touhin, Montmayeur (all of Salins), Robert from Dôle, and Pelletier from Aiglepierres. Report in *Le Franc-comtois*, 26 Dec. 1850.

81. Cited Bouvier, p. 197.

82. Cited R., p. 82.

83. 'Je te félicite de ton article, je t'en sais grand gré, il ressemble parfaitement à la nature de mon talent, et il est de cet art que j'aime tant.' Cited, R., p. 82.

84. AN. BB18 1482 dossier 8381.

85. Tradition – not a particularly reliable one – has it that the burial is that of Courbet's grandfather, in 1848. It might be so, but this would not alter the intertwining of personal and political meanings in this picture; after all, as Courbet repeated time and again, his grandfather was his great political mentor. See e.g. the manuscript

political biography, cited C., II, 49: 'Mon grand-père était un sans-culotte'. Quite a funeral for a sans-culotte! Cf. statements cited M., pp. 5–6.

86. R., p. 3, cf. V. Ch. in obituary notice, *Moniteur universel*, 2–3 Jan. 1878, 'Ses parents, braves gens qui étaient demi-bourgeois, demi-paysans.'

87. See M., pp. 6–7 and Léger (2), p. 9 on dissensions within the family – according to Léger, when Régis Courbet came to his Ornans house the women left for Flagey!

88. See Appendix 2. The folk-songs and peasant plates were being collected for Champfleury.

89. See Vigier (3), p. 116.

90. In his review of the *Paysans de Flagey*, in *L'Impartial*, Jan. 1851. He also includes G. Sand's *Petite Fadette* and *Champi*, Lamartine's *Geneviève*, A. Karr's *Jean Duchemin*, and A. Weill's *Nouvelles alsaciennes*!

91. Troubat (3), pp. 100–1, letter of Dec. 1849.

92. 'Voilà ce qu'il faut leur dire, interrompit le cantonnier avec une certaine vivacité: privé de l'aide de Jean Grusse incarcéré et de mon Valentin parti pour le régiment, abattu moi-même par la maladie, j'étais hors d'état de continuer le bail sur l'ancien pied; et M. Crochot prétendait à une augmentation! De là à réduire le fermage, il y avait trop loin. Il laissa passer mars, avril et me proposa de remettre les choses comme par le passé. Les terres étaient en souffrance; consentir, c'était le tromper, et, pis que la ruine, se jeter dans les dettes. Il me restait du bétail et du matériel: j'aurais tout perdu. J'ai mieux aimé rompre sur-le-champ et vendre ce que j'avais en mobilier à mon voisin Jean-Denis. J'en ai retiré quelque argent, ce qui nous aide à vivre, car notre travail et le courtil de Jean Grusse, écorné par le fisc, n'y suffiraient pas.' Wey (2), pp. 175–6.

93. Wey (2), p. 179.

94. 'Les bourgeois, quelques uns du moins, car je ne dis pas cela pour Monsieur, les bourgeois ignorent que la ruine du cultivateur rejaillit sur eux.' Wey (2), p. 186.

95. Wey (2), p. 159.

96. Champfleury (13), p. 128, in course of conversation about an eviction.

97. Champfleury (13), pp. 3–4.

98. Champfleury (13), p. 9.

99. 'Guenillon had not forgotten the avaricious usurer justly punished by God.' Champfleury (13), p. 185; cf. pp. 64–5 for the *colporteur* and the children.

100. Sand, p. 40.

101. Sand, pp. 36–7, preface of Sep. 1848.

102. It had been serialized in part in 1844; Gautier certainly knew it (see his review of Courbet); Wey probably did. Champfleury mentions having 'just' read it in a diary entry of 1857; see the epigraph to my Postscript.

103. Compare Lukács – the first classic essay on *Les Paysans* – with Macherey's essay.

104. P. 87 of this book. Cf. Macherey, p. 306. His verdict is right, but he underestimates the closeness of certain parts of Fourchon's speech to the discourse of actual peasant rebels.

105. Macherey, p. 300. His whole account derives from Roman Jakobson's fundamental ideas on the essentially 'metonymic' structure of Realism – and these again can be applied directly to Courbet, especially the emphasis on a method of juxtaposition, of 'contiguous relationships', digression, and a fondness for 'synecdochic details'. See Jakobson, pp. 77–8.

6. Courbet in Dijon and Paris 1850–51 (pp. 121-54)

1. 'M. Courbet ne fait que ce qu'il veut; il a vu laid; il a peint comme il a vu Ce monsieur en habit noir, dont le nez, comme celui du Père Aubry, *aspire à la tombe*, M. Courbet lui a serré la main. C'est vrai, horriblement vrai. Est-ce une excuse suffisante? Non . . . nous soutenons qu'en peinture, comme en poésie, il faut faire un choix.'

2. 'Le coloris est vrai comme le sentiment, et l'expression est charmante comme le coloris. Cette étude consciencieuse restera, et notre musée serait heureux de la posséder.'

3. 'Ce gros et court personnage au crâne luisant, au nez épaté et sensuel, qui tourne les feuillets de son livre en pensant probablement aux truites de la Loue qui l'attendent au souper, il existe quelque part.'

4. AN. F18 262. Other papers published in Dijon in 1850 included *Le Spectateur, Journal de la Côte d'Or, Courrier républicain, Le Châtillonais, La Tribune, L'Ordre, Union provinciale, Démocrate de Saône et Loire, Socialiste de la Côte d'Or* and *Courrier de la Côte d'Or.*

5. 'Chronique de la Contre-Révolution Européenne', 9 Dec. 1849.

6. P-G report, 9 Apr. 1850, AN. BB30 377.

7. 11 May 1850, AN. BB30 377.

8. 'Soumis chaque jour à l'influence d'une propagande démagogique qui ne se ralentit pas, ces hommes peu éclairés se laissent égarer, mécontents qu'ils sont surtout du bas prix de leurs produits et de la stagnation des affaires.' AN. BB30 377.

9. The first phrase occurs in the same P-G report. See AN. BB18 1488 Dossier A9213 for various reports on the paper by the Procureur.

10. On Dijon at this time see Nolle, subtitled 'Notes on a crisis of economic growth', and Gauchat.

11. See Gauchat, pp. 341–2.

12. 'Une grande et immense cité, une ville premier ordre'. Cited Nolle, p. 25.

13. Nolle, p. 35. 'A l'actif de ces années, retenons donc surtout l'affermissement de sa position de marché des céréales, une prise de conscience de plus en plus nette de ses possibilités, la conquête de certains moyens indispensables à leur réalisation.' On pp. 29-34 he describes the piecemeal process of change in the city's trade and industry.

14. Compare the date-lines of his letters to his mother in May and June 1850.

15. 'Il n'est pas encore temps de dire l'impression que produiront ces scènes domestiques, grandes comme des tableaux d'histoire, et où l'auteur n'a pas reculé à peindre la bourgeoisie moderne en pied avec son costume provincial et brossé. L'époque des plumets est passée, beaucoup regrettent les costumes de Van Dyck; mais M. Courbet a compris que la peinture ne doit pas tromper les siècles futurs sur notre costume. Et cependant . . . [For Baudelaire citation see B.O.C., p. 950]. Le peintre ornanais a compris entièrement les idées d'un livre rare et curieux (Le Salon de 1846, par M. Baudelaire).'

16. Vigneron had exhibited *Convoi du pauvre* in the 1846 Salon (it is mentioned in the 1848 booklet *Quelques vérités . . .*); Augustin Roger had an *Enterrement de village* in the 1822 Salon, see Nochlin (1), ill. no. 74.

17. 'It costs a good deal to die in Paris, and funerals, Sir, are monstrously dear.' *Quelques vérités . . .* title page, from *Les Etourdis* by Andrieux, scene I.

18. Da., p. 11.

19. Champfleury (13), p. 180.

20. See Flaubert (2), pp. 380–3, for the funeral, and Flaubert (1), p. 352, for the letter.

21. See *Quelques vérités . . .* ; and L. Aubineau, 'Des Enterrements', *L'Univers* 25 Mar. 1851.

22. See Da., p. 348; on the Dijon incident, see P-G report, 11 May 1850, AN. BB30 377.

23. 'Pour compléter la démonstration, le journal de la réaction aurait dû nous prouver qu'ils n'étaient pas socialistes ces prolétaires qui allaient par milliers prier au pied de la croix principale des cimetières en mémoire de leurs parents, *morts trop pauvres pour obtenir une tombe à eux seuls*. Que les *Débats* en soient bien convaincus, ces malheureux n'étaient pas réactionnaires. Nous les avons vu les adversaires du socialisme, des hommes, des femmes à la mise élégante, ne priant ni devant la fosse commune ni devant des fosses particulières, mais se promenant dans les allées du Père-Lachaise comme on se promène aux Tuileries.' 'Le Jour des Morts', *Démocratie pacifique*, 8 Nov. 1849.

24. Montaiglon, *Le Théâtre*, 26 Feb. 1861.

25. See Nochlin (1), pp. 173–4.

26. The woman is reminiscent of some of Daumier's early paintings like *Le Fardeau*, which Courbet could have seen; for the bearded head, cf. *L'Homme à la pipe*, or even his self-portrait in *Après-dîner à Ornans*.

27. List of 1851 'Salons': the dates given are of the articles on Courbet. J.-J. Arnoux, *La Patrie*, 30 Jan. T. de Banville, *Le Pouvoir*, 9 Jan. E. Bonnassieux, *Courrier de Paris*, March. L. Bourgoin, *L'Impartial de 1849* (Besançon), 2 Jan. M. Buchon, *L'Impartial de 1849* (Besançon), 17 Jan. A. de Calonne, *Opinion publique*, 23 Feb. Champfleury, *Messager de l'assemblée*, 24–26 Feb. P. de Chennevières, *Lettres sur l'art français en 1850*, Argentan, 1851. Courtois, *Le Corsaire*, 14 Jan. A. Dauger, *Le Pays*, 19 Jan., 9 Feb. E. J. Delécluze, *Exposition des artistes vivants, 1850*, Paris, 1851. A. Desbarolles, *Courrier français*, 13 Jan. L. Desnoyers, *Le Siècle*, 9 Feb. A. Desplaces, *L'Union*, 29 Jan. A.-J. Dupays, *L'Illustration*, XVII, 71–3, 104. L. Enault, *La Chronique de Paris*, 16 Feb., p. 120. G. de Ferry, *L'Ordre*, 10 Jan. A. de la Fizelière, *Le Siècle*, 21 and 22 Apr. A. de la Fizelière, *Exposition nationale, salon de 1850–51*, Paris, 1851. A. Galimard, *Le Daguerréotype théâtral*, Jan.–Feb. (no mention of Courbet). T. Gautier, *La Presse*, 5, 6, 14 Feb., 15 Mar., 8 Apr. T. Gautier, 'Distribution des Récompenses', *L'Artiste*, 15 May, pp. 116–18. L. de Geofroy, *Revue des deux mondes*, 1851, pp. 928–37. P. Haussard, *Le National*, 7 Jan., 20 Feb. Havas, *L'Impartial de 1849* (Besançon), 2 Jan. F. Henriet, *Le Théâtre*, 11 Jan. J. La Beaume, *Lettres sur l'exposition des artistes vivants, salon 1850–51*, Langres, 1851. P. Mantz, *L'Evénement*, 15 Feb. F. de Mercey, 'Les Arts en France depuis le dernier Salon', *Revue des deux mondes*, 1 Jan. 1852, pp. 125–47. Méry, *La Mode*, 26 Jan. E. de Mirbel, *La Révolution littéraire*, I, 26–7. A. de Montaiglon, *Le Théâtre*, 26 Feb. 'N', *Indépendance belge*, 22 Jan. A. Léon Noël, *La Semaine*, 17 Jan. L. Peisse, *Le Constitutionnel*, 8 Jan., 20 Apr. T. Pelloquet, *La Liberté de penser*, second article, pp. 333–5. P. Petroz, *Le Vote universel*, 14 Jan. F. Pillet, *Le Moniteur universel*, 15 Feb. C. de Ris, *L'Artiste*, 1 Mar. G. Planche, 'Géricault', *Revue des deux mondes*, May 1851 (comparison with Courbet). P. Rochéry, *La Politique nouvelle*, 2 Mar., pp. 29–32, 131–2. Roux-Lavergne, *L'Univers*, 1 Feb. F. Sabatier-Ungher, *Salon de 1851*, Paris, 1851. Thénot, *Gazette de France*, 30 Jan., 25 Feb., 10 and 14 Apr. (no mention of Courbet). E. Thierry, *L'Assemblée nationale*, 22 Feb. C. Vignon, *Salon de 1850–51*, Paris, 1851. A. Vitu, *Le Magasin des familles*, Mar. 1851, pp. 609–23.

Also Cham, *Revue comique du salon de 1851*, Paris, 1851. Foulquier, 'Revue comique du Salon', *La Semaine*, 17 Jan.

All my other Salon citations will refer to this list.

28. *Le National*, 22 Apr.

29. 'Ces grandes toiles, faites pour provoquer l'œil, visent à peindre le peuple, à l'enseigner lui-même par des exemples et à enseigner la société par le spectacle de ces conditions souffrantes et déshéritées.' *Le National*, 22 Apr.

30. See e.g. Dauger, 14 Feb., Gautier, 11 Apr., and defence by Petroz, 18 Feb.

31. Mirbel, p. 66.

32. Report by Pelloquet, *Le National*, 9 Jan.

33. Typical example, de la Fizelière (2), p. 62. 'Quelle misère et quelle honte ! Epargnez-moi celle de vous dire le sujet de ce tableau, . . . etc.' cf. attacks by Petroz, Noël.

34. 'De l'art grec vivant'. Sabatier-Ungher. Critics like Ferry, Mantz, Rochéry, and Dauger were hostile to Chassériau in 1851, calling him an imitator; Haussard and Montaiglon, for example, saw his originality. Delacroix had many defenders by now – Noël, Peisse, Gautier, Petroz, C. de Ris, Rochéry, Dauger, even an execrable critic like Enault.

35. According to Gautier, 8 Apr.

36. Geofroy.

37. Meyer Schapiro's phrase, talking of the *Stonebreakers*, p. 166.

38. 'Tous les tableaux de M. Courbet ayant été désignés pour être remontés, nous avons cru pouvoir garder pour le Salon carré celui qui nous était le plus utile pour l'arrangement, celui qui avait été plus particulièrement l'objet d'une vive controverse de la part du public et des artistes, et du Jury en particulier.' Jury de placement, Session de 10 Mar., in Archives du Louvre, Salon of 1850-51, Carton 1. The confusion surrounding the vote was Cogniet's excuse for not obeying it. The move to the cornice was noted in *L'Illustration*, 15 Mar., p. 163.

39. 'Sa peinture est une machine révolutionnaire. . . . On ajoute même, pour augmenter notre effroi, que cet art nouveau-né est fils légitime de la République; qu'il est le produit et la manifestation du génie démocratique et populaire. Par M. Courbet l'art s'est fait peuple.'

40. Roux-Lavergne.

41. Cf. 'N': 'Il aurait, dit un de nos confrères, découvert, inventé une nouvelle face de l'art, et sa peinture serait une catapulte révolutionnaire'. 'N' even objects to the fact that Courbet has given his pictures such enormous signatures 'en rouge', and curiously enough this was one criticism that the painter took to heart. He painted out the great red signature at the bottom left of the *Burial*, though its traces are still visible. Depays notes that Courbet's art is claimed as 'l'inauguration d'un nouvel art populaire . . . l'avènement d'un art nouveau, de l'art du peuple, selon l'abus des grands mots.' Gautier talks of 'des peintres animés, dit-on, d'idées républicains ou socialistes'. And Thierry, in the most extravagant attack of all: 'C'est bien. Voilà un beau triomphe ! Le socialisme doit applaudir de toutes ses mains. . . . Courbet a trouvé la réponse. Il a détruit l'art d'un seul coup, et il l'a remplacée. Il n'y a pas d'art, puisque la négation de l'art peut suppléer l'art lui-même. . . . C'est bien. Mes yeux ont vu la peinture égalitaire.'

42. E.g. p. 36, 'le peuple, entré dans la politique, veut aussi entrer dans l'art.'

43. *L'Evénement*, 11 Mar. 1866, cited C., II, 223, and in full in Vallès (2), pp. 411-15.

44. See A. Tudesq, 'L'Influence du romantisme sur le légitimisme sous la monarchie de juillet', in *Romantisme et politique*, pp. 30f.

45. Against: Courtois, Dupays, Gautier, Haussard, Henriet, Montaiglon. For: Buchon, Desbois, Bourgoin, Arnoux, Champfleury, Fizelière (2), Méry, Petroz. Courbet finds some odd defenders on this point. The conservative Arnoux: 'vous tenez à faire penser devant votre œuvre, vous voulez nous faire voir ce qu'est un enterrement dans nos provinces moins affairées, moins distraites, moins frivoles que la capitale.

'C'est pour cela, c'est pour frapper fortement les imaginations, que vous avez donné de telles proportions au sujet que vous choisissiez.' Or this, from Fizelière: 'L'Enterrement à Ornans, de M. Courbet, va nous servir à comprendre qu'un sujet épisodique peut ambitionner les plus vastes proportions, s'il est concentré dans les exigences d'une conception une et simple.'

46. The 13: Bourgoin, Arnoux, Bonnassieux, Delécluze, Enault (very threadbare remarks in passing), de Ferry, Gautier, Geofroy, Haussard, Mantz, Montaiglon, Petroz, Vignon. Desbarolles wrote, 'Les localités sont partout attaquées hardiment et c'est là, nous n'en doutons pas, ce qui donne au tableau son cachet de vérité; rien n'appelle les yeux, tout les repose, et par cela même on trouve du plaisir à le regarder.'

47. 'L'avilissement ou le baroque prodigieux de l'idée a gagné l'exécution même. La disposition des lignes semble calculée à l'encontre de toute règle et pour la plus grande laideur pittoresque: figures à la file ou dos à dos, groupes décousus ou contrariés, entassement plutôt que masse, discordance continue au lieu d'harmonie, rien n'y manque.

'La peinture se met aussi à l'unisson du sujet. . . . Dans l'ensemble, ou bien l'effet tombe dans une monotonie grise et sale, ou bien il tourne aux crudités de l'enluminure, quand pour sauver de tels types et de telles scènes, il faudrait les chocs vigoureux et les éclairs de teintes du Caravage ou l'envelop-pement magique du clair-obscur de Rembrandt.'

48. Petroz; Geofroy; Bonnassieux; Gautier.

49. 'Quant à l'art non-seulement il n'y en a pas d'ombre dans cette composition mais il est évident que l'auteur s'est très-volontairement gardé d'en mettre, et qu'il a même affecté une ignorance et une simplicité qu'il est loin d'avoir.'

50. 'Maniériste du laid'. Gautier.

51. 'Vulgarité des types', 'recherche de l'ignoble', 'figures triviales'. Roux-Lavergne; Desplaces.

52. 'Le parti pris de la laideur'. Cited Marcel, p. 37.

53. The critics who make this perplexity about intention clearest are Haussard and Arnoux (cited), Desbarolles, Gautier, Montaiglon.

54. 'Cette longue file de masques burlesques et de difformités prises sur le fait, ce clergé de village et ses acolytes impayables; ces deux marguilliers aussi cramoisis de trogne que de robe; ce loustic, en chapeau tromblon et moustache à croc, qui porte le cerceuil, cet épais fossoyeur qui pose solennellement un genou en terre sur le bord de la fosse; ce sérieux, ce bouffon, ces pleurs, ces grimaces, ce deuil endimanché en habit noir, en veste, en béguin, tout cela figure un enterrement carnavalesque sur dix mètres de long, une immense complainte en peinture où il y a pour rire bien plus que pour pleurer?'

55. On the Carnival in Ornans see Courbet's letter, Appendix 2; on the orgiastic goings-on in Paris on Ash Wednesday, see Starkie (1), pp. 61-4.

56. 'Mais voici qui est plus attristant: d'où viennent, au milieu de la cérémonie funéraire, ces lazzis de mauvais goût sur la 'rouge

trogne' des chantres et des bedeaux? Pourquoi venir ici me montrer avec tant de complaisance toutes ces laideurs écœurantes, ces faces ignominieusement sales, ces grotesques platitudes? Est-ce une épigramme à l'endroit de la sacristie? Mais prenez garde! Vous ne m'avez averti que vous peigniez une mascarade, que vous recommenciez sur toile les drôlatiques funerailles de *Malbroug*, porté en terre par quatre z'officiers, en donnant seulement à la chanson populaire les proportions de l'épopée.

'J'entends, c'est du Shakespeare que vous avez voulu faire. Ce crâne que vous mêlez à la terre fraîchement remuée, sur les bords de la fosse, c'est, dans votre esprit, celui d'Yorik.'

57. 'The ceremony over, each one went to bed, some of them with their wives, and the others all alone, it's not that they were lacking, for I know plenty of them, blondes and then some brunettes, and also some red-heads. I won't say any more on the subject, for that is quite enough.' Illustrated in Mistler, p. 113.

58. Compare Gautier: 'Peut-être M. Courbet a-t-il voulu transporter à Ornans l'*Enterrement* des scènes populaires d'Henri Monnier, avec ses trivialités discordantes et les contrastes choquans ou mélanger, comme dans la scène des fossoyeurs d'*Hamlet*, à la mélancolique pensée de la mort l'insouciante grossièreté de la vie; toujours est-il que sa pensée n'est pas claire, et que le spectateur flotte dans l'incertitude.' Or Desbarolles: 'N'aurait-il pu se réserver une toile à part pour y peindre des caricatures, et sont-elles a leur place dans une scène d'enterrement? ou bien a-t-il voulu imiter Shakespeare?' And Montaiglon: 'il y avait vraiment à demander au peintre ce qu'il avait voulu faire dominer, de la charge ou de la douleur.' Other critics referred to different aspects of popular art. Champfleury compared Courbet's pictures to the naive woodcuts of rue Gît-le-Cœur – the *Burial*, he said, surprises us in the same

way as these pictures of the latest murders. Labeaume was more hostile: 'les types de ses paysans sont visiblement empruntés aux mirobolantes décorations qui égaient les foires, et traités avec le même sans-gêne d'expression, la même distinction d'agencement et de couleur. Je me trompe; les tableaux de la foire ont un mérite qui manque à ceux de M. Courbet, la naïveté!' And so was Louis de Geofroy: 'il ramène l'art tout simplement à son point de départ, à la grossière industrie des maîtres imagiers.' Sabatier-Ungher of course defended Courbet's popular qualities – he talked of the accuracy of Courbet's observation, the simple truth of the contrasts he painted. They were 'du haut comique populaire'. 'Voici la démocratie dans l'art. Il faut mettre de côté les petites délicatesses des littératures énervées. Le peuple ne craint ni les mots crus ni les images fortes qui donnent mal aux nerfs aux gens de goût . . .' p. 63.

59. See Mandrou, pp. 168–70.

60. 'Peint avec une furie espagnole de franc goût'. Geofroy (who calls the portrait 'Jean Journet en Juif Errant'): '. . . beau de caractère, de style et nous dirions même – de couleur'. Noël (cf. 'un portrait de Jean Journet, l'apôtre fouriériste, qui représente assez bien le Juif-Errant . . . Ce portrait n'est pas ressemblant, dit-on; peu nous importe!').

61. 'Villageois et villageoises'. Dauger. 'Le peuple de nos campagnes'. Haussard.

62. 'Ménagerie des bipèdes'. Roux-Lavergne; he went on to other definitions.

63. Peisse.

64. 'Les caricatures ignobles et impies des juges, du garde-champêtre et de tous ceux dont vous avez entouré la fosse béante'.

65. 'On voit des hommes noirs plaqués sur des femmes noires, et, derrière, des bedeaux et des fossoyeurs à figures ignobles, quatre porteurs noirs avantagés d'une barbe démoc-

soc, d'une tournure montagnarde et des chapeaux à la Caussidière! Voilà!' Caussidière was the revolution's chief of police for a short while in 1848 and dressed his men in sashes and wide-brimmed hats.

66. Arnoux; Desplaces.

67. 'Les hommes faits causant d'affaires', 'Les désœuvrés de province en paletots et en pantalons noirs n'ont pas de têtes assez attrayantes pour qu'on néglige ainsi toutes les ressources du procédé'.

68. Gautier, Desbois, Mantz, Méry respectively. I have deliberately left this sequence of quotations untranslated. None of the French is difficult, yet it seems to me that it is travestied by translation.

69. Roux-Lavergne (see note 68).

70. Ferry (see note 68).

71. Compare Vitu's 'des paysans endimanchés'; Pillet's 'ces villageois endimanchés'; Haussard's stress on differences of costume, 'ce deuil endimanché en habit noir, en veste, en béguin'; Geofroy's contempt, 'ces affreux habits neufs dont il orne presque toujours ses paysans'.

72. 'Une nature sans distinction grande certainement, mais tenant bien sa place au moins, et ne visant pas a l'exagération du vulgarisme'.

73. 'Nous connaissons dans cette école réaliste un jeune homme de talent et d'avenir . . . celui-là du moins a une poésie à lui, une sauvagerie qui impose, une mise en scène qui repousse ses personnages et les tient à bonne distance. Il s'appelle François Millet, et il a envoyé au salon deux toiles. . . . Toujours la nature aux champs; mais c'est bien là qu'il faut l'aller chercher. Le *semeur* est un rude paysan qui n'y va pas de main morte et dont la grossièreté primitive n'a rien à craindre de son séjour en plein Paris: il restera toujours ce qu'il est, campagnard de pied en cap . . .'

74. In *Le Siècle*; he is arguing that Millet's view of the countryside is in fact more honest than this typical escapist city view.

75. Desnoyers.

76. Bourgoin.

77. Arnoux; Henriet.

78. 'Elles trouvent pour les admirer un mystérieux et formidable parti.'

79. Desplaces.

80. 'Une faction fort compromettante de l'école naturaliste'. Mercey. 'Plusieurs figures, rouges de fureur'. Méry. 'Demandez à Courbet ce qu'il faut pour prendre et déterminer l'opinion? Il faut avant tout lui faire violence.' Thierry.

81. 'Les louanges étranges décernées à M. Courbet ont eu pour premier organe certain populaire aviné qui envahit les banquettes du Salon-Carré. Qu'avait-il là à regarder en effet, si ce ne sont les plus mauvaises croûtes? – Puis des rapins ont fait écho, de proche en proche, il a été question de M. Courbet.
 'Pour moi, M. Courbet doit avoir longtemps barbouillé des enseignes, particulièrement celles des fumistes et des charbonniers, et probablement il n'avait pas une prétention plus élevée lorsqu'il courait les foires, à ce que prétendent des médisants qu'on dit bien informés, exposant ses incroyables toiles dans une baraque sur laquelle était écrit: GRANDS TABLEAUX DE COURBET, OUVRIER PEINTRE.'

82. See 'Rapport de 1855 sur le Nombre des Visiteurs à l'Exposition Universelle des Beaux-Arts', AN. F21 519, which gives the history of these experiments.

83. In *La Feuille du peuple*, June–Aug. 1851.

84. A. Lireux in *Le Constitutionnel*, 20 Jan. 1851.

85. Lecouturier, cited Ch., p. 459.

86. Cited Ch., p. 459.

87. See Ch., p. 366. On Paris as an immigrant city, see Chevalier (1), and Daumard. See also the pseudo-sociological *Physiologies* of the 1840s, like the *Physiologie du provincial à Paris*, 1841.

88. Ch., esp. pp. 360–79. Cf. Da., pp. 184–212.

89. On the new *quartiers*, see Chevalier's brilliant 'Les Pierres de la cité', Ch. pp. 368–77; on the *banlieue* insurrection, see Molok.

90. 'On prie M. Courbet de vouloir bien faire raccommoder la chemise et laver les pieds à ses casseurs de pierres. – Un homme propre et délicat.' Preserved in AN. F21 519.

91. See Da., pp. 226f., on the effect of immigration on all social milieux. See Da., pp. 249–86, on the recruitment from provincial rural milieux into all levels of the bourgeoisie. On the importance of marriage to social success, see Da., p. 263.

92. Da., p. 258.

93. On the way in which this section of the bourgeoisie merged with the working class and the artisanate, see Da., pp. 250–7. She calls it a 'petite bourgeoisie populaire' or even a 'capitalist proletariat'.

94. Cited Da., p. 246.

95. The first was commonplace, e.g. in our period, P. Mayer, 'Le Spectre rouge de 1852' in *La Patrie*, 17 Apr. 1851: 'La bourgeoisie, c'est tout le monde. . . . Quiconque aujourd'hui gagne son pain ou le fait gagner à d'autres; quiconque manie honnêtement et virilement l'outil d'une industrie . . . etc.'; the second is Baudelaire on Daumier; next Baudelaire in the 1846 Salon; last Flaubert to G. Sand, 1867, cited in Sartre.

96. AN. étude, LXXVI, testament déposé 19 Oct. 1841 (written 1838–39), cited Da., p. 256.

97. E.g. *La Comédie sociale, l'ouvrier et le paysan* by B. Gastineau, in *Le Travail* (Dijon), 25 Jan. 1850. It is odd that this theme of bourgeois rejection of peasant parents appears in *Le Travail*, which was the direct successor of *Le Peuple*. Four months later, the same paper published Buchon's advertisement.

98. Niépoivié, p. 117, cited Da., pp. 245–6.

99. These very surprising facts are given Da., p. 397.

100. This sketch of a complex and often contradictory body of work is based on the following kind of book-cum-pamphlet, which poured off the presses at this time: Romieu, De Thiais, Blanqui, Modeste, De Lasteyrie, Bonnemère, Villermé, Durrieux.

101. Da., p. 285.

102. Cf. Lévi-Strauss, p. 52, on two Bororo myths. 'It would therefore seem that the two myths, taken together, refer to three domains, each of which was originally continuous, but into which discontinuity had to be introduced in order that each might be conceptualized. In each case, discontinuity is achieved by the radical elimination of certain fractions of the continuum. Once the latter has been reduced, a smaller number of elements are free to spread out in the same space, while the distance between them is now sufficient to prevent them overlapping or merging into one another.'

103. 'Le paysan trouve dans son existence rude et sévère des compensations inconnues aux classes ouvrières de nos grandes cités. Il est le collaborateur plutôt que le salarié de celui qui l'emploie. Il fait partie de la famille du cultivateur; il mange le même pain noir que lui à la table commune . . . Qui pourrait dire aussi le charme qu'il éprouve à parcourir du regard le petit enclos qui entoure sa chaumière, l'arbre qu'il a planté, la vache qui nourrit ses enfants; à contempler sa vigne et son figuier, enfin! Il a peu de jouis-

sances, mais il a peu de besoins, et souvent il nous plaint de vivre au sein des villes et des tentations, pendant que nous le plaignons de vivre dans son village, étranger à nos emotions factices et à nos passions délirantes.' Blanqui (1), XXVIII, 13.

104. 'Cette marche parallèle et sinistre de la richesse et de la misère, dans le pays de grande industrie comme dans les pays de grande culture.' Blanqui (1), XXVIII, 23.

105. 'L'homme de loi, le vrai fléau des populations rurales . . . un homme d'affaires, un huissier retiré, un greffier qui a vendu la charge qu'il avait au prétoire, un avocat sans clients, un licensier avorté, qui cultive à la fois son petit enclos et ses petites causes, et qui vit de menus frais, habilement répétés jusqu'à épuisement du plaideur. C'est lui qui pratique ou dirige l'usure sous les formes variées qui la distinguent dans les campagnes; c'est lui qui divise la terre en parcelles atomistiques pour les ventes, et qui exploite avec une habileté consommée l'ignorance et les passions du paysan.' Blanqui (1), XXX, 14.

106. The view of the peasant as brute regularly and thoughtlessly coexisted with the view of the countryside as idyllic and its inhabitants as noble. E.g. Romieu, pp. 317–18. 'Le paysan a volontiers recours au mensonge; c'est l'habitude des Orientaux et des sauvages. . . . Vingt siècles lui ont donné le respect absolu de la force. . . . On fit roi dans les forêts (dit ce vieux poète du temps de saint Louis) *le plus brutal* et le plus ossu de la bande.' Cf. p. 318. 'La contemplation involontaire de la nature, toujours solennelle et toujours grande, [communique] à l' homme des champs une gravité recueillie qui contraste avec la bruyante verve et l'allure aventureuse des ouvriers de nos chantiers. Le travailleur agricole n'a rien de cet esprit pétulant et hasardeux que l'atelier favorise.' She then goes on to half-justify the contradiction by saying that the first type of peasant is typical of districts not yet 'modernized'; but she has, a few pages before, stressed the

permanence of peasant attitudes, and especially of the peasant's hostility – it is easily transferred, she says, from the old *seigneur* to the new proprietor. David de Thiais likewise swaps a view of present degradation for a vision of a new rustic golden age.

107. 'Le paysan est généralement jaloux du bourgeois; sa supériorité morale et sa fortune l'offusquent'. Thiais, p. 14; 'Le paysan d'aujourd'hui se méfie de l'homme riche qui, vêtu d'un frac noir, doit sa fortune à son industrie et paye grandement le travail des manœuvriers qu'il emploie.' Romieu, p. 315.

108. 'A ces traits principaux se mêle une défiance extreme, un habit noir est un ennemi pour l'homme des champs.' Durrieux, p. 25; 'Le bourgeois campagnard a la glorieuse mission de régénérer nos contrées . . .' Durrieux, p. 23.

Postscript (pp. 155–61)

1. Champfleury (12), p. 246.

2. 'C'est le peuple qui va tout à l'heure donner le ton en personne; mettez-vous donc à l'unisson de ses fanfares, qui ont pour elles la consécration du passé et la certitude de l'avenir.
'Si vous voulez que le peuple vous comprenne, endossez vite sa blouse bleue, dans vos œuvres; enfoncez-vous vite son casque à mèche jusque sur la nuque, chaussez vite ses gros souliers. Un peu de fumier aux mains ne vous siérait même, à l'occasion, pas trop mal. . . . Oui, oui, du fumier! J'insiste sur le mot. Pincez-vous le nez si cela vous offusque. Tout provient du fumier dans ce qui nous alimente et nous habille, et nous-mêmes nous ne sommes non plus que du fumier, à ce que disent la Bible et la chimie.' Buchon (6), p. 92.

3. See Borel (1), p. 78. Addition to the catalogue introduction.

4. Troubat (2), p. 162.

5. Dolléans, p. 256.

6. See his 1852 booklet 'A l'appui de la vérité du 2 décembre 1851', reprinted in Bruyas (1), pp. 5–6.

7. 'Les puissants ont sur vous raison'. See, e.g., Bruyas (1), pp. 33, 75.

8. See Bruyas (2), p. 37. It seems strange to me that previous writers on Courbet and Bruyas have not said the obvious – that Bruyas was, in his writings at least, rather more than eccentric. Closer to madness in fact; closer to Jean Journet (there are traces of a half-baked Fourierism in his views on politics).

9. See letter from T. Silvestre to Bruyas, 14 Feb. 1874 (the incident still rankled!), Bibliothèque municipale de Montpellier, Ms. 365. The whole correspondence is full of the old quarrel. At one point, 22 Feb. 1874, there is, curiously, mention of Baudelaire, à propos of Courbet. 'Quant à ce que vous dites de notre cher et regretté Baudelaire, vous avez bien raison: Lui n'était pas un goujat, comme l'autre; c'était un parfait gentleman.'

10. Identified by Nochlin (3).

11. I have found Mandrou by far the most searching study of popular art – the only study to go beyond the collector's attitude. The following account leans heavily on his analysis of its themes and historical development.

12. See Soboul (3), pp. 672–3, for analysis of a tinker's box seized in the month of Pluviôse, An II.

13. See Borel (1), p. 75, letter to Bruyas. The evidence of the Jury des Admissions confirms this. In the session of 7 Apr. La Rencontre is marked Rejected then revised to Admitted. See AN. F21* 2793.

14. See Reff (1), for a full discussion of the picture's iconography.

Select Bibliography

1. Primary Sources

ARCHIVES NATIONALES. Especially Series BB18. – Justice. Correspondance générale de la division criminelle. (Including dossiers 1449, Colportage et crieurs publics, 1849–50; 1470, Délits de presse, 1848–50; 1472, Sociétés secrètes, 1832–50; 1482, Emblèmes et insignes séditieux, 1849–50; 1487 et seq. Poursuites contre la presse, 1850–52.)

BB30. – Cabinet du ministre de la Justice. (Contains the invaluable *Rapports politiques des procureurs généraux*, 1849–68, dossiers 370–382.)

C944–967. – Assemblée Nationale, Enquête sur le travail de 1848.

F1C III. – Esprit public et élections. (Especially F1C III Besançon, 8. Correspondance, etc.)

F7. 12238. – Police générale. Dossier sur les saltimbanques, etc.

F18.262. – Imprimerie, Presse etc. Etats des journaux, 1849–51.

F21. – Beaux-Arts. (Among a mass of material, the most useful were: Dossiers 12–60, Commissions, etc., 1841–50; 61–112, Commissions, etc., 1851–60; 519–22, Exposition de 1855; 527, Salons, 1848–53; 566, Competition for Republic figure; F21* 2793–7, Exposition de 1855; 4006, Budget des Beaux-Arts, 1849.

ARCHIVES DÉPARTEMENTALES, Doubs. Especially Series M. – Police, Esprit Public (Including dossiers 734, Rapports et correspondance des préfets et sous-préfets, 1849; 735, Correspondance ministérielle, visite présidentielle, 1850; 736, Préfets, sous-préfets, police, 1850; 738–40, Préfets, sous-préfets, 1851.)

ARCHIVES DU LOUVRE. Documentation on the Salons of 1848, 1849, 1850–51: including the artists' *Notices* for their entry, Registers of pictures received, and 'Procès-verbaux des Juries d'Admission'.

BIBLIOTHÈQUE NATIONALE, MANUSCRITS.

BIBLIOTHÈQUE NATIONALE, SALLE DES ESTAMPES.

2 Secondary sources

This book and Clark (3), listed below, were researched together and therefore share a bibliography.

ABE, Y. (1) 'Un Enterrement à Ornans et l'habit noir baudelairien', *Études de langue et littérature françaises*, 1, Tokyo, 1962.

— (2) 'Baudelaire face aux artistes de son temps', *Revue de l'art*, 4, 1969.

— (3) 'Les Relations de Baudelaire et de Courbet (1): Avant 1850'. Chapter Two of unpublished thesis on Baudelaire and Realism, n.d.

ADHÉMAR, H. 'La Liberté sur les barricades de Delacroix, étudiée d'après des documents inédits', *Gazette des Beaux-Arts*, 43, Feb. 1954.

ADHÉMAR, J. *Honoré Daumier*, Paris, 1954.

ALEXANDRE, A. *Honoré Daumier, l'homme et l'œuvre*, Paris, 1888.

AMMAN, P. 'A *Journée* in the Making: May 15, 1848', *Journal of Modern History*, 42, no. 1, March 1970.

ANGRAND, P. 'L'Etat-mécène, période autoritaire du Second Empire (1851–1860)', *Gazette des beaux-arts*, May–June 1968.

ANTAL, F. (1) *Florentine Painting and its Social Background*, London, 1948.

— (2) *Classicism and Romanticism, with Other Studies in Art History*, London, 1966.

ARAGON, L. *L'Exemple de Courbet*, Paris, 1952.

ARMENGAUD, A. *Les Populations de l'Est-Aquitain au début de l'époque contemporaine (vers 1845–vers 1871,)* Paris, 1961.

BALZAC, H. DE *Les Paysans*, ed. J.-H. Donnard, Paris, 1964. 1st pub. in book form 1855, 1st serialized in part 1844.

BANDY, W., AND J. MOUQUET *Baudelaire en 1848*, Paris, 1946.

— AND C. PICHOIS *Baudelaire devant ses contemporains*, 2nd edn, Paris, 1967.

BAUDELAIRE, C. (1) *Les Fleurs du mal*, ed. J. Crépet, Paris, 1922.

— (2) *Les Fleurs du mal*, ed. J. Crépet and G. Blin, Paris, 1942.

— (3) *Correspondance générale*, ed. J. Crépet and C. Pichois, 6 vols., Paris, 1947–53.

— (4) *Œuvres complètes*, ed. Y.-G. Le Dantec and C. Pichois, Paris, 1961.

— (5) *Les Fleurs du mal*, ed. J. Crépet, G. Blin and C. Pichois, 1st vol., Paris, 1968.

— (6) *Catalogue de l'exposition Baudelaire*, Petit Palais, Paris, 23 Nov. 1968–17 Mar. 1969.

— (7) *Le Salut public, reproduction en fac-similé*, ed. F. Vanderem, Paris, n.d.

BÉNÉZIT, E. *Dictionnaire critique et documentaire des peintres, sculpteurs, dessinateurs et graveurs*, 8 vols., Paris, 1948–55.

BENJAMIN, W. (1) 'Paris – Capital of the Nineteenth Century', *New Left Review*, 48, Mar.-Apr. 1968.

— (2) *Illuminations*, London, 1970.

— (3) 'The Author as Producer', *New Left Review*, 62, July–Aug. 1970.

BERGER, K. 'Courbet in his Century', *Gazette des beaux-arts*, 24, 1943.

BIBLIOTHÈQUE NATIONALE. *La Revolution de 1848, exposition organisée par le comité national du centenaire*, Paris, 1948.

BLACHE, N. *Histoire de l'insurrection du Var en décembre 1851*, Paris, 1869.

BLANC, C. *L'Œuvre de Rembrandt, décrit et commenté par M. C. Blanc*, Paris, 1853.

BLANQUI, A. (1) 'Tableau des populations rurales de la France en 1850', *Journal des économistes*, 28, Jan. 1851, and 30, Sep. 1851.

— (2) 'Les populations rurales de la France', *Annales provençales d'agriculture*, 1851.

Blin, G. *Le Sadisme de Baudelaire*, Paris, 1948.

Boime, A. (1) 'Thomas Couture and the Evolution of Painting in Nineteenth-century France', *Art Bulletin*, 51, March 1969.

— (2) *The Academy and French Painting in the Nineteenth Century*, London, 1971.

— (3) 'The Second Republic's Contest for the Figure of the Republic', *Art Bulletin*, 53, March 1971.

Bonnemère, E. *Histoire des paysans*, Paris, 1857.

Borel, P. (1) *Le Roman de Gustave Courbet*, 2nd edn, Paris, 1922.

— (2) *Lettres de Gustave Courbet à Alfred Bruyas*, Geneva, 1951.

Bouillon, J. 'Les démocrates-socialistes aux élections de 1849', *Revue française de science politique*, 1956. no. 1.

Bourguin, G. and M. Terrier, *1848*, Paris, 1948.

Boyer d'Agen. *Ingres d'après une correspondance inédite*, Paris, 1909.

Bouvier, E. *La Bataille réaliste (1844–57)*, Paris, 1914.

Bruyas, A. (1) *Salons de peinture*, Paris, 1853.

— (2) *Explication des œuvres de peinture du cabinet Alfred Bruyas*, Montpellier, 1854.

Buchon, M. (1) *Poésies*, Arbois, 1843.

— (2) *Poésies allemandes de J.-P. Hebel, Th. Koerner, L. Uhland, H. Heine*, Salins, 1846.

— (3) *Poésies complètes de J.-P. Hebel, suives de scènes champêtres*, Paris, 1853.

— (4) 'Le Matachin', *Revue des deux mondes*, 6, 2nd ser., June 1854.

— (5) 'Le Gouffre-gourmand', *Revue des deux mondes*, 8, 2nd ser., Oct. 1854.

— (6) *Recueil de dissertations sur le réalisme*, Neuchâtel, 1856.

— (7) *Noëls et chants populaires de la Franche-Comté*, Salins, 1863.

— (8) *Poésies franc-comtoises*, 3rd edn, Besançon, 1868.

Cassagne, A. *La Théorie de l'art pour l'art en France*, Paris, n.d.

Cassou, J. *Le Quarante-huitard*, Paris, 1948.

Castagnary, J. 'Fragments d'un livre sur Courbet', *Gazette des Beaux-Arts*, Dec. 1911–Jan. 1912.

Châle, T. 'Débardeur et piocheur de craie de la banlieue de Paris', *Les Ouvriers des deux mondes*, t. 2, 1858.

Champfleury (J.-F.-F. Husson) (1) *Essai sur la vie et l'œuvre des Lenain, peintres laonnois*, Laon, 1850.

— (2) *Les Excentriques*, 2nd edn., Paris, 1877, 1st pub. 1852.

— (3) *Contes domestiques*, Paris, 1852.

— (4) *Contes d'été*, Paris, 1853.

— (5) *Les Aventures de Mlle Mariette*, Paris, 1853.

— (6) *Les Oies de Noël*, Paris, 1853.

— (7) *Contes d'automne*, Paris, 1854.

— (8) *Grandes figures d'hier et d'aujourd'hui*, Paris, 1861.

— (9) *Nouvelles recherches sur la vie et l'œuvre des Frères Le Nain*, Laon, 1862, 1st pub. in *Gazette des beaux-arts*, 1860.

— (10) *Histoire de la caricature moderne*, Paris, 1865.

— (11) *Histoire de l'imagerie populaire*, Paris, 1869.

— (12) *Souvenirs et portraits de jeunesse*, Paris, 1872.

— (13) *L'Usurier Blaizot* (original title in *feuilleton*, *Les Trois Oies de Noël*, then in book form *Les Oies de Noël*), 2nd edn, Paris, 1880.

CHAMPFLEURY (14) *Œuvres posthumes. Salons 1846–51*, ed. J. Troubat, Paris, 1894.

CHEVALIER, L. (1) *La Formation de la population parisienne au XIX^e siècle*, Paris, 1950.

— (2) 'Fondements économiques et sociaux de l'histoire politique de la région parisienne (1848–1852)', unpub. thesis, Paris, 1951.

— (3) *Classes laborieuses et classes dangereuses à Paris pendant la première moitié du XIX^e siècle*, Paris, 1958.

CHEVILLARD, V. *Un Peintre romantique, Théodore Chassériau*, Paris, 1893.

CHIRICO, G. DE *Gustave Courbet*, Rome, 1926.

CLARK, T. J. (1) 'A Bourgeois Dance of Death: Max Buchon on Courbet – 1', *Burlington Magazine*, CXI, April 1969.

— (2) 'A Bourgeois Dance of Death: Max Buchon on Courbet – 2', *Burlington Magazine*, CXI, May 1969.

— (3) *The Absolute Bourgeois: Artists and Politics in France 1848–1851*, London, 1973, USA edn, *Artists and Politics in France, 1848–1851*, Greenwich, Conn., 1973.

COBBAN, A. 'The Influence of the clergy and the "instituteurs primaires" in the election of the French Constituent Assembly, April 1848', *English Historical Review*, 1942.

Compte rendu du dernier procès du Démocrate franc-comtois, Besançon, 1850.

CONSTANT, ABBÉ. *La Dernière Incarnation*, Paris, 1847.

COOPER, D. (1) 'The Challenge of Courbet', *Times Literary Supplement*, 27 June 1952.

— (2) 'Courbet in Philadelphia and Boston', *Burlington Magazine*, 102, 1960.

Courbet dans les collections privées françaises, Galerie Claude Aubry, Paris, May–June, 1966.

COURTHION, P. (1) *Courbet*, Paris, 1931.

— (2) *Courbet raconté par lui-même et par ses amis*, 2 vols., Geneva, 1948 and 1950.

COUTURE, T. *Thomas Couture, 1815–1879, sa vie, son œuvre, son caractère, ses idées, sa méthode, par lui-même et son petit-fils*, Paris, 1932.

CRÉMIEUX, A. *La Révolution de février: étude critique sur les journées des 21, 22, 23, et 24 février 1848*, Paris, 1912.

CRÉPET, E. AND CRÉPET, J. *Baudelaire*, Paris, 1907.

CROUZET, M. *Un Méconnu du réalisme: Duranty 1833–80*, Paris, 1964.

DANSETTE, A. (1) *Histoire religieuse de la France contemporaine*, 2 vols., Paris, 1948.

— (2) *Louis-Napoléon à la conquête du pouvoir*, Paris, 1961.

DAUMARD, A. *La Bourgeoisie parisienne de 1815 à 1848*, Paris, 1963.

DAUMIER, H. *Daumier raconté par lui-même et par ses amis*, ed. P. Cailler, Geneva, 1945.

DAVID D'ANGERS, P. J. *Les Carnets de David d'Angers*, ed. A. Bruel, 2 vols., Paris, 1956.

DELACROIX, E. (1) *Œuvres littéraires*, 2 vols., Paris, 1923.

— (2) *Correspondance générale*, ed. A. Joubin, 5 vols., Paris, 1936–38.

— (3) *Journal de Eugène Delacroix*, ed. A. Joubin, 3 vols., 3rd edn., Paris, 1960.

— (4) *An exhibition of paintings, drawings and lithographs*, The Arts Council, intro. L. Eitner, catalogue L. Johnson, London, 1964.

DELTEIL, L. *Le Peintre-graveur illustré*, Paris, 10 vols., 1925–30.

DE LUNA, F. *The French Republic under Cavaignac, 1848*, Princeton, 1969.

DELVAU, A. *Histoire anecdotique des cafés et cabarets de Paris*, Paris, 1862.

DEMETZ, P. 'Defenses of Dutch Painting and the Theory of Realism', *Comparative Literature* 15, Spring 1963.

DESAUNAIS, A. 'La Révolution de 1848 dans le département du Jura', in *Volume du centenaire de 1848 dans le Jura*, Lons-le-Saunier, 1948.

DESSAL, M. 'Le Complot de Lyon et la résistance au coup d'état dans les départements du Sud-Est', in *1848 et les Révolutions du dix-neuvième siécle*, 1951.

DEUTSCHER, I. *The Prophet Armed, Trotsky: 1879–1921*, Oxford, 1970.

Dictionnaire de biographie française, vol. 7, Paris, 1956.

DOLLÉANS, E. *Proudhon*, Paris, 1948.

DOLLÉANS, E. AND J.-L. PUECH *Proudhon et la révolution de 1848*, Paris, 1948.

DOUCE, F. *Holbein's Dance of Death*, London, 1858.

DROZ, E. *P.-J. Proudhon (1809–1865)*, Paris, 1909.

DROZ, W. 'L'inspiration plastique chez Baudelaire', *Gazette des beaux-arts*, 1957.

DUCHARTRE, P. AND R. SAULNIER *L'Imagerie populaire*, Paris, 1925.

DUMENSIL, A. *La Foi nouvelle cherchée dans l'art, de Rembrandt à Beethoven*, Paris, 1850.

DUPEUX, G. *Aspects de l'histoire sociale et politique du Loir-et-Cher, 1848–1914*, Paris, 1962.

DUPONT, P. *Chants et chansons, poésie et musique*, 4 vols., Paris, 1852–9 (publication dates proper uncertain, 1st vol. probably pub. 1851).

DURRIEUX, A. *Monographie du paysan du département du Gers*, Paris, 1865 (written 1860–1).

DUVEAU, G. (1) *Raspail*, Paris, 1948.

— (2) *1848*, Paris, 1965.

ESTIGNARD, A. *G. Courbet, sa vie et ses œuvres*, Besançon, 1896.

Exposition des œuvres de G. Courbet à l'école des Beaux-Arts, Paris, 1882 (with supplement by Castagnary).

Exhibition et vente de 40 tableaux et 4 dessins de l'œuvre de M. Gustave Courbet, avenue Montaigne, 7, Champs-Elysées, Paris, 1855.

Exposition Gustave Courbet, 1819–1877, Musée des Beaux-Arts de Besançon, Aug.–Oct. 1952.

(FERNIER, R.) (1) 'Une Œuvre inconnue de Courbet', *Les Amis de Gustave Courbet: Bulletin No. 4*, 1948.

FERNIER, R. (2) 'En marge de l'enterrement d'Ornans', *Les Amis de Gustave Courbet: Bulletin No. 10*, 1951.

— (3) *Gustave Courbet*, London, 1970.

FLAUBERT, G. (1) *Correspondance* (vol. 6 of *Les Œuvres de Gustave Flaubert*), Lausanne, 1964.

— (2) *L'Éducation sentimentale*, ed. E. Maynial, Paris, 1964 (1st pub. 1869).

— (3) *Madame Bovary*, ed. J. Suffel, Paris, 1966 (1st pub. 1857).

FOUCHÉ, J.-L. 'L'Opinion d'Ingres sur le salon. Procès-verbaux de la commission permanente des Beaux-Arts, 1848–49', *Chronique des arts*, Mar. 1908.

FOURCAUD, L. *François Rude*, Paris, 1904.

FREY, H. *Max Buchon et son œuvre*, Besançon, 1940.

FRIED, M. (1) 'Manet's Sources. Aspects of his Art, 1859–1865', *Artforum*, Mar. 1969.

— (2) 'Thomas Couture and the Theatricalization of Action in Nineteenth-Century Painting', *Artforum*, June 1970.

GAILLARD, J. 'La Question du crédit et les almanachs autour de 1850', *Études, bibliothèque de la Révolution de 1848*, t. 16.

GALIMARD, A. *Examen du salon de 1849*, Paris, 1849.

GAUCHAT, R. 'L'Urbanisme dans les villes anciennes: les faubourgs de Dijon', *Mémoires de la commission des antiquaires de la Côte d'Or*, t. 23, 1955.

GAUTIER, T. (1) *L'Art moderne*, Paris, 1856.

— (2) *Emaux et Camées*, new edn, Lille-Geneva, 1947.

GAUTIER, T. (3) *Œuvres érotiques*, Paris, 1953.

G. *Courbet*, Paris, Petit Palais, 1955.

GEORGEL, P. 'Delacroix et Auguste Vacquerie', *Bulletin de la société de l'histoire de l'art français*, 1968.

GOSSEZ, R. (1) 'Les quarante-cinq centimes', *Études de la société de l'histoire de la Révolution de 1848*, 1953.

— (2) 'Diversité des antagonismes sociaux vers le milieu du XIXᵉ siècle', *Revue économique*, no. 3, 1956.

GRATE, P. *Deux Critiques d'art de l'époque romantique, Gustave Planche et Theophile Thoré*, Stockholm, 1959.

GRÉARD, V. *Meissonier. His Life and Art*, London, 1897.

GROJNOWSKI, D. 'Baudelaire et Pierre Dupont – La Source d'inspiration de l'Invitation au voyage', *Europe*, no. 456-7, Apr.–May 1967.

GROS-KOST, E. *Gustave Courbet, souvenirs intimes*, Paris, 1880.

GUILLEMIN, H. (1) *Lamartine en 1848*, Paris, 1948.

— (2) *La Tragédie de quarante-huit*, Geneva, 1948.

GUINARD, P. *Dauzats et Blanchard peintres de l'Espagne romantique*, Paris, 1967.

GUINARD, P., AND R. MESURET. 'Le Goût de la peinture espagnole en France', in *Trésors de la peinture espagnole*, Musée des Arts Décoratifs, Paris, Jan.–Apr. 1963.

Gustave Courbet (1819–1877) Exposition à l'Académie de France, Villa Medici, Rome, 1969-70.

Gustave Courbet, 1819–1877, Philadelphia Museum of Art, Museum of Fine Arts, Boston, 1959-60.

HAMILTON, G. 'The Iconographical Origins of Delacroix's "Liberty Leading the People"', *Studies in Art and Literature for Belle da Costa Greene*, Princeton, 1954.

HAUBTMANN, P. *P.-J. Proudhon, genèse d'un antithéiste*, Paris, 1969.

HEMMINGS, F. *Emile Zola*, 2nd edn, Oxford, 1966.

HERBERT, R. L. (1) 'Millet Revisited – 1', *Burlington Magazine*, July 1962.

— (2) 'Millet Revisited – 2', *Burlington Magazine*, Sep. 1962.

— (3) *Barbizon Revisited*, catalogue of exhibition in San Francisco, Toledo, Cleveland and Boston, Boston, 1962.

— (4) 'Millet Reconsidered', *Museum Studies*, 1, 1966.

— (5) 'City vs. Country: The Rural Image in French Painting from Millet to Gauguin', *Artforum*, Feb. 1970.

INGRES, J.-D. *Peintures. Ingres et son temps*, Exhibition catalogue (Inventaire des collections publiques françaises, no. 11), Montauban, 1965.

JAKOBSON, R. 'Two Aspects of Language and Two Types of Aphasic Disturbances', in JAKOBSON, R. AND M. HALLE, *Fundamentals of Language*, The Hague, 1956.

JAMES, H. (1) *Daumier, Caricaturist*, new edn., London, 1954.

— (2) *The Golden Bowl*, new edn, Harmondsworth, 1966.

JEAN-AUBRY, G. *Eugène Boudin d'après des documents inédits. L'homme et l'œuvre*, Paris, 1922. Illustrated edn in English, London and Greenwich, Conn., 1969.

KLINGENDER, F. 'Géricault as seen in 1848', *Burlington Magazine*, 1942.

LABROUSSE, E. (1) '1848–1830–1871. Comment naissent les révolutions', in *Actes du congrès historique du centénaire de 1848*, Paris, 1949.

— (ed.) (2) *Aspects de la crise et de la dépression de l'économie française au milieu du dix-neuvième siècle, 1846–1851*, Bibliothèque de la Révolution de 1848, Paris, 1956.

LACAN, J. *Écrits*, Paris, 1966.

LARKIN, O. (1) 'Courbet and His Contemporaries, 1848–67', *Science and Society*, 3, Winter 1939.

— (2) *Daumier: Man of his Time*, London, 1967.

LASTEYRIE, F de. *Le Paysan. Ce qu'il est – Ce qu'il devrait être*, Paris, 1869.

LAURENT, R. *Les Vignerons de la 'Côte D'Or' au 19ᵉ siècle*, Dijon, 1958.

LECOUTURIER, F. *Paris incompatible avec la République*, Paris, 1848.

LEFEBVRE, G. 'La Révolution française et les paysans', in *Études sur la révolution française*, Paris, 1954.

LÉGER, C. (1) *Courbet selon les caricatures et les images*, Paris, 1920.

— (2) 'Courbet, ses amis et ses élèves', *Mercure de France*, 1928.

— (3) *Courbet*, Paris, 1929.

— (4) 'À la découverte de Courbet. Documents inédits', *L'Amour de l'Art*, No. 10, Oct. 1931.

— (5) 'Baudelaire et Courbet', *Mercure de France*, 1939.

— (6) *Courbet et son temps*, Paris, 1948.

LEMANN, B. 'Daumier and the Republic', *Gazette des Beaux-Arts*, 1945.

LEPOITTEVIN, L. (1) *Catalogue de l'exposition Millet*, Musée Thomas-Henry, Cherbourg, July–Sep. 1964.

— (2) 'J.-F. Millet, mythe et réalité', *L'Œil*, 119, Nov. 1964.

Les Ouvriers des deux mondes. Etudes sur les travaux, la vie domestique et la condition morale des populations ouvrières des diverses contrées, 5 vols., Paris, 1857–75.

LÉVI-STRAUSS, C. *The Raw and the Cooked. Introduction to a Science of Mythology: 1*, London, 1970.

LÉVY, C. 'Notes sur les fondements sociaux de l'insurrection de décembre 1851 en province', *Information historique*, Sep.–Oct. 1954.

LÓPEZ-REY, J. *Velasquez. A Catalogue Raisonné of his Œuvre*, London, 1963.

LÜDECKE, H. *Eugène Delacroix und die Pariser Julirevolution*, Berlin, 1965.

LUKÁCS, G. 'Balzac: The Peasants' in *Studies in European Realism*, London, 1950.

MACHEREY, P. '*Les Paysans* de Balzac; un texte disparate', in *Pour une théorie de la production littéraire*, Paris, 1966.

MACK, G. *Gustave Courbet*, London, 1951.

MAC ORLAN, P. *Courbet*, Paris, 1951.

MAISON, K. *Honoré Daumier: Catalogue Raisonné of the Paintings, Watercolours and Drawings*, 2 vols., London and New York 1968.

MALLARMÉ, S. *Correspondance 1862–1871*, ed. H. Mondor, Paris, 1959.

MANDROU, R. *De la culture populaire aux 17ᵉ et 18ᵉ siècles*, Paris, 1964.

MARCEL, H. *Théodore Chassériau*, Paris, 1911.

MARLIN, R. (1) 'L'Élection presidentielle de Louis-Napoléon Bonaparte dans le Doubs', *Annales littéraires de l'université de Besançon*, 2, fasc. 3, 1955.

— (2) *L'Epuration politique dans le Doubs à la suite du coup d'état du 2 Déc. 1851*, Chazelle-Dole, 1958.

MARX, K. (1) 'The Class Struggles in France', reprinted in *Karl Marx and Frederick Engels, Selected Works*, vol. 1, Moscow, 1962.

— (2) 'The Eighteenth Brumaire of Louis Bonaparte', reprinted *ibid.*

MELTZOFF. S. 'The Revival of the Le Nains', *Art Bulletin*, 24, 1942.

MIETTE DE VILLARS. *Mémoires de David, peintre et député à la convention*, Paris, 1850.

MISTLER, J. *Les Origines de l'imagerie populaire*, Paris, 1961.

MISTLER, J., F. BLAUDEZ AND A. JACQUEMIN. *Epinal et l'imagerie populaire*, Paris, 1961.

MODESTE, V. *De la Cherté des grains et des préjugés populaires qui déterminent des violences*, Paris, 1850.

MOLL, L. *Excursion agricole dans quelques départements du Nord de la France, entreprise aux frais du gouvernement*, Paris, 1836.

MOLOK, A. 'Les Mouvements révolutionnaires dans les banlieues de Paris pendant l'insurrection de juin 1848', *Annuaire d'études françaises*, Moscow, 1964.

MOREAU-NÉLATON, E. (1) *Millet raconté par lui-même*, 3 vols., Paris, 1921.

— (2) *Bonvin raconté par lui-même*, Paris, 1927.

MURGER, H. *Scènes de la vie de bohème*, Paris, 1851.

NICOLSON, B. (1) 'Courbet at the Marlborough Gallery', *Burlington Magazine*, 95, 1953.

— (2) 'Courbet's "L'Aumône d'un mendiant"', *Burlington Magazine*, 104, 1962.

NIÉPOIVIÉ. *Études psychologiques sur les grandes métropoles de l'Europe occidentale*, Paris, 1840.

NISARD, C. *Histoire des livres populaires ou de la littérature de colportage depuis l'origine de l'imprimerie jusqu'a l'établissement de la commission d'examen des livres de colportage*, Paris, 1854.

NOCHLIN, L. (1) 'The Development and Nature of Realism in the Work of Gustave Courbet: A Study of the Style and its Social and Artistic Background', unpublished Ph. D. dissertation, New York University, 1963.

— (2) 'Innovation and Tradition in Courbet's *Burial at Ornans*', in *Essays in Honour of Walter Friedlaender*, New York, 1965.

— (3) 'Gustave Courbet's *Meeting*: A Portrait of the Artist as a Wandering Jew', *Art Bulletin*, 49, Sep. 1967.

— (4) 'The Invention of the Avant-Garde: France 1830–80', in *Art News Annual*, 34.

NOLLE, Y. 'Dijon au début du Second Empire, 1851–58', *Annales de Bourgogne*, 24, 1952.

NORMANBY, LORD. *Une Année de révolution*, 2 vols., Paris, 1857.

NOVALIS. *The Novices of Sais*, New York, 1949.

OSIAKOVSKI, S. 'Some Political and Social Views of Daumier as shown in his Lithographs', unpublished Ph.D. thesis, London University, 1957.

PICHOIS, C. *Baudelaire, études et témoignages*, Neuchâtel, 1967.

PICHOIS, C. AND F. RUCHON. *Iconographie de Charles Baudelaire*, Geneva, 1960.

POE, E. A. *Selected Writings of Edgar Allan Poe*, ed. D. Galloway, London, 1967.

POUTHAS, C.-H. *La Révolution de 1848 en France et la Seconde République*, Paris, 1952.

Précieux livres, reliures et manuscrits . . . lettres et manuscrits de Charles Baudelaire, Sale Catalogue, Hôtel Drouot, Paris, 1963.

PRÉCLIN, E. 'La Révolution de 1848 en Franche-Comté', in *Etudes d'histoire moderne et contemporaine*, 2, 1948.

PROUDHON, P.-J. (1) *Du Principe de l'art et de sa destination sociale*, 2nd edn, Paris, 1875 (1st pub. 1865).

— (2) *Système des contradictions économiques ou philosophie de la misère*, 2 vols., ed. R. Picard, Paris, 1923 (1st pub. 1846).

— (3) *La Révolution sociale démontrée par le coup d'état du 2 décembre*, ed. E. Dolléans and G. Duveau, Paris, 1936 (1st pub. 1852).

— (4) *Philosophie du progrès*, ed. Th. Ruyssen, Paris, 1946 (1st pub. 1853, written Dec. 1851).

— (5) *Carnets de P.-J. Proudhon*, ed. P. Haubtmann, S. Henneguy and J. Faure-Fremiet, Vol. 1, 1843–6, Paris, 1960, Vol. 2, 1847–48, Paris, 1961.

Quelques Vérités sur le commerce des enterrements à Paris, Paris, 1848.

REFF, T. (1) 'Pissarro's Portrait of Cézanne', *Burlington Magazine*, 109, Nov. 1967.

— (2) '"Manet's Sources": A Critical Evaluation', *Artforum*, Sep. 1969.

RÉMUSAT, C. DE *Mémoires de ma vie*, vol. 4, 1841–1851, Paris, 1962.

RIAT, G. *Gustave Courbet, peintre*, Paris, 1906.

ROBAUT, A. (1) *L'Œuvre complet d'Eugène Delacroix*, Paris, 1885.

— (2) *L'Œuvre de Corot*, 4 vols. Paris 1905.

Romantisme et politique 1815–1851. Colloque de l'École Normale Supérieure de Saint-Cloud, 1966, Paris, 1969.

ROMIEU, MME *Des Paysans et de l'agriculture au XIX^e siècle*, Paris, 1865.

ROSENTHAL, L. *Du Romantisme au réalisme*, Paris, 1914.

ROUSSEAU, M. 'La Vie et l' Œuvre de P.-A. Jeanron, peintre, écrivain, directeur des musées nationaux', unpublished thesis, Archives du Louvre, F.8, 1936.

RUDÉ, G. *The Crowd in History 1730–1848*, London, 1964.

SADE, D. A. F., MARQUIS DE *Français, encore un effort si vous voulez être républicains*, preceded by M. Blanchot, *L'Inconvenance majeure*, Paris, 1965.

SAND, G. *La Petite Fadette*, edition introduced by G. van den Bogaert, Paris, 1967 (1st pub. 1849).

SARTRE, J.-P. (1) *Baudelaire*, London, 1964 (1st pub. 1947).

— (2) 'La Conscience de classe chez Flaubert', *Les Temps Modernes*, 240–241, May–June 1966.

SCHANNE, A. *Souvenirs de Schaunard*, Paris, 1866.

SCHAPIRO, M. 'Courbet and Popular Imagery. An Essay on Realism and Naïveté', *Journal of the Warburg and Courtauld Institutes*, Apr.–June 1941.

SCHARF, A. *Art and Photography*, London, 1968.

SCHMIDT, C. *Les Journées de juin 1848*, Paris, 1926.

SENSIER, A. *La Vie et l'œuvre de Jean-François Millet*, ed. P. Mantz, Paris, 1881.

SERULLAZ, M. (1) *Les Peintures murales de Delacroix*, Paris, 1963.

— (2) *Mémorial de l'exposition Eugène Delacroix*, Paris, 1963.

SILVESTRE, T. (1) *Histoire des artistes vivants, français et étrangers*, Paris, 1857.

— (2) *Les Artistes français*, Brussels and Leipzig, 1861.

SLOANE, J. (1) *French Painting Between the Past and the Present*, Princeton, 1951.

— (2) *Paul-Marc Chenavard, Artist of 1848*, Chapel Hill, 1962.

SOBOUL, A. (1) 'La question paysanne en 1848', *La Pensée*, nos. 18–20, 1948.

— (2) 'Documents, Les Troubles agraires de 1848', *1848*, 39, 1948.

— (3) *Les Sans-culottes parisiens en l'An II: mouvement populaire et gouvernement révolutionnaire*, Paris, 1958.

— (4) 'The French Rural Community in the eighteenth and nineteenth centuries', *Past and Present*, 10, Nov. 1958.

STARKIE, E. (1) *Petrus Borel, the Lycanthrope*, London, 1954.

— (2) *Baudelaire*, 2nd edn, London, 1957.

STERN, D. (Comtesse d'Agoult). *Histoire de la révolution de 1848*, 3 vols., Paris, 1850–53.

TABARANT, A. *La Vie artistique au temps de Baudelaire*, Paris, 1963.

TAINE, H. *Notes sur Paris: vie et opinions de Thomas Graindorge*, 2nd edn, Paris, 1867.

TCHERNOFF, I. *Associations et sociétés secrètes sous la Seconde République (1848–1851)*, Paris, 1905.

TÉNOT, E. *La Province en décembre 1851*, Paris, 1865.

THIAIS, D. DE *Le Paysan tel qu'il est, tel qu'il devrait être*, Poitiers, 1856.

THOMPSON, E. *The Making of the English Working Class*, Vintage edn, New York, 1966.

THORÉ, T. *Salons de T. Thoré, 1844, 1845, 1846, 1847, 1848*, Paris, 1868.

TOCQUEVILLE, A. DE *Souvenirs*, Paris, 1944.

TRAPADOUX, M. *Histoire de saint Jean de Dieu*, Paris, 1844.

TROUBAT, J. (1) 'L'Art à Montpellier. Un portrait de Baudelaire par Courbet', reprinted in *Plume et Pinceau*, Paris, 1878 (1st pub. 1874).

— (2) *Une Amitié à la d'Arthez. Champfleury, Courbet – Max Buchon, suivi d'une conférence sur Sainte-Beuve*, Paris, 1900.

— (3) *Un Coin de littérature sous le second empire. Sainte-Beuve et Champfleury. Lettres de Champfleury*, Paris, 1908.

TUDESQ, A.-J. (1) *Les Grands Notables en France (1840–1849)*, Paris, 1964.

— (2) *L'Élection présidentielle de Louis-Napoléon Bonaparte*, Paris, 1965.

TUIN, H. van der. *L'Évolution psychologique, esthétique et littéraire de Théophile Gautier*, Amsterdam, 1933.

VALLÈS, J. (1) *Les Réfractaires*, Paris, 1865.

— (2) *Le Cri du peuple, février 1848 à mai 1871*, ed. L. Scheler, Paris, 1953.

VEUILLOT, L. *Mélanges réligieux, historiques, politiques et littéraires*, 2nd edn, 4, Paris, 1861.

VIDALENC, J. (1) *Louis Blanc*, Paris, 1948.

— (2) *La Société française de 1815 à 1848: 1. Le Peuple des campagnes*, Paris, 1970.

VIGIER, P. (1) *La Seconde République dans la région alpine. Etude politique et sociale*, 2 vols., Paris, 1963.

— (2) *La Monarchie de juillet*, 2nd edn, Paris, 1965.

— (3) *La Seconde République*, Paris, 1967.

VILLERMÉ, L. 'La Propriété rurale en France', *Revue des deux mondes*, 32, 15 Mar. 1861.

VINCENT, H. *Daumier and his World*, Evanston, 1968.

WALLON, J. *La Presse de 1848*, Paris, 1849.

WASSERMAN, J. *Daumier Sculpture. A Critical and Comparative Study*, Harvard, 1969.

WEINBERG, B. *French Realism: The Critical Reaction*, New York, 1937.

WEY, F. (1) *Manuel des droits et des devoirs. Dictionnaire démocratique*, Paris, 1848.

— (2) *Le Bouquet de cerises, suivi des souvenirs de l'Oberland*, 3rd edn, Paris, 1862.

WOODCOCK, G. *Pierre-Joseph Proudhon: A Biography*, London, 1956.

Photographic Acknowledgments

Archives Photographiques: 4, 5, 24, 34. Bulloz: II, III, IV, 1, 16, 17, 29, 30, 31, 38. Courtauld Institute of Art: 8. Giraudon: I, V, VI, VII, 17, 19. Service de Documentation Photographique: 13, 36, 37. John Webb: 26.

List of Illustrations

Measurements are given in inches and centimetres, height before width, unless otherwise stated.

Index

Courbet, Gustave—cont.

Man with Pipe 34, 42–3, 44–5, 46, 78, 132; *II, 18*; *The Meeting* 23, 32, 156–60; *VII*; *The Middle of the Day* 50; *The Painter* 50; *Peasants of Flagey* 17, 73, 78, 83–5, 110, 114, 130, 133; *IV*; *Portrait of Baudelaire* 41, 43, 44, 51, 69, 74–6, 78, 129; *III*; *Portrait of Berlioz* 43, 51, 132; *26*; *Portrait of Francis Wey* 132; *Portrait of Marc Trapadoux* 41, 44, 50, 69, 70–1; *25*; *Portrait of Monsieur X**** 39, 41, 42; *11*; *Portrait of Promayet* 44, 45; *Portrait of Urbain Cuénot* 42, 50; *13*; *Return from the Conference* 156; *Rocks at Ornans* 50; *23*; *St Nicholas Reviving the Little Children* 43–4; *20*; *Le Salut public* 46, 48; *21*; *The Sculptor* 39–40, 41, 44; *9*; *Self-portrait with Black Dog* 39; *Sleeping Bacchante* 45; *The Stonebreakers* 17, 30–1, 74, 78, 79–80, 82, 83, 84, 88, 109, 112, 113, 116, 122, 133, 135, 142–6, 149, 153, 156, 162–4, 166; *31*; *The Studio* 50, 52, 74, 78, 133

Courbet, Juliette 36
Courbet, Régis 114
Courbet, Zélie 36, 50
Courrier français, Le 137
Couture, Thomas 40, 137
Cubism 19
Cuénot, Urbain: arrest of 99; and Courbet 71, 99; Courbet's portrait of 42, 50; *13*; models for Courbet 44; politics of 100

Dada 19
dandy, cult of 18
Dauger, Alfred, critic 145
Daumard, Adeline, 151
Daumier, Honoré: *and avant garde* 14; and Baudelaire 65, 68; and Bohemia 34; classicism of 19; Champfleury's letter to 65; influence of on Courbet 129; and Paris 29; on peasantry 148; 40; and political art 9; and Salon 146;
David d'Angers, Pierre Jean: *Portrait of Blanqui* 16; *1*
Deburau, Jean-Baptiste Gaspard 54
Degas, Edgard 19
Delacroix, Ferdinand Victor Eugène; 46, 68; and Salon of 1851 131–2, 134; *Liberty Guiding the People* 48, 49; *Lion Hunt* 132
Démocrate Franc-Comtois, Le 99, 109, 112, 113
Démocratie jurassienne 112
Démocratie pacifique 128
Démocratie salinoise 111
Denis, Maurice 19
Desbois, R. 122
Delécluze, Etienne-Jean 136, 137, 140
Deroy, Emile 41
Desbarolles, Adolphe 136, 137
Desplaces, Auguste, critic 134, 142
Dickens, Charles 53

Diderot, Denis: *Rameau's Nephew* 65–6
Dijon 93, 94; Courbet exhibits at (1850) 85, 94, 121, 123–4, 127, 146, 162–4; politics in 93, 94, 98, 99, 113, 123–4
Doré, Gustave 156
Dumas, Alexandre 32
Dumas, Alexandre, the younger 23
Dupays, A.-J., critic 142
Dupont, Pierre 29, 145; and almanachs 156; and Baudelaire 68; Champfleury and 66, 113; and Courbet 52, 68–9; in June revolution 49, 53; and politics 93, 94; 'Chant des paysans' 93
Duranty, Louis Edmond 14, 54
Dürer, Albert 73
Duval, Jeanne 52

elections 86, 87, 88, 99–100
Eliot, T. S. 161
Enault, Louis, on Courbet 9, 10, 134, 140
Exposition Universelle, the 158, 160

Faust (Goethe) 50
February revolution: Champfleury and 66; Courbet and 47; Proudhon and 47
Ferry, Gabriel de 134, 146, 149
Flaubert, Gustave: *L'Education Sentimentale* 128; *Madame Bovary* 39, 155, 166; and Madame Sabatier 14
Fourierism 32, 141, 158; Buchon and 111; Courbet and 22; peasantry and 87
Français, François-Louis 134
Funambules, the 29, 53, 54
funerals, importance of 127–8

Gauguin, Paul 158
Gautier, Amand 39
Gautier, Théophile 20, 111, 121; on *Biez de Serine* 116; and Bohemia 33; on Champfleury 54; and classicism 19; on Courbet 69, 134; and Madame Sabatier 14; pantomimes by 54; and political art 9–10
Gazette de France 135
Geofroy, Louis de 139 153
Géricault, J.-L.-A. Théodore 14, 41, 127; and popular art 20; *Artist in his Studio* 46; *Portrait of a Vendéen* 42; *12*
Gérôme, Jean-Léon 19, 132; *Greek Interior* 131; *35*
Gill, André 160
Goethe, Johann Wolfgang von: *Faust* 50
Golden Bowl, The (James) 15–16
Gossez, Remi 33, 34
Gros-Kost, E. 45
Guercino 42

Hals, Frans 43, 75
Haussard, Prosper 121; on Courbet 23, 50, 70, 130, 136, 137, 138
Hebel, J.-P. 66, 111
Hédouin, Pierre-Edmond-Alexandre 43

Hegel, Georg Wilhelm Friedrich 19, 20, 29
Hegelianism 66
Hesse, Auguste 39, 44
Hoffmann, E. T. A. 31, 53–4, 65
Hogarth, William 81
Holland, Courbet visits (1847) 43
Houssaye, Arsène 137
Huguenin, Jean-Pierre-Victor 77
Hugo, Victor 111; Champfleury on 67; Zola on 24

Icarie 67
Impartial, L' 122
Impressionism 160
Ingres, Jean-Auguste-Dominique 42, 131

James, Henry: *The Golden Bowl* 15–16
Jean Guêtré, Almanac du Paysan 156; *39*
Jeanron, Philippe-Auguste 70, 130
Joigneaux, Pierre 88
Journal des débats 93, 128, 150
Journet, Jean: Baudelaire and 44; and Bohemia 34; Courbet's portrait of 21–2, 34, 44, 51, 132, 139, 157; *6*; influence of on Courbet 32–3; *7*
July Monarchy 96, 147, 148, 158
June revolution: *avant-garde* in 14; Bohemians in 14, 33–4; Champfleury and 53, 67; Baudelaire in 14, 19, 49, 53, 68; Courbet and 34, 49; Dupont in 49, 53; intelligentsia in 34; Wey in 53; workers in 148; peasants in 148
Jury des Récompenses 70

Lacenaire, Pierre François 14
Lacoste, Jules 130
La Fizelière, A. de 134, 136, 145–6
Lagenevais, F. de 69–70, 73
Lamartine, Alphonse de 32
Lansberg, Mathieu 93
Laon, Champfleury at 66, 67, 73
Lautréamont, Isidore Ducasse 14
Ledru-Rollin, Alexandre Auguste 86, 99
Léger, Fernand 161
Legitimists 135, 142
Leleux, Adolphe 43, 79, 130, 131
Leleux brothers 69
Le Nain brothers: Champfleury on 73; influence of on Bonvin 73; influence of on Courbet 16, 72; *The Peasants' Supper* 72; *29*
Lille museum 70, 77
l'Isle-Adam, Villiers de 19
Louis Napoleon (Napoleon III): at Besançon 100–109; Bruyas admires 156; Buchon attacks 113; and Courbet 78; Ornans votes for 100; and see *coup d'état* of 1851
Louis-Philippe, King of France 41
Louvre, the 42, 44, 72
Lyons, Courbet in 29

Macaire, Robert 149
Macherey, Pierre, critic 120
Madame Bovary (Flaubert) 155, 161